Aesthetics and subjectivity:
from Kant to Nietzsche

To my parents, and to the memory of Jean Robertson

ANDREW BOWIE

Aesthetics and subjectivity: from Kant to Nietzsche

Manchester University Press
Manchester and New York

Distributed exclusively in the USA and Canada by St. Martin's Press

Published by Manchester University Press
Oxford Road, Manchester M13 9PL, UK
and Room 400, 175 Fifth Avenue,
New York, NY 10010, USA

Distributed exclusively in the USA and Canada
by St. Martin's Press, Inc.,
175 Fifth Avenue, New York, NY 10010, USA

British Library cataloguing in publication daˑa
Bowie, Andrew
 Aesthetics and subjectivity: from Kant to Nietzsche.
 1. Aesthetics
 I. Title
 111′.85

Library of Congress cataloging in publication data
Bowie, Andrew, 1952–
 Aesthetics and subjectivity: from Kant to Nietzsche/Andrew Bowie.
 p.cm.
 Includes bibliographical references.
 ISBN 0–7190–2445–5
 1. Aesthetics, German—18th century. 2. Aesthetics, German—19th
 century. 3. Aesthetics, Modern—18th century. 4. Aesthetics,
 Modern—19th century. 5. Subjectivity. I. Title
 BH221.G33B68 1990
 111′.85′094309033—dc20 89–49178
 ISBN 0 7190 2445 5 *hardback*

Photoset in Linotron Ehrhardt by
Northern Phototypesetting Co., Bolton
Printed in Great Britain
by Billing & Sons Ltd., Worcester

CONTENTS

PREFACE

This book would not have been written but for the 'European Thought and Literature' course at what is now Anglia Higher Education College in Cambridge. I hope the course retains its integrity in the new consumer-oriented world of British higher education. The commitment over the years of the students I have so far taught on that course was my greatest inspiration. I am deeply indebted to them. Julian Roberts suggested I write a book on German aesthetic theory, and I am glad that, thanks to him, I overcame my initial scepticism about doing so. My suspicion that the direction of contemporary theory in the humanities was awry developed particularly in the meetings of the now sadly defunct Cambridge 'Literature Teaching Politics' Group. Many of the ideas I question in this book first came alive to me in the context of the meetings of the group. The book is devoted to the idea that creative remembering is the vital task for contemporary theory in the humanities: I hope that what was important in those meetings will not be forgotten by the group's members.

The substance of the book was worked out on a year's unpaid leave from the Anglia College, spent in West Berlin. The financial support for the book was provided by my return to the Berlin jazz scene. Having already financed the completion of my doctorate whilst in Berlin in the late seventies by playing jazz, I was glad to be able to finance the present book by combining theory and practice with old friends. Hannes Engels, Gerhard Tenzer, Werner Scheel, Klaus Sonntag, Andreas Janssen, Wolfgang Rügner, Harald Abstein, Jürgen Potthoff, Jimmy Wallat, Bill Peatman, Horst Henschel, Volker Stamm, the late Claudius Littbarski, and many others contributed directly and indirectly to what I have tried to say.

Listing the contributions of friends and colleagues always involves the necessity of omission: I apologise now to those not mentioned by name who also contributed. Without the encouragement and intellectual stimulus of Liz Bradbury, Andrew Benjamin, Steve Giles, Stephen Hinton, Corinna Stupka, Chris Lawn, Don Watts, David Isaac, Simon Schaffer, Jim McGeachie, Peter Middleton, Michael Moriarty, and Kiernan Ryan the book would not have been

possible. My special thanks go to Manfred Frank, whose philosophical work gave me the direction I had been looking for, and whose support and criticism at crucial moments were invaluable. Any distortion of his ideas in the present book is entirely my own fault. Peter Dews' exemplary critical comments on an earlier version enabled me to avoid some serious pitfalls, and his friendship and advice were vital in the many stages of writing the book.

All the translations from German texts cited in the book are my own and are based solely on the original German. I have provided a list of selected translations of some of the important texts used. Many have not been translated, and many of the existing translations are seriously flawed. I hope I have provided a degree of impetus for new translations of a tradition whose real time may only now have come.

<div align="right">

Andrew Bowie
Cambridge, August 1989

</div>

INTRODUCTION

Aesthetics and modernity

In a German politico-philosophical manifesto of 1796 the 'highest act of reason' is proclaimed as an 'aesthetic act'. At the end of the eighteenth century such a startling connection of aesthetics and reason is not an isolated phenomenon. Although questions of beauty and art have played a role in Western philosophy since Plato, it is only around the middle of the eighteenth century in Europe that the notion of a distinct area of philosophy called 'aesthetics' develops. The present book wants to take a new look at how questions of art and beauty are seen in relation to the rest of philosophy between the end of the eighteenth and the end of the nineteenth century in Germany. It will thereby become clear that much contemporary theory, particularly theory which works on the borders between literary theory and philosophy, is inextricably bound up with the history of aesthetic theory in ways that are rarely acknowledged. This blindness to aesthetics is a major reason why many present-day versions of the history of modern philosophy fail to deal appropriately with the question of subjectivity. Furthermore, many of the critical impasses that are now becoming apparent in literary theory are repetitions of problems that already emerged in the history of philosophical aesthetics.

Modern philosophy begins when the basis upon which the world is interpreted ceases to be a deity whose pattern has already been imprinted into existence and becomes instead our reflection upon our own thinking about the world. The ground for this is prepared in the seventeenth century by Descartes' making 'I think' the point of certainty from which philosophy can begin. Descartes, though, relies upon God to guarantee the order of the universe. Towards the end of the eighteenth century Kant makes it the task of philosophy to describe the structure of our consciousness, without having recourse to a divinity

whose order is already inherent in the world. For Kant the only cognitive and ethical certainty philosophy can provide becomes grounded in ourselves, not outside ourselves. However, in order to suggest possible links between the external world of nature and the internal world of self-consciousness, he subsequently becomes concerned with what makes us appreciate and create beauty. The reasons for Kant's turn to aesthetics will form the starting point of the present book.

The turn of philosophy to subjectivity accompanies the complex and contradictory changes wrought by 'modernity': the rise of capitalist individualism, the growing success of scientific method in controlling nature, the decline of traditional, theologically legitimated authorities, and the gradual emergence, together with aesthetics as a branch of philosophy, of aesthetic 'autonomy', the idea that works of art have a status which cannot be attributed to any other natural object or human product. From being a part of philosophy concerned with the senses, and not necessarily with beauty, 'aesthetics' becomes devoted to the significance of natural beauty and of art.

Aesthetics is not simply to be equated with Plato's view of beauty as the symbol of the good, because it is bound up with the emergence of subjectivity as the central issue of modern philosophy. Recent philosophy sees the role of subjectivity as being undermined by its failure to provide a stable ground for philosophy because of its dependence on language. However, this view can already be seen in some of the reflections upon subjectivity which follow Kant. Reflections upon self-consciousness that see the experience of beauty and the fact of aesthetic production as vital to self-consciousness often reveal an excess in subjectivity which cannot be theorised in terms of a subject knowing itself as an object.

These reflections are frequently connected to the form of art most distant from representation: music. The analogies between the growth in importance for philosophy at the end of the eighteenth century of the non-representational form of music, and ideas about the subversion of self-consciousness based on rejecting the model of language as the representation of the ideas of a subject, seen in structuralism and post-structuralism, are not fortuitous. Towards the end of the eighteenth century 'absolute music', music without a text, becomes increasingly important in musical praxis, in philosophical reflection upon the significance of art, and as a means of understanding subjectivity. The significance of music as the most symptomatic art form in this period will be central to my argument. Music makes evident the fact that

understanding subjectivity can never be fully achieved through theoretical articulation.

The importance attributed to art near the end of the eighteenth century has its roots in the decline of theology and the disintegration of theologically legitimated social orders: 'All that is solid melts into air', as Marx put it in the *Communist Manifesto*. The loss of a nature whose meaning is inherent within it and whose structure is divinely guaranteed leads to a search for other sources of meaning and coherence. The idea that nature can be *per se* beautiful, rather than being merely an expression of the deity, and the idea that human beings can create aesthetic products whose interrelating parts are meaningful in ways which natural science cannot explain, become major philosophical issues. Once it is clear that the coherence of the world, including ourselves, can no longer be assumed to be guaranteed by God, the relation of the human and the natural becomes a major problem. The task set by the philosophy of the time is seen as the creation of a coherent world with whatever natural capacities we possess and whatever innovatory capacities we can develop. The question of subjectivity is a reflection upon what these capacities are and how they relate to nature in ourselves and outside ourselves.

This reflection is two-sided: the exhilarated sense of liberation from theological constraints can give way to a suspicion of this freedom and the sense that the universe is inherently meaningless. The move that can be traced from early German Idealism to Schopenhauer is a move between these two opposing responses, responses which both occur in the work of Nietzsche. Both responses to modernity, though, attach an enormous significance to art, either as an image of what the world could look like if we were to realise our freedom, or as the only means of creating an illusion which would enable us to face an otherwise meaningless existence. The two positions are not necessarily wholly opposed. This is evident in their sharing a fundamental suspicion of the growing dominance of quantifying forms of rationality as the essential principle of modern life.

At the moment when philosophy becomes concerned with scientific method and the de-mythologising capacity of science, it also becomes concerned with what is excluded by science. Nothing in the sciences provides a sense of the meaning of nature for the individual subject: the point of science is the production of laws which subsume individual cases. Nature seen with the eyes of modern science starts for many people, though, to look like a machine. Added to this is the awareness

that the increasing domination of capitalism leads to nature being regarded in terms of the profit which can be extracted from it. One of the key attributes of the aesthetic is the fact that what makes an object beautiful has nothing to do with its usefulness or its exchange value. Though art works will more and more become commodities, neither their use-value nor their value as commodities constitutes them as works of art. The potency of aesthetic theory lies not least in its attempts to explain this.

Schelling states in 1800 that demanding usefulness from art 'is only possible in an age which locates the highest efforts of the human spirit in economic discoveries'. Many of Marx's insights into the nature of capitalism have roots in aesthetics. The critique of the commodity form gains part of its force from the idea of an object which cannot be represented by anything else: the work of art. This idea occurs in aesthetic theory when it questions the turning of nature into an object which is subsumable under general scientific rules, rather than seeing it also as worthy of contemplation for its own sake.

The process of rationalisation that leads to the penetration of rule-bound and quantifying procedures into all areas of science, administration and exchange is both the irreplaceable foundation of the advances of modernity and a major problem. Aesthetics is a constant reminder that there are other ways of seeing nature and human activity. The beauty of nature need have no ulterior function. If art has rules they are the products of human freedom, not of the attempt to grasp objective necessities or natural regularities. In the light of the ecological crisis the questions that are raised by aesthetics seem more and more significant today. In this perspective aesthetics need in no way, then, be associated with a rejection of reason. Instead it becomes the location in which what has been repressed by a limited conception of reason can be articulated. The awareness of the danger of this repression, which is one of the main sources of the appeal of contemporary post-structuralist critiques of metaphysics, is already apparent in two of the founding figures of aesthetics: Alexander Baumgarten and J. G. Hamann.

Baumgarten's *Aesthetica*, part one 1750, part two 1758, and Hamann's *Aesthetica in nuce*, of 1762, already begin to suggest what is at stake in the emergence of aesthetics as an independent branch of philosophy. Despite their obvious differences, Baumgarten and Hamann share a concern with the failure of the Rationalist traditions of the eighteenth century to do justice to the immediacy of the individual's sensuous relationship to the world which is part of aesthetic pleasure.

Philosophy based on the Cartesian ideal of clear and distinct ideas finds aesthetic works a problem because they live from their particularity, which is not reducible to conceptual generalisation. Hartmut Scheible has suggested of Baumgarten that his life and work were 'formed by the short historical moment where it is possible, still safeguarded by an unshaken religious world picture, to devote one's attention uninhibitedly to the single empirical phenomenon'.[1] Aesthetic theory from Kant onwards faces the problem of finding a whole into which the particular can fit in a meaningful way, once theological certainties have been abandoned. Both Baumgarten and Hamann are able to celebrate the multiplicity of sensuous particularity because each particular has its meaning in a whole which is divinely guaranteed.

For Baumgarten the rules of art were simply different from the rules of logic. The natural sciences demanded Cartesian 'intensive clarity', the analytical reduction of complexity to simple constitutive elements. Art demanded 'extensive clarity', which allows ever greater differentiation into particularity. Revaluing the sensuous particular and giving it primacy in one branch of philosophy poses problems: how does one abstractly grasp the particular without abolishing its value as particular? Since Parmenides Western philosophy had been suspicious of the unreliability of the sensuous world and had tried to transcend it into an intelligible world of essences. The method of modern science seemed the most appropriate way of achieving this.

The very beginning of modern aesthetics raises, then, the question of the truth which may be attached to individual perceptions. Baumgarten reveals the incompatibility between a conception of truth based on sensuous particularity and a metaphysical world order, without it becoming a problem for him. The endless multiplicity of the particular and individual is an occasion of celebration, which points to an infinity of meaning, not, as it will often do subsequently, to a meaningless randomness. Baumgarten sees aesthetic truth as the *Wahrscheinliche*, that which *appears* as true, even if it cannot be finally proven to be true. The sciences can only ever claim truth for what is clear and distinct. However, this excludes from any kind of truth most of the content of what Husserl will term the 'life-world', the untheorised horizon of our everyday experience of the world.

Baumgarten sees empirical perception in the 'life-world' as an inherent part of the truth of our relationship to the world, hence his insistence upon including aesthetics as a constitutive part of philosophy. The problem of the meaning of this world does not arise, because our

aesthetic pleasure in it suffices to fill the role played by metaphysics, even when the principle of the aesthetic, the particular, points to problems to come. What happens – for Baumgarten this is evidently unthinkable – if there is no centre from which to organise the endless multiplicity, if this particular pleasurable moment has no connection with any other?

However little else he may share with Baumgarten, Hamann does share the wish to celebrate the endless multiplicity of the world. This wish is also grounded in theology: 'The unity of the creator reflects itself in the dialect of his works; – in all of them One note of unmeasurable height and depth!'[2] Hamann's reliance on the word of God is based on the awareness of our dependence on language. This brings him close to contemporary philosophical issues. Language for Hamann is an endless process of translation 'from a language of angels into a human language, that is, thoughts into words, – things into names, – images into signs',[3] which never achieves total communication from one person to another. Significantly, the oldest language is music, and self-presence of signifier and signified, the moment of identity, complete adequacy of what we say or write about the world *to* the world, is not the philosophical ideal. If it were it would stop the celebration of the fullness of existence, a celebration which is the basis of Hamann's conception of aesthetics.

Despite, or perhaps because of, his theology, Hamann comes at times close to post-structuralism. For Hamann the signifying chain can be celebrated for its endless differentiality *because* it can never come to an end. There can be no priority of the abstract over the immediate, indeed such distinctions make little sense in relation to either his theology or the conception of language which develops out of it. *Aesthetica in nuce* has analogies to Baumgarten's aesthetics, but has a more critical accent. Hamann does not strive to integrate the aesthetic into a wider view of philosophy which is still based upon an Enlightenment conception of Reason.

The basis of Hamann's thought is the primacy of the image, of sensuous thinking, before its subsumption into generalised abstractions: 'Nature works through senses and passions. How can someone feel who mutilates its tools?'[4] The 'Muse', poetry, 'will dare to cleanse the natural use of the senses from the unnatural use of abstractions'.[5] Reason for Hamann depends upon language. Language, though, is never wholly separable from sensuousness, it is never the pure articulation of truth. As such, Hamann suggests, in a manner analogous to Rousseau, that 'Poetry [*Poesie*] is the mother tongue of humankind' and

that 'Senses and passions speak and understand nothing but images':[6] the prior form of human thinking is attached to images and direct sensuous activity. This is directed against Rationalist assumptions about the ultimate foundation of reason in mathematics, and thus in abstraction, the world of the intelligible. For Hamann the development of scientific abstraction is built upon foundations which are historically prior and which are inherently sensuous, but which are constituted in language, which, along with its undoubted intelligible aspect, has an inherently sensuous element. Our reason is constituted historically by the work of previous generations and by its transmission in particular languages to us.

The 'Enlightenment' which is based on mathematics therefore depends upon a much more fundamental Enlightenment: 'Let there be light! with this begins the feeling [*Empfindung*] of the presence of things'.[7] This is reminiscent of the later Heidegger's hermeneutic insistence upon the *Lichtung des Seins*, the 'clearing of Being', the necessary and never fully articulable condition of the specific sciences, which Heidegger sees in language. Without the prior 'opening up' or 'enlightenment' of Being, any more specific cognitive relationship to it can make no sense. This 'Erschlossenheit', or 'openness' of Being, is a structure more fundamental than being able to quantify it or subsume it under a law. Hamann's enlightenment insists upon the inclusion of every aspect of sensuous existence in any philosophical project, hence the importance of the aesthetic in a conception of reason which would not be based on exclusion of the particular.

In a strange way Hamann's thinking is both behind, and way ahead of, its time. On the one hand, because of his dogmatic theological convictions, Hamann belongs to the past: like Baumgarten, he still holds on to the metaphysical position which prevents the world threatening to fall apart. Much of what he says is, however, reminiscent of the treatment of philosophy and language in contemporary post-structuralist debates: think of the insistence upon the materiality of the signifier or of Derrida's attention to metaphor in philosophical texts as a way of questioning the dualisms of sensuous and intelligible in Western philosophy. This ambivalent status is common to many of the thinkers I shall be looking at. Much of what they say may belong to ways of arguing that we feel sure we have gone beyond. At the same time significant parts of their work now seem to have a striking relevance to modern philosophy. At a time when suspicion of reason is rife it is important to look again at earlier versions of that suspicion to be found in aesthetic theory.

Aesthetics and 'post-modernity'

An intense critical debate about the nature of 'modernity' has developed in the last few years. In some places this has led to the announcement that the whole 'project' of modernity is now discredited and that we have moved into a 'post-modern' era. According to such arguments, and to Habermas, the modern era was established upon the principle of subjectivity. Both the advocates of post-modernity and Habermas regard this principle as having shown itself to be fatally flawed, albeit for very different reasons. The former wish to question the very idea of rationality, whereas Habermas wishes to sustain the demands of rationality associated with modernity via the turn to intersubjective communication as the new central focus of philosophy.

One of the main aims in what follows will be to show that subjectivity in modern philosophy is conceived of in more complex ways than is usually acknowledged. The history of subjectivity in modern philosophy current in most debates over modernity involves certain thinkers, usually Kant, Hegel, and Nietzsche, to the exclusion of others. The ideas of Fichte, Schelling, Schleiermacher, and the early Romantics, who are central figures in the present book, rarely appear in a serious form in these debates,[8] despite their evident importance to the questions at hand. The fact is that philosophers for whom aesthetics is a central concern often suggest ways in which reason cannot ground itself in subjectivity that are analogous to contemporary arguments. At the same time they also suggest why it is a mistake for philosophy to relegate the issue of subjectivity to being simply a function of something else.

The story of modernity told by the proponents of the 'post-modern condition', such as Jean-François Lyotard, has its roots in the work of Martin Heidegger. Many of Heidegger's most significant arguments, though, have their roots in German Idealist and early Romantic thinkers, as was already suggested in relation to Hamann. Heidegger's thinking is also never far away from questions concerning art. The power of Heidegger's ideas is evident in the way they have directly and indirectly influenced most contemporary theories of modernity, which is why it is important to outline them briefly here. The story he tells is, however, highly questionable, as much of the present book will try to suggest.

For Heidegger the centrality of subjectivity in modern philosophy is part of the story of 'metaphysics', which begins with Parmenides. Heidegger's story is a story about truth. It questions the assumption that

truth is all about saying 'what is really the case', whether because God made it like that or because that is the way we necessarily see it. Truth need not be equated with conceptual determination. Western philosophy, he claims, has sought the truth about 'Being' (*Sein*), by asking what Being is or seeking a way of accounting for the fact *that* it is. Being comes to be regarded as an object to be grasped, by theology, by technological manipulation, or by scientific theories. Being becomes solely there 'for us'. The *Neuzeit* – the term Heidegger uses for what we have termed modernity – begins for him with Descartes, when the 'certainty of all being and all truth is founded on the self-consciousness of the single ego: *ego cogito ergo sum*'. Philosophy becomes an expression of the 'subjectification' of Being, in which everything is seen in terms of its relation to our consciousness. For Heidegger this is most notably the case in German Idealism, which tries to prove that subject and object are identical, so that the way we think the world and the world itself are unified in the same overall process. Heidegger questions whether philosophy can establish a place from which it could answer the question of how thinking and Being relate: what is the Being of thinking, and what is the thinking of Being?

In this story – which is also followed by Gadamer in *Truth and Method* – the emergence of aesthetics as a distinct part of philosophy is part of the process of subjectification: beauty becomes solely a matter of subjective feeling, of 'taste'. Art works are reduced to the contingencies of their reception. An aesthetics based on subjectivity has no way of articulating the truth in works of art that goes beyond their reception at a particular time. At the same time, near the beginning of the nineteenth century, Heidegger claims, the era of the production of great art comes to an end because art can no longer aspire to being true in any emphatic sense, truth being now defined in terms of a subject's capacity for objectifying the world in science. This, for Heidegger, is the real import of Hegel announcing the 'end of art' as a form of truth in his *Aesthetics*. Heidegger, like Hegel, excludes music from the realm of great art. The fact, though, that Beethoven's music is exactly contemporaneous with the supposed end of art will be a vital factor in the alternative story of modernity which I wish to tell. In the wake of Hegel's view of music and of Nietzsche's critique of Wagner in his later philosophy, Heidegger rather superficially sees the growth of the importance of music in modernity as grounded in an attitude to art solely based upon feeling 'which has been left to itself' and he links this to the notion that modern culture has declined from something greater. Music therefore lacks the

seriousness of earlier art, only 'great poetry and thinking' really provide the kind of truth about existence which Heidegger demands.

Anyone familiar with modern music would confirm that this is a questionable position: the idea that musical production (and even its reception) is based solely on feelings is hard to defend. The failure to take music seriously is often the index to why key positions in modern philosophy are questionable. The centrality of music for German aesthetic theory lies in music's complex relationship to language. It is the fact that music is a non-representational, non-conceptual form of articulation which makes it so important as a way of understanding other aspects of subjectivity that are not reducible to the cognitive, the ethical, or the emotive. Some aspects of what music does are also present in verbal language. This, as Schleiermacher suggests, potentially introduces an aesthetic component into all communication, something that the subjectless view of language in Heidegger and his followers would have trouble accounting for.

Heidegger's view of subjectivity is accompanied by a questioning of science and technology which is more significant than his desire to remove subjectivity from philosophy. For Heidegger the objectification of nature as a system of regularities that it is science's task to discover is only one way of interpreting how nature presents itself to us. Nature also presents itself to us in art works, as the attention to art as the counterpart of modern rationalisation in Baumgarten and Hamann already suggested. Heidegger gives a role to certain forms of art as the 'happening of truth'. They are a way of revealing Being which does not make it into an object for a subject. A Van Gogh painting of a pair of shoes can, in these terms, make us appreciate the 'thereness' of things, in a way that a photograph, for example, might not. However, much of the substance of Heidegger's view of art can be seen in the thinking about art which derived from the worries about rationalisation in post-Kantian philosophy. The story of modernity Heidegger tells is highly selective.

In Lyotard's version of Heidegger's story the 'grand narratives' of Enlightenment that emerge in Kant and German Idealism, the stories in which (subjective) Reason was to free us from enslavement to nature and ourselves, have been wholly discredited. Reason is equated with a dominating subjectivity, a will-to-power, without any acknowledgement of how complex the notion of subjectivity actually is in modern philosophy. The realisation of the dependence of consciousness on language, the 'linguistic turn', is read in this perspective as a major factor in the discrediting of subjectivity as the principle of modern philosophy.

For Heidegger the dominance of the subject is subverted by our always already being located in languages which we do not invent and which we need in order to articulate ourselves and the world. In the wake of Heidegger the very notion that subjectivity is a central issue in philosophy gives way to the idea that subjectivity is an 'effect' of the 'discourses' or 'texts' we are located in. For Lyotard the post-modern world is characterised by a multiplicity of competing 'language games', none of which can claim any ultimate legitimation for its way of opening up the world.

This story looks questionable when it is realised that the 'linguistic turn' takes place much earlier than is usually recognised. The origins of modern hermeneutics, the characteristic feature of which is the refusal to give any world view absolute validity because of the need to interpret such views in particular languages, lie clearly in the period of the supposed totalising 'grand narratives' at the end of the eighteenth century. Hamann's critique of Kant in 1784 is based upon Kant's failure to see the necessary role of particular languages in the constitution of the categories. In Schleiermacher's work and in some Romantic reflection upon music and language similar insights are used to give a view of subjectivity, language, and art which can seriously put into question many contemporary theories of language and literature. The real problem of the post-Heideggerian theorists of modernity is the one-dimensional view of subjectivity upon which they base their diagnosis of the present.

The critics of modernity ignore some very obvious features of modernity. The link between the centrality of the subject in modern philosophy and the dominance of science and technology over nature is hardly a direct one. The emergence of aesthetics and its concern with those aspects of subjectivity which are incompatible with wholesale rationalisation, such as music, make this clear. Scientific method and bureaucratic rationalisation attempt to *exclude* the individual subject in the name of 'objectivity'. This objectivity, though, depends upon its other, the subject which defines it: there would be no way of understanding the term object without its other. What sort of object is the subject which is attempting to grasp reality objectively? Unravelling the complexities of this question as it appears in Kantian and post-Kantian philosophy will be one of the main tasks of the present book.[9] The subjects that will emerge are not the conceptual tyrants of Heideggerian thinking: much aesthetic theory is concerned with non-conceptual truth, with the way in which the aesthetic object affects the subject

without the subject wishing to determine the object. Neither are the subjects slaves to language: the capacity for situated linguistic innovation will be fundamental to the subject as conceived by some of the thinkers to be considered.

It is more apt to tell the story of modernity both in terms of the increase of control over nature, based upon the objectifying procedures of the sciences, and the simultaneous emergence *and* repression of new individual attributes of human beings. These factors are complexly intertwined. Modernity gives rise to greater possibilities for subjective freedom in all areas. This is apparent in aesthetic production, where the diversity of means of expression, and creation of meaning, increase, whatever one may think of the import of what is produced. At the same time the scientific, organisational and technological factors which help give rise to these possibilities can lead to an ever profounder sense of the ultimate pointlessness of that freedom. Modernity both creates space for the proliferation of individual meaning and tends to destroy the sense that such meaning really matters in terms of the general goals of society. Philosophical aesthetics has to find ways of thinking the paradoxes involved in unifying the potential for individual meaning that results from the decline of theology with the requirement that meaning should attain some kind of general validity.

The 'post-modern' account of such issues leads to brutal reductionism. One can, and should, see the attempts to theorise the history of self-consciousness that appear in the philosophy I shall be considering as a way of understanding the pathologies of the present from which everyone potentially suffers. As such, it is vital to find ways of telling the story appropriately. There is no way of knowing in advance how this is to be achieved: one is not looking for a coherent history of an already constituted principle of subjectivity, but neither is one looking at an objective process. It seems in thinkers like Lyotard that subjectivity is itself the pathology. From this viewpoint there is no *reason* to attempt to retrace the ways in which the supposed principle of modernity becomes problematic. *Who suffers from it?* There are few grounds for announcing the advent of the post-modern after the death of the subject. Furthermore, such theories are often merely regressive: the portentous announcements of the radically new era beyond subjectivity that are present in the earlier Foucault and in Lyotard have more to do with repression of, than with a serious desire to engage with a past we cannot simply escape.

In this context it is notable that towards the end of his life Foucault

himself became concerned with an 'aesthetics of existence' and with the invention of 'new forms of subjectivity'. In an interview in 1983 he suggests that the 'transformation of one's self by one's own knowledge is, I think, something rather close to the aesthetic experience'.[10] In 1984 he states: 'I do indeed believe that there is no sovereign, founding subject, a universal form of subject to be found everywhere. . . . I believe, on the contrary, that the subject is constituted through practices of subjectification, or, in a more autonomous way, through practices of liberation'.[11] If the subject can be constituted by 'liberation' there must be some way in which one can conceive of what a free subject is. This was one of the key tasks of aesthetic theory from Kant onwards, which, like Foucault, did not always regard the subject as 'sovereign'. It is notable how far Foucault seemed to move back towards this tradition in his later period.[12] Given this shift of perspective by a thinker notable for his earlier antagonism to subjectivity, the issue of subjectivity seems ripe for a re-examination.

The story I wish to tell is primarily motivated by contemporary theoretical debates, not simply by interest in the history of philosophy. This is the reason, along with simple reasons of length, for the perhaps eccentric emphasis on certain thinkers and the omission of others, the most obvious of whom is Schiller. I have not seriously considered questions of influence, and the social and political importance for their own time of the ideas looked at is necessarily a secondary consideration. The texts are often so complex that it is hard to know what effect they would have had. The first task in relation to these texts is an attempt to understand them as responses to certain key philosophical and socio-political problems that still concern people now. Some texts to which I devote considerable space were not published at the time they were written and were only heard as lectures, or, if they were published, they were not always widely read. The complexities of the route which, for instance, leads from Schelling and Schleiermacher, via Feuerbach, to Marx, or which leads from Schelling, via Schopenhauer, to Nietzsche – and beyond – are too great and as yet still too little researched to allow one to make really warrantable assertions about influence. Any such assertions would also have to confront the fact that many vital relevant documents may have been lost forever.

It is clear that the existing stories in the English-speaking world about German Idealism, Romanticism, and hermeneutics are in need of substantial revision, as is the assessment by both left and right of the status of aesthetic theory in philosophy then and now. This revision will

also require a different view of the origins and validity of many positions in contemporary literary theory. I have for this reason often given a substantial amount of technical exposition of little known arguments: without a serious philosophical engagement with these arguments many of the dead-ends of recent theory seem bound to recur. I have not adopted a neutral stance in my analyses: the position from which I am arguing is very close to that of Manfred Frank, and some of the work of Dieter Henrich. Given the general lack of awareness of their work in the English-speaking world, I hope I can thereby begin to help fill a large gap. I hope also that this book can complement Peter Dews' critique of post-structuralism in *Logics of Disintegration*.[13]

The story, of course, does not stop where I do. One of my intentions is to lay the foundations for a subsequent volume which will consider the development of the Marxist tradition of aesthetic theory in this century via Lukács, Benjamin, Adorno and others, and the hermeneutic tradition via Heidegger and Gadamer, to the present. I have tried to suggest links of the thinkers I have directly dealt with to these later thinkers. It should be clear from the way I make these links that it is time to reassess the resources offered by T. W. Adorno in this area. It should also be evident from this volume that the relationship between the Marxist, the hermeneutic, and the post-structuralist traditions is more complicated than it is often made to look.

1

Modern philosophy and the emergence of aesthetic theory: Kant

Self-consciousness, knowledge and freedom

Kant's concern with aesthetics as part of his philosophical system follows the revolution begun by the *Critique of Pure Reason* (*KrV*) of 1781.[1] To understand the importance of the *Critique of Judgement* (*KdU*) of 1790 one must first look briefly at the first two Kantian critiques. The essential problem which emerges in them is that of the relationship between a world seen as governed by natural necessity and a world in which we are autonomous beings. The third critique tries to suggest ways of bridging this divide. It does so by trying to understand natural and artistic beauty. The third critique threatens to bring down the edifice which Kant has constructed in the epistemological and ethical parts of his philosophy. The *KdU* also, though, provides substantial material for subsequent attempts to solve the problems posed by Kant's philosophy.

Dieter Henrich sees the centre of Kant's epistemology as the justification of 'forms of cognition from the form and nature of self-consciousness'.[2] It is the status of this self-consciousness which is the central issue: as we shall see, regarding even Kant's philosophy as part of the subjectification of Being in modern philosophy is questionable. Descartes had located certainty in the thought that I am, albeit only as a thinking being. Doubting this thought involves an undeniable relationship of the doubter to the thought that is being doubted, which therefore provides one with a minimal point of certainty. However, it provides one with little else. Descartes needed God to establish the bridge back to the world outside self-consciousness. Kant wishes to extend the certainty to be derived from subjectivity without using theological support. The problem is how subjectivity can be its own foundation, how subjectivity can constitute warrantable objectivity without

relying upon the assumption of a pre-existing objectivity of the world of nature.

Kant sees any kind of linking of perceptions from the multiplicity of sense data as requiring a *synthesis*, which creates identity from endless difference. This synthesis cannot be derived from our sensuous experience of nature, which could just consist in endless particularity. The central issue becomes, therefore, the identity of that which synthesises, of the subject. As Henrich shows,[3] Kant shifts Descartes' emphasis on the *existence* of self-consciousness onto the *relationship* of the thinker to every thought that the thinker could have. He believes that if one can demonstrate that this relationship requires a binding identity then there will be a way of maintaining a cohesion in philosophy which is not derived from an external source.

The ability to describe the rules that allow one to move from one case of 'I think' to the next becomes fundamental. Kant's argument requires that the synthesis of the data of sensuous experience should entail a necessity which cannot be dismissed without contradicting the incontrovertible fact of self-consciousness. Unless philosophy can give an account of the way in which self-consciousness is sustained between different cases of 'I think', it will abandon the only certain foundation it can now have.

For Kant it is clear that we can only know the world as it *appears* to us via the constitutive categories of subjectivity, which synthesise sense data. The world as an object of truth is located in the structure of the consciousness we have of it. This means that we cannot know how the world is 'in itself'. Knowledge's warrantability, the mechanical necessity of the law of causality, for instance, is dependent upon the subject, not upon the empirical data given to the subject or upon the inherent relatedness of one part of nature to another. Instead of seeing cognition as following the object, the object *qua* object comes to depend upon the subject's constitution of it as an object.

Kant's investment in the distinction between appearances and things in themselves has an essential motivation. It enables him to sustain freedom as part of his philosophy. Nature for Kant appears to work according to mechanical laws of causality, even if these laws are now constituted by a subject. If the laws of nature were properties of the object world 'in itself' they would also apply to ourselves as objects in the world. In such a view the world, including ourselves, would become a machine. Kant, though, is most concerned with the fact that human agency involves the ability to follow moral imperatives, which cannot be

explained in terms of causal laws. If I also am subject to the division between the phenomenal and the noumenal, between how things appear to consciousness and how they are in themselves, my action can be subject to causality as phenomenon but free as something in itself. The will which determines the action is thus inaccessible to cognition in the same way as the thing in itself is inaccessible. We seem, therefore, to exist in two distinct realms: as sensuous beings in the realm of appearance we are determined by the laws of nature, laws which are given to nature by us. We are also, though, free agents. Such a division raises fundamental problems both with regard to the access we have to our capacity for cognition and to the capacity of our will to transcend determination by natural laws. The question is: what sort of object is this subject when it wishes to look at itself?

The basic difficulty is very simple: what Kant is trying to describe is not empirical. Kant is convinced that we have sufficient warrantable necessity available to us to be able to attempt to see why it is warrantable, without invoking theology. He has no doubt about the truth of the propositions of mathematics and their capacity to generate validable scientific knowledge. Neither does he doubt the fact of binding moral imperatives. What he wants to know is what *in us* makes them possible.

It will already be clear that the articulation of what makes cognition and morality possible is achieved in Kant's theory at the expense of everything individual in the subject. This has consequences for aesthetic theory. At the very beginning of the main text of the second edition of the *KrV* (p. B 36), the 'Transcendental Aesthetic', Kant adds a footnote about Baumgarten's new use of the word 'aesthetics' to designate the 'critique of taste', suggesting that the attempt to bring judgements of beauty into philosophy is in vain because such judgements are always based on empirical rules which cannot have the binding force of a priori rules of science. Kant would prefer to reserve the use of the word aesthetic for its old sense, in which he is using it in the *KrV*, of the 'science of all principles of sensuousness' (p. B 35, A 21). By the time of the *KdU*, though, Kant will have moved much closer to Baumgarten. He writes a complex philosophy of aesthetic judgements which suggests links between natural necessity and the freedom of rational beings.

The unity of the subject

Kant's philosophy depends upon establishing certain major distinctions. These distinctions, though, reveal themselves as hard to sustain. The

point of the transcendental aesthetic is to establish the difference between 'empirical intuition', and the concepts which will judge it. This introduces a key word. English uses the technical term 'intuition' to translate the German word *Anschauung*. The word has multiple senses which are not always clear: the word *anschauen* simply means to 'look at'; its philosophical significance is a major theme of German philosophy in this period. Kant sees intuition as the most immediate form of relation of cognition to an object, which 'only takes place to the extent that the object is given to us' (p. B 33, A 19). This lays the ground for the distinction between appearances, objects as given to us, and things in themselves.

The question is how 'inside' and 'outside' relate to each other. Everything turns on the status of 'intuition'. The initial status of an intuition is empirical: the sensation, say, of the hardness of a piece of rock. Kant separates empirical intuitions from 'pure intuition', which is concerned with 'extension and form' of the object. Pure intuition is the form in which we necessarily see things: there are two such forms, space and time. We cannot conceive of an object of the senses which would exist in a non-spatial and non-temporal form. We can, though, conceive of forms of thinking which are non-spatial and non-temporal, namely those aspects of thought which are wholly non-empirical. For Kant these make possible the syntheses of intuitions which make them into reliable cognitions. Cognition has two sources, sensuousness, which provides intuitions, and Understanding, which thinks objects as objects of knowledge by applying categories to intuitions, making difference into identity. The Understanding, though, cannot be given to our knowledge in the same way as things are given in sensuous intuition, because the Understanding is the prior condition of knowing at all.

The first stage of making coherence out of the multiplicity of sensuous data is the effect of *Einbildungskraft* ('imagination'), which turns sense-data into coherent images, *Bilder*, which it has the power (Kraft) to institute into (*ein*) ourselves. In version A of the *KrV* the 'imagination' has a hybrid position: it both produces associations which cohere into something, and is able to reproduce intuitions without the presence of the object of intuition. The imagination seems in this version to be both productive and receptive. Productivity is part of the Understanding, which is necessary for any synthesis of intuitions, receptivity is characteristic of sensuousness.

In the second version of the *KrV* Kant changes the role of the 'imagination', in order to sustain the boundary of sensuous and

intelligible. The problems of the boundary become most apparent in the fundamental part of Kant's attempt to deduce the structure of our subjectivity: the attempt of the I to describe itself as object. It is this part of Kant's philosophy which will have a major effect on German Idealism and early Romanticism, and thus upon aesthetic theory.

The problem is that the highest principle of philosophy, the I, cannot be available as an intuition. Earlier in the *KrV* Kant introduces the argument that 'The *I think* must *be able* to accompany all my representations' (B p. 132). This Kant terms the 'synthetic unity of self-consciousness', because it is constructed via the unifying of different moments, as opposed to Descartes' *cogito*, the 'analytical unity of self-consciousness', in which the thinking and the being of the subject are immediately identical. The consciousness of myself which accompanies each thought, that makes it my thought, does not link this particular 'I think' to any other case of 'I think'. It is only the synthesis of different moments of such consciousness that allows me to become aware of the identity of my own self-consciousness. The synthesis is dependent upon an act of what Kant calls 'spontaneity' (B p. 133): it is 'self-caused', rather than being caused by something else. If it were the result of something else the task would then be to ground that something else in something else, and so on, either until one found a theological first cause, or ad *infinitum*, in which case the synthesis would never happen, which would make self-consciousness impossible.

The spontaneity cannot itself belong to sensuousness. It synthesises what is given in sensuous intuition, according to rules which Kant is describing in the transcendental deduction. This means, though, that the identity of consciousness actually depends upon the multiplicity of intuitions which it synthesises according to the rules of the Understanding: without the data of the object it would be empty. At the same time, it is the synthesising process which enables me to identify myself: 'for otherwise I would have a self which is as differently multi-coloured as I have ideas that I am conscious of' (B p. 134). The identity of the I must lie in the stability of the way I judge intuitions, not in the endless difference of what they are applied to.

The I, thus conceived, is a set of linked cognitive rules that process sensuous data. But what sort of awareness do I have of this self, according to Kant? Kant's answer boils down to the fact that our self-awareness must be of the same order as our intuition of objects: it is of ourselves only as appearance, not as what we are in ourselves. This raises obvious difficulties. The synthetic unity of the I is not guaranteed

by our empirical perception, though empirical perception is a necessary condition of it: it is self-caused. Manfred Frank points out the necessary further aspect of Kant's account: 'In order to be aware of its own appearance (in time) the simple Being of self-consciousness must always already be pre-supposed – otherwise it is as if the self-awareness were to lose its eye'.[4] Consciousness must *already* exist in some way if it is to be aware of the series of intuitions which constitute its appearance as object to itself. Kant acknowledges this problem:

> I am conscious of myself in general in the synthesis of the multiplicity of representations, therefore in the synthetic original unity of apperception, not as I appear to myself, neither *as* I am in myself, but only to the extent *that* I am. This representation is *thinking*, not *intuition* (B p. 157).

The I must have some kind of ontological status which is not exhausted by what I can say about it as appearance. I can, though, say nothing about the manner of its existence.

If I wish to *know* myself I need to use the condition of knowing itself, which is self-caused. I can, though, only use it in relation to my appearing self, which Kant insists I do not create. Self-consciousness is not ultimately a *cognition* of oneself. *Even for Kant, then, reflecting upon oneself as an object, splitting oneself into subject and object, cannot give a complete account of the nature of self-consciousness.* A full cognition of oneself would have to be an *intuition* of something which is wholly in the realm of the intelligible. It would require a self-caused intuition of the self-caused synthesiser of intuitions: an *'intellectual intuition'*.

Kant rejects such an idea because it contradicts his conviction that intuitions without concepts are blind and concepts without intuitions are empty, the argument that the identity of the I depends upon its having intuitions to synthesise. Kant sees intellectual intuition as the mode of awareness of a deity. Manfred Frank puts it like this: 'The whole deduction of the possibility of an objective cognition would become redundant if Kant were to have assumed an intelligence which creates its object from its own powers'.[5] The intelligence Kant thinks he can describe constitutes the truth, not the existence, of the object, via its synthetic powers. The truth of the subject is, though, not adequately articulated in such an account. The highest point of cognitive philosophy cannot know itself, even if it must acknowledge the necessity of its own existence.

Kant has, therefore, a serious problem in using self-consciousness as the highest principle of his philosophy. This also causes problems in the

moral philosophy. As we saw, there can be no evidence of freedom, which Kant calls a 'fact of Reason', because it cannot appear. Freedom is, though, the centre of Kant's enterprise. He talks of a 'causality through freedom' which can bring about new states of the world which can only result from our free activity. Reason, the 'capacity for purposes', realises something which cannot be empirical – freedom – in the world. How, though, are we to know this? As we shall see, Kant's aesthetics will later try to provide an answer to this question. Reason involves something which is infinite, in the sense that it cannot in any way be determined by anything finite we know about the world. It 'shows a spontaneity so pure that it goes far beyond everything with which sensuousness can provide it' (*GMS* BA p. 109).

The recurrence of the term 'spontaneity' is important, in that it links the problem of our free will to the problem of describing the existence of our self-consciousness. It is as if Kant is in the position of Moses in Schönberg's *Moses und Aron*. The most fundamental part of his philosophy cannot be shown, just as Moses is faced with the unenviable task of persuading people to believe in a God they cannot see. As Kant puts it:

> For we can explain nothing except what we can reduce to laws whose object is given in some possible experience. But freedom is a mere Idea, whose objective reality cannot be shown either according to laws of nature and thus also not in any possible experience (*GMS* BA p. 120).

Our will is on the one hand motivated by natural appetites, which are explicable in terms of the Understanding because they are based on laws of nature, and on the other by something in the realm of the intelligible, which cannot be explained. We exercise our rational will in order to bring about changes in the world which would not happen if all were ruled by nature as seen by the Understanding. Kant sees the fact that we can act in ways which are not in accordance with our appetites, and are in accordance with our moral duty, as revealing a capacity to make binding laws that point to a higher purpose in existence.

The problem Kant is left with in the moral philosophy is that, as in the *KrV*, the fundamental principle is not articulable in philosophy. In the moral philosophy Kant more than once invokes the spectre of 'intellectual intuition'. Discussing the categorical imperative – *'Act only according to that maxim through which you can at the same time will that it becomes a universal law'* (*GMS* BA p. 52) – he says that our consciousness of it is a 'fact of reason'. Evidence for this fact would, though, require

access to freedom, which would entail 'an intellectual intuition which one cannot in any way accept here' (*KpV* A p. 57). In both the theoretical and the practical parts of his philosophy, then, Kant leaves a gaping hole where the highest principle is located.

The unification of nature

The problem established by the first two critiques is how the new principle of philosophy, the subject, could demonstrate in a non-circular, and in non-theological fashion, the real foundation of its activities. Why do we synthesise intuitions in a law-bound manner, why do we have a capacity for choosing to act counter to natural inclination in the name of a higher duty? Has this latter ability a goal which is linked to the way in which we see nature functioning, or is it completely independent of what we know about nature? It would seem strange if there were no connection, in that, for Kant, both our cognitive faculty and our freedom are self-caused.

If one cannot suggest a way beyond this account of our relationship to internal and external nature the consequences look disturbing. Is our capacity for reason, as Hobbes or La Rochefoucauld suggest, actually just a form of self-interest? This is not just a theoretical problem. Kant's separation of the spheres of epistemology and ethics into different aspects of ourselves mirrors the separation of the sphere of science and technology from the sphere of law and morality. Nature comes to be seen in terms of regulation and classification, as the new cognitive relationship to it produces the ability to manipulate it to an ever greater extent. Nature becomes an object which the subject determines. Grounding decisions about what ought to be done with the apparently limitless capacity of the Understanding to generate new synthesised material becomes an ever greater problem.

The last thing Kant would have wanted are the consequences of the concrete division of what become reduced to 'fact' and 'value'. For Kant Reason is more important than Understanding. What he sought were ways of unifying the two via self-consciousness. The historical result of the issues Kant reveals is the separation of a world of cold scientific objectivity from a world lacking ethical certainty. Accompanying this development, though, is the complex and diverse development of modern art. Art in modernity can be seen as the place in which those aspects of self-consciousness that are excluded by the dominant processes of modernity find their articulation. The constitution of the

philosophical discipline of aesthetics is an important disruptive factor in the development of modern philosophy. Baumgarten and Hamann already suggested why: aesthetics pays attention to what is not reducible to scientific cognition and is yet undeniably a part of our relationship to the world. Despite the strictures of the first critique, Kant comes to see the importance of this.

The *KdU* is an attempt to show that the kind of consensus achieved via the compelling results of the activity of the Understanding may be extended into realms in which the Understanding has no right of legislation. The question is again how we synthesise the potentially infinite multiplicity of the world, once the synthesis is no longer guaranteed externally. The Understanding, once liberated from any kind of a priori constraint with regard to what it can synthesise, is confronted with complete randomness. There can be no end to what the synthetic rules of the Understanding could apply to.

The attention to the Faust story in this period is not fortuitous. The dark side of modern science makes it clear just how threatening the uncontrolled Understanding is. Divorced from any sense of the possibility of its goals being integrated into a meaningful whole, the machine of science, which derives from the conception of nature as a machine, leads to a 'dialectic of enlightenment', where the liberation from theological tutelage becomes a new form of imprisonment.

The basis of the third critique, the '*power* of judgement' – *Urteilskraft* – is a synthetic capacity which connects the particular to the general. This can happen in two ways. The first is when the Understanding subsumes the particular intuition under a general category. This Kant terms 'determinant' judgement. The law exists prior to the individual case and just needs to be applied. The problem with this kind of judgement is that no amount of applying it will demonstrate that the multiplicity to which it applies has any kind of unity. The sciences can never form a total system: successive processes of subsumption under more and more general principles can never reach something non-contingent. These laws themselves cannot in any way guarantee a systematic relationship between each other because that would require a higher principle which demonstrated that they fitted together. Such a principle would reintroduce dogmatic metaphysics because it would cross the boundary of sensuous and intelligible by making nature inherently intelligible. How, then, are we to know that those parts of nature for which we as yet have no laws really have laws at all?

All the laws we have are based on the need for intuitions to fill the

concepts. This means they must be empirical and thus cannot provide the higher principle required to make nature a unified system. As an attempt to confront this problem Kant introduces the second form of judgement, 'reflective' judgement, whose task is to move from the particular to the general. To do this it entails assuming a higher principle inherent in nature, as otherwise nature becomes a 'labyrinth of the multiplicity of possible particular laws' (*KdU* p. 26). The principle, though, is a necessary *fiction*, which assumes that nature in fact does function in a purposive way: 'as if an Understanding contained the basis of the unity of the multiplicity of its empirical laws' (*KdU* p. B XVIII, A XXVI).

Kant underpins this argument with the fact that natural products are on the one hand mechanical, in terms of the laws which apply to them, but, on the other hand, when seen as 'systems, e.g. formations of crystals, all sorts of forms of flowers, or in the inner construction of plants and animals' they behave '*technically*, i.e. at the same time as *art*' (*KdU* p. 30). 'Art' here has the Greek sense of 'techne', the capacity to produce in a purposive way. Natural products seem to contain an 'Idea' which makes them take the form they do. It is as if the whole of such an organism preceded the parts which we can observe empirically: '*An organised product of nature is that in which everything is an end and on the other hand also a means*. Nothing in it is in vain, pointless, or to be attributed to a blind mechanism of nature' (*KdU* p. B 296, A 292).

This echoes the second critique's concern that rational beings should always be ends in themselves, and not just the means for the ends of other beings. The dissecting capacity of the Understanding in analysing an organism destroys the integrity of what it analyses. The plant which has become an object of scientific dissection can no longer exist as an organism because it has been taken apart as an object in terms of its other, the subject. Similarly, the procedures of scientific analysis of nature do not make nature into a coherent whole. Instead, nature is threatened with disintegration into endless difference. Applying such a conception to society means that the goals of society can only be legitimate if they sustain the integrity of all members of that society. This analogy between Kant's approaches to the natural and the social world plays a major role in Idealist aesthetics.

If Kant had continued to work solely within the terms of the *KrV* the status of the object as integral organism would not have been philo-sophically graspable. In the *KrV* the world was not just endless random difference, because the subject established its own identity by the way in

which it synthesised the 'sensuous manifold'. At this level the Heideggerian critiques of Kantian philosophy's subjectification of Being, the making of the truth of Being into a function of the subject, are apt. However, the purpose of the synthesis, as we saw, could not be established in the terms of the Understanding.

The 'spontaneity' which produced the synthesis pointed beyond the syntheses it produced to the founding principle of our capacity for cognition. If we were to have access to this principle we would know the value of knowledge. The second critique introduced a further spontaneity, which again pointed, beyond anything we could know, to a higher purpose than could be described in terms of a nature legislated by the Understanding: how can we contradict natural causation in the name of higher Ideas? The third critique tries to link this sense of a higher purpose to the sensuous experience of both natural and artistic beauty. Such experience is based upon the pleasure derived from contemplating how each part of the object contributes to the whole of that object. This contemplation involves both intuition of the object and a relationship to the object which is not based upon reducing the intuition to what it has in common with other intuitions. The coherence of a particular object cannot be reduced to a general law of how things cohere.

In Schopenhauer's words, the *KdU* is the attempt at the 'baroque unification of cognition of the beautiful with cognition of the purposiveness of natural bodies in *one* capacity for cognition':[6] judgement. Judgement is to function 'according to the principle of the appropriateness of nature to our capacity for cognition' (*KdU* p. B XLII, A XXXIX). This appropriateness cannot be proven because the proof would again entail access to the intelligible. Such access demands an explanation of why there is a congruence between the way we necessarily synthesise intuitions in the Understanding and some inherent coherence of nature. Although Kant rejects such a conception, he is aware that without such an argument his philosophy cannot achieve its aim.

The basis of aesthetic judgement is the distinction between feelings of pleasure and non-pleasure. This connects the capacity for cognition and the capacity for desire, because it analytically divides objects into those which give pleasure and those which do not. The division is, though, not based on a cognition of the object, but rather upon whether the object gives pleasure or not. What is being established is the nature of a feeling in the subject, not a synthesis of intuitions of the object.

Kant suggests that although we now derive no pleasure from the synthe-
sising activity of the Understanding:

> in its time there must have been some, and only because the most common
> experience would not be possible without it did it gradually mix with simple
> cognition and was no longer particularly noticed any more (*KdU* p. B XL, A
> XXXVIII).

The activity of cognition appears, then, to have a history in which it is
initially motivated by pleasure. It therefore involves a purposive sense in
our cognitive capacity, that goes beyond its subsuming intuitions under
rules, its functioning as a self-activating machine.

The danger in this is that cognition could easily come to be seen as
motivated by interest in domination, in making the object simply a
source of self-aggrandisement for the subject, a consequence which
Nietzsche will later draw, in the notion that the intelligible basis of
ourselves is the 'will to power'. However, Kant is concerned to establish
a kind of pleasure which does not fall prey to the notion of self-interest.
It would be analogous to Reason, in that Reason, though based on the
capacity for desire, can desire against the natural inclinations of the
subject in the name of a higher purpose. The feeling of pleasure upon
which judgement is founded derives from the sense of a coherence in
nature which the Understanding cannot establish. When I see a green
meadow the Understanding can use Newton to tell me why it appears
green, but I can also derive pleasure from its greenness. The pleasure,
Kant repeatedly insists, is solely that of the subject, and tells us nothing
about the object except its capacity to evoke a harmonious play of the
faculties. The pleasure is, though, an effect of the object on the subject,
rather than a synthesis by the subject.

Kant himself often returns to the idea that nature may give some
indication that 'it contains in itself some basis, a law-bound corres-
pondence of its products to our pleasure which is independent of all
interest' (*KdU* p. B 169, A 167), and he talks of a 'code through which
nature talks to us figuratively in its beautiful forms' (p. B 170, A 168).
Given our own status as natural beings, the idea is tempting, especially
as Kant sees the fact of agreement over judgements of taste as testifying
to some kind of *sensus communis*: saying something is beautiful does not
just mean it only pleases me (*KdU* p. B 19, A 19). It involves a judgement
which can command general assent that results perhaps – and Kant is
emphatic about the perhaps – from 'what can be regarded as the
supersensuous substrate of mankind' (*KdU* p. B 237, A 234). One

should not forget that, for the Kant of the *KrV*, nature is that which appears to us in terms of universal laws, not the living nature of German Idealism and Romanticism. The laws sustained their general validity because they were the conditions of our thinking and did not have to be tested every time to see if they were inherent in the endless multiplicity of things. The *KdU* starts to undermine this view of nature by its attention to the other ways in which the subject relates to it.

The purpose of beauty

Any aspect of Kantian philosophy which tries to come to terms with the 'supersensuous substrate', the teleological principle, of the subject's relationship to the object threatens to invalidate the boundary between law-bound nature and the autonomy of rational beings. A philosophy which aspires to grounding our place in the world via the principle of subjectivity also requires, though, an account of subjectivity which does more than describe its ability to legislate nature in terms of regularities and its ability to prescribe ethical limitations to itself. Kant's problem is that the completion of his philosophy would entail access to the spontaneity involved in both our knowledge and our ethical self-determination: the two foundations of ourselves as subjects. However this is looked at, subjectivity is in some way evidently *not*, even for Kant, wholly separated from objectivity. The distinction of subject and object can be 'deconstructed'. The structure of the *KrV* is determined by the need to produce more and more ways of creating *relationships* between what is supposed to be a priori separate: self-consciousness and its object. If Kant wished to postulate a purpose in nature, any such postulate could only be convincing to the extent that it included *us* in the meaning of nature. The fact that in aesthetic contemplation of nature the object affects us, instead of us determining it in terms of general rules, points, as Scheible indicates, to a 'mimetic' side to the imagination. It suggests we can harmonise with the existence of nature by allowing it to affect us, without our wishing to order it in any other way than it is already constituted when we feel the disinterested pleasure it gives us.

We also get a sense of a possible purpose to nature in our freedom to initiate new states of affairs, according to ideas of what we would wish to be the case and to ideas of what we ought to do to fulfil our duty. Whether this sense is any more substantial than that we cannot *know*. Neither do we know how it connects to nature as we know it. The

tendency in the Enlightenment is to see ourselves as the potential 'lord and master of nature', thereby ignoring the question of what, so to speak, nature might 'think' of this. Given our own inability, for Kant, to give a definitive account of what our thinking *is*, beyond its being a capacity for synthesis, this is not a mystical question. Our capacity for manipulation of nature depends on something which is as inaccessible to us as nature is in itself.

Kant's attention in the *KdU* to trying to find a way of linking our cognitive and ethical capacities via a third capacity points to his awareness of the dangers that are present if we cannot make such a link. Historically, attention to natural beauty arises when nature is no longer mainly a threat, because we have developed our powers to come to real rather than mythical terms with it. We can then become aware of its value in itself as object of contemplation. At the same time the question arises as to whether the removal of the mythical and the theological from our relationship to nature in science means that the role played by theology and myth has been wholly abolished. From Schelling and the early Romantics, to Marx, to Nietzsche, this will be a central issue in aesthetic theory.

Aesthetic judgements for Kant rely upon the fact that the object is received in the subject in terms of 'feeling' and in terms of a harmonious play of Understanding and imagination. Kant gets into difficulties in the first version of the *KrV* with the faculty which links sensuousness and the Understanding, the 'imagination'. As Scheible puts it in his excellent account of this issue, the problem of how the outside world is instituted in us is bound to remain because Kant 'brought the imagination temporarily into play as a capacity whose function exhausted itself in providing for the Understanding',[7] thereby limiting the relationship to nature to one of dominance. All the Understanding can do, though, is to subsume under laws, but, as the question of reflective judgement revealed, this capacity does not exhaust our relationship to nature: it gives no reason to believe that these laws cohere into a whole.

To become an object of knowledge the first stage of processing by the imagination must be added to by a further stage, in which the Understanding discovers, as Scheible puts it: 'the *one* characteristic which allows a replacement of the intuitive synthesis of the imagination by the abstract unity of the conceptual system'.[8] The object becomes wholly determined by the subject. Subjectivity and objectivity rigidly reflect each other, in terms derived from the transcendental deduction, the point of which was to reveal the logical priority of the subject in

cognition. The Understanding therefore involves a repression of my particular, phenomenological relation to the object.

In the *KdU*, though, Kant realises the importance of what the imagination does which is *not* subsumable under categories. He suggests that in cognition the imagination is limited by the 'compulsion of the Understanding', which was already the objection of Baumgarten and Hamann. The term 'compulsion' points to what the compulsion is opposing: a notion of freedom. In the aesthetic relationship to the object: 'the *imagination* is free, beyond every attunement to the concept, *yet* uncontrivedly, to provide extensive undeveloped material for the Understanding, which the latter paid no attention to in its concept' (*KdU* p. B 198, A 195–6). Kant begins to see that scientific cognition excludes aspects of ourselves from its view of nature, that must be accounted for in other than cognitive terms. The freedom of the imagination, he claims, enlivens the powers of cognition, enabling them to develop further. He thereby suggests a sense of the purpose of these powers. More importantly, Kant introduces a notion, freedom, which for him belongs in the realm of the supersensuous, into our sensuous relations to the world.

The very fact that Kant now begins to use the term 'aesthetic ideas' suggests how far he has come from the *KrV*. The 'Aesthetic' there provided the 'rules of sensuousness', which provided intuitions for the Understanding. 'Ideas' were the basis of Reason and could not be available to intuition because they would thereby have to be subsumed under the laws of the Understanding. Ideas can now become aesthetic. Kant defines an aesthetic idea as:

> that representation of the imagination which gives much to think about, but without any determinate thought, i.e. *concept* being able to be adequate to it, which consequently no language can completely attain and make comprehensible (*KdU* p. B 193, A 190).

The lack of a concept means that language cannot completely represent these ideas: this leads other thinkers, particularly the early Romantics and Schopenhauer, to look for a language which *would* be adequate for this purpose. The language in question, though, will be the concept*less* language of music, which will thereby in some cases attain a higher status than conceptual language. The point about music for these thinkers is that, although it is sensuous, it does not necessarily represent anything. As such, it may be understood as 'representing' what cannot be represented in the subject, the supersensuous basis of subjectivity

which Kant's philosophy cannot articulate. Furthermore, the way musical language comes to be understood will be influential in putting into question the notion that verbal language represents pre-existing concepts. The questioning of language as representation will be one of the main bases of the critiques of metaphysics that lead from their roots in Romanticism, to Nietzsche, and to post-structuralism.

Kant himself follows the tradition of understanding music of his time by seeing music as a 'language of emotions' (*KdU* p. B 220, A 217): music represents feelings, in the same way as language represents concepts. Music communicates aesthetic ideas, but these are 'not concepts and determinate thoughts', their purpose is solely to 'express the aesthetic idea of a coherent whole' (ibid.), the pleasure of which is generated by the mathematical proportions upon which it is based. Because it just plays with feelings music is the lowest form of art. This fact is reinforced by music's transience. What Kant sees as music's empty formalism will, though, soon become crucial to the concept of art: the divorce of music from representation is the vital step in the genesis of a notion of aesthetic autonomy which removes the work of art from any obligation to represent anything but itself. This autonomy will entail a break with the direct connection of aesthetic ideas with ethical ideas. Given Kant's evident intention to link beauty and morality – beauty is a symbol of morality for Kant – his suspicion of music is consistent with the aim of the third critique. However, though the idea of aesthetic autonomy is far from Kant's intentions, it is the *KdU* which helps open up the possibility of its emergence.

Kant's aesthetic ideas are non-conceptual, but this does not exclude them from philosophy. Kant assigns a specific philosophical status to aesthetic ideas. Kant's aesthetic ideas 'strive towards something beyond the boundary of experience' (*KdU* p. B 194, A 191): Kant gives the example of how poets attempt to make the ideas of 'the invisible Being, the realm of the blessed, hell, eternity, the creation' (*KdU* p. B 194, A 191) into sensuous images. He says that aesthetic ideas are the 'Pendant' to ideas of Reason, in that the ideas of Reason, such as goodness, cannot be demonstrated empirically. It should be clear from this why Schiller comes to see art as a means for the 'aesthetic education' of the people, by making morality available through pleasure, not just through compulsion.

How is it, though, that the beauty of nature and the beauty of humanly-created products are to be judged in the same terms? Without some connection between natural and artistic beauty the divisions we

have seen would be reinstated. Related to this is the question as to what status the pleasure has which we gain from aesthetic contemplation. In order to keep the faculty of judgement separate from Reason Kant opposes 'the pure disinterested pleasure in the judgement of taste' (*KdU* p. B 7, A 7), to a judgement based on an 'interest' in an ulterior purpose. Gadamer suggests that in aesthetic judgement 'no one could meaningfully ask the question of what it is useful for: "What is it useful for that one has pleasure in that in which one has pleasure?" '.[9] Initially aesthetic pleasure does have an autonomous status of its own: it serves no other purpose. This view of art is, in different forms, essential to many versions of subsequent aesthetic theory. Aesthetic objects can be seen as irreplaceable and without price in terms of their aesthetic value, however much they may have a price in the market-place which can make them useful for buying something else. However, Kant's role for the aesthetic is greater than this.

Aesthetic pleasure must be generalisable if the object is to be *beautiful* rather than the source of random individual pleasure. For a judgement of taste to be general it must entail rules. In relation to the question of rules, Kant gives primacy to natural beauty over the beauty of art, for important reasons, which will later be significant for Schelling. The problem with rules of the Understanding is that they are imposed from one side of the intelligible/sensuous divide. The rules governing the pleasure evoked by beauty must be in some way part of the object. Kant sees the aesthetic object first as nature, which affects the subject. If the priority were reversed and artistic beauty were primary, the rules of art, as products of the subject, would be simply another way in which we legislate nature.

The unprovable postulate of the coherence of nature in reflective judgement has to hold Kant's philosophy together. The postulate is based on the fact that natural organisms are more than aggregates of their empirically observable parts. Our pleasure at that coherence is what is at issue. There could be no link of sensuous and intelligible if judgement were to function as it does in the Understanding.

In *Truth and Method* Gadamer argues that Kant 'subjectivises' aesthetics. This does not square, though, with the way in which Kant sees the subject's relation to aesthetic rules. Kant introduces the apparently bizarre argument that 'beautiful art is an art insofar as it at the same time appears to be nature' (*KdU* p. B 179, A 177). Art should be seen to be art but 'the purposiveness of its form must appear as free from all compulsion by arbitrary rules, as if it were simply a product of nature' (ibid.). He

goes on to say that 'Nature was beautiful if at the same time it looked like art' (ibid.): this is the basis of reflective judgement and the notion of the organism. The artist must not appear to have worked according to a pre-existing rule of the kind provided by the Understanding for a scientist or someone applying scientific rules for a technical purpose. Instead, the artist should appear to have produced something which has the coherence of a natural organism.

The natural organism's capacity to evoke pleasure is not limited, as Gadamer's argument would suggest, to the pleasurable effect of its form upon the subject: Kant insists that the 'existence' (*Dasein*) (*KdU* p. B 167, A 165) of the object pleases, independently of any appeal to the senses or any purpose of the object. Determining how the *existence* of an object can create aesthetic pleasure would be beyond the capacity of a philosophy which Heidegger and Gadamer wrongly suppose to be based upon the subjectification of the object by a dominating subject.

The next stage of the argument is the most significant. Kant introduces the notorious concept of 'genius'. Gadamer claims that genius is introduced into the *KdU* in order to give art the same status as natural products. There is more to it than this. Kant describes genius as follows:

> *Genius* is the talent (gift of nature), which gives the rule to art. As talent, as an innate productive capacity of the artist, itself belongs to nature, one could also put the matter as follows: *genius* is the innate aptitude (ingenium) *through which* nature gives the rule to art (*KdU* p. B 181, A 178,9).

In the modern period rules in artistic creation are supposed to be the basis of *individual* products. Individuality and rules are inherently opposed to each other, as we shall see most clearly in Schleiermacher. Kant confronts this problem through the notion of genius.

He argues that judgements about artistic products cannot be based on rules derived from concepts:

> Thus art [*schöne Kunst*] cannot devise the rule for itself, according to which it is to produce its product. As, nevertheless, a product can never be called art without a preceding rule, then nature must give the rule to art in the subject (and through the attunement [*Stimmung*] of the subject's capacities), i.e. art is only possible as a product of the genius (*KdU* p. B 181,2 A 179).

The product's coming into existence cannot be described theoretically: Kant says that the genius cannot tell anyone how the work came into existence, let alone tell anyone the rules which would enable them to emulate the genius. This makes sense, for example, in music, where

Beethoven changes the canon of musical rules. One can describe this retrospectively in terms of the new theoretical canon, but this will not explain what made Beethoven make the new moves, nor will it enable any person who knows the old and the new rules to produce music as great as Beethoven's.

Here we again reach a point in Kant's philosophy where the essential principle is self-caused in ways which philosophy cannot articulate. Genius can be regarded as a 'spontaneity'. The difference is that this spontaneity produces empirical products, which are available to intuition and which in Kant's terms must be derived from intelligible nature. It is not hard to see why the early Schelling will be tempted to see art as the 'organ of philosophy', precisely because it makes the highest point of philosophy available to intuition in this way. If nature gives rules to the free productivity of the genius, the division of sensuous and intelligible is no longer absolute.

The whole edifice of Kant's philosophy is threatened by this. The art work of the genius seems to be where the subject can intuit itself in terms of its spontaneous, intelligible capacities, and can therefore objectify itself, something which Kant consistently denied was possible in relation to the capacity to know, or in relation to freedom. As Kant uses the notion, 'genius' has an ambiguous status. On the one hand it points to a potential which is constitutive of being an autonomous human being: the ability to express oneself in ways which cannot be prescribed in advance or reducible to someone else's way of expressing themselves. On the other hand it is also a capacity limited to a few individuals. The fact that, for Kant, products where 'nature gives the rule' are limited to a few people, Scheible maintains:

> is necessary in a society in which the potential for alienation has already grown so much that the ability to help nature express itself uninfluenced by pre-given rules and norms is already limited to a few individuals.[10]

The danger of this argument is that it relies upon an implicit assumption that the self-expression of nature is repressed by social forms, missing the sense that the positive 'natural' potential in subjectivity may only emerge via the engagement with forms of social organisation.

The argument does, however, point to the essential dialectic of modern art: at the same time as the objective conditions for the liberation of individual subjectivity come into existence, not least via the application of the generalisable results of science, the conditions which contradict the potential of the individual subject are also produced, via

the new division of labour and the forms of regulation it involves. Modern art is located between the desire for subjective self-expression, the fear of this being devoid of any collective meaning, and the danger of it being a threat to the continued existence of any collective formation.

It is not fortuitous that the association of art and madness, seen in such figures as Lenz and Hölderlin, is a major issue in this period. Scheible rightly suggests that the notion of genius reveals why, in modernity, the aesthetic of the autonomous work of art becomes more significant than the hopes for collective aesthetic production in a community. Modern societies often fail to create the space for forms of individual self-realisation that are not based upon appropriative interest. The availability of the object world as commodity develops the consuming subject at the expense of other capacities of subjectivity. One can re-read Hegel's account of Lordship and Bondage in these terms: in modern capitalism it is more and more possible to be in the position of the consuming lord and not to be in the position of the developing bondsman.

In modernity it is in the realm of art that what is repressed by our cognitive and economic domination of nature, and by our disciplining of ourselves under the division of labour, may articulate itself. This will be another of the reasons for the importance of music in subsequent aesthetic theory. Because of its status as a non-representational medium, music seems to be one of the few remaining locations where rules arise which have no validity beyond the constitution of the medium itself. The medium itself is, though, despite its non-representational nature, not seen as devoid of meaning. The tendency of modern art to move away from representation – which happens most obviously in visual art – is pre-figured in music, with philosophical consequences that are central to the present book. Although the *KdU* suggests how these issues emerge, Kant still sees aesthetics as one part of the wider task of Reason.

The limits of beauty

Much of the debate that follows Kant, until the present, revolves around whether there can be a reconciliation of our subjectivity with a nature which is both in us and outside us. Kant is fully aware that nature can appear, as it does to Schopenhauer and others, as an endless chain of eat or be eaten. He takes the example of plants, asking what they are there for, which leads into the chain of their being there for the animals that

eat them, and those animals being there for the animals that eat them. Only rational beings can attempt to transcend this, by seeing nature as a 'system of purposes', rather than as a machine. This leads Kant to the ideas of happiness and of culture, which would realise potential in us that is also a potential of nature. As Kant puts it in the following odd formulation, on the need to discipline our natural inclinations to achieve the higher form of culture, there is a 'purposive striving of nature which makes us receptive to higher purposes than nature itself can provide' (*KdU* p. B 394, A 390). The dual use of the word nature makes the problem clear.

The problem is that we do not, and cannot, *know* what our nature is. It does not, however, exhaust itself in natural inclination. Kant says our 'nature is not of the kind which will stop and be satisfied somewhere in the midst of belongings and enjoyment' (*KdU* p. B 389, A 385), thereby refusing to see the nature in us as solely appropriative. This was also evident in his view of aesthetics. Art and science are means for the development of Reason: as we have seen, though, the way in which Kant theorises them also reveals much about why this project, the project of self-legislating modernity, will prove so problematic.

Perhaps somewhat unexpectedly, given the arguments we have seen, Kant regards the scientist as more important than the genius, even though he is excluded from being a genius by the fact that what he does can be reproduced by following the rules he produces. This is because the scientist contributes to the 'ever-progressing greater completeness of cognitions and of all usefulness that depends on this' (*KdU* p. B 184, A 182). Kant has to depend here upon the postulate of reflective judgement, that there *is* a system inherent in what the scientist can only investigate in a piecemeal way, which would enable one to work towards the completion of the system.

Nietzsche will revoke such a postulate in *The Birth of Tragedy*, thereby further increasing the importance of aesthetics. For Kant the postulates of reflective judgement were founded upon seeing nature as art. Kant's priority of the scientist over the artist is historically explicable in terms of the importance of the public communicability of scientific knowledge and of its potential for reducing the misery of feudal life. Scientific knowledge is seen as inherently emancipatory. Its potentially repressive side is, however, already present in what Kant has said in the *KdU* about the imagination's escape from the compulsion of the Understanding.

Kant backs up his contention that science has a prior importance by maintaining that art 'somehow stands still by having a limit beyond

which it cannot go, which has also presumably been reached and cannot be further broadened' (*KdU* p. B 185, A 182). This is not a historical claim, because art is a static category for Kant. His judgement is significant for historical reasons, however. The genius, for Kant, cannot be relied on, because his talent dies with him and there is no saying when nature will endow someone with the talent to give the new rule to art. Kant does not see any relationship between socio-historical conditions and the emergence of the significant artist. The argument for the priority of the accumulation of cognition in science over what art can communicate does, though, point to difficulties in the sphere of artistic production which result from the speed of scientific and technological advance.

The relation between sensuous existence and its intelligibility to modern science will become increasingly distant. The limits of art will eventually lead to the very notion of art being questioned. Related arguments concerning the limitations of art will recur in Hegel's view of the 'end of art', and in Marx's puzzlement over the continuing appeal of Greek art despite the scientific and technological developments in subsequent history. Hegel's and Marx's positions derive from a sense of a crisis in art which results from the advance of science, an advance which depends in many respects on the growing elimination of the sensuous.

Kant's sense that art has a 'limit beyond which it cannot go' leads to a final important aspect of the *KdU* – the 'sublime' – which must be considered before moving on in the next chapter to reactions to Kant's philosophy in German Idealism and early Romanticism. The point of beauty and art was that they made something 'infinite', Reason, sensuously available. If art has a limit, this suggests that the ways in which it can connect the sensuous and the intelligible are also limited.

The 'sublime' only relates to nature, not art. Whereas natural beauty is concerned with the form of the object, the sublime is concerned with what is unlimited or even formless in nature. The sublime cannot, therefore, rely on the pleasure generated in judgement's sense of the purposefulness of the natural, or aesthetic, object. As such, the sublime does not have the import which the natural object that affected the subject had: it is only significant to the extent to which it reveals a 'purposiveness' in ourselves with regard to our capacity to 'transcend' nature.

The sublime has to do with big things, things that are so big they initially make us feel small. The bigness is not empirical, it depends

upon an idea: '*something is sublime in comparison with which everything else is small*' (*KdU* p. B 84, A 83). This has to result from something which allows us to think beyond any quantity the senses could measure, which excludes it from the Understanding's capacity for rules. It is, though, an intuition: 'Nature is sublime in those of its appearances the intuition of which carries the idea of its infinity in it' (*KdU* p. B 93, A 92). What it does is to remind us of the limitations of our sensuous relationship to nature.

The argument is dialectical: the sense of limitation entails the sense of its opposite, the fact that we also have a capacity for Reason not limited by sensuousness. This is the 'mathematically sublime'. The 'dynamically sublime' is experienced at those moments when we are confronted with natural forces which are beyond our power to control, such as lightning, volcanoes, hurricanes, but from a position of safety. This, claims Kant, provokes in us a resistance which makes us wish to measure ourselves against nature. The physical threat of nature can make us aware of our capacity for Reason. This potential, the potential of Reason's non-finite relation to the laws of nature, is actually generated by the way in which nature reveals its irreducibility to our interests as sensuous beings in the experience of the sublime. The basis of Kant's argument will be central in post-Kantian philosophy. Because we feel our limits we must *also* feel what is not limited in ourselves, otherwise we would have no way of being aware of a limit. Freedom emerges from a situation which seems empirically to be nothing but constraint.

In the sublime, then, the supersensuous becomes available in a negative way, its effect is to 'broaden the soul' (*KdU* p. B 124, A 123). The argument takes a strange but significant turn when Kant cites the ban on images in Jewish theology as being the most sublime passage of the law book. He claims, oddly, that it explains the enthusiasm for religion at the period of the institution of the ban. If the senses have nothing left as their object 'and the inextinguishable idea of morality still remains' (*KdU* p. B 125, A 123), the imagination becomes limitless. It therefore becomes necessary to institute something to prevent the imagination running riot in the production of sensuous images. Kant maintains that governments which ignore this sort of sublimity and surround their religion with sensuous representations thereby limit their subjects' capacity to 'extend their spiritual forces over the barriers' (*KdU* p. B 125, A 124) (of the sensuous), and thus make them more passive.

I suggested above that in the first two critiques Kant himself was in the situation of Moses, in trying to use the supersensuous as the

foundation of our place in the world. He was unable to do more than postulate what could only really be available to us in an 'intellectual intuition'. Intellectual intuitions are not possible for us, so Kant is left with a gap to fill. The very fact that there is a third critique is not least a result of the insufficiency of the first two critiques in this respect. The crucial difference of the sublime from beauty is that the '*unfathomability of the idea of freedom* completely cuts off any positive representation of it' (*KdU* p. B 125, A 124). In the aesthetic products of the genius the ideas of Reason were sensuously available. The sublime, which can only emerge in relation to nature, does not represent ideas sensuously, *it merely points to the limitations of sensuous representation.* The same, as we suggested, could, in the realm of art, be said of music.

The complexities of Kant's sublime are too great to do justice to here. The important fact is that the moves upon which the idea of the sublime is based set the terms for the issue of whether art can only sustain itself at the expense of any substantial cognitive or ethical content, or whether it has a more committed function in the political life of the community. Kant's observations on using sensuousness as a political tool in religion suggest the problem: the highest functions of thinking are seen as beyond any sensuous representation.

The importance of aesthetic ideas in relation to the rest of Kant's thinking was that they gave an, albeit limited, means of 'striving beyond the boundary of experience' and thereby of making the idea of nature as a coherent whole sensuously available and communicable in a general way. Because it is a result of resistance to the threat of nature, the sublime only provides a reminder that whatever our sensuously based thinking produces is inherently inadequate as a means of understanding the supersensuous basis of ourselves and nature. In the face of any immediate sensuous intuition we are reminded that what matters most is beyond intuition.

This has a variety of possible consequences. One is the retreat of the subject into itself, which is a result of the sensuous object only ever revealing itself as limited: we see the volcano destroy some part of the empirical world, but this becomes a challenge to our ability to see beyond the immediacy of destruction to our ability to transcend it as rational beings. One side of Hegel's suspicion of the sensuous in the *Aesthetics* will will be based on this transcendence. Kant's account of the ban on images as being a privileged instance of the sublime also relies on the perceived need to transcend sensuous particularity to reach higher ideas.

Hamann's theology, as we saw, lived on the endless revelation of the divine in the sensuous. Kant could in no way accept such an approach, for very obvious reasons. The impetus behind Hamann's view is, though, implicit in the issue of the sublime. Kant wishes to reject the suspicion that the power of the supersensuous might lead to the danger of what he terms *Schwärmerei*, roughly translatable as uncontrolled fantasy. *Schwärmerei* is described as a sort of madness which '*wishes to see something beyond every boundary of* **sensuousness**, i.e. to dream in terms of principles (to rave with Reason) [*mit Vernunft rasen*]' (*KdU* p. B 125, A p. 124). This is not that far from Hamann. Once the infinite nature of our reflection, in the sense of the ways in which the self can transcend the immediacy of the object world, is established, there is no necessary reason to limit it, either in terms of the potential of the object, or of the subject.

Kant regards the fact that the sublime is only a reminder of the failure of representation to be adequate to the supersensuous as sufficient reason not to spend one's time trying to represent something which is more than sensuous. However, the extremity of the description, itself a kind of 'raving with Reason', says more than Kant would wish to. The fact is that early Romanticism will precisely be based on an attempt to see something in the sensuous that is beyond the sensuous, which in certain ways was the point of the *KdU* anyway. Given Kant's lack of success in convincingly establishing the division of the sensuous and the intelligible it is hardly surprising that subsequent philosophy will try to revoke Kant's dualisms of appearances and things in themselves, of sensuous and intelligible, nature and freedom. The Romantic attention to 'absolute music', music without words, will be based upon music being a sensuous medium which cannot be understood in terms of representation.

Music in early German Romanticism is inextricably linked with the notion of aesthetic autonomy, the ability of art to represent that which cannot be represented in any other way. The problem is whether the individual mode of articulation can generate any kind of collective significance. Art in the nineteenth century will tend to be located between two extremes. One is best embodied in the Naturalist attempt to collude with the advance of science, the other is exemplified by the rise of absolute music and the related development of notions of 'pure poetry', art devoid of representation. Kant limited the sublime to nature, but as nature becomes more and more an object of scientific manipulation the attempt to reveal a non-sensuous truth not available to science is

transferred into art. What that truth is is no longer representable in any other medium than the particular work of art concerned, which becomes an attempt to say the unsayable. Once the importance of language to these issues has been realised they will lead to essential questions that still concern philosophy today.

It is for such reasons that the distinction of the beautiful and the sublime can be seen as the basis of the tension in post-Kantian philosophy between the desire for a 'new mythology' and the idea of the autonomy of the aesthetic work. A 'new mythology' would sensuously present ideas of Reason as a means of communicating the advances of autonomous subjectivity to all levels of society. It would thereby integrate science and art into a unified collective project. The superiority of the autonomous work of art over science and philosophy relies upon the unrepresentability of the highest principle of philosophy. Art preserves ways of articulating the world which are not in the service of instrumental purposes. This distinction will occur in some form in all subsequent debates about aesthetics and politics, from Marx, to Lukács, to Brecht, to Adorno and beyond. It is Kant's baroque honesty which opens up the conceptual space for these issues in modernity. The attempt to ground truth in subjectivity constantly reveals new complexities which Kant is compelled to explore. The further work of exploration is carried on at an often remarkable level of sophistication in German Idealism and early Romanticism, to which we must now turn.

German Idealism
and early German Romanticism

Introduction

Kant's attempt to ground philosophy in the principle of subjectivity does not achieve its final aim. The immediate consequences of this in subsequent philosophy are apparent in two areas of philosophy which carry the broad names 'German Idealism', and 'early Romanticism'. 'Early Romanticism' is defined in this way to distinguish it from later reactionary doctrines which will often bear the name Romanticism in Germany. The term Romanticism is notoriously vague, and it is important to see that the early Romantics can be characterised in a specific way that distinguishes them from later German Romanticism. The Nazis, for instance, were not in the least bit fond of the early Romantics, who were cosmopolitan and devoid of the attributes which enabled the Nazis to enlist 'Romanticism' as part of their ideology. The wealth of ideas which come under the headings German Idealism and Romanticism make it difficult to regard them as unified philosophical schools. Aspects of each are often seen in the other: Schelling, for instance, can be seen as at times belonging to both. There are, however, certain areas in which the two can sometimes usefully be distinguished.

Peter Szondi says of German Idealism: 'One could say crudely that the philosophy of German Idealism tried to win back via the path of speculation what Kant's criticism had to renounce: the unity of subject and object, of mind [*Geist*] and nature'.[1] 'German Idealism', which I shall refer to as Idealism from now on, has nothing to do with the philosophical idealism represented by Berkeley. Kant makes this clear when he insists upon the need for intuitions given from outside the subject to fill the concepts of the Understanding. 'Transcendental idealism' requires warrantable notions of truth to acknowledge the necessary role of the subject in the constitution of truth. Objectivity

depends upon a subject to constitute the object as an object of truth. The subject need not constitute the existence of the object.

In order to achieve the unification of subject and object the subject would have to demonstrate the identity of itself as a knowable object of intuition with itself as an autonomous, intelligible subject. In this way the realms of necessity and freedom would no longer be separate, because the purposes which guide my free moral action would be united with the overall purpose of nature embodied in myself as natural being. Each passing, sensuous moment would thereby find its truth in a totality which gave it its meaning, as opposed to being simply another part of an endless chain or a random sequence. This might sound merely theological, and there is no doubt that the impetus behind the idea is to replace discredited forms of theology. Schelling in particular, though, begins as an atheist, though he will later adhere to a form of Christianity. Idealism ponders what it would mean for knowing and the value of knowing to cease to be separate. In order to become part of a unified totality the finite aspect of existence must be overcome.

Idealist philosophy relies in varying ways on a version of Spinoza's 'all determination is negation': something can only become what it is by its negative relationship to everything else, which defines what it is not. In terms of the subject's capacity to move beyond anything specific we can know as a scientific fact, this means that *within* subjectivity there is a capacity which is unlimited in a much more emphatic sense than Kant would allow. It will be the task of Idealist philosophy to articulate what this ability to move beyond limitation can mean for philosophy. For this to be possible the totality of the individual aspects, the Absolute, must have a different status from the differing elements within it, in order to make their difference into a higher identity. German Idealism seeks ways of representing this relationship between the finite and the infinite without retreating into the metaphysics which Kant had refuted. One of these ways will be via the work of art seen, in the manner of the *KdU*, as an object whose individual parts are transcended into a greater whole. One of the other ways will be Hegel's attempt to create a self-transparent system of philosophy. The relationship between these two contrasting approaches is the basis of much of what this book has to say. Do art and philosophy have the same purpose, or can they be separated? What does this mean for philosophy? The contrast between Schelling and Hegel is one of the places where the issue can best be explored.

The essential thought behind the Romantic, as opposed to the

Idealist, view of the post-Kantian situation was present in the implications of Kant's notion of the sublime. The sublime indicated an inability to represent the infinite. At the same time it invoked the infinite via the feeling of finitude it produced. Kant holds onto a firm conviction that Reason, the 'capacity for purposes', is undeniable, but also undemonstrable. Early Romanticism acknowledges the undemonstrability of the sense of reality as a whole, but, in the manner of Kant's *Schwärmer*, cannot stop the endless attempt to grasp the infinite via the desire to see it in the sensuous.

This expresses itself in 'longing', a notion that plays a major role in Romantic philosophy and art. Schlegel says of the sublime: 'The feeling of the sublime must naturally arise for everyone who has really abstracted. Whoever has really thought the infinite can never again think the finite'[2] (*KSF* 5 p. 98). The Absolute becomes unrepresentable: 'The impossibility of positively reaching the Highest by reflection leads to allegory' (*KSF* 5 p. 105). The Understanding, which the Romantics do not reject, can only dissect reality, that which could reassemble it is only present as a sense of loss: '*The essence of philosophy consists in the longing for the infinite and the training of the Understanding*' (*KSF* p. 99).

Romantic art becomes concerned with representing that which is *per se* unrepresentable. It is not the location of the link between the sensuous and the intelligible, as it partially was for Kant, and will be for Schelling's *System of Transcendental Idealism* (*STI*). Philosophy must also attempt to come to terms with its own incomplete status. As I shall show, these arguments have distinct similarities to aspects of post-structuralism. A philosophy of inherent incompleteness is a philosophy of deferral. It should be remembered, though, that if there were not some, perhaps inarticulable, sense of a lacking completion, the notion of deferral would be meaningless. Deferral means putting off for later, not abolishing.

The standard story of German Idealism is that it is inaugurated by Fichte's questioning of Kant's philosophy, is continued in Schelling's *STI* and 'Identity Philosophy', and culminates in Hegel's system. Hegel is then superseded by Marx, who turns Hegel's speculation into a new form of materialist philosophy. A logic of development is thereby suggested which is implicitly Hegelian: each stage of the process takes up the truth of the previous stage, refutes that stage's errors, and moves onto a higher stage. Views of history based on continuity are now increasingly questionable: they make the same mistake as Hegel in presupposing that what emerges from such conflicts is part of an

inherent developing truth. It is, though, often the case that what has apparently been superseded has merely been repressed, and will return later because it was never fully articulated. I want to suggest that this has happened to many of the ideas to be looked at in this book. The contemporary attention in post-structuralism and elsewhere to the kind of questioning of the notion of truth that is characteristic of Heidegger has its roots in the issues of post-Kantian philosophy.

It is possible to tell a different story about German Idealism and Romanticism's relationship to subsequent philosophy, which shows that very few of the questions that were asked have really disappeared from the agenda of philosophy. This is evident if one looks at the role of aesthetic theory in the philosophy of the period with contemporary eyes. It is not fortuitous, for instance, that Richard Rorty should now regard philosophy as a kind of literature. Such a notion has nothing surprising about it for a Romantic thinker, and is not alien to Schelling's *STI*. The hyperbolic status attached to art in German Idealism and early Romanticism is not just the result of expectations about the ability to link the sensuous and the intelligible in a positive way: very often art seems rather to 'deconstruct' the boundary of intelligible and sensuous. The importance of art results from the realisation that if collectively warrantable truth is only available in the form of natural science based on causal relations and supposedly objective observation, we will be living in a meaningless world. The only serious truth in these terms would be what results from the subsumption of nature under general laws. The laws, as we saw in Kant, are based on a faculty which we could only account for if we were able to make the subject see itself in a different way from that in which it sees the object of knowledge, which Kant denies is possible.

The third critique suggested ways in which this *might* be possible: after Kant aesthetics becomes the philosophical realm where meaning based on more than the sciences is sought. In the face of the ecological crisis we are often able to understand the arguments of philosophers of this period better than they understood themselves. Their attention to art is thus not just a concern with the icing on the cake of a post-theological world. It pays attention to the fact, already implicit in Kant, that nature is not just an object and is part of ourselves as subjects in ways we do not understand, and could not ever fully understand.

The 'new mythology'

Both Idealism and Romanticism are aware, as the younger Marx was, that the revelation of the hollowness of theology does not mean that the need which motivated it disappears. The 'opium of the people' does not just numb any capacity for resistance by blurring the real nature of a humanly created oppressive reality, it also kills the pain of meaninglessness by making it part of something more than itself. Replacing dogmatic theology is one of the major tasks of modern German philosophy from Idealism to Feuerbach, to Marx, Nietzsche and beyond. As such, the concern, in both Idealism and Romanticism, with mythology should not be lightly associated with later reactionary appropriations of mythology as a return to primordial origins.

The so-called 'Oldest System Programme of German Idealism' (*SP*), which is reprinted in the Appendix, is a manifesto for a new philosophy and exemplifies the spirit of early Idealism. It was written down in the hand of the young Hegel (in June 1796?), has some of the characteristics of the thought of the young Hegel, but most people would consider that it was probably written by Schelling. (Some people consider neither to have been the actual author.[3]) The impetus of the text was suggested in Szondi's remark at the beginning of this chapter. It wants to re-unify the world that has been split up by Kant's radical critique of traditional metaphysics, at the same time as hanging on to Kant's insistence on our capacity for self-determination. Beginning with Fichte, for reasons to be explained later, German Idealism attempts to give a far more emphatic role to the free activity of consciousness than is evident in Kant's cautious formulations. The *SP* is a manifesto and has no pretensions to coherent argumentation. Despite this it demonstrates very clearly certain major issues.

The basis of the *SP* is a radical notion of freedom: 'The first idea [*Idee*] is naturally the idea [*Vorstellung*] of *myself* as an absolutely free being'. As was evident in Kant, once 'dogmatism', in the sense of theology, ceases to arbitrate our place in the world it becomes our task to do this. Whereas Kant would not wish to make an absolute claim for the ego because this would entail intellectual intuition to back it up, the *SP*, in the light of Fichte's *Wissenschaftslehre* ('Doctrine of Science'), has no doubts that this Absolute can legitimate itself. The *SP* asks: 'How must a world be constituted for a moral being?'. The question is thereby posed as to how we as subjects can aptly relate to the world of internal and external nature, and it is posed emphatically from the side of the subject.

The text abruptly jumps to the call for a new physics, suggesting how far such thinking is from simply assuming the clear boundaries between the realm of the Understanding and Reason in Kant's sense. It will be a central concern of both Schelling and Goethe that nature, even within the realm of natural science, should not be just regarded as an object to be brought under causal laws. The immediately following abrupt attack on the *State* as a 'machine' that cannot correspond to the 'Idea' of mankind is inseparable in such thinking from worries about modern science's turning nature into a machine. This returns us to Kant.

The antidote in Kant's philosophy to the mechanistic view of nature was the conception that natural *organisms* could be seen as functioning as if they followed an 'Idea'. The Idea entails more than the sum of the observable attributes of the object. Kant linked it to the art work produced by the genius, thus linking natural teleology, the growth of the organism into its particular form, and artistic production. The idea of the organism is fundamental to the *SP*. Manfred Frank defines organisms as

> structures whose parts take part in the purpose of the whole and in *such* a way that the purpose is not external to them, but, rather, their own purpose.[4]

For the state to become an organism the individual organisms in it must be united to form a greater organism. For this they need a purpose. A purpose justifies a new state of reality not by what is *known* of reality up to now but by what reality ought to become. As Frank puts it:

> Whilst only *Understanding* is necessary to comprehend the mechanical linking of states of matter . . . in order to perceive purposes one needs *Reason*, . . . the capacity to turn plans into deeds . . . a purpose is not something given [*gegeben*], it is a task [*aufgegeben*].[5]

This distinction is important: without our activity, and the plans we base it on, Reason cannot be realised: it is not something which is 'given', it is a potential which we have in us, hence, as we saw, the sense of Reason being infinite.

The culmination of the conception of the organism, even for Kant, is the idea that *if* nature is thought of as an organism then there must be a purpose in nature which can be linked to human purposes and activities. Access to such a purpose would enable one to legitimate a form of social organisation which could bring us into harmony with what we are as part of nature. This purpose, it should be remembered, is not to be seen as a controlling divinity, though Kant does talk about nature's purposes. The

'spontaneity' which freedom is as part of nature is not fulfilling a preordained plan: it is, precisely, self-caused. On the other hand, if there is no purposiveness one is faced with a disintegrated series of warring forces that have no essential direction, a view that will later be evident in Schopenhauer and Nietzsche.

In this context the *SP* introduces the 'Idea that unites all Ideas, the Idea of *Beauty*, taken in the higher Platonic sense', in a manner analogous to Kant's introduction of the notion of reflective judgement and his linking natural teleology and works of art. This Idea is supposed to overcome the gap between laws of nature constituted via the Understanding and what we do with this endless diversity of particular laws via our Reason. It is the *SP* that maintains that the 'highest act of reason' is an 'aesthetic act'. The aesthetic act would connect truths produced by the Understanding, and practical reason's integration of these into a purposive whole.

The work of art is purposively produced, via free human initiative. At the same time, though, it relates to the Understanding because it is an object of 'intuition': you can see it, hear it, etc. As such, it partakes of the two realms which Kant's first two critiques had sundered, and which Kant tried to unite in the third critique. Manfred Frank suggests the consequence of this:

> Even when I do not produce an aesthetic product, but enjoy one, I still must use my freedom. For nothing sensuously visible and reconstructable in thought is sufficient to impress the character of the aesthetic on an object of nature [i.e. the Understanding cannot produce aesthetic judgements]. I must, in order to become aware of the *freedom* represented in the object, use my own freedom.[6]

The aesthetic product becomes a utopian symbol of the realisation of freedom: in it we can see or hear an image of what the world could be like if freedom were realised. We can only see it in this way because of that aspect of self-consciousness whose basis cannot be articulated in philosophy.

In this view Kant's postulated 'kingdom of ends', which philosophy cannot describe, becomes available to intuition in the work of art. In the kingdom of ends the crucial factor was that which was an end in itself, not a means to another's end. For Kant this was ourselves as intelligible beings, who thus were supposed to unite the finite and the infinite. The *SP* now relates this to art. Bernhard Lypp has termed this view 'aesthetic absolutism', the 'invocation of the unity of absolute experience which

rests upon the materiality of the aesthetic sense'.[7] Because the aesthetic product still remains, *qua* created object, in the realm of intuition, it is able to point to why the world of the senses is not radically separate from the intelligible world. What makes the work a work of art which gives aesthetic pleasure depends upon our free judgement, which is independent of interest. Without the object, though, we would have no real access to our freedom. In the terms of the *SP* we have this access via the work of art, which gives us a sensuous image of freedom.

This might sound like just making into a certainty what Kant had been careful to leave in the realm of the 'as if'. We saw, though, that even in Kant's terms there is more than just a determination by the subject in aesthetic judgement. As Scheible puts it:

> Only where the subject on its part can be affected by the object, in the aesthetic judgement, can the object be really 'known' [*erkannt* in the sense of 'recognised'], as only here does it cease to be simply 'determined' [*bestimmt*].[8]

The transcendental subject's connection of intuitions gives rise to a nature whose coherence depends upon the subject's determination of what can be connected in it. The aesthetic sense, though, always involves a non-determining relationship to objects: the object affects us in ways about which the connection of phenomena in terms of rules of regularity can tell us nothing. However many physiological and psychological tests are done on people listening to music, this will not generate an aesthetics of music, for example.

As I have suggested, Kant's distinction between the beautiful and the sublime creates the conceptual space for issues of aesthetics and politics from this time onwards. The *SP*'s view of beauty is not just based on the political import of organicist ideas. The political dimension which plays a major role in later debates over aesthetics and politics is already apparent in the *SP*'s scepticism about *abstraction*, in the sense of the failure to see beyond the Understanding's production of general rules to what they might mean to individual human subjects in the life-world. Philosophy without aesthetic sense, the *SP* claims, is based on the Understanding's quantitative determination of objects, which denies their sensuous particularity. In this view even the imperatives of practical philosophy, the very basis of concrete ethical life, involve the danger of abstraction, in that they may simply be incomprehensible to most people in their theoretical form.

The philosophical exploration of the relationship between the

sensuous and the intelligible, and the political issues of modernity, are closely connected. The attachment of art to sensuousness both suggests its political potential and gives rise to important suspicions. Kant's introduction of the sublime and his approval of the ban on images in Jewish theology tend to suggest that the sensuous world is simply there to be overcome. Suspicion of the sensuous will also be important in Hegel's *Aesthetics*, where art is a lower form of truth because of its sensuous existence, and it will be a major target in Feuerbach's and Marx's attacks on Hegel and the later Nietzsche's attack on previous philosophy.

Kant himself was, as we saw, in the position of Schönberg's Moses, trying to make people believe in a God they could not see – Reason – and often doing so in a language devoid of aesthetic appeal. It is clear, though, as anyone teaching philosophy knows, that key abstract ideas can best be explained by trying to tell stories about them. Derrida's work can be read as revealing how the stories may not even be separable from the ideas at all: the metaphors on which philosophy lives may not be a removable extra. The idea that there is a boundary between the sensuous and the intelligible at all can be questioned, hence Derrida's concern with deconstructing such oppositions. Analogous ideas to Derrida's are legion in post-Kantian philosophy: the deconstruction of the sensuous/intelligible divide is prefigured in Schelling's notion of 'absolute indifference', a version of the Idealist attempt to reveal the unity of diversity, in which there is no absolute division between the sensuous and intelligible because they are part of the same infinite continuum.

For radical Enlightenment thinkers, like the early Schelling, this is also a political issue. The disintegration of the theological world view brings with it a loss of agreed syntheses that could reveal a super-sensuous truth via the world of intuition, of the kind which used to be present in the stories of mythology. The attention to works of art which seem to articulate collective concerns and which retain something of the status attached to cult objects grows accordingly. The loss of meta-physical coherence need not, of course, be seen just in terms of loss. Habermas sees the separation of the spheres of validity of cognitive, ethical, and aesthetic judgements in modernity as a key to its advances. However, this separation is already perceived by Idealist and Romantic thinkers as also involving substantial dangers, which a new mythology should try to overcome by a new synthesis of art and science.

The Idealist and the Romantic perception is of the need to find new

ways of linking individual ways of making sense, which have an inherent basis in intuition, to the products of the Understanding and to the purpose of these products. The products and their purpose are sometimes no longer theorised as being separate. Novalis suggests in the light of Fichte's philosophy that 'All inner capacities and forces and all outer capacities and forces must be deduced from the productive imagination',[9] that faculty in Kant which, as we saw, caused problems because of its hybrid status. If science depends on the production of images which the Understanding processes, the production of images can be seen as more fundamental than the one particular kind of synthesis achieved by the Understanding. If the basis of the organisation of the Understanding were the productive imagination, the sensuous would have the *same* status for both science and art. Furthermore, in this view, nature's own productivity would not be essentially different from ours, and the new science would reflect the conviction that the genesis of the product and the genesis of the knowledge of the product are inseparable.

Such ideas have generally been written off as pure speculation. Interestingly, though, the kind of speculation linking aesthetic and scientific praxis characteristic of the Romantics and of Schelling's *Naturphilosophie* does produce a lot more than merely speculative scientific results. The discovery of ultra-violet, theories of the ice age, and electromagnetism, for instance, are all worked out as part of Romantic science. Looking at the genesis of new science often reveals that it is not merely the result of new synthetic acts based on the capacity for rules of the Understanding, but in fact often requires an aesthetic component. Recent speculative science also seems to confirm this. Stephen Hawking, the present holder of the chair Newton held at Cambridge University, whose enormously successful *A Brief History of Time* often seems to breathe the air of Idealist and Romantic science, has, for instance, recently remarked upon the extent to which he initially thinks in images rather than in abstract mathematical formulae. The perception of science which develops later in the nineteenth century in Germany largely obliterates attention to these matters. Significantly, they have returned in the light of the new physics and of the contemporary changes in the perception of science effected by Kuhn, Foucault and other thinkers, many of whom are demonstrably dependent upon ideas deriving from the period at issue here.

The complexities of the relationship of the theoretical and the sensuous are being revealed as a hardly understood dimension of the

politics of modernity. The problem is that, with the liberation of subjectivity, the object can, *qua* aesthetic object, be articulated in an infinity of ways, be it in high art or in advertising, thereby losing any binding sense of its truth for a community. The Understanding, on the other hand, processes the object in such a way that it is reduced to being valid in one respect only. Importantly, although natural science relies for its validity claims upon the exclusion of individual imaginative articulations of the object, it does increasingly have recourse to the aesthetic when it comes to the attempt to communicate its claims to the rest of society. This tension between the cognitive and the aesthetic relation to the object is essential to the culture of modern capitalism.

Modern capitalism leads increasingly to all objects becoming commodities and thus involved in a process of abstraction not unlike the constitution of an object of science by the Understanding. The object as exchange value is abstracted from all its sensuous particularity in order to make it exchangeable for any other commodity. Advertising raids the sphere of aesthetics in order to give an individual sensuous appeal to the object of exchange value. The object *qua* exchange value often needs the adjunct of the aesthetic image for it to function as a desirable use value. Furthermore, the 'need' for the object may itself have initially been stimulated by the aesthetic images attached to the object, which are used to add a gloss to its status as, say, just another cancer-causing cigarette.

Aestheticisation of the commodity creates an increasingly difficult situation for serious artists, who have often responded with a revolt against sensuous beauty. They need to escape complicity with the adding of aesthetic pleasure to exchange values and need to sustain the notion of art as being independent of appropriative interest. This need is one root of the emergence of the avant-garde, which refuses to communicate in terms of any existing form of communication and makes no attempt to be sensuously pleasing, thereby once again invoking the limits of representation suggested in the sublime.

The development of the avant-garde can be seen as connected to the failure of the sort of hopes suggested in the *SP*. The synthesis of sensuous image and abstraction seems only to take place in a collective way in contemporary societies in the sphere of advertising and in the manifestations of administered mass culture, not in a new political public sphere in which the aesthetic is an integrated part of Reason. That any such syntheses take place at all in mass culture is, though, not something simply to be judged in moralising terms. The needs which are being catered for in these ways are real, however illusory their

fulfilment may be. Modern societies are evidently intolerable to their members without some sensuous way of relating to their technological and economic basis, however much this basis actually depends upon the elimination of sensuous particularity. The increasing incursion of the ad-men into the world of science, technology, and economics should not be underestimated.

The *SP*, then, points to coming dangers which result from the manifestation of Kant's separation of Understanding and Reason in the actual historical world. It is in this perspective that one has to understand the call for a 'new mythology', which would link the abstract and theoretical notions of philosophy and science to sensuous experience, in the form of images and stories. It is important to note that the mythology demanded is a mythology of reason: the point is that it is up to us to make the mythology, in the same way as Kantian Reason is the task we have as autonomous beings.

The *System Programme* concludes with the demand for a 'polytheism of the imagination and of art', and a 'mythology of *reason*', which would synthesise the potential released by science, art, and critical philosophy in the manner that myths integrated the contradictions between nature and society in traditional cultures. As the *SP* puts it: 'Before we make the Ideas aesthetic i.e. mythological, they are of no interest to the *people* and on the other hand before mythology is reasonable the philosopher must be ashamed of it.' Such a view raises the issues of Gramsci's conception of hegemony: if intellectual developments are not just to reinforce existing power structures, ways must be found of communicating those developments to the people, in order that they can make them effective in political emancipation. The synthesis of aesthetics and reason in the name of the radical democratic politics demanded by the *SP* is consistent with the Idealist philosophical desire to reveal the higher unity in the diversity of the sensuous world and thus to prevent a disintegration of the world into mere particularity. This again points to the extent to which the philosophy of the period is inseparable from political and cultural concerns. The failure of the vision of the *SP* will suggest the *political* failure of this version of the Idealist project. It also points to the major difficulties that will be faced by Marxist theory in coming to terms with the significance of art in a world where the collective theological basis of society has disintegrated.

The Romantic 'new mythology'

Friedrich Schlegel's 1800 *Discourse on Mythology* points to a similar relationship between art and mythology to the *SP* and the *STI*. Schlegel, however, begins to break with a central assumption of the *SP*. He already suggests reasons for the emergence of the new notion of aesthetic autonomy, which will be connected with the failure to synthesise the sensuous and the theoretical in an Idealist 'new mythology'. Karl Heinz Bohrer has argued that:

> Schlegel's *Discourse on Mythology* is precisely 'new' in that the 'new mythology' which it announces, as opposed to the demand of the *SP* and to the aesthetics of the young Schelling, is expressly not 'in the service of the Ideas', i.e. not a 'mythology of reason'.[10]

Schlegel's argument moves away from the emphasis seen in the *SP* on revolutionary demands for new forms of communication in the political public sphere.

The sense that human creativity is linked to a wider *purpose* in nature begins to give way to an ontology of spontaneous creativity of the kind to be seen in Nietzsche's *The Birth of Tragedy*. Schlegel's argument loosens the links between aesthetics and ethical goals present in Idealism. Bohrer suggests, though he exaggerates the extent to which this is important in the *Discourse,* that Schlegel initiates 'aesthetic reduction': 'the reduction of the time of the philosophy of history to an ecstatic moment'.[11] This reduction is particularly apparent in Schlegel's notion of *Witz* (roughly 'humour'), the capacity to create correspondences suggesting an essential unity of totally diverse phenomena, and thus of the whole world, in the manner of a myth. The moment is, though, characterised by randomness, suddenness, and transience. Art begins to involve a temporality which does not need to point beyond itself, which lives in the present of the engagement with the work of art and is irreducible to anything else. This, of course, will be a central issue in modernist art: Proust's *moment privilégié* bears traces of the Romantic idea. The other side of art becomes allegory, which Schlegel sees as a result of the impossibility of achieving the Absolute by reflection. Allegory points beyond itself and therefore is not itself a sensuous embodiment of what it really means, which again parallels Kant's sublime. One is left with an unhappy alternative between the evanescent transcending of the sensuous and a failure to represent a transcendent unity. The aptness of these ideas is revealed in the extent to which they

become preoccupations of so much modernist art from this time onwards.

In the *Athenäum Fragments* Schlegel had stated:

> A philosophy of absolute art [*der Poesie überhaupt*] would begin with the independence of the beautiful, with the proposition that it is separate from the true and the moral and should be separate from it and have the same rights as it (*KSF* 2 p. 129 Fragment 252).

The culmination of this idea will be the contention of Nietzsche in *The Birth of Tragedy* that the only justification of existence itself is as an 'aesthetic phenomenon', which is contemplated immediately for its own sake because it lacks any teleological justification. Schlegel, though, retains the Romantic idea that art can hint beyond itself towards an unrepresentable absolute.

The problem of the modern artist for Schlegel is that he must 'work out from the inside' and create 'every work like a new creation from nothing' (KSF 2 p. 201). Modern art lacks a 'centre', of the kind that mythology was for ancient cultures, from which to derive collectively binding images and symbols. Schlegel insists that the new mythology cannot use 'the nearest and most lively aspects of the sensuous world' in the manner that Greek mythology did, it

> must on the contrary be formed out of the deepest depths of spirit [*Geist*]; it must be the most artificial of all works of art, for it is supposed to grasp all other arts within it, a new bed and container for the ancient eternal original source of poetry (*KSF* 2 p. 201).

The new mythology would link all forms of articulation, from the arts to the sciences: hence the need for it to be artificial, a synthesis of what modernity has begun to separate into differing spheres.

The crucial difference of Schlegel's position from the *SP* resides in the fact that he sees *Poesie* as originating in the negation of the 'progress and laws of rationally thinking reason'. We should instead be plunged into 'the beautiful confusion of fantasy, into the original chaos of human nature, for which I know of no better symbol until now than the colourful swarm of the ancient Gods' (*KSF* 2 p. 204). The potential for the new mythology is seen as dependent on a suspension of reason. Schlegel wishes to see the creative potential beyond every particular sensuous object, which leads to an endless proliferation, of the kind Kant warned against in his reflections on the sublime. The proximity to Hamann's *Aesthetica in nuce* is evident. Mythology and art for Schlegel derive from

the same source, which is an endless process of articulation at all levels of nature and of human activity: 'Mythology is . . . a work of art of nature . . . everything is relation and transformation, formed and reformed' (ibid.).

The potential for eliminating the subject from the centre of this process is clear. Lévi-Strauss' structuralist account of mythology, whose analogies to aspects of Romantic thinking are apparent in its connecting of music to mythology, and mythology to language, is seen by Paul Ricoeur as 'a categorising system unconnected with a thinking subject. . .homologous with nature; it may perhaps be nature'.[12] Schlegel is similarly not concerned with the reflecting subject at this point: the vital aspect is the surrender to the other, the loss of identity. Certain tendencies in post-structuralism parallel this subjectless generation of endless difference. This is not surprising, given post-structuralism's links to Romanticism via Nietzsche. The view of nature as endless formation and reformation which is at the heart of Schlegel's *Discourse* is often associated with the myth of Dionysus, and with music, whose importance grows substantially at this time.

Already in the 1762 *Aesthetica in nuce* Hamann had stated:

> Do not dare enter the metaphysics of the arts without being versed in the orgies and Eleusinian mysteries. But the senses are Ceres, and Bacchus the passions; – old foster parents of beautiful nature[13]

thereby suggesting the connection of Dionysus to the arts characteristic of Idealist and Romantic thinking. In the essay *On the Study of Greek Literature* of 1797 Schlegel says of Sophocles that he amalgamates 'the divine intoxication of Dionysus, and the deep sensitivity of Athene, and the quiet collectedness of Apollo' (*KSF* 1 p. 107). Dionysus is seen here as the principle of dissolution which needs to be balanced by forces which give form to chaos. In *Der kommende Gott* (The Coming God) Manfred Frank shows how the figure of Dionysus plays an important role in both Idealist and Romantic thinking:

> Dionysus is the God who does not have a high opinion of the principle of individuation, who drags everything into the frenzy, makes 'women into hyenas', tears down the barriers between the sexes, and in general manipu-lates the separate realms of being as he wishes, by on the one hand pulling them down into the whirlpool of undifferentiated identity, on the other, as the liberating God dedicated to progress and evolution, separating the realms of being anew and – in the literal sense of the word – differentiating them. Thus he participates both in the principle of unity and of separation.[14]

The principle of creativity necessarily involves destruction: this apparent paradox is at the root of the philosophy of this period.

The myth of Dionysus expresses a version of the 'identity of identity and difference', which is central to early Schelling and to Hegel. The fascination of Dionysus has two related sources. The myth of the God that is destroyed and reformed can be linked to the story of Christ, as it frequently was, from the eighteenth century onwards – the myth clearly played a role in the initial formation of Christian mythology. At the same time a key problem in Idealist and Romantic thinking – how can the universe be shown to be both one and divided infinitely within itself? – appears in the form of Dionysus. This link of unity and division is itself one way of interpreting the passion of the son of God in Christian mythology. Dionysus becomes the basis of the intelligible world, which produces endless forms out of itself. For both Schopenhauer and Nietzsche this basis will be most readily intuitable in music. The initial reasons for this are best outlined here: the topic will frequently recur later.

The link of music to Dionysus can be understood if we consider Schlegel's view of 'Romantic art'. Romantic art is

> still in a process of becoming; yes, that is its real essence, that it can eternally only become, can never be completed. It cannot be exhausted by any theory

and multiplies itself 'as if in an endless row of mirrors' (*KSF* 2 p. 114–15). Romantic art is thus analogous to Dionysus, the God who combines creation with destruction: each reflection is destroyed in the next but the overall process is endless. Whereas the Idealist new mythology would be a binding together in collective forms of the products of modernity, this view suggests the unleashing of a world of decentred diversity. The process of 'infinite reflection' in Romantic art is associated with music because of music's dependence upon the passing of time for the different moments of a piece of music to become unified into a whole. The condition of the identity of the whole is the difference of its moments in time, a thought wholly consistent with Idealism. What this whole signifies, though, cannot be articulated in a definitive way: music is non-representational and seems to point beyond itself, without our being able to say what it is pointing to. This makes it the form of art most likely to be associated with the failure to represent the Absolute in a positive manner.

The tendency of the idea of the 'new mythology' towards music reveals the challenge of the idea, and a fundamental contradiction in

modern art. Music inherently has the potential to sustain aesthetic autonomy via its non-representational character, but it also becomes a major political issue. Wagner will attempt to revive a national mythology by using music which has been emancipated from existing norms of form. Wagner's project combines the political sense of the *SP*, albeit in a distorted form, with the Romantic view of the liberation of the aesthetic. The power of the results, and their highly questionable subsequent reception and use in practical politics, particularly by the Nazis, make it evident that aesthetic issues go to the very heart of modern politics. Analysing what is at stake in such aesthetic questions for the history of modern self-consciousness will be the major task of the subsequent chapters.

Naturally we find the idea of the 'new mythology' worrying: the most spectacular political success of a 'new mythology' was that of the Nazis, whom Walter Benjamin, no stranger to the thinking of this period, saw as 'aestheticising politics'. It has been argued that the failure on the left to establish at least some aspects of a 'rational mythology' was a major factor in the failure of the left to oppose Hitler. Ernst Bloch and Benjamin were well aware of the irrationality of the mobilisation of energy via aesthetic means by the Nazis. They were also aware, though, that such an ability to make ideas 'sensuous' is vital to any political project, as is the ability to find a place to articulate what was previously articulated in the religious feeling of the inherent incompleteness of sensuous existence. The consequences for art of trying to come to terms with these conflicting demands can, of course, be catastrophic. Much of the tension in debates over aesthetics and politics in this century can be related to the issues glimpsed in the *SP* and the *Discourse*. The demand to make Ideas aesthetic as a means of making them more accessible to people's experience and wishes, at the same time as sustaining the claims of reason, is never fulfilled. The driving of the aesthetic into radical autonomy is a reflex of this problem. If one is to grasp the full implications of the problems suggested here it is necessary to retrace the philosophical basis of their emergence. So much of what is debated in this area today can be better understood by considering the conceptual resources generated in the reaction to Kantian philosophy in Idealism and Romanticism.

Reflections on the subject:
Fichte, Hölderlin
and Novalis

Fichte

Although he wrote little of any significance about aesthetics, the importance of J. G. Fichte (1762–1814) for subsequent philosophy and aesthetics can hardly be overestimated. His importance has been best explained by his most influential contemporary interpreter, Dieter Henrich, who suggests that

> Fichte was the first to arrive at the conviction that all previous philosophy had remained at a distance from the life and self-consciousness of human-kind. It had had ontological categories dictated to it which were taken from the language in which we communicate about things, their qualities and their changes. With these categories philosophy had then investigated powers and capacities of the human soul. It was therefore fundamentally unable to reach the experiences of this soul, the processes of consciousness, the structure and flow of its experiences and thoughts.[1]

Fichte radicalises the Kantian turn towards the subject, not just, as is well known but little understood, by making the world into a product of the I, but also by an exploration of the structures of self-consciousness which reveals the irreducibility of self-consciousness to anything we can say about the object world. It is this exploration which leads to Romanticism and beyond, as well as to many of the most important ideas in aesthetic theory that we shall be looking at in the rest of the book.

Just how significant Fichte is can be demonstrated by considering a part of a famous later account of subjectivity: Freud's thirty-first 'New Introductory Lecture', on the 'Dissection of the psychic personality'. It is unlikely that Freud knew Fichte's work in any serious way. Despite this, his initial question in the lecture is remarkably reminiscent of the questions which Fichte poses for modern philosophy. In the lecture

Freud develops the model of the psyche which divides the I into id, super-ego, and ego. The lecture concludes with the famous injunction that "*Wo Es war, soll Ich werden*" (Where Id [It] was, Ego [I] should become).[2] The hope of psychoanalysis is for the I to become able to integrate more of its basis in natural drives and to become more independent of those imperatives internalised during socialisation which prevent it from developing.

The analysis of the subject in Freud reveals that the I is divided within itself. The term 'dissection' has proto-medical connotations, and locates the enterprise within the discourse of natural science. When he embarks on the 'dissection' Freud says the following:

> We want to make the I into the object of this investigation, our most personal [*eigenstes*] I. But can one do that? The I is after all the most essential subject, how should it become an object? Now, there is no doubt that one can do this. The I can take itself as object, treat itself like other objects, observe itself, criticise, do heaven knows what with itself. In doing so one part of the I opposes itself to the rest. The I is, therefore, splittable, it splits itself during many of its functions, at least temporarily. The pieces can unite themselves again afterwards.[3]

Freud's reflection is remarkably glib about the ease with which the dissection can be legitimated methodologically. If one looks a bit more carefully the argument entails a serious problem and points to a way of understanding the import of Fichte's notoriously difficult philosophy.

The first problematic assumption was implicit in Henrich's assessment of Fichte. *Can* the I look at itself like any other object? We already saw in Kant there was a difficulty in explaining the consciousness which must already be there for our multiple representations to be the representations of an 'I'. Kant said that our awareness of this consciousness was limited to the way in which it synthesised intuitions, including of itself as appearance in time. He had, though, to assume the *existence* of the consciousness, despite his inability to say anything about it beyond describing the results of its operation. It was clear that this consciousness did not have the status of an object: it was a 'spontaneity'. The 'spontaneity' is the prior condition of any attempt to know what it, or anything else is. Freud is faced with an analogous difficulty, which becomes apparent when he says that, having split itself up into subject and object, the I can reunite itself afterwards.

The question is which piece (which is Freud's own word) is able to do the reuniting? What does the reuniting cannot be an object of the same

order as what it reunites. What is the principle that brings the pieces back together? The answer in Freud's terms is the I itself, the I of the theorist. This, though, is circular: the I becomes defined as that which can reunite itself having split itself into subject and object. Without being able to deal with this problem we become unable even to account for consciousness at all, as Kant was aware: what stops it disintegrating into the objective pieces into which it is split in the act of reflection? A related problem is this: can the I which does the looking at itself be shown to be the same as the I which is being looked at? This only seems possible on the basis of an initial assumption that what we begin with is a unified I. The point of the investigation, though, was to establish the structure of the I. We also need an account of what brings about the act of reflexive splitting, the action of the I making itself into an object. Something that makes itself into an object cannot initially be an object.

Freud's account is consistent with his desire for psychoanalysis to be a science. For this he requires the knowledge of the psyche to be of the same kind as other knowledge. The complexities and confusions in Freud's endless reformulations of his theory and the battles over its reception can be seen as in part a result of the failure to deal adequately with the fact that consciousness cannot be described via the assumption that one is looking at an object. The attempt of the I to look at itself can be metaphorically understood by taking the obvious way in which the looker can look at him or herself, namely in a mirror. This, as the passage from Freud suggested, tends to be how theories of self-consciousness are formulated. Henrich calls such a theory of consciousness 'reflection theory':

> this theory assumes a priori a subject that thinks. It then explains that this subject continually relates to itself. The theory further maintains that this relationship comes into existence via the subject's making itself into its own object. This capacity of becoming conscious of oneself via a reflexive act distinguishes human beings from animals.[4]

Fichte was the first person to realise just how problematic this theory is.

Fichte wishes to found philosophy upon the one precondition which must be absolute and immediately certain. Since Descartes this principle had been the I. Fichte begins with the need to establish the Cartesian foundation in a more certain way than Kant had been able to. Kant's problem was that he had tried to see the I as a fact, a *Tatsache*, literally a 'deed-thing'. For Fichte the I must be an action, a *Tathandlung*, literally a 'deed-action', a word he concocts to try to

express the idea that the 'fact' of the I is to be understood as action rather than as a fact. This action is not of the same order as the action of the ego in synthesising intuitions: 'As it should not be contained in those actions, which are all necessary . . . it must be an action of freedom' (*Werke* 1 p. 71).[5] The highest act of philosophy has to be the spontaneous act of coming to think about thinking. If it were not it would be part of a mechanical series of causes and effects. As Fichte suggests (and the adherents of the myth of artificial intelligence would do well to listen): 'The mechanism cannot grasp itself, precisely because it is a mechanism. Only free consciousness can grasp itself' (*Werke* 1 p. 510). This cannot be the result of anything which determines that it happen, as this would require an account of what determines the determiner and so on, either *ad infinitum*, or to a point which has to be assumed as the absolute origin, which for Fichte is precisely, the I.

How, though, do we give an account of this action? Fichte's answer is simple: one cannot. The evidence for the act is the very act of philosophical thinking about the I itself, which is both theoretical and practical. Fichte:

if [philosophy] starts with the fact it places itself in the world of existence and finitude and will have difficulty finding a way from this world to the infinite and supersensuous; if it starts with an action it stands at precisely the point which links both worlds and from which they can be surveyed in one gaze (*Werke* 1 p. 468).

The 'infinite' in the passage quoted refers to action which cannot be *defined* as knowledge would be. Grounding philosophy in the I leads to the realisation that the most important aspect of philosophy cannot appear in empirical consciousness. This part, as it was for Kant in the transcendental unity of apperception, is the very basis of empirical consciousness:

It is . . . the ground of explanation of all facts of empirical consciousness that before all positing in the I the I must itself previously be posited (*Werke* 1 p. 95).

The difference from Kant is that Fichte refuses to accept that we have no access to this ground. Our access is not cognitive: it entails the realisation that we have a capacity which raises us above all the rest of nature and which has no ground other than itself. This realisation can only come about by doing the realising.

Fichte's philosophy is a challenge to any thinking which would give

primacy to the objectivity of knowledge. The challenge of his philosophy is a personal one, and is often reminiscent of Sartre:

> Whoever is in fact only a product of things will never see themselves in any other way, and they will be right as long as they only talk of themselves and people like them (*Werke* 1 p. 433).

Fichte's philosophy is a philosophy of praxis: 'We do not act because we know, rather we know because our vocation is to act; practical reason is the root of all reason' (*Werke* 2 p. 263). There can be no empirical evidence of the act of thinking, as we are always already engaged in it when we wish to intuit it. Fichte's problem is to find a way of describing an 'eye', or more problematically a 'look' – consciousness – that could 'see' itself seeing. It is clear to him that the reflection model of consciousness, the model we saw in both Kant and the passage from Freud, cannot grasp the undeniable fact of self-consciousness.

If Fichte is right this means that any claim to ground scientific knowledge absolutely is doomed to failure. This gives a heightened importance to aspects of consciousness that are not based on the Understanding, and points towards Schelling's and the early Romantics' attention to aesthetics. The only absolute for Fichte is the action of the I, all other kinds of knowledge are secondary, even if they are wholly coherent in themselves. This is not an idealism like that of Berkeley:

> one is very wrong if one believes transcendental idealism denies the *empirical* reality of the world of the senses etc.: it just demonstrates the forms of knowledge in empirical reality and for this reason destroys the sense that they are self-sufficient and absolute (*Werke* 2 p. 104).

The ability to describe the forms entails the fact that the I must transcend these forms in order to be able to reflect upon them, in the same way as the I in Freud had to be of a different order from that which it splits and reunites. What this implies becomes apparent in Fichte's refutation of 'reflection theory'.

Fichte's objections to 'reflection theory' are most powerfully stated in the splendid 'Attempt at a New Presentation of the Doctrine of Science' of 1797. As Manfred Frank has shown,[6] Fichte's account of self-consciousness is not touched by most of the Heideggerian and post-structuralist attacks on subjectivity, which seem unaware of the existence of Fichte's argument, preferring to see him solely as the most characteristic representative of Western philosophy's 'subjectification

of Being'. Even though Fichte will not achieve a philosophically viable account of self-consciousness, his 'original insight' (Henrich) has retained its importance, and is by no means superseded by subsequent developments.

Fichte begins by asking me, the reader, to ponder what I do when I think 'I'. This thought is special because in it thinker and thought cannot be separate. The action of the I thinking itself is an action upon itself. The I results from the return of thinking to itself: if it were always only thinking of an object there could be no I; there would merely be unconnected empirical data, as Kant had already shown. Fichte sees the problem of reflection as follows:

> *You* are – conscious of *your* self, you say; accordingly you necessarily differentiate your *thinking* self [*Ich*] from the self that is *thought* in the thought of yourself. But in order for you to be able to do this, the thinking part of that thinking must be again the *object* of a higher thinking in order to be able to be an object of consciousness; and immediately you get a new *subject* which has again to be conscious of that which was *being* conscious of yourself (*Werke* 1 p. 526).

The result is one of those infinite series, of the kind 'I know that you know that I know that you know' etc., where *what* is supposedly known disappears in the endless reflection. In Fichte's terms it is a case of 'I am conscious that I am conscious that I am conscious' etc. In the *Vocation of Man* of 1800 he starkly presents the problem as follows: 'And do I really think or do I just think a thinking of thinking? What can stop speculation acting like this and continuing asking to infinity?' (*Werke* 2 p. 252). Clearly consciousness cannot be explained in this manner.

The problem is to differentiate the first and the second 'I', but without losing their ultimate identity. Henrich puts it as follows:

> how can self-consciousness know that it knows itself if this knowledge is supposed to come about via an act of reflection? It is obvious that it cannot have this reflected knowledge without being able to lay claim to a preceding knowledge of itself.[7]

The nature of this 'knowledge' will be the problem for Idealist and Romantic philosophy. Even trying to find a word to characterise it which does not repeat the problem of reflection raises difficulties. The 'knowledge' cannot be like seeing oneself in a mirror: how would I know that I was seeing *myself* if I did not already somehow 'know' that it was myself that was doing the looking? Rorty's objections in *Philosophy and the*

Mirror of Nature to the mirror as the dominant metaphor for consciousness in Western philosophy do not, then, apply to this argument.

Fichte is led to the demand for an *immediate* access to consciousness which does not entail any kind of splitting: he will spend the rest of his philosophical life failing to give an adequate account of this immediate access. The subject *qua* object upon which the philosopher reflects must already be given in the original spontaneous *act* of self-consciousness. As such, the Kantian divisions of theoretical and practical, sensuous and intelligible must result from a preceding unity *in the I*, which could only be denied if one were to deny the fact of self-consciousness itself. Such a unity does not just apply to my individual I: it is the very principle of thinking itself.

Fichte adopts the notion of 'intellectual intuition' in the attempt to grasp this principle, but he characterises it in a different way from Kant, seeing it as 'that through which I know something because I do it' (*Werke* 1 p. 463). It is both the act of thinking and the consciousness of that act:

> the consciousness of my thinking is not something which is just coincidental to my thinking, something which is added to it afterwards and thus linked to it, rather it is inseparable from it (*Werke* 1 p. 527).

To this extent consciousness is not subject to the division of theoretical and practical: the (practical) action of the I intuits itself as (theoretical) object of philosophy. The intellectual intuition which Kant rejects is analogous to the arguments of people who accept the ontological proof of God, who 'must regard the existence of God as a simple consequence of their thinking' (*Werke* 1 p. 472). This kind of intuition would have to create a non-sensuous being, that of the 'thing in itself' (as opposed to our intuitions of it), by pure thinking. Fichte's intellectual intuition is not the creation of a non-sensuous *existence* via thinking, it is an intuition of the *action* of thinking itself. This does, though, lead to the apparently bizarre but consistent idea in Fichte that this activity, which is both theoretical and practical, is the highest principle of reality. Why should this be?

The highest principle cannot be located in an external world of nature because without the activity of the I the very idea of a highest principle would not emerge. External nature, the realm of objects, can, in this argument, only be, as it will be for Hegel, a product of thought:

> *the consciousness of a thing outside us is absolutely nothing else than the product of our own capacity for thinking* and . . . we know nothing more of the thing than we precisely know about it, posit via our consciousness (*Werke* 2 p. 239).

Because we always require the activity of the I for knowledge we only know even what is 'outside' us by what is 'inside' us: 'everything that occurs in consciousness is *grounded, given, caused* via the conditions of self-consciousness; and a basis of the same outside self-consciousness absolutely does not exist' (*Werke* 1 p. 477). If this sounds absurd it is worth trying to say anything about the world whilst subtracting the I which thinks what is to be said. Any specific empirical thought will be filled by the reflection on the object, be it this tree or myself at this moment. This, though, is not what is most important for Fichte, as it had not been for Kant. The ability to *move* from one specific thought to something beyond it is the real basis of self-consciousness.

This requires freedom: nothing in the realm of necessity, the realm of the synthesising of intuitions into categories, could give rise to this basis. Consciousness has a status which puts it above anything one can say about objectivity, because it is for Fichte, as it was for Kant, the condition of objectivity. It must, as such, be both subject and object. Otherwise it cannot account for its own action: '*That whose being (essence) simply consists in the fact that it posits itself as being* is the I as absolute subject' (*Werke* 1 p. 97). The notion of the Being of the world independent of our thinking can make no sense for Fichte:

> the concept of a Being that should occur, from a certain point of view, independently of thinking [*Vorstellung*], would yet have to be deduced from thinking, as it is only supposed to exist via thinking (*Werke* 1 p. 500).

We shall encounter another version of this argument in Hegel. Fichte is insistent that 'One cannot abstract from the I' (*Werke* p. 500): to do so would require the I to abstract from itself, which is obviously absurd, in that the abstraction would require an account of what does the abstracting, which must be the I itself.

What is puzzling for most people about Fichte's view is why we experience the world as external, hard, objective necessity if it is in fact our thinking which is the condition of the world's objectivity. Manfred Frank warns against a hasty dismissal of Fichte's arguments:

> If it is right that our feeling of being compelled [by the thing in itself as external to ourselves] presupposes as condition of its possibility the consciousness of our self, then we do not have the slightest right to reverse the sequence of the facts and to maintain that it is rather the thing (in itself) which determines our consciousness (including the consciousness of our receptivity).[8]

The reason that the I is the highest principle for Fichte lay in a radicalisation of Kant's notion of practical reason, of the capacity to move beyond any apparent compulsion, in the making of ethical decisions. This entailed a spontaneity. 'Spontaneity' was also the basis of cognition, in that the synthesising of sense data requires that which synthesises, which is not reducible to the data themselves. As the basis of the first two critiques was this spontaneity, it seems clear to Fichte that the task of philosophy is to articulate the spontaneity. Doing this, though, means attempting to make the fundamental free action into something which philosophy can describe.

This gives rise to the question of why the I should objectify itself in both the world and ourselves, which, in these terms, are not ultimately separate. Fichte's answer is that the I needs the non-I to emerge. This is consistent with the fundamental principle of modern philosophy since Spinoza that determining what something is requires the determination of what it is not. Either the Absolute, the unity of subject and object, remains enclosed in itself as an undividable unity, which means that any philosophical articulation is a priori impossible, or a division must take place within the Absolute, which would enable philosophy to articulate the Absolute. Given that the highest thought for Fichte is that of the I, which is necessary for any articulation, there must be a way of articulating the Absolute, in that the I is *characterised* by its *lack* of limitation. As Frank puts it, the ego 'was, before this distinction [from the non-ego], originally an infinite and unlimited activity; for, so he says, only an activity which is in itself unlimited could be subsequently limited'.[9] As was evident in Kant's account of the sublime, thinking can move away from its inherent limitation towards unlimitedness once the awareness of the limitation is necessarily part of thinking. The essential tension in Idealist and Romantic thought resides in the uneasy *coexistence* of the desire to be able to *say* what it is in thinking that is unlimited, with an accompanying sense of the impossibility of saying it. The Romantic attachment to art will derive from an awareness of this tension.

The tension is the source of a major philosophical problem. Fichte's account gets into difficulties because the activity of his 'absolute I', the unlimited dynamic principle of reality, has to generate an I and a non-I which are relative to each other. This means that it becomes very hard to know in what sense the absolute principle could be referred to as an 'I': seeing A as opposed to not-A is impossible if it has to happen in terms of A itself. The problem is a mirror image of Freud's difficulties in giving an account of the overall structure of the psyche, given the fact that all

psychic energy is seen as deriving from the id, which is unconscious. The id splits itself and directs its own forces against itself by the integration of the ego and the super-ego into the structure of itself. Grounding a description of this requires, though, the forces of the id itself to describe themselves, which leads to another version of the problem of reflection. For the id to know itself as the chaotic, drive-basis of the I, it would already require the division into itself and its other. This division, though, means that the id itself cannot be represented theoretically as it must always already be split into the representer, the conscious ego, and what is supposed to be represented, the unconscious id. Faced with the analogous problem with the I, which is, like the id, the source of all activity, Fichte is forced into the bizarre move whereby '*I oppose in the I a splittable I to a splittable non-I*' (*Werke* 1 p. 110). Whilst it is possible to argue, as Fichte does, for the necessity of a prior subject without which the notion of an objective world makes no sense, calling the overall process 'I' within which I and not-I become separate, is inconsistent, as Hölderlin will be one of the first to see.

If there is to be an Absolute, an unconditioned basis of philosophy, any dependence of the highest principle on something else must be transcended. If self-consciousness is relative to its other, Fichte's project must fail because it introduces a moment of dependency that the whole project had to avoid if it was to achieve what Kant had failed to achieve. Fichte's attempt to give an account of free self-consciousness which does not reduce it to being an object is inadequate: his later philosophy makes this clear by attempting varying routes to an account of our freedom. The early Fichte's achievement should not be forgotten, though, as Henrich has argued. Fichte's real insight is that reflection on the subject by the subject reveals a reality which will never exhaust itself in what could be known objectively. It is this fact that will make him so important to those engaged in aesthetic theory and aesthetic praxis.

Hölderlin

The problems in Fichte's philosophy were quickly seen by a poet, Friedrich Hölderlin (1770–1843), who in his youth was a friend of both Schelling and Hegel. The investment in understanding the I will be central to literature to an ever greater extent from this period onwards. Hölderlin's ideas were expanded in certain versions of Schelling's philosophy (as we shall see, Schelling was not always wholly consistent about his relationship to Fichte). Three key texts show Hölderlin's

prophetic insight: a letter to Hegel in January 1795, the fragment 'Judgement and Being' of 1794/5, and the untitled essay usually called 'On the Procedure of the Poetic Spirit'.

In the letter Hölderlin questions Fichte's use of the I as the highest principle of philosophy:

> his absolute I . . . contains all reality; it is everything, and outside of it there is nothing; there is therefore no object for this absolute I, for otherwise the whole of reality would not be in it; but a consciousness without an object is unthinkable, and if I am this object myself, then as such I am necessarily limited, even if it only be in time, thus not absolute; thus there is no consciousness thinkable in the absolute I, as absolute I [*Ich*] I [*ich*] have no consciousness, and to the extent to which I have no consciousness I am (for myself) nothing, therefore the absolute I is (for me) nothing.[10]

The highest principle can, therefore, never appear in my reflection on anything as object, including myself, as this would contradict its very essence as the Absolute. It requires an intuition which is beyond any division of subject and object.

'Judgement and Being' questions the separation of subject and object, which it sees as united in 'intellectual intuition'. Hölderlin sees the origin of consciousness as entailing an 'original separation' (the German word *Urteil* means both judgement, and, via the artificial separation of its two parts into *Ur-Teil*, 'original-separation') of subject and object. The two presuppose each other, as we have already seen in Fichte. Hölderlin, though, suggests that they also presuppose a 'whole of which subject and object are the parts'.[11] This whole he terms '*Being*'. Hölderlin sees Being as that which cannot be subsumed into the relationship of our thinking to the world we reflect upon (including ourselves); Being becomes 'transreflexive', not determinable in the way that a subject determines an object of knowledge, including itself, as opposed to itself.

It is worth citing Hölderlin's argument at some length. For Hölderlin '*Being* – expresses the link of subject and object . . . this Being must not be confused with identity'. As we shall see again in Novalis, the identity in the statement I=I entails a non-identity, in that what should be unified has been taken apart in an act of reflection in the attempt to demonstrate its unity. Hölderlin continues:

> If I say: I am I, then the subject (I) and the object (I) are not unified in such a way that no separation can be undertaken without infringing upon the essence of that which is to be separated; on the contrary the I is only possible via this separation of the I from the I.

There can be no analytical account of the I which would grasp it as it must exist pre-reflexively, although to be aware of itself as an I it must reflect:

> How can I say 'I' without self-consciousness? But how is self-consciousness possible? By my opposing myself to myself, by separating myself from myself, but despite this separation by recognising myself in the opposition as the same. But to what extent as the same? I can, I must ask the question in this way; for in another respect the ego is opposed to itself. Thus identity is not a unification of object and subject that happens absolutely, thus identity does not = absolute Being.

The total coincidence of subject and object that would constitute the Absolute cannot, then, be articulated by consciousness because consciousness is located in a structure which it can never fully grasp: it always involves a relation in which one term depends upon the other, a judgement, which separates that which it wants to unify in the act of demonstrating its unity. This dependence Hölderlin terms Being: although this, as yet, is being formulated in terms of the problem of self-consciousness, the argument clearly points forward to Heidegger. For Hölderlin the act of self-identification is subsequent to the existential fact of consciousness, which is not to be understood as just 'mind', but as the primordial unity of subjective and objective, as their inarticulable ground. Hölderlin sees reflective consciousness as being unable to provide the unconditioned foundation that Fichte tried to provide with the idea of the 'absolute I'. This, though, leaves a significant problem.

Hölderlin explores the problem in 'On the Procedure of the Poetic Spirit', a text which would require far more space than I have here to do proper justice to it. Most of the implications of critiques of the inherent dependence of subjectivity from Schopenhauer to post-structuralism are already contained in it, but it does not draw the consequence that self-consciousness of the kind which is central to Fichte is therefore not a real issue for philosophy.

Hölderlin wishes to show the inadequacy of three major attempts to give an account of the fundamental fact of self-consciousness, the basis of any philosophy which does not retreat into a pre-Kantian position. All three attempts end up splitting the I in ways which make it impossible to sustain the undeniable necessity of self-consciousness. The requirement of Kant's 'transcendental unity of apperception' was for an I which was not 'as differently multi-coloured as I have ideas that I am

conscious of' (B p. 134): without this unity nothing can be said about either the world of the subject or the world of the object. Kant himself, as we saw, failed to give a convincing account of this I.

Hölderlin sees the three views in question as revealing an I which is 'in real contradiction with and for itself', in that it can be grasped neither (1) as something known grasped by the knower; (2) nor as a knower grasped by the knower; (3) nor as known and knower grasped by knowing, or as knowing grasped by the knower. In (1) the difference of knower and known (I as subject and I as object) would have to be regarded as a 'deception . . . which the I makes to itself as unity, in order to recognise its identity, but then the identity which it thereby recognises is also itself a deception, it does not recognise itself',[12] a formulation that is remarkably reminiscent of Lacan. Hölderlin rejects this position and does not use it as an excuse to make self-conciousness into the form of narcissistic self-deception it is for Lacan. In (2) the I assumes that it is inherently divided in itself: the very act of knowing presupposes the division of knower and known, which would also apply to the knowledge of oneself. This means, though, that the acts which the I performs cannot be identified as its *own* acts because it is already unable to identify itself as a unity: to which part of itself would the acts belong, to itself as knower or as known? If the I is inherently divided this division cannot be a result of the I, because the whole point is to establish the prior unity of the I. As such, 'the I is not that which is different from itself, rather it is its nature [which is different from itself], in which it behaves to itself as something driven',[13] thereby becoming unable to account for why it is aware of it*self*. The problem is much the same as the one seen in Freud's thirty-first 'New Introductory Lecture', where an initially unified I was required which breaks itself up and is yet still there to reunite itself, having broken itself up. It also relates to the other problem we saw in Freud. As it is the id which provides the energy for the ego, which is a result of the drives of the id being divided against themselves, it becomes impossible for the I to *know* its real basis, the id, as it requires it for the knowing. In (3) the I wishes to see itself as identical with itself, as split into subject and object. To do this, though, again requires a structure of reflection, splitting, which destroys the unity which is supposed to precede the reflection: to see itself as itself requires prior awareness of itself as not divided from itself. The argument is another version of Fichte's argument against 'reflection theory', and it now radically denies that the I can represent its own essential nature.

Hölderlin does not overcome this problem, but rather sees the striving for the unity of the I in these three moves as leading to questions of 'poetic representation'. The internal reflection of the I leads to the awareness of its inherent dividedness, once it tries to grasp itself as itself. Hölderlin therefore sees the necessity of moving beyond this division: 'It is a matter of the I not simply remaining in interaction with its subjective nature, from which it cannot abstract [by reflecting on itself] without negating itself'.[14] If it remains in this state it will be likely to resign and regress to the childhood state, where it 'was identical with the world', which is what Lacan means by the 'imaginary'. In the imaginary the I only reflects itself and does not move beyond this illusory form of self-identification. The other alternative for Hölderlin will be that the I will 'wear itself out in fruitless contradictions with itself'.[15] The attempt to move beyond this requires the exercise of the I's free spontaneity in the choice of an external object, which will reveal the I's 'poetic individuality'. The external object *qua* object is necessarily divided from the I, but if the choice of the object is the result of the most fundamental act of the I, free choice, a new form of relationship can result. In it the I escapes imprisonment within the imaginary by the engagement with the freely chosen external object, but is also able to recognise itself by the fact that it can abstract from the object of its choice and reflect upon itself *via the object*. The stress is on the creative relationship to the object, not upon a cognitive relationship.

'Poetic individuality' relates closely to the argument we saw in the *SP* (it has been argued that Hölderlin was involved in the writing of the *SP*), where the 'highest act of reason' was an 'aesthetic act': *only* the I, as free spontaneity, can see nature aesthetically or produce aesthetic objects. The object thus enables the subject to grasp what it would be like to realise its most fundamental self, and prevents the sense that the division in self-consciousness leads merely to alienation. Because it recognises itself in the external world without surrendering itself, which it would if it made itself dependent upon the desire for the object, the I can begin to realise how it need not repress its divided nature. The division, it is important to remember, came about, as it did in Fichte, by the free act of reflection, which moved the I beyond the imaginary stage in childhood into the complex world of self-conscious reflection.

Hölderlin wishes to make the dividedness of self-consciousness part of its own creative potential, which strives to show in aesthetic production what it would be to overcome the division without regressing into an imaginary unity. His poetry will reflect the struggle that results

when the objective political and social world makes it harder and harder to believe in the possibility of realising this vision: it will more and more take on the attributes of autonomous art in its growing complexity and lack of immediate accessibility, which is combined with a remarkable tragic power. Hölderlin himself will be worn out in contradictions with both himself and the object world: he goes mad.

In Hölderlin, then, reflection upon the subject leads, via the realisation of the impossibility of objectively grounding subjectivity, to the realm of aesthetics. There is, though, in the fate of Hölderlin and that of not a few other artists of the age, a warning. Hölderlin himself was evidently aware, as his letters show, that attempts creatively to explore the I which are not backed up by vital social and political advances will lead to disaster. The need seen in the *SP* to link the aesthetic and the political is a necessary part of Hölderlin's vision. The fact that his aesthetic production moves in the direction of autonomy is an index of the failure to achieve such a link in a manner which would not be a perversion of the vision it is based on. As I suggested in the last chapter, this pattern is characteristic of the fate of modern art.

Novalis

Friedrich von Hardenberg (1772–1800), who called himself Novalis in his published work, conceives his philosophy, like Hölderlin, in relation to Fichte. In the English-speaking world he is rarely considered as a philosopher, being seen as the archetypally doomed Romantic poet. However, like so many of his contemporaries, he did not regard the boundaries between forms of theoretical and creative activity as fixed. His philosophy is an integral part of a wider project which includes scientific, literary, and other work. Novalis is important now because he asks questions about subjectivity which sound familiar in the light of the accounts of the subversion of the subject that are the stock in trade of much of post-structuralism. The claims to be saying something unheard of that are characteristic of the worst aspects of post-structuralism should be tempered by the evidence from Novalis and others that, from the very earliest stages of modern philosophy, the subject does not occupy the position of sovereign, not least because of its dependence on language. I want to give a brief account, mainly based on the so-called 'Fichte-Studies' (*FS*)[16] of 1795–6, of Novalis' reflections upon subjectivity. These reflections will again lead in the direction of aesthetics.

The *FS* are not a coherently argued whole: they are a series of

fragments relating to Fichte's *Wissenschaftslehre*. The difficulty for the interpreter is that the problems they consider are repeatedly explored in differing vocabularies which are only comprehensible within the particular context of their use. The context itself cannot be reconstructed with any degree of certainty, so that grasping its significance will depend upon an attempt to relate the context to other analogous contexts. The problem is not extraneous to the philosophical content of the FS: it is inherent in the way Novalis sees intellectual activity.

The problem Novalis begins with is the same as concerned Kant, Fichte, and Hölderlin. How can the I, as the highest principle of philosophy, give an account of itself? The most obvious way seems to be the statement of identity: 'I am I'. However, Novalis, like Hölderlin at much the same time, shows that the very attempt to determine the nature of the I by such a statement of identity robs it of its essential nature:

> The essence of identity can only be demonstrated in an *apparent statement* [*Scheinsatz*]. We leave the *identical* in order to represent it – Either this only apparently happens – and we are persuaded to believe it by the imagination [*Einbildungskraft*] – what already Is *happens* – naturally via imaginary separation and unification (*FS* p. 104).

The formulation is characteristically cryptic: understanding Novalis often entails the use of one's own imagination. The basic point is, again, that in splitting the already existing and acting I by reflection its character as absolute spontaneity is lost. The first and the second I would again need a prior I to unite them. Fichte already made this problem clear. As Hölderlin suggested, if I need to reflect on myself to know myself as myself then it is already too late. Any result of this reflection will be a self-deception because the result of my reflection cannot be the same as what initiates the reflection in the first place.

Novalis' central concern is with the difficulty of representing the I: how do I represent myself to myself? He invokes the painting in which 'the picture is painted in the position that it paints itself' (*FS* p. 110). In such a painting the painter includes himself or herself as painter of the picture in the picture, and thereby reminds the viewer that without him/her there would be no painting. At the same time we see the painter as object, not as creating subject: s/he appears as visible phenomenon *within* the painting, which is supposedly his/her own. We can deduce from this that s/he is theoretically necessary for the coming into existence of the image we have before us, but we have no access to what

generates the image, because we see the creator as object, as a result of reflection. To see him/her as subject we would have to become him/her as I, and thus be able to generate the painting ourselves.

A famous example of such a painting is Velasquez' 'Las Meninas'. In this painting the matter is complicated in a way which gets us close to Romantic thinking. (I am concerned here not with a historical interpretation of the significance of this painting, nor with Foucault's account of it in *The Order of Things*, but solely with certain of the positions it suggests for a theory of the I.) In 'Las Meninas' there would have to be a mirror in the position where the viewer of the painting is located, which the painter would be looking at in order to see himself and to be able to paint his own reflection. In fact, though, one deduces that in the position of the assumed mirror is the object that the painter is supposedly painting: the King and Queen of Spain. We deduce this by the fact that the object the painter is supposed to be representing exists as empirical object, within the painting, as a faint reflection in a mirror that is represented on the farthest wall of the painting. The I – the painter – retreats into a position in which he cannot be represented as active I, in that he is dependent upon a reflection in a non-existent mirror. It is clear, though, that this does not have to mean that the I does not exist: *the very sense of its absence points to its undeniable existence*, not least as the ironic creator of an aesthetic object which causes so much bafflement. This evokes the world of Novalis' reflections upon the I and hints at how they relate to aesthetics. Significantly, an aesthetic image is best able to suggest a way of understanding the philosophical problem.

Novalis adds a crucial new element to the issue of how the I could represent itself, by taking into account the fact that such representation involves language. In order to represent the identity of the I we are always already in the position of using the 'signifier' (*Zeichen*) 'I'. The signifier 'I' is not identical with the I that uses the signifier: I am not a spoken or written word. I do not create the signifier *qua* signifier and it already requires another for it to be a signifier at all. For Novalis the signifier 'I' is the 'Non-being' (*FS* p. 106) of the I because it tries to represent the I. If the signifier is to represent the I to anyone else, for it to be a signifier at all, it must be recognisable to another as designating the I, but therefore not *being* the I. It cannot express the free spontaneity of the I, because it is a *necessary* condition of the I being recognised by another as I: 'Every *comprehensible* signifier must therefore have a *schematic* relationship to what it signifies' (*FS* p. 109). By 'schematic' Novalis means that it must be repeatable, that it can reduce difference to

identity. The signifier 'I' must be able to be used by both you and me, however different we may be. Our ability to do this requires the identity of the signifier: 'I' must repeatedly signify what we freely agree it signifies.

The identity of the signifier, however, is constituted, as it will later be for Saussure, by its difference from every other signifier: 'In its place each is only what it is by the others' (*FS* p. 109). It is, as such, wholly determined by its relationship to everything else: 'I' is not 'you', is not 'he', etc. For Novalis the signifier and the signified are of a different order from each other, and can only be identified by a third, for which the signifier functions by designating the I, without being able to represent it. Oddly, the dependence of the signifier on its not being *all* other signifiers for its identity means that what determines it – all other signifiers – also points to the opposite of determination. There seems to be a negative way of representing the Absolute, such that the very relativity of the attempt to represent it makes us aware of what is being missed in the attempt. This happens, though, in a way which we cannot articulate: 'We feel ourselves as a part and are precisely for that reason the whole' (*FS* p. 138). This 'feeling' leads Novalis to a central idea in early Romanticism.

The idea is that philosophy sees things the wrong way round because it relies on reflection.[17] The inability of the I to grasp itself as the highest principle is a *result* of its trying to make itself into an object. Philosophy since Fichte begins with reflection upon the activity which is required for reflection to take place at all: the action of the I. The I is, therefore, already subsequent to its basis: without some *prior* sense of the I there would be no reason to reflect at all, as there would be nothing to reflect upon. Novalis, following Fichte, terms this basis *Gefühl*, literally 'feeling'. 'Feeling' is a technical term that refers to the pre-reflexive spontaneity of the I, not some kind of vague intuition. However, it entails a fundamental problem.

If the I is to be represented as the highest principle of philosophy it must be able to give an account of its pre-reflexive basis. This basis, though, as we have seen from a similar argument in Hölderlin, is not available to reflection: 'Feeling cannot feel itself' (*FS* p. 114). Novalis insists that it is 'not possible to represent the pure form of feeling. It is only One and form and matter as composed [in the sense of made up of differing elements] are not at all applicable to it' (*FS* p. 116). Reflection begins by an awareness of the difference of subject and object, a limitation of the self by what it is not. 'Feeling' cannot be this because it

is an unarticulable *self*-limitation within what is essentially unlimited. For Novalis, philosophy puts what is derived, the I of conscious reflection, before what it is derived from, 'feeling', thereby inverting the real sequence. Only that which is unlimited could subsequently become *aware* of limitation. The opposite cannot be true: 'What reflection *finds*, *seems* already *to be there* – Attribute of a *free* act' (*FS* p. 112). For philosophy to grasp the real nature of the absolute I it seems, therefore, to have to correct the inversion which results from putting reflection first. This will, incidentally, be Marx's response to Hegel, whose philosophy must be stood on its feet because it reverses the relationship between thought and social being. It seems likely that there is a traceable route from these ideas, via Schelling, Schleiermacher, and Feuerbach to Marx.

The metaphor of the mirror can help here. In a reflection of myself in a mirror what is in fact my right eye will appear as my left eye. In order not to confuse the reflected image with my real being I must further reflect in my 'mind's eye' to invert what I see and arrive at a correct image. The 'correct' image, though, is an image created by a double reflection: it is not myself. If one applies this to the absolute I the result is the realisation that it is unrepresentable, in that what is to be represented would itself have to do the representing at the same time. Novalis says of freedom

> All words, all concepts are derived from the object [*Gegenstand*, in the sense of that which 'stands over against'] – [they are] objects – and they therefore cannot fix the object. Namelessness constitutes its essence – for this reason every word must drive it away. It is non-word, non-concept. How should something make an *echo* which is only a voice? (*FS* p. 202).

If words are constituted differentially, no word could be absolute because of its dependence on all other words. In this sense words are objects, in the same way as any other object is dependent upon the other of itself to be itself. The argument points towards the realisation that philosophy cannot positively achieve its task of showing the identity of subject and object.

Hegel will suggest that the Absolute is present in the very principle of philosophical reflection; everything is the other of itself, and the process in which this is revealed is the Absolute, Novalis maintains that 'the true philosophy could never be represented' (*NW* p. 557). He also maintains that *Poesie*, which means art in general, in the sense of *Poiesis*, creation, 'represents the unrepresentable' (Vol. 3 p. 685). This is in many ways

the essential early Romantic position, which does not separate art and philosophy.

Philosophy for Novalis is 'striving' to think an absolute basis (*Grund*) that would be its completion: 'If this were not given, if this concept contained an impossibility – then the drive to philosophise would be an endless activity' (*FS* p. 269). The need that generates philosophy could, therefore, only be satisfied in relative terms, and thus never be satisfied. Freedom, the activity of my I, is inherently destined not to achieve the Absolute because it would thereby cease to be itself, in that the drive to philosophise, which is itself the free act of the I, is based upon a 'voluntary renunciation of the Absolute' (*FS* p. 268–70). This can be understood via Novalis' thought that the 'Ideal' can never be achieved because

> it would destoy itself. To have the effect of an Ideal it must not stand in the sphere of common *reality*. The nobility of the I consists in free elevation above itself – consequently the I can in a certain respect never be absolutely elevated (*FS* p. 259).

If the goal of philosophy were present there would be no need for philosophy to seek it.

Novalis introduces a strikingly modern temporality into the argument: 'Time can never stop – we cannot *think away* time – for time is the condition of the thinking being – time only stops with thinking' (*FS* p. 269). This, anticipating Nietzsche, breaks with conceptions of philosophy which see it as concerned with the representation of the eternal. It also leads in the direction of a conception of art which, as I suggested in relation to Kant's sublime, sees the limitation of the finite as a way of attempting, always inadequately, to experience what is beyond the finite.

If philosophy is a *striving* for the Absolute, the Absolute cannot already be achieved in philosophy, even though philosophy presupposes the Absolute as its object; without it philosophy would not be philosophy. As such: 'The Absolute which is given to us can only be recognised negatively by acting and finding that what we are seeking is not reached by any action' (*FS* p. 270). This leads Novalis to question certain fundamental assumptions, though never in a systematic way. He relies on the paradoxical principle, which will influence Adorno, that philosophy 'must be systemlessness brought into a system' (*FS* p. 289). He ponders (characteristically in brackets) why philosophy should have a beginning at all: '(What is a *beginning* for at all? This unphilosophical or half-philosophical goal leads to all mistakes)' (Vol 3 p. 383). Instead of

thinking that philosophy could reach the fundamental ground, the 'initial impulse' of freedom that Fichte posits as the absolute beginning, philosophy must realise its own inherent failure to be complete.

Philosophy which adopts such a position gravitates towards art. Novalis suggests one cannot be sure that the Absolute should be conceived of as an origin: the notion of a 'beginning is already a late concept. The beginning [because it is a category of reflection] arises later than the I, for this reason the I cannot have begun. From this we see that we are in the realm of art' (Vol. 3 p. 253). It is not completely certain what this means, which in the context, is appropriate. However, the logic of the argument tends to suggest that the necessary failure to represent an absolute ground, in this case a beginning for the I, leads to thinking about forms of representation which incorporate this failure. This is the basis of a Romantic notion of art. The I is inherently lacking, but this very fact leads beyond itself:

> I means that Absolute which is to be known negatively – what is left after all abstraction – What can only be known by action and what realises itself by eternal lack./Thus eternity is realised through time, despite the fact that time contradicts eternity./(*FS* p. 270).

This requires a medium in which the sense of lack can be articulated. What is lacking would be somehow gestured towards, without it being able to appear as itself. Novalis relates this idea to language and art. It is particularly appropriate to the inherently temporal form of music.

Language for Novalis is constituted differentially, each signifier 'is only what it is by the others' (*FS* p. 109). Language is marked by reflexivity, and thus by each element *lacking* something which can only be completed by the other elements. Language shares the fate of the absolute I, in that the need in the signifier for all other signifiers for it to be itself points to an unrepresentable totality. The temporality of thinking means that the attempt at such a completion will be a continual movement from signifier to signifier. Anyone familiar with Derrida will recognise that something like *différance*, the deferral of signification as presence, occasioned by the signifier's differential dependence on other signifiers, is part of Romantic thinking. However Novalis avoids the incoherence of the notion of deferral, which must entail some kind of presence which is put off for the notion to make any sense. Novalis relates his conception of language to art, in bizarre fragments on the relationships between rhythm, music, language, and philosophy. The relationships seen here will be echoed in some of the views of aesthetics

and philosophy to be considered in more detail in subsequent chapters.

Novalis wishes to see music as a 'general language', an idea what we will see again in Schopenhauer. In a famous fragment Novalis sees philosophy as 'really homesickness, *the drive to be at home everywhere*' (Vol 3 p. 434). Our sense of the Absolute as lack is clear in this: we feel ourselves homesick and thus have a sense of what home would be. One can put this remark into the context of what he says about music. Music, he claims, enables the mind to be 'for short moments in its earthly home', because the mind is '*indeterminately* excited' (Vol 3 p. 283). In such excitement it seems to escape the traps of reflexivity. In the *FS* Novalis frequently formulates the problem of reflection in terms of the separation of the determiner from what it determines. Music is thus linked to 'feeling', which does not entail such a separation, because it 'cannot feel itself'.

Novalis imagines an attempt to 'speak *determinately* through music', our language having lost its initial musical quality and become prosaic. Language 'must become *song* again' (Vol 3 p. 283–4). As such, music reveals a lost past and a hoped-for future, based upon what lacks in the present; it contains a dynamic which integrates all dimensions of time, thereby fulfilling the demands of philosophy. In verbal language indeterminate propositions 'have something musical' and are able to give rise to 'philosophical *fantasies* – without expressing any determinate path of philosophical thinking' (Vol 3 p. 319). As we saw, Novalis refused to give freedom a name: music seems better able to express freedom, despite, or because of, its *indeterminacy*, its divorce from representation.

Music is best able to evoke what Novalis requires for the 'Universal system of philosophy', which 'must be like time, A thread along which one can run through endless determinations' (*FS* p. 289–90). It cannot be a '*positive system*'. Like signifiers in language the notes depend upon other notes for their significance, they attain their full sense in the overall temporal continuum of the piece. This comes across in the idea of rhythm, to which Novalis attaches serious philosophical importance, however ironic his comments sometimes may be. Novalis claims: 'All method is *rhythm*', and that 'Fichte did nothing but discover the rhythm of philosophy and express it verbalacoustically' (Vol 3 p. 309–10). Rhythm, like language, is a form of meaningful differentiality; a beat becomes itself by its relation to the other beats, in an analogous way to the way in which the I of reflection is dependent upon the not-I, the signifier on the other signifiers. Rhythm is a form of reflection. It is

constituted temporally and is not semantically determinate. Rhythm is the *movement* from one articulation to the next within a pattern.

It is not clear from this how one gives an account of the ability to *identify* the movement as a movement between articulations which are in some way identical: the problem is not so far from Kant's difficulties with the transcendental unity of apperception. To regard a rhythm *as* a rhythm requires a subject, for which it is a series of linked articulations, and not a random set of phenomena. Something similar, as we shall see in a later chapter, applies to the problem of linguistic meaning in Derrida's account of it. What is important in Novalis is the attention to forms of articulation, which are not dependent on representation, as a means of finding new ways of understanding self-consciousness. He does not, as Derrida does, cease to pay attention to self-consciousness because of its resistance to representation.

Novalis' reflections on the subject relate to Schelling's *Naturphiloso-phie*, which concentrates not upon the determinate product but on infinite living productivity, which, for Novalis, is only negatively representable. Novalis' fragmentary hints about the importance of art for philosophical reflection can be linked to Schelling's related, but different, attempt in the *System of Transcendental Idealism (STI)* to demonstrate how art must be the "organ of philosophy". Art in the *STI* unifies conscious thinking with its unconscious motivation which could never be reflexively known. Subject and object can be united, but only via a medium which relies on intuition and not on concepts. The story of the subject from Fichte onwards repeatedly shows that the attempt to objectify our relationship to ourselves and nature in philosophy must be a failure. The turn to art becomes an attempt to say the unsayable.

4

Schelling: art
as the 'organ of philosophy'

Introduction

Schelling's initial significance for modern philosophy derives from the way he develops a new dynamic conception of nature in the light of Kant's transcendental philosophy. In his early philosophy Schelling attributes considerable importance to art for his understanding of nature, with consequences which are relevant, as we shall see, to thinkers such as Nietzsche, Adorno, Heidegger, and Derrida. Fichte's I realises itself by bringing a nature to life which dogmatic thinking had reduced to dead objectivity. In some of his philosophy before 1800 Schelling follows Fichte's position. Even in this period, though, he works on the idea that *nature* itself is not just dead objectivity either, given the fact that we ourselves are living organisms of the kind to be found in the rest of nature. If modernity is not simply to become the arrogation to itself of the thinking subject's right to subjectify nature, this question must be faced.

A particularly acid comment by Schelling in 1801 in a letter to Fichte, not long before they broke off their correspondence, makes clear why he has moved against Fichte's conception of the I by this time:

I am thoroughly aware of how small an area of consciousness nature must fall into, according to your conception of it. For you nature has no speculative significance, only a teleological one. But are you really of the opinion, for example, that light is only there so that rational beings can also see each other when they talk to each other, and that air is there so that when they hear each other they can talk to each other?[1]

By 1806 he will become even more critical:

in the last analysis what is the essence of his [Fichte's] whole opinion of nature? It is this: that nature should be used . . . and that it is there for

nothing more than to be used; his principle, according to which he looks at nature, is the economic-teleological principle (I/7 p. 17).[2]

Clearly this view tends to diminish too far the import of Fichte's work for contemporary philosophy. It does, though, point to how philosophies of self-consciousness can become philosophies of subjectification. Schelling's counter to this is that the forces of his I are forces which *depend* on nature.

Nature cannot be seen as simply being there to be dominated, because such domination could lead to domination of ourselves as part of nature, an idea which will later be central in the Critical Theory of the Frankfurt School. Kant had seen beauty as 'purposiveness without purpose' because it involved a disinterested relationship to the object, which revealed something fundamental about our place in nature. Schelling's suspicion of Fichte is closely connected to this side of Kant's third critique.

The essential thought of Schelling's *Naturphilosophie* is that, in the same way as the I of self-consciousness is both active and yet can try to reflect upon itself as object, nature is both 'productive' (in the sense of Spinoza's *natura naturans*) and a 'product' (*natura naturata*). The Understanding looks at transient 'products'; *Naturphilosophie* tries to theorise nature's 'productivity', without which there would be no products. Schelling tries to deal with the problem of thinking the identity of the process of nature and the process of thought in terms that most people will be familiar with from Freud. Nature is seen as being 'unconsciously' productive, and 'mind' as being 'consciously' productive. Manfred Frank and Gerhard Kurz suggest that:

> Freud and Schelling both presume that consciousness means becoming conscious, a fragile synthesis of voluntary and involuntary motivations, and that this consciousness, like existence in general, is only to be grasped as the memory of a dark, never fully recoverable basis.[3]

This does not make Schelling the irrationalist he is sometimes portrayed as being: 'Schelling's concept of reason is enlightened about itself. Reason is not the Other of nature, it is its – undeveloped – part'.[4]

Schelling attempts to envisage nature as subject via the following argument, which derives from Fichte's refusal to turn the subject into an object, and, as we shall see, recurs in an unacknowledged way in Schopenhauer:

As the object is never absolute [*unbedingt*] then something *per se* non-objective must be posited in nature; this absolutely non-objective postulate is precisely the original productivity of nature (I/3 p. 284/352).

The I of Fichte's *Wissenschaftslehre* is seen as the highest principle of philosophy, and thus as the highest 'potential' (*Potenz*) of nature: without it nature would be 'blind'. However, the *Wissenschaftslehre* in Fichte's sense is only 'philosophy about philosophy' (I/4 p. 85/17). It is based upon the functioning of the I as already the highest principle, which attempts to look at itself.

Schelling believes that the I is only possible because it has a prior unconscious history in nature. In the essay 'On the True Concept of Naturphilosophie and the Correct Way to Solve its Problems' of 1801, in which Schelling completes the move away from Fichte which is prepared in the *STI*, he claims that to get to such a history one needs to subtract the conscious attributes of the I. By abstracting from the reflective I one is left with the '*purely objective*' (I/4 p. 86/18), which gives the 'concept of the pure subject-object (nature), from which I raise myself up to the subject-object of consciousness (=I)' (ibid.). The conscious I, then, emerges from unconscious, but not inert, nature. This happens because '*That pure subject-object is already determined for action by its nature* (the contradiction it has in itself)' (I/4 p. 90/22): the contradiction is the dynamic principle of living nature. This principle then develops to its highest point, the conscious I, which is the light with which nature reveals its inner nature to itself, as light reveals external nature.

For Schelling natural products are limitations of an infinite productivity, 'intuitions' of nature by itself. At the base of the finite product is a Dionysian reality:

> The . . . idea of something absolutely formless which cannot be represented anywhere as determinate material is nothing but the symbol of nature approaching the productivity. – The nearer it is to productivity the nearer it is to formlessness (I/3 p. 298/366).

The seeds of a Schopenhauerian or Nietzschean view of the essential foundation of nature are present here. Both Schopenhauer and Nietzsche, of course, associate such a vision with the basis of art, as the Will or as Dionysus. Unlike Schelling, though, they do so at the expense of reason, which tends to become a form of self-deception. Schelling tries to construct a philosophy which would be '*One* uninterrupted row which ascends from the most simple in nature to the highest and most

complex, the work of art' (I/4 p. 89/21). Schelling's investment in a view of nature which sees the best way of seeking meaning for our place in nature not in science but in art has again become important, especially in the light of contemporary concerns about science's relationship to the ecological crisis.

In the *SP* it was claimed that art and beauty show how the sensuous and the intelligible are linked, thereby making into a certainty what Kant had cautiously postulated in the *KdU*. This is the core of the Idealist view of aesthetics, contrasting with the Romantic view, in which art only negatively represents the Absolute. Importantly, the *STI* sees aesthetics, as the *SP* had seen the 'new mythology', which the *STI* also invokes, as inseparable from reason. Schelling's work provides important arguments as to why a modern conception of reason must include an adequate account of aesthetics. He offers a very clear counter to Hegel's contention, to be considered in the next chapter, that modern philosophy has gone beyond art and that philosophy's task now lies elsewhere. Though the *STI* may not succeed as a philosophical system, the questions it raises are not made redundant by Hegel.

The development of consciousness

The 1800 *STI* has an ambiguous relationship to Fichte's philosophy. By the time of the essay 'On the True Concept of Naturphilosophie and the Correct Way to Solve its Problems' Schelling was emphatic that the *Naturphilosophie* he sees as lacking in Fichte is the necessary *prior* philosophy because it describes the ascent of nature to the highest potential, the thinking I, which can then be considered in the 'transcendental philosophy' in the manner of the *Wissenschaftslehre*. The *STI* tries, somewhat confusingly, to keep *Naturphilosophie* and 'transcendental philosophy' on an equal footing.

In the *STI* the 'transcendental philosophy' tries to explain how it is that 'life', the infinite 'productivity' of the *Naturphilosophie*, comes to the point of being able to think about itself at all. This entails an account of how it is able to find a medium – art – in which it can represent itself, given that it cannot have access to itself as an object of knowledge. Such access, as was clear in Fichte, always already presupposes what it is supposed to prove: the existence of that which is to carry out the proof. The 'transcendental philosophy' wishes to write what Schelling terms the history of the 'transcendental past' of the I. The fact that the self-conscious I comes to the point of tracing its own past means that the

I must become aware of the necessities it depends upon for its own existence as I. This awareness cannot be derived from a reflexive splitting of the I into knower and known because, as Hölderlin and Novalis suggested, the I would be unable to recognise it*self* in the stages which precede self-conscious reflection. Schelling's history tries to trace the development of the I in the way that the development of organisms in nature from lower to higher forms can be traced by seeing how the present developed form must have resulted from a previous less developed form. The *STI* begins with lower forms of spirit, which function much in the way that natural organisms do, and ascends to the higher forms, culminating in art.

The *STI* takes over the assumption, seen in Fichte, that the I must be both subject and object, but questions exactly how this is the case. Schelling best explains these changes himself in his Munich lectures of (probably) 1833–4, where he looks back at his own philosophical development in relation to Fichte. Fichte had seen the 'imagination', in the Kantian sense of the power that institutes images into the subject which are then processed as objective reality by the Understanding, as the source of our sense of an 'external' world. For Fichte the producer of images cannot see itself producing whilst in the act of production: 'Hence our firm conviction of the reality of the things outside us, and without any contribution on our part, because we do not become conscious of the capacity for their production' (*Werke* 1 p. 234). Schelling suspects the manner in which Fichte makes the act of the I into an absolute act which generates subject and object:

> With this self-positing: I am, the world begins for every individual, this act is in everyone the immediately eternal, timeless beginning both of themself and of the world (I/10 p. 90/506).

For Schelling this act has a history because the world of hard external necessity produced by the I is produced by something in the I which is not dependent upon its '*Will*', but rather upon its '*Nature*'. My I is thus dependent in a way Fichte, at the time of the early versions of the *Wissenschaftslehre*, could not accept. He will later move to a position much closer to Schelling's.

The initial Fichtean move is unquestionable, but is in Schelling's terms little more than an extension of Descartes: 'it is no doubt the case that the external world is only there for me in so far as I myself am there at the same time and am conscious of myself' (I/10 p. 93/509). The *existence* of the 'I think', however, does not warrant the assumption that

everything else exists because I, as empirical, reflecting subject, exist: 'the *already conscious* I cannot in any way produce the world' (I/10 p. 93/509). If my 'already conscious' I cannot produce the world, this does not mean that the pre-conscious 'I', the I of 'productivity' which has a history of unconscious development leading to my particular conscious I, should not.

For Schelling it is clear that one cannot use the reflexive I – me thinking about myself thinking – to get to the idea of the external world:

> Nothing, though, prevented one going back with this 'I' which is *now* conscious within me to a moment where it was not yet conscious of itself, – nothing prevented one assuming a region beyond my *now present* consciousness and an activity which does not itself come but rather only comes via its result into consciousness (I/10 p. 93/509).

The result is what is seen as the 'external' world. In this way the 'imagination' itself has a history: the actions which lead to its development can be traced by reflection upon the actions it now performs. This history starts from the lowest form of sensation and rises to the highest point of being able to reflect philosophically.

Philosophy, argues Schelling, in a view usually attributed to Hegel's *Phenomenology of Spirit*, must be concerned with retracing the process, which has already taken place, that has led us to reflection upon this world that feels external to us, and yet of which we are a part. Philosophy is a history of what consciousness has *become*: 'this coming-to-itself that expresses itself in the I am presupposes a having-been-*outside* and -away from itself' (I/10 p. 94/510). Schelling stresses the fact that the I which is prior to my consciousness is not yet an individual I, in the way you or I are, and it only becomes this in each of us in the process of coming-to-itself. Schelling attributes a central role to art as the means of grounding his argument.

Schelling links natural 'activity', which he sees as 'unconscious', with what the human will does in acting in the world. The difference is that the latter involves reflection. Reflection, though, as we saw in the last chapter, leads to infinite regression. Schelling's attempt to break out of this regression involves finding a medium in which the 'unconscious activity' of nature and the conscious activity of our thinking can be shown to belong together. This medium cannot, therefore, be simply located within philosophical reflection, in thinking about thinking. The *STI* wants to insist that the Absolute must include both the development of nature and the process of reflection. The aim is to overcome the split

of theoretical philosophy, in which nature is the apparently external world, and practical philosophy, in which the actions of the I in Fichte's sense are central, in a way which does not entail Fichte's problems.

Philosophy needs some form of 'intellectual intuition' to get beyond the difficulties seen in Kant, but this cannot be just thought's immediate grasping of itself in the act of thinking. Philosophy has to include the activity of nature which leads to our being able to have consciousness. Schelling tries to show that consciousness itself involves both conscious, reflexive, *and* unconscious activity. This fact could not be revealed, as it is for Fichte, solely by reflection which relies on a 'direct inner intuition' (I/3 p. 350/418) of the activity of our thinking. In Schelling the subject is 'decentred', and needs to 'remember' what has gone on in nature that is continued in its reflection, but on a different level.

The following passage from the Munich lectures makes the idea clear: the I

> having arrived at the *I am*, whereby its individual life begins, no longer remembers the path that it has covered up to this point, for as only the end of this path is then consciousness, the (now individual) consciousness has covered the path to consciousness itself unconsciously and without knowing it (I/10 p. 94/510).

Our present consciousness as reflecting philosophers cannot be the ground of this, as it can only reflect its own activity, not what precedes it and is a condition of it. As Dieter Jähnig says:

> As what is to be remembered is something that, before its being remembered, was never 'in consciousness', then it obviously cannot be an act of memory that is *only* concerned with consciousness.[5]

Schelling's view of consciousness, despite many confusing shifts throughout his philosophical career, always sees a tension in consciousness, which is not fully present to itself – hence his attention in the *STI* to art as a non-conceptual means of understanding it. Consider the following from the Munich lectures, which takes up matters relating to reflection theory in a manner reminiscent of Hölderlin and Novalis:

> But the subject can never possess itself *as* what it is, for precisely as it addresses itself [*sich Anziehen*] [which has the sense of 'putting on' what one is] it *becomes* another, this is the basic contradiction, the misfortune in all being (I/10 p. 101/517).

Once one tries to look in a mirror in order to see oneself one has already surrendered oneself to the other: having seen oneself in a mirror one thinks differently of oneself. The simplistic attacks on the concept of the subject in Western philosophy that are characteristic of much recent philosophy, particularly in some areas of post-structuralism, ignore the complexity of the concept of the subject in Schelling and the thinkers considered in the last chapter. The 'echoes' of Lacan in the last passage, which we also saw in Hölderlin and Novalis, are not fortuitous. The lines which lead via Hegel, Nietzsche and Heidegger to post-structuralism are more complex than is generally assumed.

In the *STI* Schelling postulates that the productivity of nature is 'originally identical' with that which appears in our will – otherwise it is impossible to explain how it is that this will can affect the world of external nature at all. As such, the products of nature 'will have to appear as products of an activity that is both *conscious and unconscious*' (I/3 p. 249/417). Nature appears *both* as produced in an analogous way to being conscious – in the constitution of organisms which 'give the law to themselves' as we do in practical reason – *and* as a blind mechanism – when it is an object of the Understanding. Nature is '*purposeful without being explicable in terms of purposes*' (ibid.). This takes us back to Kant's third critique, where *beauty* was 'purposiveness without a purpose'.

For Schelling the way we can understand nature as both blind mechanism and as organism is via an activity which is both conscious and unconscious: aesthetic activity. Philosophy relies on 'intellectual intuition', in the sense of thinking about thinking. This is itself productive, an active process, but it is directed inwards, not towards an object, 'whereas the production in art is directed outwards, in order to reflect the unconscious through products' (I/3 p. 351/419). Bernhard Lypp has summarised the issue most aptly:

> According to Schelling the I cannot become cognizant of its unconscious strivings because in reflection the power of the intelligible ego is only directed at itself; reflection admittedly goes back into itself, but it has no objective content. In the framework of the transcendental system only that activity has the power to grasp unconscious strivings of the intelligible ego which is in the situation of being able to objectify itself in material form. This activity is aesthetic productivity.[6]

Art becomes the 'document' and 'organ' of philosophy. It turns into intuitable objects processes which otherwise must remain hidden because they have been forgotten.

The *STI* is a difficult work because it tries to tell a story for which there can be no direct empirical evidence: it extends the notion of consciousness in ways which will never be fully amenable to conceptual articulation. The story is the story of consciousness, *including what happens before self-consciousness.* Odo Marquard has pointed out the analogies of this project to what Freud was to attempt one hundred years later in the *Interpretation of Dreams.*[7] Schelling and Freud share a model which entails both conscious and unconscious aspects. Both use the notion of 'drive' (what Schelling calls 'activity') which is limited, 'repressed' (Schelling uses the term *verdrängt*). Repression enables the development of the conscious mind which is thereby divided in itself, cannot directly satisfy itself, and cannot have direct access to its own history: it 'only finds in its consciousness as it were the monuments, the memorials of that path, not the path itself' (I/10 p. 94–5/510–1). The task of 'Science' (albeit in very different senses – Freud's conception of science tends to be positivist) is an 'anamnesis' of what precedes our conscious reflections. In Freud this is to reveal the repressed aspects of the self which lead to the neuroses of the present. In Schelling it is still a way of coming to terms with the apparent division in the I between nature and reflection, which can ultimately be transcended in the work of art.

The process Schelling describes has to be necessary: without it we would not be able to arrive at the point of reflection from which he tells his story of the 'progressive history of self-consciousness' (I/3 p. 331/399). The difference between Schelling and Hegel is that Schelling, even at this early stage of his work, does not see philosophy, 'science', as being able to grasp the Absolute in a conceptually articulated way. Schelling sustains the need for a notion of truth that depends upon intuition, a form of access to the world that cannot ever be wholly articulable by concepts: hence the insistence upon aesthetics. For Hegel this will mean a failure to carry out the 'exertion of the concept', the full process of reflection necessary to reveal the *conceptual* truth about art. This process, as I suggested, will lead Hegel to subordinate art to philosophy and to the idea that art has reached an end as a medium of truth.

Schelling is swimming against the historical tide of his time, and he does not sustain the emphatic view of art of the *STI* in his later writings. As Hartmut Scheible puts it, though, Schelling's

> determined emphasis on intuition over the concept . . . is historically necessary in order to counteract a process which Plessner has described as the

'gradual separation of intuition and conceptualisation' in our dealing with nature.[8]

Schelling plays an important role in establishing some of the bases for subsequent hermeneutic questioning of the pretence of scientific conceptualisation to represent the only kind of truth possible about nature. The separation of intuition from the conceptualisation of nature in natural science can also be seen in terms of the growing dominance of 'instrumental reason', which treats nature as subordinate to whatever aims science wishes to achieve. Schelling's criticism of Fichte's attitude to nature and his emphasis on aesthetics, rather than conceptually articulated philosophy, point to his awareness of vital issues in modernity. Seen in this light, Schelling's failure gives us ways of grasping the origins of pathologies in contemporary subjectivity. The work he begins is carried on in this century by Adorno. Adorno tries to trace the pathologies of modernity via reflection upon the subject's relationship to internal and external nature, not least via philosophical reflection upon art. Schelling's history of the development of consciousness, then, contains the seeds of a critique of scientific modernity that will be vital to later aesthetic theory. Let us now look in more detail at the *STI*.

The structure of the System of Transcendental Idealism

The main terminological difficulty in understanding the *STI* lies in its frequent use of words referring to self-consciousness, or the I, which have divergent meanings. The essential distinction, which we saw in Schelling's view of Fichte in the Munich lectures, is between the self-consciousness of ourselves as individuals, which is relative to the object world and tries to grasp itself by reflection, and the absolute 'I' which cannot be grasped with the means of reflection (I shall use 'I' to designate this usage). Schelling's use of the term 'I' for the latter is a residue of his attachment to Fichte; the meaning of the term, though, is clearly different from its meaning in Fichte. The confusion this generates results from Schelling's using 'I', which suggests the need for a 'not-I' for it to be identified, and thus a structure involving a relation, to designate the absolute. This leads him to talk also of the 'absolute identity' or 'absolute indifference' of subject and object, and later, when he realises that even this implies a relation of mutual dependency and determination, of Being, somewhat in the sense we observed in Hölderlin's *Judgement and Being* in the last chapter.

The *STI* goes through the necessary stages of how an 'intelligent', in the sense of differentiated and organised, nature leads to our differentiated and organised thinking. The 'I', the Absolute principle, is seen as infinite activity. Because it cannot be grasped as such – any limitation of it from outside itself would stop it being infinite – the activity must be limited by *itself*:

> If you think of an infinitely producing activity spreading out without resistance then it will produce with infinite speed, its product is a being [i.e. static], not a becoming. The condition of all becoming is therefore limitation or the barrier [*Schranke*] (I/3 p. 383/451).

The limitation of the 'I' sets a process in motion which, as Manfred Frank puts it,

> fulfils the demand for the infinity of the I (every barrier which is put up is crossed into infinity) and the demand for finitude (the process will never represent itself in what is not a finite product).[9]

This corresponds to the *Naturphilosophie*, where the productivity is the central aspect, not the finite products, but the two are also inseparable. Nature produces 'unconsciously'; our thinking about it (including ourselves), though, is conscious.

The *STI*, as we saw, wishes to suggest that art is the medium in which the combination of the two sides can be understood, thereby giving us a sense of our place as part of the whole process of the kind Kant hints at but leaves in the realm of the 'as if' in the *KdU*. The actual combination can only be postulated in intellectual intuition, initially in the manner of Fichte:

> intellectual intuition presupposes a capacity simultaneously to produce and intuit certain actions of mind, so that the object and the intuition itself are absolutely one. . . . But this intellectual intuition is itself an absolutely free act, this intuition cannot therefore be demonstrated, it can only be demanded (I/3 p. 369–70/437–8).

The apparently external 'object world' is thus seen as part of the process of the 'I''s attempt to intuit itself (*sich anschauen*). To us as reflecting beings it appears as the other but in fact derives from the same of which we are a part. We cannot 'know' this in the sense that we determine objects of nature in science, hence the need for the postulate of intellectual intuition. The further need, though, is for a means which would enable us as free human beings to understand this postulate in a non-cognitive way: in the *STI* this will be art.

To get to the point where art is able to achieve this the *STI* goes through various stages of 'intuition', which are the 'I''s attempts to 'see' itself without knowing at the outset that this is what it is doing: 'the I cannot simultaneously intuit and intuit itself as intuiting, thus also not as limiting' (I/3 p. 403/471). The argument is close to Fichte's, but the attitude to nature and the conception of the history of the 'I' are particular to Schelling. The first stage is 'sensation', an unreflected splitting of the 'I', whereby difference arises at all. Then comes 'productive intuition', in which an infinite activity produces finite products. This is the level of the material world of nature. Following this is the stage of 'organisms', living natural beings such as plants, which are 'symbols of the intelligence' (I/3 p. 490/558) because they are self-determining wholes whose life is their own self-production. The next stage, the act of 'absolute abstraction', takes one from the world of nature into the realm of consciousness and self-consciousness.

The basic problem is that raised by Kant: how do concepts relate to what they are concepts of? For Schelling, by asking how concepts in consciousness can correspond with objects one has already separated them:

> a philosophy which starts with consciousness [in the sense of reflective separation of subject and object] will therefore never be able to explain that correspondence, neither is it to be explained without original identity, whose principle necessarily lies beyond consciousness (I/3 p. 506/574).

Schelling takes the example of *sleep*, where 'original production', i.e. the living activity of the organism, is not interrupted, but conscious reflection and the accompanying individuality are: 'Object and intuition are completely lost in each other and precisely for this reason neither the one nor the other are present in the intelligence for itself [i.e. in a reflected form]' (I/3 p. 506–7/574/5). Life does not stop when we are asleep, conscious reflection does.

Conceptual thinking, reflection, is a continual limitation, a 'schematisation' of something which is never demonstrably identical with the activity of limitation. The point of the schematisation is to unite concept and object. This happens, though, via the *activity* of the 'intelligence', which cannot be subsumed into this unification:

> In every intuition two things must be distinguished: the intuition as such inasmuch as it is an action, and what determines the intuition, what makes the intuition into the intution of an object, in a word, the concept of intuition (I/3 p. 511/579):

the two cannot be the same. Even Kant makes such a distinction, but he does not believe one can say anything about the action itself. The point is analogous to Freud's insistence that only the ideas that represent drives can be an object of consciousness, never the drives themselves. The *activity* involved cannot be determined in the way that an object of cognition is determined: it is itself required for the determination. Our conceptual access to it can thus never be direct. The impetus towards other forms of access, of the kind offered in aesthetic productivity, is already apparent here.

The *STI* next considers human autonomy. Schelling links the self-determination of a natural organism to our capacity for self-determination. There is a major difference, however: 'Every plant is completely what it should be, what is free in it is necessary and what is necessary is free. Man is eternally a fragment' (I/3 p. 608/676). We are determined by inner division: our consciousness cannot ground what motivates that consciousness itself because the motivation derives from the absolute 'I'. In our conscious reflection this 'I' 'is to become aware of itself as producing unconsciously. This is impossible and only for this reason does the world appear to it as . . . present without its action' (I/3 p. 537/605), as the 'thing in itself'. We are, though, able to change the object world and ourselves by actions based on our will. Schelling links the 'absolute will' of the 'I' with our freedom. There can, though, be no *proof* of our freedom, apart from our ability for self-determination. If there could be a proof one would be able to determine freedom, which would be self-refuting: 'What that self-determination is, nobody can explain who does not know it via their own intuition' (I/3 p. 533/601). The argument is derived from Fichte's attempt to achieve what Kant had not, but now has a different foundation and different implications.

The implications are central to Schelling's thought and to understanding its difference from that of Hegel. The question of freedom is left unarticulated. A dialectic of recognition, of the kind Hegel uses in the *Phenomenology*, that enables me to reflect my freedom in the consciousness of another person via our mutual acknowledgement of the other as subject, does not, despite Hegel's claims, tell me what freedom is. If another person demands that I *should* do something they give me the choice of fulfilling the demand or not. This way the 'action is *explained* if it happens [as a product of my free-will], without its *having* to take place' (I/3 p. 542/610). Whilst our *consciousness* of having a will does require the other person, this does not *explain* our will.

The problem is again the problem of reflection that Fichte

discovered. I must *already* be aware in a non-defined way (the definition requires the other) of what it is to exercise my freedom, otherwise there would be no way of *understanding* another person's demand that I exercise my freedom in relation to the other's appeal to my capacity for decision. Nothing guarantees that this can be the case: freedom involves an irreducible indeterminacy, but this is precisely its price. Hegel sees the truth of freedom in its articulation via reflection in the other; Schelling emphasises the way in which the highest principles in philosophy are not conceptually knowable. There is an excess in subjectivity which philosophy cannot grasp. The differences over aesthetics between the two will derive from this fundamental contrast.

The aesthetic Absolute

How, then, does Schelling make art the culmination of the system? The *STI* wants a view of nature in which our free actions can be in accordance with what happens in both external and internal nature. Schelling used the model of the plant, which is what it is without the need to postulate some higher purpose or design to make it what it is, as a way of suggesting the unity of subject and object, freedom and necessity. The plant is self-sufficient. Any reflection upon it, for example in scientific analysis, involves an unconscious foundation that motivates the reflection. Reflection can inherently never be in unity with itself: its very essence is its difference from, and dependence on the object, which it tries to overcome by grasping it in the concept. No conceptual analysis can exhaust the organism, as science constantly reveals: there is always another way of looking at it. Furthermore, in the case of organic life, analysis will tend to destroy it. The plant is self-determining: it forms itself as that particular organism. The *process* of that formation cannot be an object of analysis.

The basis of Idealist philosophy is inherent in the metaphor: one can differentiate the process of the organism into an infinity of different moments, but the crucial fact is their ultimate identity within the organism. The single moment is inherently dependent upon all the others. As we saw in the *Naturphilosophie*, 'productivity' is the highest notion, not the product. The *STI* wants to find how the 'last foundation of the harmony of subjective and objective can become objective *to the I itself*' (I/3 p. 610/678). The *STI* seeks a way of recognising, beyond the self-determination to be observed in natural organisms, how our individual productivity – including reflective consciousness – can be revealed

as being part of the same process as these organisms.

The work of art in the *STI* is the medium in which the unity of the theoretical and the practical can be *shown*. The medium is not itself a self-transparent philosophy: art cannot provide an articulated 'proof' of such unity, as science cannot ever conceptually grasp the life of an organism. Nature as blind purposiveness, the plant growing into its particular form, is, in the terms of the *STI*, the unity of conscious and unconscious activity. The 'productivity' involved in the growth of the plant does not lead to a random product. At the same time there is nothing in the plant or our cognitive accounts of what the plant is that would explain why the plant takes that particular form. To go beyond this:

> One must therefore be able to show an intuition in the intelligence via which in *one and the same* appearance the I is at the same time conscious and unconscious *for itself* (I/3 p. 610/678).

In the actions of my will I have awareness for myself of free activity but this cannot be demonstrated objectively: freedom cannot be objectified. The medium in which philosophy is able to show what otherwise would not be available to it has to include both the reflexive level of our consciousness and its basis in what can never be available to reflection.

Cognitive science for Schelling is an infinite task. Art, on the other hand, *already* shows how the two productivities coincide: the conscious intention of the artist coincides with the unconscious compulsion of the artist's genius. It need, therefore, have no purpose beyond this because the finite human product embodies a purpose which cannot be known, but only intuited, like that of the organism. Whilst Schelling attributes a hyperbolic role to art in the *STI*, his reasons for doing so remain significant for philosophy and aesthetic theory even now.

In the *STI* intellectual intuition can only be postulated: philosophy's highest point cannot be articulated in concepts. The role of intellectual intuition is to unify subject and object in order not to fall prey to Kant's problems. The question for Schelling becomes how one is to make any *sense* of this unification from our perspective as finite, striving, divided individuals: our thinking cannot articulate a way of overcoming division because division is the very nature of reflection. Previous philosophy had answered such questions in terms of dogmatic theology.

Schelling wishes to avoid theological solutions, and to find a means of making sense in a way which is accessible to people's everyday views of their existence. Art is 'the generally acknowledged and undeniable

objectivity of intellectual intuition. For aesthetic intuition is intellectual intuition which has become objective' (I/3 p. 626/694). Art 'always and continually documents anew what philosophy cannot represent externally, namely the unconscious in action and production and its original identity with the conscious' (I/3 p. 627–8/695–6). What is separate in nature (unconscious) and history (conscious) is united in art. The process of nature in the *STI* begins in an unreflexive way but develops towards our conscious reflection. Schelling sees art as a reversal of this: art begins in the artist's reflections about what is to be produced, but it ends unconsciously because what is produced cannot be made identical with the techniques and thoughts which were required to produce it. As such it can represent the Absolute, as the 'sole true and eternal organ and at the same time document of philosophy' (I/3 p. 627/695). To reach its highest point, then, pure thought requires a means of representation that avoids the divisions of cognitive thinking.

The investment of the *STI* in the aesthetic becomes apparent when the development of history is seen in the same terms. The results of our conscious actions are never exactly what we intended. The overall process of history is conceived of teleologically. History is not a random movement because its ground is productivity, which is the attempt of the 'I' to grasp itself. At the same time it is clear that reflection cannot tell us where the process is leading. Schelling links the notion of genius to the notion of destiny. In the way that 'the power, which, via our free activity without our knowledge and even against our will, realises purposes which have not been imagined is called destiny' (I/3 p. 616/684), the inexplicable side of apparently free, self-determining aesthetic production that adds an 'objective' (in the sense of unconscious and unintentional) aspect to the product is 'genius'.

Clearly this is an attempt to skirt the consequences of removing divine Providence from history. If one can find a domain of human existence where the apparently inexplicable effects of our activity appear to make perfect sense, then the potential for making history more than random contingency is not renounced. The significance of this kind of thinking for Feuerbach and the early Marx should not be underestimated: if history is to be the fulfilment of our 'species being', then the goal will have to be achieved with powers given to us by our nature. We cannot as yet fully grasp these powers because their potential has not been fully revealed. The notion of genius can, then, be seen as a somewhat mystified version of the attempts of post-Providential philosophies of history to make history intelligible.

All the same, the role of the notion of genius in the argument is obviously problematic. It is a way of looking at that level of aesthetic production which can never be reduced to the results of technique, which points to a level of productivity in excess of what could ever be learnt. Such ideas can be and evidently are ideologically abused and do not stand up well to methodological scrutiny. The argument should, though, be seen historically: such views of art only become possible in the philosophical climate we are concerned with here. This climate is determined by two factors of modernity which are highlighted by aesthetic theory. The liberation from theological constraint releases hitherto unknown capacities in the subject, which give rise to a sense of limitless potential. At the same time this is combined with an awareness of the subject's inability to be wholly transparent to itself. Schelling's idea of the genius combines these two factors. Schelling insists that art is the *unity* of conscious and unconscious activity, as part of the attempt to make philosophy confront aspects of self-consciousness which philosophers like Kant can only put into a realm to which philosophy has no access. Schelling is convinced that these aspects are accessible, and faces the philosophical consequences of showing how this is the case.

In *Aesthetic Theory* Adorno suggests that the emergence of the term genius in philosophy at this time relates to what we have seen as the tension between the 'new mythology' and aesthetic autonomy, the tension between art being a synthesis, which includes philosophy, of all the means of articulation of a community, and art saying what no other means of articulation can say. Adorno sees the notion of genius as becoming important at the moment when

> the character of the authentic and the obligatory, and the freedom of the emancipated individual move apart from each other. The concept of genius is the attempt to bring the two together by a piece of magic.[10]

Genius is a false reconciliation of the general and the individual. The 'authentic and the obligatory' corresponds to the new mythology, in that it suggests that the products of the genius point to a collectively binding sense of value in the work of art of the kind seen in a theological culture. The 'emancipated individual' is an illusion. For Adorno the attempt to reconcile individual and general in modernity can only end in the suppression of the individual. Art ends up retreating into autonomy in order to resist such a false reconciliation and to preserve that which has been repressed in the enforced reconciliation from being forgotten. The 'genius is supposed to be the individual whose spontaneity coincides

with the deed of the absolute subject',[11] thereby, as it does in the *STI*, playing the role of fulfilling the Idealist project.

The 'untruth' of the notion of genius also lies for Adorno in the way that it ignores the fact that works of art are not living organisms: art is *Schein*, appearance, not a real reconciliation of self and nature. Furthermore, the technical side of aesthetic production depends upon the preceding *social* labour of others who establish the forms within which the supposedly authentic and autonomous artist works.

Adorno, however, is also aware of that side of the notion of genius which is important for the *STI*: 'Despite all misuse . . . the concept of genius reminds one that the subject in the work of art is not wholly reducible to the objectification [i.e. the art work itself]' (ibid.). Adorno retains from the Idealist position vestiges of a conception of the reconciliation of nature and consciousness. The ambiguity inherent in Adorno's position comes out in the following passage, which questions the use of the term genius by insisting upon the prior material and technical basis of artistic production: 'The whole Appassionata lies in the keyboard of every piano, the composer only has to get it out, and for that one admittedly needs Beethoven'.[12] Adorno's failure to give an adequate account of what he means by the 'Beethoven' required to get the Appassionata out of the piano suggests why the notion of genius should not be dismissed too lightly. It may not deserve the dignity Schelling affords it, but it does point, as Adorno seems aware, to one of the ways in which aesthetics is irreducible to conceptual articulation, and is thus able to suggest that what is beyond conceptuality may not be absolutely inaccessible.

A further problem in the *STI* is that it sees the work of art produced by the genius in terms of organic unity and self-containment: it is an image of the aims of Idealist philosophy. From our contemporary perspective it seems clear that the Idealist version of aesthetics makes less sense than some of the ideas of Novalis and Schlegel. The Romantic conception of the unrepresentability of the Absolute led to the idea that the work of art always pointed to its own incompleteness, whilst also suggesting what is beyond it. This opens up the characteristic sense in modernist art of a continual striving for something which is never really achieved, but which is the motor of aesthetic production. In the *STI* we have obvious problems with the description of an art in which 'Every drive to produce stops with the completion of the product, all contradictions are negated, all puzzles solved' (I/3 p. 615/683). The description sounds exactly like a description of ideology, the reconciliation of contradiction in an

illusory form, or like the 'imaginary' in the sense seen in Hölderlin, where the I regressively ignores the necessity really to engage with the otherness of the object.

The issue is, though, more complex than this: Hölderlin himself, of course, saw a way *out* of the imaginary in art. In considering the organic view of the work of art it is important to remember that Schelling does not attribute a functional role to the aesthetic. This leads him in the direction of aesthetic autonomy. Like Kant, who insisted it be without 'interest', Schelling regards the demand that art be useful as 'only possible in an age which locates the highest efforts of the human spirit in economic discoveries' (I/3 p. 622/690). As Kant did in the *KdU*, Schelling shows a prophetic awareness of the dangers of modern rationalisation. This becomes, as we saw, a central concern of Marxist theorists, like Adorno, who see the importance of Marx's critique of commodity exchange, the valuation of everything in terms of its equivalence to something else, as the vital issue in aesthetic theory. Schelling is, as Adorno will be, concerned to preserve a sphere of meaning that cannot be subsumed into the demands of scientific or economic rationality. In the *STI* the work of art's self-contained organic status means that its purpose lies within it and need not be sought elsewhere. As such, organicism is vital to sustaining the aesthetic as a sphere whose value lies in itself. One should not, for example, under-estimate the importance of some notion of organic coherence in musical works, which, because they do not function in terms of representation, cannot derive their logic from outside themselves.

The misuse of organic conceptions of art to legitimate reactionary political views has, though, been a constant factor in political life since this period. The reactionary notion of organicism subordinates urgent political and social conflicts which are directly or indirectly apparent in aesthetic works to the demand that we should contemplate the unity the human spirit is capable of in artistic production. All critical and analytical approaches to art come to be seen as infringing upon the integrity of the artistic totality, which thereby takes on the status of a quasi ritual object. In our century Brecht and others have rightly questioned the organic view of the work of art. There is, though, another dimension to the argument, that can be illustrated by considering a passage from a letter of Hölderlin's to his brother in 1799, not long before the appearance of the *STI*. In it he points to a view of aesthetics that is often underestimated in reflections on aesthetics and politics, particularly in the light of views of art which see it merely as ideology,

and of deconstruction. This again involves the tension between the desire for the 'new mythology' and the emergence of aesthetic autonomy.

Hölderlin's letter is a critique of German society, pointing to its narrow-mindedness and lack of awareness of the need for a community if individuals are to flourish. Hölderlin sees some hope in the liberation suggested in Kantian philosophy, and in the growth of interest in the political concerns of the community. This is, though, not enough. He goes on to attack the way the importance of art in public life is under-estimated, which he sees as evident in the view of art as play or game (*Spiel*):

> one took [art] as a game because it appears in the modest form of the game, and so also, reasonably enough, no other effect could result from it than that of the game, i.e. diversion [*Zerstreuung*, which also has the sense of dispersal], almost the exact opposite of its effect when it is present in its true nature. For then people compose themselves in it and it gives them peace, not empty but living peace, where all powers are alert and are only not recognised as active because of their inner harmony. It draws people closer and brings them together, not in the manner of the game, where they are only unified by the fact that they forget themselves and nobody's living particularity is able to appear.[13]

Whereas philosophico-political education can unify people in the recognition of duty and the law, far more is needed if a harmonious community is to be established.

A sense of what this might be is present in the organic unity of the work of art. Hölderlin concludes his letter with a passionate political affirmation, which clearly relates to the nature of his own poetry, of the need to

> bring everything human in us and others into ever freer and profounder connection [*Zusammenhang*], be it in aesthetic [*bildlich*] representation or in the real world, and if the realm of darkness should break in with *violence*, then we will throw the pen under the table and go in God's name to where the need is greatest, and where we are most needed.[14]

Whilst one is again confronted with hyperbolic construals of the aesthetic, the essential point is political.

The political potential of the semantic resources which Hölderlin sees in art's ability to achieve organic cohesion are those which Ernst Bloch, himself profoundly influenced by Schelling, saw as lacking in the Left's political armoury in the fight against Fascism. It is, therefore, not

always clear that the organic implications of the aesthetic theory present in the *STI* are politically reactionary. Bloch's argument was that if the Nazis, however temporarily and deceptively, fulfilled real needs, there is no point in trying to conjure these needs away. Modernity, as we saw in relation to the *SP*, inherently produces a need to unify the results of the essentially random proliferation of reflexive knowledge with the contexts of meaning of everyday life and the unfulfilled hopes and desires of that life. Art is one of the areas in which such a unification can be felt.

The question is whether this is just a retreat into the imaginary. The stringency of an Adorno is based upon his sense, in the light of his experience of historical catastrophe, that such a unification is always a deception. This leads him to the insistence upon aesthetic autonomy, in order to preserve a sphere of meaning which cannot be subsumed into any other. Within that sphere it is, though, noticeable that he uses attenuated notions of organic coherence: without any sense of possible unity the very possibility of meaning disappears for Adorno. In the Germany of the time of the *STI* organic notions have the character of a utopian hope rather than of self-deception. In the *STI* aesthetics leads to the issue that will become central for Schelling's later thinking: mythology.

Mythology, art and modernity

The final part of the *STI* turns to the idea of the 'new mythology'. Philosophy, argues Schelling, is born originally of 'Poetry' (*Poesie*), in the sense of creativity, *poiesis*. The 'completion' of philosophy would be its return to the 'general ocean of poetry'. Art brings our conscious reflection into harmony with what is given to us by nature, performing an analogous role to that of mythology in pre-modern cultures. The return of 'science' (in the broadest sense of philosophy, which would include natural science) to 'Poetry' would have to take place via the kind of integrated world picture present in mythologies. Such a mythology would overcome the divisions between the cognitive, the ethical, and the aesthetic that are characteristic of modernity. As we saw in Chapter 2, this raises controversial issues.

Hegel will see it as the task of philosophy to achieve this integration, because of the limitations of thinking in which intuition still plays a central role, such as mythology and art. More recently, Habermas' accounts of modernity see the separation of these spheres as precisely what enables the scientific, legal, and artistic advances characteristic of

modernity. Conflating validity claims from the different spheres leads in his view to the kind of irrationality characteristic of feudalism, which it was the task of Enlightenment to overcome. The spheres are also conflated in fascism, where criteria of public accountability become randomly decisionistic.

It is not clear that Schelling's position is rendered invalid by such objections. In the face of the disasters of scientific modernity, and of the coercive forms of integration characteristic of modern capitalism, one needs to re-examine the basis of how we think about the relationship of cognitive, ethical, and aesthetic spheres. If the aesthetic is the one realm in modernity where any sense of the harmony of our reflexive and of our natural being is sustained, it may yet offer resources that the growing separation of the spheres has tended to obliterate. In the light of subsequent history it is clear why Habermas is so wary of the idea of a new mythology: its effect in politics is rarely anything but catastrophic, from Schelling's time to the present.

The crucial fact about Schelling's new mythology is that it must be made, and it is the task of *reason* to make it. It cannot be re-established from the past, and has nothing to do with later reactionary nationalist conceptions of mythology as a return to lost origins. The problem is that the mythology would have to be produced collectively. Schelling has no delusions about the difficulty of this in modern societies. He attaches great importance to the collective reception of art, frequently citing the links between the genesis of Greek tragedy and the fact that Athenian society was based on 'public freedom', not on the 'slavery of private life'. The holy is constituted at the level of the community, not in the individual: 'A nation which has nothing holy . . . cannot have true tragedy' (I/6 p. 573/583). The problem for modern art is that the collectively binding status of Greek tragedy as a norm for the community could not be achieved by an individual artist:

> But how a new mythology, which cannot be the invention of the individual poet, but of a new people [*Geschlecht* – it should be remembered, in order to counter the apparent hint of racism, that the *STI* also argues the need for a cosmopolitan constitution to guarantee human freedom], which as it were represents One poet, can arise, is a problem whose solution can only be expected from the future fate of the world and the further course of history (I/3 p. 629/697).

How could the individuality of a non-theologically based art ever gain collective public significance? In modern capitalism collective

significance is increasingly the preserve of the administered mass media, which constitute a public sphere with no founding ethical content. If art is to retain ethical force it must have this collective significance: if it does not, any link between the aesthetic and the ethical is broken. As we saw, the notion that the ethical and the aesthetic should be separated starts to emerge at exactly the time Schelling writes the *STI*, in the work of Friedrich Schlegel.

What, then, does the artist who sees his or her task in terms of the need for a new mythology do in the meanwhile, in a society which seems to be moving further and further away from the integration sought in the new mythology? This was precisely Hölderlin's problem, in a way which suggests how intense the problem can become for the modern artist. Widely divergent responses are possible to this dilemma. The artist may have to give up art altogether, as Hölderlin suggested, in the name of political praxis. In the case of Wagner, art really is supposed to become the mythology of the present. Wagner attempts this, however, in an often regressive way. At the same time as taking on the challenge of the new aesthetic freedom in some ways more effectively than any other composer, he also tries to resuscitate old national mythologies, thereby regressively ignoring the need for a new, cosmopolitan mythology. Those aspects of his music which were later to be effortlessly assimilated into the culture industry point to other dimensions of this regression. The complex but more than tenuous links between Wagner's music-drama and the use of aesthetic modes in Nazi political praxis suggest the dangers in his response. The avant-garde artist, on the other hand, can produce an art which tries to remind a society of all it has repressed, by refusing to communicate in the terms of the dominant society, with the danger that s/he will either not be understood, or simply ignored. The fact is, as Schelling makes clear, that there is no individual solution to these dilemmas. Subsequent – particularly Marxist – aesthetic theory tries – and is still trying – to come to terms with the conflicts between these alternatives.

Mythology, language and being

As well as raising key aesthetic problems, mythology for Schelling leads to many issues in modern philosophy which are often not directly associated with aesthetics. As we saw, Schelling tries, like the other Idealists, to overcome the divisions that become the dominant framework for modern philosophy from Kant onwards. The particular ways in

which he does so point to issues that re-emerge in the questioning of modernity in this century, and particularly to some current concerns arising out of this questioning.

Schelling develops some of the *STI*'s ideas on art and mythology in the slightly later – 1802–3 – *Philosophy of Art (PA)*. The *PA* argues that something vital is lost when the modern world ceases to be able to articulate meaning in the manner of mythology: 'The modern world begins when man tears himself away from nature, but as he has no other home he feels himself alone' (I/5 p. 427/255). Schelling tells a story that will recur in a similar form in Lukács' *Theory of the Novel* and Benjamin's *The Origins of German Trauerspiel*, and, implicitly, in aspects of Heidegger's philosophy. In this story myth-based cultures do not reach the level of reflection on which the images used to interpret reality are radically separate from other, abstract, articulations of reality. This separation is part of the loss of 'home' characteristic of modernity: the separation of subject and object. Rereading this aspect of Schelling's theory in the light of contemporary debates gives interesting alternative perspectives on questions of language of the kind raised by Heidegger and others.

The *PA* argues that Greek mythology tells the story of the origins of the world in 'concrete' terms, in terms of stories and images. The divisions expressed abstractly in the *STI*'s account of the 'I''s attempt to 'intuit itself' are articulated in stories of the Gods, much in the same way as the work of art made the highest point of philosophy available to intuition. Schelling claims that 'all the possibilities located in that realm of ideas which is constructed in philosophy are exhausted [*erschöpft*] in Greek mythology' (I/5 p. 400/228). The crucial difference is that these stories are concrete and self-sufficient: our subsequent interpretation of, say, the figure of Jupiter in such stories as, in Schelling's terms, the linking of absolute power and absolute wisdom, has nothing to do with how the story functions within its own culture. It is not that the figure of the God 'means' something else which is more abstract: the Gods '*do not mean it*, they *are* it' (I/5 p. 401/229). The gap between concrete image (be it a sculpture or a story), and what it represents, does not exist in such a culture – I am not concerned here with the historical or philosophical validity of this view, but rather with its implications for a conception of language. According to the *PA* there is no need, with regard to this sort of myth, for philosophical reflection, because what we have come to see as subject and object are inherently united. The stories are 'of' the Gods in the 'subjective' and the 'objective' genitive: they come from the Gods

and they are about the Gods.

Schelling links this conception of myth to his notion of absolute identity, which is his means, at this point in his philosophical career, of crossing the Kantian boundary. Absolute identity does not divide sensuous and intelligible, because they only differ from each other in degree, as part of the same continuum. Modernity, as we have seen, entails the growing divorce of subjective intuition from its reflection as part of the discourse of science. Schelling's questioning of this divorce becomes most significant for contemporary philosophy when language is introduced as part of the argument.

We already saw the beginnings of a characteristically modern conception of language in Novalis: the signifier, itself constituted in opposition to all other signifiers, is a condition of the reduction of my particular intuition to the general. This creates a tension which is impossible in terms of the conception of myth in the *PA*, where the transition between particular and general has no significance. Once this division becomes significant, language can begin to feel like a constraint upon the individual subject: using the general signifier for my particular experience becomes a problem, as it clearly is for many modern artists. At the same time, though, poetic language must attain an at least minimal level of comprehensibility for others, if it is to be seen as art at all.

Schelling's arguments here bring him close to Adorno. This is apparent in the *PA* when he suggests that the *universality* implicit in Greek mythology's ability to 'imagine' (in the sense of making into an image) is only available in modern art to those artists who by their *individuality* are able to create a 'closed circle of poetry [*Poesie*]' (I/5 p. 444/272), a personal mythology, from their limitation. As Peter Szondi points out, Proust, Kafka, Joyce (or, one might add, composers such as Mahler or Schönberg) *do* achieve a canonic status via their setting up an image world which has a coherence not derived from the dominant thinking or language of their society. Schelling already sees the grounds of autonomous art's refusal to communicate in the language of the rest of modern society. Individuality can point more effectively to a sense of general integration than the disintegrated products of science and technology, because it resists the repression imposed upon subjects in modern rationalisation. As we saw, Novalis already speculated on music as a language which might allow one to escape the restrictions of verbal language, whilst still being able to communicate the sense of the subject's freedom.

In the *PA* the special status of 'classical' art, particularly Greek

sculpture, is grounded in the fact that it implies a unity of form and content which modern art cannot have for us. This unity is again analogous to myth: the form and content of Jupiter are the same. Schelling argues that 'Beauty is posited where the particular (the real) [in the sense of the sensuous particular object] is so appropriate to its concept that the concept, as infinite, enters into the finite and is contemplated *in concreto*' (I/5 p. 382/210). This links art to the unification of image and idea which is always already present in mythology: in art 'eternal ideas of reason' become 'objective as the souls of organic bodies' (I/5 p. 383/211). The sensuous is able to communicate the Absolute when the object need not point beyond itself to that which would explain it in other terms: art in the *PA* represents metaphysical presence.

The same description could apply to a view of language in which the 'eternal idea' would become objectified in the concrete word, which would be self-contained. Schelling demands that in art each thing should have a 'particular and free life. Only the Understanding subordinates, in reason and in imagination [*Einbildungskraft*] all is free and moves in the same ether . . . each for itself is also the whole' (I/5 p. 393/221). Art becomes a language which would not entail arbitrary signification: word and thing would be inherently bound up with each other. They would not be randomly attached and therefore actually separate. Art is, in this view, related to the attempt to sustain the significance of the particular intuition, not for its particularity, but for its potential to show the totality in itself. This is the classic definition of the Symbol, as opposed to allegory's arbitrary link between signifier and signified, and again highlights the difference of Idealist and Romantic conceptions of art.

The insistence upon this function of art is characteristic of Schelling's argument in the *PA*. In modern science we cannot subtract the effects of reflection, in the sense of the separation of intuition and thought, from our relation to the object. The object's status is constituted by its separation from us, which we try to overcome in the scientific concept, thereby eliminating its particularity. It is at this level that one can already begin to see the roots of Schelling's divergence from Hegel. Whilst accepting Schelling's view of 'classical art' as vital in an earlier phase of the development of culture, Hegel sees the break-up, via reflection, of the unity of the particular object of intuition and the totality as part of the process of the Absolute. Without this break-up thinking would remain tied to particularity and unable to reach the level of universalisation

which is the foundation of modern science, and of philosophy's ability to grasp the truth of modernity. For Hegel, philosophical reflection must overcome sensuousness in order to reach its highest principle.

Hegel's attitude to the sensuous reflects the dominant pattern of modernity. In each realm of science new developments are increasingly the result of the elimination of residual mythical elements. The ever greater abstraction from the particular to the general constitutes the world more and more as the object of an abstract subject. The same applies in the world of the object considered as an exchange value in the commodity market. Worries about this process of abstraction, which are linked to questions about subjectivity, are reflected in varying ways in modern philosophy. Most recently it has been those thinkers who, like Heidegger, Foucault, and Derrida, question the conception of the subject of 'Western metaphysics', who have commanded the greatest attention. A central issue for these thinkers is language, particularly the language of poetry.

Schelling helps open the way to approaches to language that are often seen as the preserve of thinkers like Heidegger. Heidegger's account of the pathology of modern philosophy as the subjectification of Being, leads to attempts to find a different language for philosophy, which would not be that of subject and object. Despite his reference to the ancient Greek past as a source of his project, this attention to language is not wholly separable, either from the desire of modernist poets, such as Mallarmé, to 'purify the words of the tribe', or from ideas about music current in the nineteenth century. The modern need to seek a different language has its roots in the view of mythology we have been looking at. The crucial question is how this need is understood.

In the 1842 *Philosophy of Mythology* Schelling returns to the question of why, in a mythology, image and idea are not separate, claiming that this must be looked at in relation to language. His awareness of the inherent dependence of subjectivity upon a ground which is not accessible to reflection, apparent in the *STI*'s use of the idea of genius, is now linked to language. He sees language as the necessary condition of consciousness, and 'deeper', in the way living organisms are, than anything consciousness can produce of its own accord:

> But what treasures of poetry lie hidden in language in itself, which the poet does not put into language, which he, so to speak, only lifts out of it as out of a treasure chamber, which he only persuades language to reveal. But is not every attribution of a name a personification, and if all languages think or expressly designate things which admit an *opposition* with differences of

gender; if the German says der Himmel [sky], die Erde [earth]; der Raum [space], die Zeit [time]: how far is it from there to the expression of spiritual [*geistig*] concepts by male and female divinities. One is almost tempted to say: language itself is only faded mythology, in it is preserved in only abstract and formal differences what mythology preserves in still living and concrete differences (II/I p. 52/62).

The argument sees language, not the subject, as that which reveals Being, and as that which, in modernity, fails to reveal it in the same way. The conception is not so far from Heidegger calling language the 'house of Being' and from the contention that 'We do not only speak *the* language, we speak *out* of language'.[15] The argument tends to suffer from the same myth of origin as Heidegger, referring to a past where language was fundamentally different. Despite this it leads towards important questions.

The passage reminds one of the fact that natural languages are not reducible to abstract analysis, both because the analysis itself requires natural language, and because of natural languages' inseparability from intution. This makes language inseparable from aesthetics. In his critique of Kant in 1784, Hamann, who saw the oldest language as music, questions Kant's division between intuitions and concepts on the basis of language. Words for Hamann are both intuitions – you can see and hear them – and concepts – they only mean something via what is independent of intuition. Furthermore, language involves the sensuous in another way, in its inherent reliance upon metaphor, the use of the sensuous to represent the non-sensuous.

Schelling's perception of the reduction of language to the articulation of 'abstract and formal differences' relates to fears about rationalisation in modern societies. Opposition to this reduction in language is most characteristically linked to literary usage: it can even be suggested that the very notion of the literary emerges as a consequence of it. The *PA* suggests, like the *STI*, that art is a kind of language in which the infinite can appear in the finite in a concrete way, as it also does in mythology. Schelling also looks at the issue of language in another, but related, manner. Near the beginning of the *PA* Schelling makes the unmotivated statement, perhaps derived from Hamann's work, that 'Very few people reflect upon the fact that even the language in which they express themselves is the most complete work of art' (I/5 p. 358/186). The immediate reason for this is that language is 'the direct expression of an ideal – of knowledge, thought, feeling, will etc. – in something real, and, as such, a work of art' (I/5 p. 482/310): language must manifest itself as

sensory phenomenon, but it must also be intelligible.

Language is inseparable from 'absolute identity' because it is not explicable in terms of the division of sensuous and intelligible:

> sensuous and non-sensuous are one here, what is most graspable becomes a sign for the most spiritual (Geistigste). Everything becomes an image of everything else and language itself becomes thereby a symbol of the identity of all things (I/5 p. 484/312).

Language is the necessary 'real' articulation of the 'ideal', but 'absolute identity' means that this difference is only ever relative: the ideal's reflection in the real means it is dependent on it, as does the real's relation to the ideal. This view of language moves in two divergent directions. On the one hand, as we saw, in the direction of a metaphysical view of language, which, like the view of myth and art, sees it as a sign of the infinite in the sensuous, on the other, though, in the direction of the differential view already seen in Novalis, and familiar from recent French philosophy.

In Schelling's identity philosophy all difference is a matter of degree in relation to absolute identity. It is therefore difficult to see this aspect of the view of language in terms of the 'difference of a sensuous and a supersensuous world', upon which 'Western metaphysics rests',[16] as Heidegger puts it, because there is no absolute distinction of this kind for Schelling. Manfred Frank and Peter Dews have recently shown that aspects of Schelling's identity philosophy, upon which the *PA* is based, are very close to post-structuralist accounts of language. In the identity philosophy all finite differences can only be thought on the basis of the transcending of difference in the Absolute. In his classic statement of the identity philosophy, the 'Würzburg System' of 1804, Schelling, developing ideas from Spinoza, makes it clear why there cannot be any ultimate foundation for reflexive knowledge, in a way which can be related to a differential view of language. Schelling says: 'No single being has the ground of its existence in itself' (I/6 p. 193/203): it must be relative to all other beings and thus within 'absolute identity', otherwise it could have no way of being itself. He claims that 'Every single being is determined by another single being, which in the same way is determined by another single being etc. into infinity' (I/6 p. 194/204). The aim is, once again, to unite the difference of the moments into a higher identity. There can, though, be no way of *knowing* this higher identity, as knowing entails reflection.

At this stage Schelling still thinks that we have access to this identity.

He relies upon a version of 'intellectual intuition' which goes far further than Fichte's:

> The sameness of subject and object is not limited to the consciousness of myself; it is *universal*. The object of an intellectual intuition cannot therefore be an external sensuous object, but just as little can it be the empirical subject. For all objects of the same are just as limited and transitory as those of the external sense. Therefore only what is infinite, completely unlimited, what is affirmed by itself can be object of an intellectual intuition (I/6 p. 154/164).

The fact that all differentiation is only relative within 'absolute identity' relates to Saussure's idea that language is a system of differences with no positive terms, upon which Derrida bases his account of differentiality. As Peter Dews has pointed out, the notion of difference in the identity philosophy is not a great distance from Derrida's *différance*. *Différance* combines the sense of differentiality, seen in Schelling, with the notion of deferral. It thereby suggests a temporality which prevents what is differentiated ever being able to coincide with itself once it is split from itself. We already saw this problem in relation to the I in Hölderlin and Novalis. We also saw, though, that the I could not ultimately be charac- terised by reflexive division.

In Saussurean linguistics the signifier and the signified, the concept designated by the signifier, are inseparably linked, but different from each other, like the two different sides of the same piece of paper. Derrida questions whether they can be separated at all. If one assumes that there are no ideas outside the process of their articulation, which is itself dependent upon the signifier, one can only have access to what is signified via the signifier's negative relationship to other signifiers, not by reference to a pre-existing signified. We can thus only work with chains of signifiers which are mutually dependent upon each other and therefore rely on what they are not for their functioning. Each element of language therefore bears the trace of the other elements of the language in a manner analogous to Schelling's remark that 'No single being has the ground of its existence in itself'. An element can only signify via the fact that it points to another element: hence the sense of deferral. It is never fully present as itself. It could not be, because to be itself it needs the other. No specific statement can ever claim absolute validity because it can always be located within a different context which will redetermine its significance. The 'absolute context' is not knowable, precisely because knowledge of it would already presuppose a structure

of reflection that divides the context against itself.

The argument parallels Schelling. Derrida, however, could have no time for intellectual intuition, which grounds identity in the identity philosophy by attempting to get over the reflexive splitting of the subject into knower and known. Intellectual intuition for Derrida would be the classic example of the metaphysics of presence. Putting it crudely, Derrida attempts to avoid any notion of identity at all, seeing it as always already dependent on the inherent temporality of difference. In a sense, though, he just reverses the identity philosophy, turning absolute identity into absolute difference.

However, without some form of identity, even the dependence of the different beings on each other is impossible: seeing something as different entails access to the same. In the arguments seen so far this entails an account of self-consciousness for which difference is difference. Such a self-consciousness must avoid the problems that Fichte pointed out in the reflection model. It is clear that post-structuralists have no investment in giving an account of self-consciousness: they tend to celebrate the removal of the subject from philosophy. As Manfred Frank has repeatedly shown,[17] Derrida in particular only ever sees self-consciousness in terms of reflection, thereby confusing the fact of subjectivity, which Derrida does not deny, with the language in which it articulates itself. Whilst the language of self-identification is differential, the I cannot be, as was already apparent in Kant.

How, in Derrida's view, does language ever mean anything? As Peter Dews makes clear, this question involves the same difficulties that Fichte showed to be present in the reflection theory of consciousness. Dews suggests:

> just as the regress of reflection renders the phenomenon of consciousness inexplicable, so – on Derrida's account – there could never be an emergence of meaning: there would be nothing but an unstoppable mediation of signs by other signs.[18]

As Fichte insisted that there is consciousness, so it is with meaning: it may be inherently unstable, but it cannot *just* be unstable, and is a phenomenon of which we must give an account. Derrida makes absolute demands on the determination of meaning, only to prove they cannot be fulfilled. It is, as I have shown, not enough, as Derrida does, to regard signification as infinitely deferred: if something is infinitely deferred it never happens, and, as such, cannot even be considered to be deferred. If it is not infinitely deferred, there must be a way in which it happens.

To give an account of this one must, as I shall show in relation to Schleiermacher, give an account of the role of the subject in the constitution of meaning.

The appeal of Derrida's work, despite these fundamental flaws, has largely been based upon the sense that it opens up repressed resources of signification which had been threatened by the assumption that meaning, and conceptual truth, could be finally grounded by the assumption of presence, the coincidence of sensuous signifier and supersensuous signified. Some of Derrida's most convincing work results from reading philosophy as literature, and showing how philosophical discourse about truth is always confronted with the excess of signification generated by metaphor, which deconstructs the division of the sensuous and the intelligible. Schelling's refusal to ground philosophy in such a way that it would overcome the sensuous in favour of the general concept relates to this, as do aspects of early Romanticism. Far from being an unheard of new philosophy, then, post-structuralism clearly belongs to a trend in the philosophy of modernity which needs re-examination in the light of our historical situation.

There are complex lines of development which lead from German Idealism to Marx, Nietzsche, Heidegger, Gadamer, and Derrida, as well as to Benjamin and Adorno. These philosophers have in common the fact that they all reject fundamental aspects of Hegel. The non-Hegelian positions can crudely be seen as confronting the necessary failure of reflection to articulate a complete system of philosophy. Philosophy for these thinkers often enlists the services of art, which for Hegel is still encumbered with an unmediated intuition and sensuousness that will be overcome by philosophy. Feuerbach, for instance, sees art, initially following Hegel, as representing the '*truth of the sensuous*', but he also makes the senses the '*Organ of the Absolute*',[19] thereby inverting Hegel's view and refusing to dissolve the senses into *Geist*.

The non-Hegelian perspective leads Schelling, as we shall see again in the next chapter, after initial proximity to Hegel in some of the metaphysical aspects of the identity philosophy, close to what Heidegger means by the difference of beings and Being, the ontico-ontological difference. Schelling's philosophy refuses to reduce Being to the consciousness we have of it. Heidegger's 'fundamental ontology' makes the prior question the ontological 'thatness' of things, the fact of their being at all, not the ontic 'whatness', of their

determination by a particular science. In *Being and Time* Heidegger states:

> The question of Being aims therefore at an a priori condition of the possibility not only of the sciences that investigate beings as being in such and such a way, and which thereby always already move in a comprehension of Being, but of the condition of possibility of the ontologies which lie before the ontic sciences and found them.[20]

Heidegger bases his early questioning of the status of scientific thought on this distinction. Heidegger's questioning of modern technology leads him increasingly to a concern with poetic language.

He is not alone in this concern. Benjamin says in the Preface to the 1925 'Trauerspiel' book that elimination of the 'problem of representation [*Darstellung*]' in mathematics, which founds scientific cognition, also entails the 'renunciation of the realm of truth which is meant by languages'.[21] He emphasises the relationship in Plato's *Symposium* between truth and beauty in a way that parallels Schelling's views of mythology, language, and art in the identity philosophy. As we shall see in the next chapter, Adorno, himself influenced by Benjamin, regards Hegel's view that philosophical progress is the articulation of that which is undeveloped in intuition with suspicion, precisely because of its tendency to eliminate, as the process of modern rationalisation does, all that is particular and resistant to conceptual determination. Adorno will invoke works of radical aesthetic modernism in the attempt to set up a philosophy of 'non-identity', in which the irreducibility of objects to concepts plays a major role.

Like the early Schelling, Hegel is a philosopher of identity. Hegel thinks, though, that he has resolved the question of Being without recourse to a theological starting point, by revealing that Being is empty until it enters into a structure of reflection with its opposite, Nothing. Without this it is the 'indeterminate immediate': it just is, and one cannot therefore say anything about it. He thereby rejects intellectual intuition for its indeterminacy. As Jochen Hörisch puts Hegel's position:

> It is true that 'Being' is the precondition of thought and language, but in such a way that thought and language have pre-supposed it for themselves. And that is only possible because Being as well has always already gone over into the other of itself: into 'thinking'.[22]

Feuerbach, following Schelling, suggests, though, that 'As little as the

word is the thing, just as little is the *said* or *thought* Being real Being'.[23] One of Schelling's main later objections to Hegel is Hegel's equation of Being and Nothing. Schelling's doubts about Hegel's dissolution of Being into thinking, where self-consciousness is therefore able to give a complete conceptual account of itself, relate to his earlier attention to art, which articulates in a non-conceptual way Fichte's fundamental insight that self-consciousness is irreducible to reflection.

When Hegel says 'pure Being is Nothing', Schelling objects in the Munich lectures, he 'has not explained in the least the meaning of this "is" ' (I/10 p. 134/550). Why is it nonsense to say 'pure Nothing *is* Being'? Reflection has to start from the primary existential fact that the questions are being asked from the position of our always already being. Being is always prior to our cognition, the Logos is after, not before Being. Asking the question presupposes a ground which reason cannot account for unless it presupposes Being as part of itself, which is essentially what Hegel does. For Heidegger the question of Being gets forgotten until he, Heidegger, asks it again. The forgetting begins with Parmenides' identification of thought and Being: philosophy becomes concerned with the subjectification of Being in the concept. Hegel attempts to reinstate a modern version of Parmenides, and it is this which Schelling, well before Heidegger, comes to question.

In all these areas, then, Schelling's approaches to philosophy and art already open up possibilities for subsequent thinking whose potential is only now being recognised. If we are to reach an adequate understanding of the current philosophical critiques of modernity, it is evident that they need to be seen much more clearly in relation to their antecedents. The danger is that much work has already been done which has been largely forgotten. Schelling may often be an unsatisfactory philosopher, because he fails to achieve a coherent system, or to have one dominating philosophical idea. He does, however, move in directions which are again on the agenda of philosophy, and attention to him can help to prevent the repetition of problems which already have a history.

Hegel:
the beginning of aesthetic theory
and the end of art

The reflexive Absolute

Most accounts of the history of German Idealism see Hegel as making the vital steps towards a complete systematic philosophy which goes beyond the limitations of Fichte and Schelling.[1] Nowadays it is precisely this completeness that makes Hegel the target of philosophies whose aim is to deconstruct such pretension. My attention to those figures in German Idealism and Romanticism, like Schelling, who reveal ways in which reflection fails to give philosophy a wholly transparent foundation, is intended to show that there always has been a 'deconstructive' tendency in modern philosophy. It is, though, one which is associated with other conceptions of subjectivity, not one which dispenses with the subject. Hegel's own account of subjectivity involves important difficulties. In the present chapter I want to suggest that the way Hegel subordinates aesthetics to philosophy in his system leads to a conception of subjectivity which is unable to take account of the resistance of individual subjectivity to complete subsumption into philosophy.

Hegel's work on aesthetic theory appears paradoxical: he produced the most important systematic aesthetics of the nineteenth century at the same time as announcing the 'end of art' as an expression of the 'Absolute'. Hegel wants to make philosophy into the complete articulation of what is inherent in religion and art as expressions of truth. He is insistent, though, that religion and art do not themselves finally articulate the truth, and that philosophy is necessary to reveal the truth they contain.

Hegel's capacity for method is only equalled by Kant, which makes it hard to be fair to him in a short space. The complexity of Hegel's work means that any approach to it is faced with fundamental hermeneutic problems. Objections to Hegel are often rejected by Hegelians on the

basis that some other part of the system is able to cater for the objection. This leads to the situation where all one can do is to enter the textual labyrinth called 'Hegel' on the assumption that it has a centre. One cannot, of course, *know* in advance whether this is really the case: one has to assume it as an act of faith. It is arguable that Hegel himself assumes a centre of the labyrinth, called Reason, and then sets about showing us the way to it. Doing full justice to his attempt to show this path is impossible in the present context. My aim is to ask why the completion of Hegel's philosophy – what makes it a system – leads him to see aesthetics in the way he does.

Philosophy for Hegel, as it was for the other Idealists, is the attempt to reveal how the process of thinking and the process of reality are ultimately identical. The question is *how* this is to be revealed. The early Schelling, as we saw, thought this revelation took place in art. Hegel confronts in a wholly original way the problem of how Mind or Spirit, *Geist*, articulates itself. As Fichte saw, if the I is wholly opposed to something else – the world, the object, matter, things in themselves – Kant's problems remain unsolved. We have already considered various attempts to solve Kantian problems. What is Hegel's contribution to these attempts?

Schelling's philosophy retains in varying ways, and continues to do so until his later philosophy, a sense that the postulated highest principle of philosophy, the 'Absolute', cannot be represented in conceptual thought, by 'reflection'. Even though Schelling ceases to regard art as the 'organ of philosophy' he never produces a system that is wholly transparent, where thought and being can be articulated as being the same by an overall concept. This leads Hegel to say of Schelling, in the midst of the latter's career, that 'if one is to ask for a final text in which his philosophy presents itself in its most definite development one cannot name such a text' (*GP* III p. 421).[2]

Hegel himself claims to achieve what Schelling does not. Hegel:

> The deficit in Schelling's philosophy is that he places the point of the indifference of subjective and objective at the beginning; this identity is set up absolutely, without it being proven that this is the Truth (*GP* III p. 435).

Hegel's claim is that he can prove the identity of subject and object, rather than postulate it, as Schelling does in 'intellectual intuition'. Such a philosophy would be able to begin without any presupposition which could not be articulated as part of the system, and would thus be able to integrate finite and infinite. The difference we are concerned with is,

then, between a philosophy founded on the conviction that the separation of thought and being is untenable, but which never fully squares this circle by proving how it is so in conceptual thought, and a philosophy which claims to have means to solve the problem by articulating it in a new kind of conceptuality.

Hegel's argument becomes easier to understand if one sees it in its historical context. The turn to the subject in modern philosophy parallels the development of modern individualism. Jürgen Habermas suggests the main contradiction involved, which German Idealism tries to overcome:

> subjectivity reveals itself as a *one-sided* principle. It admittedly possesses the unprecedented power to produce a development of subjective freedom and subjective reflection ... but it is not powerful enough to regenerate the religious power of unification via the medium of reason.[3]

Whereas religion and mythology give an a priori basis for action and reflection, which is necessarily shared by others, a culture grounded in the individual's freedom to think and act self-interestedly must necessarily generate conflicts. Who or what legislates on the issue of whether my freedom is not your enslavement?

The power of Hegel's philosophy lies in its demonstration of the need for mutual recognition as the ground of normativity in the modern world. Habermas again:

> The experience of self-consciousness ... results for Hegel from the experience of the interaction in which I learn to see myself with the eyes of the other subject ... only on the basis of mutual recognition does self-consciousness develop, which must be anchored in the reflection of my consciousness in the consciousness of another subject.[4]

In the light of what has been said so far about reflection the problem should already be apparent: how do I know that the reflection of *my* consciousness in the other is a reflection of my consciousness? The assumption has to be that it is only as reflected in the other that I become myself. But in what sense am I *my*self? The assumption must be that the already existing consciousness, that must already be there to be reflected, only becomes its true self via the other. What contribution do I make to this? This will raise problems of the kind we have already seen. Let us first, though, try to reconstruct some of Hegel's arguments.

The *Phenomenology of Spirit (PG)* of 1807 is an account of the stages of this process of self-recognition in the other. It follows the

developmental model of the *STI*, but it wants to show how the process of reflection can be revealed as inherent in the development of thought from the lowest to the highest stages. In the *PG* self-consciousness is revealed not to be the prior principle it is in, say, Fichte, but instead as that which can only come about via that which it is not: another consciousness. For Hegel, without the other consciousness I would remain in a state of unreflecting immediacy and never reach the stage of conscious reflection. By reflecting my consciousness in that of another I reveal the fact that consciousness can only develop via its relation to *Geist*, the overall structure of consciousness that it shares with others. Self-consciousness thus depends upon self-*objectification*, the negation of itself as individual inward 'Cartesian' awareness. Only by self-*division*, relating to the other's thinking (which is therefore not *my* thinking) can one achieve real awareness of what one's own consciousness is. Consciousness itself is precisely this process of division: it is what it is via what it is not.

This structure of determination by negation, a structure of reflection, is present in Hegel's philosophy at all levels. In its most developed form it purports to prove the identity of subject and object: if the subject can only be what it is via that which it is not the two must ultimately be the same. In Hegel's terms:

> the subjective is that which transforms itself into the objective and the objective is that which does not remain as it is but which rather makes itself subjective. One would have to show via the finite itself that it contains the contradiction in itself and makes itself infinite (*GP* III p. 435).

The *Encyclopedia* counters Kantian dualisms with the following argument, which relies upon the same principle:

> the designation of something as finite or limited contains the proof of the *real presence* of the infinite, of the unlimited . . . there can only be knowledge of the boundary insofar as the unbounded is *immanent* in consciousness (*E* p. 84).

Dieter Henrich suggests that 'Hegel took the decisive step towards the thought of the Absolute, which . . . is *Geist*, by reaching the thought of something finite that is an other in relation to itself'.[5] For Hegel the finite, empirical world, the world of transience, and of common sense experience, constantly negates itself, is a constant process of change. The phrase 'constant change' captures the essence of the argument. Gadamer puts it very aptly:

what remains, what is real, is namely the fact that everything continually disappears ... constancy is, then, no longer the simple opposite of disappearing, but rather is itself the truth of disappearance.[6]

The facts of scientific theory, for example, come about in a process of negation. Hegel characterises the Understanding, our faculty for law-bound cognition, as follows:

If the determinations of thought are attached to a fixed opposition, i.e. if they are only of a *finite* kind, then they are inappropriate to the truth which is absolutely in and for itself (. . .) Thought which only produces *finite* determinations and moves within such is called *Understanding* (*E* p. 58).

The process of scientific knowledge is a continual refutation of what was previously held to be true. For Hegel, though, this does not entail scepticism. Without the previous 'truth', which has now been refuted, the present 'higher' truth could not come about. Galileo needed Ptolemaic physics to refute.

The Truth, then, is the process itself, the fact that everything finite is continually being transcended. It is the *limitations* of the Understanding that ground the Truth, which always goes beyond the particular theory that pertains at any one particular time. Henrich again: 'The Absolute is ... the finite insofar as the finite is nothing but the continual process of self-negation (*Sich-selbst-Aufheben*)'.[7] Where Kant opposes 'appearances' and 'things in themselves', Hegel wants to prove that appearance is in fact the essence of reality and, thus, that the idea of a 'thing in itself' apart from thought is *empty*:

The thing *in itself* . . . expresses the object inasfar as one *abstracts* from it everything that it is for consciousness, from all determination of feeling as well as all distinct thoughts of the object. It is easy to see what is left, – the *total abstraction*, total *emptiness* (*E* p. 69).

Once one can grasp the transient nature of all reality, the transience ceases to be transient and becomes what remains. In the words of the preface to the *PG*: 'Appearance is the coming into being and passing away which itself does not come into being and pass away, but is rather in itself and constitutes the reality and movement of the life of truth' (*PG* p. 416).

The example of the plant Hegel uses in the preface illustrates the point. Each stage of the plant from seed to flower and back negates, destroys the previous stage, but without the previous stage the subsequent stage could not exist as itself. The sequence of appearances that

make up the plant are equally a sequence of disappearances. Hegel's philosophy presents the essence of the plant (reality) as being a process where each stage destroys the previous stage but where the whole of this process is the truth. The same idea applies to philosophy: Kant needs previous metaphysics to refute and transcend, and Hegel needs Kant as the other of himself. There does seem, of course, to be no need for philosophers after Hegel.

The overall movement is only explicable via that which it is not, thus the 'Idea' of movement, the whole plant from its emergence to its decline, is not subject to the same movement as the series of appearances of the plant, but is yet inseparable from them. Hegel's thinking is, as Henrich puts it, 'a dynamised Platonism'.[8] It rejects the idea that there is truth in the transient, sensuous world which does not have to relate to its other, the eternal:

> If . . . the Idea should not have the value of truth because it is *transcendent* in relation to appearances, because no object in the sensuous world that corresponds to it can be given, this is a peculiar misunderstanding via which the Idea is not granted objective validity because it lacks that which constitutes appearance, the *untrue being* of the objective world (*L* II p. 463).

This leads to the necessary exclusion of intuition if the highest thought is to be articulated.

Art, therefore, can only show the 'sensuous appearing of the Idea', and not, as it did in the *STI*, be the organ of philosophy. As such, the goal of philosophy is the explication of the Idea. The Idea is the 'true being' of the appearances of reality. It is inseparable from the appearances insofar as they, by negating themselves as finite appearances, are necessary for the Idea. Hegel's *Logic* is thus able to claim that it can characterise all possible modes of thought independently of their particular content, as suggested in this passage from the *Logic*:

> The logic is accordingly to be grasped as the system of pure reason, as the realm of pure thought. *This realm is truth as it is without veil in and for itself.* One can therefore say that this content is the *representation [Darstellung] of God as he is in his eternal essence before the creation of nature and a finite mind* (*L* I p. 44).

The apparently bizarre status of the *Logic* as a description of thought which has no need to go through the historical stages of thought's development in relation to nature, which thus precedes both nature and history, can only be understood by assuming the absolute status of the

process described above. The *Encyclopedia* sees the division of philosophy in the following order:

> I *Logic*, the science of the Idea in and for itself, II *Naturphilosophie* as the science of the Idea in its being other [i.e. Nature is after the Idea], III *Philosophy of Geist* as the Idea which returns to itself from being other [i.e. the philosopher, as part of both nature and Mind, can return to something prior to nature and beyond nature in pure thought via the process of philosophical reflection] (*E* p. 51).

The *Logic* relies on the following argument. So far in the history of thought every approach to truth has revealed itself to be relative and transitory; as such, the *Absolute* cannot be another version of the attempt to fix an absolute principle, but will instead make relativity, the movement of negation, the Absolute. Whilst the process of revealing this is temporal, what is arrived at is not: '*Geist* appears necessarily in time . . . it appears in time as long as it does not *grasp* its pure concept, i.e. does not abolish time' (*PG* p. 584). Nothing transient or empirical can lead us to the Absolute:

> *Being* has achieved the significance of *truth* when the idea is the unity of the concept and reality; it *is* then only what the Idea is. Finite things are finite inasmuch as they do not completely have the reality of their concept in themselves, but need other finite things to have it (*L* II p. 465).

The proximity to Schelling's identity philosophy is clear in the dependence of the particular upon other particulars *ad infinitum* for its identity. Hegel's further claim is that this does not lead to an Absolute which is not articulable, because the Absolute is inherent in the movement of articulation itself. Without the transient, for Hegel, there could be no explication of the absolute status of constant change: the idea of change would be meaningless. The Absolute for Hegel has to be arrived at via determination by negation, the process of thought in history whose truth emerges as constant change.

Music and the Idea

Hegel's *Logic* is by definition 'abstract'. Characteristically, for Hegel, this makes it concrete, in that, without abstraction, the truth of the concrete cannot be revealed. The apparently most concrete, the sensuous immediacy of what is in front of you as you read this sentence, is 'abstract', in that it omits all the complex mediations required for you

to be reading it at all. The thought with which the *Logic* is concerned is that which enables us to reach the truth of the sensuous world:

> The *elevation* of thought above the sensuous, the *transcendence* of thought over the finite to the infinite, the *leap* which is made with the breaking off of the sequences of the sensuous into the super-sensuous, all this is thinking itself, this transcending is *only thinking*. Animals really do not make such a transition; *they* remain with sensuousness and intuition; this is why they have no religion (*E* p. 75).

The very process of trying to understand the *Logic* already suggests an important problem. The attempt to think in pure thought must be intransitive: the thinking must be thinking of itself, as otherwise the infinite becomes dependent upon the finite object. One cannot reverse the priority, in order to derive the infinite from the finite. The problem is how the infinite is to be represented. The problem with representing the infinite in thought is that representation inherently limits what is to be represented.

Kant's notion of the sublime was one way of suggesting how one might represent the infinite capacity of thought. In the sublime the subject negates anything sensuous; the impetus to do so is, though, given by the feeling evoked by the sensuous: it is the failure of the sensuous to represent the infinite which constitutes our access to the infinite. Hegel's way of transcending the sensuous is more ambitious, but also highly questionable. The problem with the *Logic* will be how the move is made from pure thought to nature, including ourselves as thinking individuals. Schelling points to Hegel's problem in the Munich lectures. The decision to think about thinking cannot be

> real [*wirklich*] thinking. Real thinking is that through which something opposed to thought is overcome. . . . Hegel himself describes this movement by simple abstractions, like Being, Becoming, etc., as a movement in pure, i.e. unresisting ether (I/10 p. 141/557).

Schelling uses the example of poetry as an analogy to the problem facing a philosophy of pure thought. In what way are the moves in thought of the *Logic* real? Poetry can represent a 'poetic soul in relation to and in conflict with reality . . . But poetry can also have poetry in general and in abstracto as its object – it can be poetry about poetry' (ibid.). He cites Romantic 'poetry about poetry', claiming that 'no one has held this poetry to be real poetry' (ibid.). The idea of such poetry is, as we shall see again later, associated with music. Is there really a difference between

the *Logic*'s status as thought about thought, and poetry about poetry? Significantly, one of the ways in which Hegel attempts to explicate the movement of thought in the *Logic* is by the example of music, the form of art which does not depend upon representation.

Hegel links musical harmony to his notion of the 'concept'. For Hegel the 'concept' is that which includes the whole process of that 'of' which it is the concept: the process and the concept are not different. The concept 'tree' is not the empirical object I have in front of me, nor is it my thinking of a tree when I cannot see one. Instead, the concept includes all the stages of the tree that have preceded what I now might see (as well as what will succeed these stages), *and* their reflection in my and others' thinking. Without the process of thought the process of the object could never be revealed, indeed the object itself would never be a particular object. Seeing a tree 'as' a tree involves a consciousness that sets itself against its object. At the same time the thought without the object would have nothing to think about: what would it be thought of? The concept obviously cannot be thought by an individual subject all at once, but for Hegel it is required if the concept is to be 'of' the object: hence his rejection of the immediate as a locus of truth, and his requirement that thinking be speculative. Whether this could apply to thinking of oneself remains, of course, a problem. How, though, does Hegel link his view of the concept to music?

Hegel's argument refers to diatonic music: music in a specific key, which, though it may leave this key, will return to it. In the section of the *Logic* on 'elective affinities' (where he links music and chemistry) music is an analogy for the whole method:

> the single note [like the empirical phenomenon] has its sense only in the . . . connection with another note and with the sequence of other notes . . . The single note is the tonic of a system but just as much again a member in the system of every other tonic (*L* I p. 421).

The note 'C' only becomes C by its negative relation to other notes in the key system: it is not B or D. C can be the tonic but it can as easily be the dominant of F or the subdominant of G. Hegel sees an analogy of this to the way in which elements such as carbon or hydrogen are combined in compounds. It is also analogous to the way a differential view of language thinks of the signifier. In this interpretation music is a reflexive structure: each aspect becomes what it is by being the other of itself.

In the *Aesthetics* Hegel links the 'concept' to the major triad, the basic

unit of consonance in diatonic music (e.g. the chord CEG). The triad expresses the

> concept of harmony in its simplest form, indeed [it expresses] the very nature of the concept. For we have a totality of different notes before us which shows this difference just as much as undisturbed unity (*Ä* II p. 296).

The unity of the differing notes is higher than the single note's existence by itself. Just repeating C would be like saying 'Hari Krishna', adding E and G combines difference and identity to make something deeper. The significance of diatonic music is, though, not only a result of consonance, in the same way as advance in the sciences is not based on agreement. Hegel sees musical dissonance of the kind introduced by the dominant seventh (B flat in the key of C) as creating tension that must be resolved, and he links this to the argument of the *Logic*.

It is worth quoting the passage at length. Dissonance

> constitutes the real depth of notes [*Tönen*] in that it also progresses to essential oppositions and is not afraid of their severity and disunity. For the true concept is admittedly unity in itself but this subjectivity negates [Hegel uses the verb *aufheben* with its triple meaning of negation, preservation and raising up] itself as ideal transparent unity into its opposite, into objectivity, indeed it is as the simply ideal itself only a one-sidedness and particularity . . . and only truly subjectivity when it goes into this opposition and overcomes and dissolves it (*A* II p. 297).

The next stage, then, has to be the resolution of dissonance: 'Only this movement, as the return of identity to itself, is the Truth' (loc.cit.). There is no difference here between music and the overall movement of the *Logic*. A sonata movement that begins in a particular key (the example of Beethoven fits ideally here, though Hegel does not refer to it) moves away from this key and thereby creates tension and dissonance. When the sonata returns to its initial tonality after moving into other keys the initial tonality has been deepened in a way that repeating one note or the major triad could never achieve.

The *Logic* expresses the same idea for philosophy: ultimately thought and its object are in harmony, but this can only be revealed by the process of their opposition and reconciliation. In the same way as all the notes of the chromatic scale are likely to appear in a classical symphony at some point, and at the end become part of the path to the re-establishing of the tonic key, the divisions involved in conceptual thinking are integrated into the teleology of the Idea, a sort of ultimate

harmonic resolution. The power of this conception can be experienced in a symphony like Bruckner's Eighth, where the sheer length and complexity of the path to the final resolution make that resolution into the major tonic key so overwhelming. In such a conclusion all the preceding tension becomes retrospectively oriented to its goal, the resolution into the tonic key. The beginning and the end require each other, as they do in the *Logic*.

The 'symphony' of the *Logic* culminates like this:

> The *identity* of the Idea with itself is one with the *process* [of differentiation]; the thought which frees reality [*Wirklichkeit* in the sense of what is at hand] from the appearance of purposeless changeability and transfigures it into the Idea, must not imagine this truth of reality as dead tranquillity, as just an *image*, dull without drive or movement . . . the Idea, for the sake of freedom which the concept achieves in it, also contains the *hardest contradiction* in itself; its tranquillity consists in the sureness and certainty with which it eternally creates contradiction and eternally overcomes it (*L* II p. 467–8).

A theme emerges, disappears, reappears in changed form, and is finally made part of a wider movement, which ends in a way that the varying themes, which contrasted and replaced each other, are seen as inherently belonging together. A symphony does this, though, for a listener who hears the elements and feels their effect as a coherent unity. Who the 'listener' is in the *Logic* is unclear. Schelling says that the Idea at the end of the *Logic* is: 'subject and object, conscious of itself, as the ideal and the real, which thus has no need any more to become real any more and in any other way than it already is' (I/10 p. 152/569), reinforcing the sense that the *Logic* is self-contained like a symphony, which needs to represent no more than itself.

The Idea seems to move in the manner of an organically integrated piece of music. Schelling, though, questions why, in that case, the Idea needs to prove itself by, as Hegel puts it, 'releasing itself as nature' from itself:

> But for whom should the Idea prove itself? For itself? But it is that which is certain of itself . . . and knows in advance that it will not be destroyed in being other; for the Idea this struggle would be completely pointless. Should it, then, prove itself for a Third, for a spectator? But where is the spectator? (I/10 p. 153/569)

The essential problem is that, in its desire to avoid a presupposition, the *Logic* thinks it can even make its own foundation, Being, into part of itself. It does so by the argument that Being is as nothing until it has

become part of the process of mediation. Schelling again makes the problem clear:

> in Hegel's philosophy the beginning relates to what follows as a simple nothing, as a lack, an emptiness, which is filled and is admittedly felt as emptiness, but there is in this as little to overcome as there is in filling an empty vessel; it all happens quite peacefully – there is no opposition between Being and Nothing, they don't do anything to each other (I/10 p. 137/553).

The tensions and contradictions of reality which philosophy tries to comprehend seem in Hegel already to have within them their resolution because they are in thought, and, as such, follow the necessities of the infinite movement of thought. Again, the parallel to music helps to grasp the issue: the dissonance in a symphony already has the telos of its resolution within it, as does the division of Being and Nothing. Hegel's recourse to music as part of the attempt to represent the movement of the *Logic* can be seen as pointing to the crucial weakness of Hegel's philosophy. Hegel takes a medium, music, which allows reconciliation in the realm of appearance, of art, in order to explicate a supposed reconciliation in Being itself. The medium of music does not say, however, what this resolution is: it is not a positive representation of a resolution in reality. This fact will be a major root of music's significance for aesthetics from this period onwards.[9] Hegel's conception of art does not allow him to understand why this might be.

Hegel sees music, like other art forms, as only part of the prelude to the fully transparent and articulated concept of philosophy. Because music is 'completely abstract' (*A* II p. 261) it is only a stage in the realisation of the Absolute and is a lower form of art than representational forms like drama. Implicit in this is the conviction that Being can become transparent to itself via its conceptual articulation, as suggested in the *Logic*. Seen this way philosophy would be able to give the truest account of what music is. Each step of musical change has entailed a reformulation of the canon of the acceptable. Hegel has no problem accounting for the dynamics of such a process. The revisions of the theory of harmony, for instance, would in Hegel's terms be inherent in the 'concept' of harmony that is revealed at the end as the Idea of harmony. Seen in this way, each radical turn away from the canon is presupposed in the Idea that emerges at the end of the process, which philosophy articulates.

The problem is, crudely, that this puts theory before practice, or, if you like, thought before existence, in order to grasp the whole of the

phenomenon in question conceptually. It does not account for that which brings about the innovation, which is just subsumed into its articulation in theory. Nor does it account for the importance of a medium which does not *per se* represent conceptual ideas, but which is not devoid of meaning. Hegel sees music as limited to 'subjective inwardness': as I shall show in Chapter 7, this fails to exhaust the significance of music as a way of grasping modern self-consciousness. The failure in relation to music parallels Hegel's more general problems with theorising self-consciousness, and thus with his aesthetic theory.

Language, consciousness and Being

Aesthetic innovation in modernity is inseparable from individual self-consciousness. The question of language and the question of subjectivity are inseparable. Hegel himself sees language as the 'existence (*Dasein*) of *Geist*' in the *Phenomenology* (P p. 478). In the *Encyclopedia* Hegel says of language:

> Because *language* is the product [*Werk*] of thought nothing can be said in it which is not general. What I only *mean* is *mine*, belongs to me as this particular individual; but if language only expresses the general I cannot say what I *mean*. And the *Unsayable*, emotion, feeling [i.e. that which is particular to me *qua* individual] is not the most excellent, the most true but rather the most insignificant, most untrue . . . if I say 'I' I mean myself as this person that excludes all others; but what I say, i.e. I, is what everyone is; I that excludes all others (*E* p. 56).

In one sense this is like a Wittgensteinian argument that there cannot be a private language. The structure of the identity of opposites appears again: the 'sign', 'signifier' 'I' can only gain its significance via its general application, but it is thereby able to designate my particular I. The problems of reflection theory recur as well, though: Hegel's disqualification of 'feeling', the 'Unsayable', is dependent upon the assumption that what consciousness *is* is explicable via the general structure of its reflection in the other. Thought is only really thought via its reflection and explication in the general medium of language.

Hegel, though, actually presupposes an identity which can only be postulated, not demonstrated. The generality of the sign, our using the same word to designate anything, particularly ourselves, is no ontological guarantee that this identity can be known. As Sartre puts it: 'my relationship to the other is initially and fundamentally a relation of being

to being, not of cognition to cognition'[10] (*EN* p. 289). My reflection in the signifier 'I' would only lead to infinite regression – I see myself in the word I, but, as we saw in relation to Novalis, the I doing the seeing needs some way of already knowing itself, and the signifier is only a schematic way of identifying to the other that which resists representation.

The significance of the idea of 'intellectual intuition' lay in its questioning of the reflection model by asking whether consciousness is explicable via its reflection in another, whether this is itself, another consciousness, or language. 'Intellectual intuition' was a notion of consciousness that could not be reduced to an I reflecting itself in a not-I, in order to be what it is. In 'intellectual intuition' the thinking and the thought are *immediately* the same. The real problem with intellectual intuition is that the concept still involves a duality, in which the intellect immediately intuits an other as itself. This is not the intention of the term. The intention is to escape a model in which subjectivity is regarded as an object, and thus as reducible to its concept. Manfred Frank argues:

> If self-consciousness cannot be characterised by the as-structure then it may no longer be described as conceptual knowledge (every concept relates indirectly – by virtue of an attribute which is common to many objects – to a content of thinking).[11]

Intellectual intuition, or what term for self-consciousness it is replaced by in order to avoid the duality, is supposed to be the condition of reflection, and is therefore prior to it. Hegel would see this as saying 'Hari Krishna': the truth of consciousness for Hegel is its articulation in the concept, not the moment of immediacy.

The most accessible account of the main problem in Hegel is Sartre's, although Sartre's argument has more antecedents than he was aware of. Sartre questions the cognitive model of consciousness: 'we have to abandon the primacy of cognition if we wish to found this cognition itself'; consciousness 'is, in itself, something other than a cognition turned back on itself' (*EN* p. 17), or reflected in another consciousness. Reflection gives rise to the regress seen in the preceding chapters: how does consciousness know it is seeing itself? Consciousness must in some way be 'pre-reflexive', there before it reflects itself.

Sartre explains this by the example of pleasure. My consciousness of pleasure, aesthetic pleasure in relation to a symphony, for example, cannot be separated from the pleasure itself. 'Pleasure cannot exist before consciousness of pleasure', *nor* should pleasure 'disappear

behind the consciousness it has (of) itself'. Sartre brackets 'of' because it suggests a division which he wishes to question; he also brackets 'of' in consciousness (of) oneself: the self and consciousness cannot be separated in the manner of thinking about an object. Pleasure 'is not a representation, it is a concrete, full and absolute event . . . The pleasure is the being of the consciousness (of) itself and the consciousness (of) itself is the law of being of pleasure' (*EN* p. 21). The development of the *concept* of pleasure which, as Hegel suggests, comes about by opposing it to its other, has as its precondition the *existence* of pleasure, which is not *reducible* to its subsequent conceptualisation, be it in Hegelian, Freudian, or any other terms. The same applies to consciousness: 'the very *being* of consciousness, being independent of cognition, pre-exists its *truth* . . . consciousness *was there* before being known' (*EN* p. 284).

In Hegel's argument the truth of consciousness emerges via its reflection in a universal structure which it shares with others and constitutes at the same time. My or your consciousness is formed in social interaction, in a totality within which it is ultimately subsumed. Because I need your consciousness to realise my own, the truth of consciousness is part of the universal structure which negates individual subjectivity, though it realises itself through it. Consciousness is thus implicitly already part of a whole which our common capacity for thought can reveal. Schelling's critique of Hegel in the Munich lectures reveals the problem in this in a way which demonstrably influenced Feuerbach, and thus also Marx's later critique of Hegel.

We have already seen Schelling's objection to Hegel's equation of Being and Nothing, in which '*Pure Being and Pure Nothing are . . . the same*' (*LI* p. 83). Schelling and Feuerbach have no objections to the abstract moves in thought made in the *Logic*: they recognise what a remarkable methodological achievement the *Logic* is. They want to insist, though, that the moves are *in thought*. Hegel, Schelling claims, tries to dissolve Being into its concept, however:

> Concepts as such in fact exist nowhere but in consciousness, they *are*, therefore, taken objectively, *after* nature, not *before* it; Hegel took them from their natural position by putting them at the beginning of philosophy. There he places the most abstract concepts first, becoming, existence etc.; but abstractions cannot of course be there, be taken for realities, before that from which they are abstracted; becoming cannot be there before something becomes, existence not before something exists (I/10 p. 141/557).

This parallels Novalis' insistence on the need to correct the inversion

which is the result of reflection being put first in philosophy. Feuerbach's and Marx's remarks on the need to stand Hegel on his feet derive from this. Feuerbach says of the beginning of the *Logic* in his critique of Hegel: 'Being in abstracto, Being *without* objectivity, *without* reality, *without* Being for itself is admittedly Nothing, but in *this Nothing I only express the nullity of my own abstraction.*'[12]

In the *Philosophy of Revelation* (*PO* p. 126)[13] of 1841–2 Schelling sees Hegel as providing the 'negative philosophy', which contains all the a priori possible moves of thinking. Why these moves should have any reality cannot be explained by such a philosophy. The 'positive philosophy' begins with 'unprethinkable Being' (*das unvordenkliche Sein*) (*PO* p. 161), which is the 'Not-Not to be thought' (*PO* p. 126), the ground of conceptual thinking which necessarily precedes it: 'What is the beginning of all thought is not yet thinking' (*PO* p. 161). To the objection that we could have no way of thinking this, Schelling replies that unprethinkable Being has been overcome by the free action of consciousness: thinking it therefore involves the renunciation of conceptual thinking: '*The blindly existing is that* which suppresses everything which derives from the concept, *before which thinking goes silent*' (*PO* p. 157). If 'necessary existence could be deduced from a concept which precedes it, then necessary existence would itself be renounced thereby' (*PO* p. 158) because the concept's existence would be the necessary existence, and one could remain, as Hegel does, in the realm of thought. This would again fail to explain why the Idea should become involved in nature. Schelling rejects Hegel's ontological proof that, because we have the concept of Being, the fact of Being must be articulable in the concept.

For Schelling the fact that this Being ceases to be simply opaque to itself can only be understood after the contingent fact of its ceasing to be opaque, which has always already happened when we reflect on it. It cannot be deduced from a necessary preceding Idea. If thinking is inseparable from freedom it cannot come about necessarily as part of an overall process of Reason. The *PO*, which, despite its ultimately Christian arguments, prefigures existential philosophy, refuses to accept an immanence of Reason, seeing the primary Being as contingent (*PO* p. 169). As such, thought can never catch up with its own origin: the logos is always subsequent to its basis. Freedom becomes a matter of open choice, not the development of something already inherent in Being that is revealed in the concept. In a formulation which is echoed by the late Foucault's contention that 'The transformation of one's self by one's knowledge is ... something rather close to the aesthetic

experience',[14] Schelling maintains that '*Freeing oneself from oneself* is the task of all Bildung' (*PO* p. 170). The task is not becoming what one already inherently is. One means of achieving this is aesthetic productivity, which retains a contingent individuality which can never be fully theorised if it is to sustain itself as free productivity.

Hegel assumes the primacy of the conceptualisation of an object of thought: the truth of the object emerges in the process of its interaction with the subject (and vice versa). Once this truth is revealed it gives us the essence of the object. As was already suggested, the problem in Hegel's aesthetic theory is the assumption that the truth of a work of art emerges completely via its conceptual articulation. The assumption is that the truth is always already there when I interpret a literary text for example. All I have to do is to reveal the mediations that are present in the text. This means that my role as interpreter is just to read what is supposedly latent in the text, not to reveal things about the text via my individual creative initiative. Hartmut Scheible sees Hegel's achievement as making possible the conceptual analysis of the historical development of art as part of the overall development of thinking. The price for this historicisation of the truth of art is that 'with the turn towards an aesthetics of conceptually fixed content the individual subject ceases to play a role in the constitution of aesthetic truth'.[15] Art becomes comprehensible to an unprecedented extent, and becomes subsumable within the wider truth of philosophy, thereby ceasing to be a significant means for the articulation of truth. The result is, though, both a reduction of the semantic potential of art and the repression of the subject's individuality. In the next chapter I shall show how Schleiermacher offers ways of resisting this repression.

The reasons for questioning Hegel's position can be shown by the following example. In *The Man Who Mistook His Wife For a Hat* Oliver Sacks describes the case of a patient he calls the 'autistic artist'. Sacks' patient moves from almost total non-communication to being able to articulate himself in drawings of natural objects which have a peculiar intensity. He does not learn to communicate linguistically. Sacks says of the autistic:

Lacking, or indisposed to, the general [they] seem to compose their world entirely of particulars. Thus they live, not in a universe, but in what William James called a 'multiverse', of innumerable, exact and passionately intense particulars. It is a mode of mind at the opposite extreme from the generalising, the scientific, but still 'real', equally real, in a quite different way.[16]

In Hegelian terms the truth of an autistic world is simply that of particularity which has not been transcended in order to reach its concept: it is caught in the particular via its lack of a means of general articulation. Sacks' point is that there are lessons to be learnt from his patient. The 'autistic artist' escapes dominant attitudes to the natural world which are increasingly the norm in the Western world; he does not, so to speak, 'subjectify Being'. He has an intensity of relation to the particular plant, animal, or whatever which 'normal' people lack, and becomes able to communicate this in images.

I do not wish to argue that mental pathologies are able to lead to profane revelation. However, if one accepts the fact that such pathologies are not just the unsolved problems of medical and social engineering, one must take seriously the reality that Sacks refers to, the reality of a self-consciousness which can never be wholly transcended into a universal structure. To take an example near to Hegel: artistic creation and mental pathology are often closely linked in the nineteenth century. Hölderlin – once Hegel's friend, and, as we saw, a philosopher of some considerable talent – eventually became mentally ill. Before reaching the stage of being unable to carry on writing poetry he produced poems which use language in a manner that still challenges us now.

Hölderlin's experience is characteristic of the most significant modern artists: they exhibit an almost unbearable tension between individual consciousness and the collectively acknowledged systems of signs in which that consciousness tries to articulate itself. Hegel's view of language, and of aesthetics, necessarily subordinates this tension to the truth of language as the general means of articulation.

Paradoxically, as anyone who has read much Hegel will be more than aware, Hegel's own relationship to language is hardly an illustration of his theoretical point: not the least fascination of Hegel's philosophy is the struggle for articulation carried on within the text. Furthermore, the fact that there is still no agreement about what Hegel really meant – I am sure some Hegelians will already be up in arms about my interpretation – suggests the complexity of the matter.

It is no coincidence that at this time other thinkers in Germany are increasingly concerned, as we saw Novalis was, with the 'Unsayable'. This has for too long been understood as though it were solely a mystical Romantic quirk. What seems so important about this other view is that it refuses to subsume the 'Unsayable' into a form of general articulation. The subject is not just regarded in terms of its transparence to the

general linguistic community, or, to cite the contemporary version of the same problem, in terms of its being an 'effect' of the textual mirror in which it reflects itself. Consciousness, as we have already seen in Schelling and the Romantics, is seen as having a ground which can never be fully transparent to itself. Thinking about these issues is linked to reflection on language, aesthetic theory, and to music. Hegel's attempt to resolve the inherent contradictions in the principle of subjectivity (its 'one-sidedness', as Habermas put it), and his announcing the end of art, coincide with the emergence of radical reflection upon language and a flowering of musical creativity that need further investigation. Whilst Hegel inaugurates vital dimensions of historical reflection upon aesthetics, he at the same time fails to understand how many of the issues he raises will undermine the rest of his philosophical project. Let us now turn to the *Aesthetics*.

The Idea as sensuous appearance

Hegel defines beauty as the 'sensuous *appearing* of the Idea' (*Ä* I p. 117). In the light of the arguments seen so far, qualifying beauty as the 'sensuous' appearing of the Idea puts beauty into a subordinate position. Beauty's reliance on the sensuous means that it is contaminated with the transient. As we saw, the Absolute was the non-transient revelation of transience: knowing that everything specific ceases to be is a higher truth than determining what something specific is. One side of the argument on beauty is easy to understand if one thinks of Shakespeare's contemplation of the transience of (female) beauty in the sonnets. However much such beauty seems to point beyond its finite status, it is yet bound to fade and cease to be. For Hegel even art works, which are not subject to the same natural iron law of disappearance, are not able to sever all connection with the transient. Only the Idea, speculative philosophy in Hegel's sense, can do this.

Hegel is insistent that beauty in works of art has a higher status than natural beauty, thereby reversing Kant's priorities. Beauty depends upon the development of thought, not upon an immediate pleasurable contemplation of the natural world: 'natural beauty appears only as a reflex of beauty which belongs to *Geist*' (*Ä* I p. 14). 'Only' in this statement suggests the problem. Hegel's argument about the beauty of nature and the beauty of art suggests that if nature is mainly seen as a threat that must be overcome by *Geist* in the interests of self-preservation it cannot appear beautiful. Beauty is linked to subjective

control over nature, which allows thought to move beyond an immediate empirical relationship to nature. When the mountain is no longer just a danger it can become an object of contemplation that makes it more than brute resistant matter.

In *Aesthetic Theory* Adorno approvingly cites Verlaine's line 'la mer est plus belle que les cathédrales'[17] to suggest the complex dialectic involved in this issue in modernity, of which Hegel tends only to see one side. In order to be aware of the superior beauty of the sea one might first need cathedrals, but for Gothic cathedrals, for instance, one also needed the forms of trees. Adorno stresses the fact that natural beauty is a result of a non-instrumental relationship to nature, a result of contemplating nature as appearance: 'Like the experience of art, aesthetic experience of nature is an experience of images',[18] not of something concrete that is to be worked upon. This only becomes possible at a certain stage of the development of the capacity to control nature, in the eighteenth century, and is clearly also linked to the demise of the dogmatic theological view of the world, where beauty was a celebration of God's creation.

As we saw, Hegel does not equate appearance with illusion or deception: though it passes away it is also the 'reality and movement of the life of truth'. Thus, in the *Aesthetics*, Hegel states: 'Far from being simple appearance the appearances of art should be seen as possessing the higher reality and the truer existence in relation to normal reality' (*A* I p. 20). Unlike immediate empirical reality, which appears to common-sense to be the most obvious truth, but is actually only transient, artistic appearance 'points through itself to something spiritual [*Geistiges*]' (ibid.). A picture of a mountain involves a process of mediation which someone just contemplating the mountain would not go through: think of looking at a Caspar David Friedrich painting. However, even this dependence on the empirical means for Hegel that art is a lower manifestation of the Idea. It is the *sensuous* appearance of the Idea, which therefore must have non-sensuous ways of appearing. Any dependence upon particular intuitions (*Anschauung*) means for Hegel that the object has not come to itself via its 'concept', which has, as we saw, to include all the stages of the object, not just one particular aspect of the object at a particular moment in time.

In addition, Hegel makes the notorious point that art, because it is 'limited to a distinct content', no longer 'fulfils our highest need'. 'Thought and reflection have overtaken [*überflügelt* in the sense of 'flown over'] art' (*A* I p. 21). The arguments of the *Logic* about the need to

transcend the particular and the transient are thus linked to a historical assessment of art's relationship to philosophy. This failure of art to fulfil our highest need means that the higher truth belongs to other modes of reflection, culminating in Hegel's system. He is blunt about the matter:

> The constitution of reflection of our contemporary life makes it necessary, both in relation to the will and in relation to judgement, to establish general view-points and accordingly to regulate the particular, so that general forms, laws, duties, rights, maxims are valid as the bases of determination and are the principle rulers. . . . The *science* of art is thus in our time much more necessary than in times in which art for itself as art provided complete satisfaction (*Ä* I p. 21).

Aesthetic theory, therefore, emerges for Hegel at the time when aesthetic praxis is no longer vital to the articulation of truth.

This argument must itself be understood historically before one questions it. There is no doubt that the establishment of the modern cultural spheres of natural science and law depends on overcoming the particular and on setting up universal ways of thinking that can be applied to the particular case. The fight against feudalism and the arbitrary authority of the Church in the name of universal rights and scientific objectivity are inescapable necessities in modernity. Hegel's argument is worrying to the extent that *everything* is only of significance to the extent that it points beyond itself to a wider structure that is its truth. This was already the reason for the turn towards a philosophy of sensuous particularity for Baumgarten. If one shows that Hegel's argument is inadequate to the case of art, the consequences will affect all levels of his project. The question is one of meaning: Hegel only allows ultimate significance to socially and conceptually agreed general truths.

One does not have to concur with Schelling in the *STI* and suggest that art really is the expression of the Absolute. It is possible to show that Hegel's philosophy most clearly shows its weakness in relation to aesthetics without making any such claim. Let us take a central example from the *Aesthetics*, which is already familiar from the *PA*. Hegel frequently supports his arguments about the subordinate role of the aesthetic with the example of the superiority of Christianity over Pagan, particularly Greek, religion. Hegel is monotheistic. Greek art, which represents the Gods in human form, has as its content 'the unity of human and divine nature, a unity which precisely because it is *immediate* and *in itself* can be adequately manifested in an immediate and *sensuous* manner' (*Ä* I p. 86). The *knowledge* of the unity of human and divine,

which requires reflection, cannot for Hegel be present in a concrete object like a sculpture. We have already seen a version of the argument in Schelling. Classical art (by which Hegel usually means Greek sculpture) expresses a stage of the development of *Geist* where the sensuous and *Geist* are unified: the material is removed from its just being a block of marble and is formed by *Geist* into a sensuous representation of itself. The advance in Christianity is that God

> should be known as *Geist* and in Geist. His element of existence is thereby essentially inner knowledge and not the external natural form via which he will only be representable immediately and not according to the whole depth of his concept (*Ä* I p. 79).

This argument should also be familiar.

It is close to Kant's fascination with the ban on images in Jewish theology, in his account of the sublime's pointing to the limits of sensuous representation of the supersensuous. Kant does not articulate the highest principle of his philosophy. Hegel thinks his own philosophy has been able to articulate what Kant could not, and therefore does not need sensuous representation. He therefore renounces the idea of the 'new mythology' which would make ideas aesthetic. He also does not see art as articulating a lack that cannot be overcome, as the Romantics did. Interestingly, Freud was later to see this question in a similar way to Hegel. This convergence can be seen as demonstrating their mutual adherence to Heidegger's and Derrida's 'Western metaphysics', where thought reaches its highest principle by the elimination of sensuousness. It should already be clear, though, as was already apparent in Hamann and was evident in Schelling, that within the tradition there is a counter-movement, which does not rely on the elimination of the sensuous.

The origin of what Freud calls the 'Moses religion' is linked to the ban on images, whereby one is compelled to honour a God one cannot see. For Freud this meant a

> subordination of sensuous perception to an idea that is to be called abstract, a triumph of spirituality [*Geistigkeit*] over sensuality, strictly speaking a renunciation of a drive with its psychologically necessary consequences.[19]

The renunciation of a drive is, though, likely to give rise to neurosis, one of the primary forms of the return of the repressed. The philosophical history of subjectivity entails a history of repression, as we already saw in the way Schelling described the development of the 'I' in the *STI*. The question is what kind of repression this is.

This question is more complex than it looks in Freud. The constitution of the truth of subjectivity as *Geist* represses in more than one way. As has been recently pointed out by Genevieve Lloyd,[20] this triumph of spirituality is attached by Freud to a story which has patriarchal implications. The suppression of the sensuous results from the privileging of the father, whose invisible role in the production of children is given primacy over the visible role of the mother. To do this involves an abstract deduction that an act committed nine months before the appearance of the child is the vital act, hence Freud's interpretation. The same kind of story is told at the end of *Oresteia*. The achievements of *Geist* are at the expense of the female.

The repressions in the constitution of reason are underestimated by Hegel, which is one reason why he deals with the aesthetic in the way he does. Whilst Hegel is aware of the pain and contradiction involved in the advance of reason, it does not lead him to question the immanently teleological notion of reason which is implied in the development of *Geist*, which Schelling and others come to question. Freud is aware, particularly in *Civilisation and Its Discontents*, that reason is bought at a high price, even if he does not realise its links to the repressive history of patriarchy. Schelling and Freud are insistent upon the roots of our reflection in nature, whereas for Hegel, as Scheible puts it, 'the process of mediation of mind and nature . . . results in the carrying out of the claim to domination of mind over everything which is external to it'.[21] This domination requires the systematic elimination of the sensuous image, and the idea that all aesthetic awareness is ultimately just a prelude to something higher. There is not space to do justice to it here, but it is clear that a feminist account of aesthetics could provide important new insights into this question.

Hegel's account of the development of art relies on the progressive diminution of the significance of the sensuous. He sees three stages of the development of art: the Symbolic, the Classical, and the Romantic. In 'Symbolic' art the meaning of the work and the form used to express it are not essentially related. Hegel sees mythological stories about abstract themes like life and death as symbolic. *Geist* seeks to express abstract ideas via what can be observed in nature: the observation of how plants die and grow again the next year is used as a story to explain death and the continuation of life in general. In Hegel's terms this way of thinking always involves the disadvantage of beginning with the specific and the concrete – e.g. a particular story like the myth of Persephone – which is not adequate to express the general truth of *Geist*. The Sphinx

is for Hegel the 'Symbol of the Symbolic itself' (I p. 352): human *Geist* attempts to emerge from the animal realm but does not fully succeed, the animal body remains.

The animal body is linked to a female torso: Hegel's interpretation of this, like Freud's story of monotheism, omits a whole dimension of the history of patriarchy, in which the lower forms of mind are associated with the female, something which recurs in his view of Antigone. His very method of classifying the forms of art in a developmental history fails to take account of the way in which the *interpretation* of symbols is a process which can never be fully controlled. Symbols for Hegel retain something which is not clearly *articulated* (a word that constantly recurs in the *Aesthetics*), and must, as such, be transcended. As we will see in the next chapter, at the same time as Hegel is arguing this view of symbol, Schleiermacher is developing a view of hermeneutics which will undermine it by pointing to the ways in which interpretation can never be complete. For Schleiermacher the ability to transcend the particular into the general is never total because of the nature of language.

Hegel's next stage of art, the 'Classical', unites 'meaning and corporeality' (*Ä* I p. 418): 'only the externality of man is capable of revealing the spiritual in a sensuous manner' (*Ä* I p. 419). Hence Greek sculpture based on the human form is an expression of the Ideal, a point largely borrowed from Schelling's *PA*. The next stage, the 'Romantic', makes it clear just how much Hegel is indebted to Lutheran theology. The Romantic stage is founded in the idea of incarnation: God becomes flesh and thereby undergoes the pain of self-division. There is an echo here of the statement at the end of the *Logic*, that the already constituted Idea *'freely releases'* itself into nature (*L* II p. 573). In Christianity – which is what Hegel means by 'Romantic art' – this is expressed in the story of Christ's crucifixion, which is followed by God's return to himself in the resurrection and the ascension. Romantic art expresses this in a concrete story, thus still remaining at the level of the image.

The story, though, is dynamic in a way that Greek sculpture's 'noble simplicity and quiet greatness' (Winckelmann) in the face of pain and death is not. For Hegel Romantic art 'sublates', in the threefold sense of negation, preservation, and elevation, the divisions that Greek art only contemplates. This parallels the move from sense-certainty (contemplation) to self-consciousness (an active relation to self and other) in the *Phenomenology*. It can be argued that Hegel's philosophy is Protestant theology which has been raised above its residual attachment to the particular story, such as the incarnation and the crucifixion, in order to

reveal the universality it contains. The example of death in the *Aesthetics* tells us much about Hegel's philosophy.

In Romantic art death

> is only a dying off of the natural soul and of finite subjectivity, a dying off which only relates negatively to that which is itself negative, which sublates that which is vain [*das Nichtige* i.e. the transient] and thereby mediates the liberation of *Geist* from its finitude and division, as well as mediating the reconciliation of the subject with the Absolute (*A* I p. 504).

Whereas Greek art's external existence as an object reflected a view of life as the external existence of the body, and death was, correspondingly, simple negativity:

> In the Romantic world view death means negativity i.e. the negation of the negative, and therefore turns just as much into the affirmative, as the resurrection of *Geist* out of its simple naturalness and inappropriate finitude (ibid.).

In the same way as Hegel's philosophy is constant change, so this kind of theology suggests that death is the life of *Geist*. The philosophy and the theology are not far apart.

It is not that interesting to show how far Hegel's philosophy still relies upon Protestant theology. It is more interesting to see how such thinking is in complicity with some of the problematic aspects of modernity that we have suggested earlier. This complicity becomes apparent when Hegel explains why art must become subordinate to philosophy. One side of this should be already clear: the arguments of the *Aesthetics* involve the same attitude towards sensuous existence as did those of the *Logic*: it is only the overcoming of the sensuous that is its truth.

Hegel relates this argument to the historical issue of aesthetic theory, when discussing the end of art. For Hegel, Classical art's combination of the spiritual and the natural is the 'completion of the realm of beauty. There cannot be anything, and nothing can become, more beautiful' (*A* I p. 498). As such, in Romantic art 'beauty in its most appropriate form and its most apt content is no longer the ultimate aim' (*A* I p. 499). Instead of trying to reflect the truth externally Romantic art realises that the truth of thought is independent of contingency, physicality, and externality. In that case it does not really matter which external content is used in such art: even the most prosaic objects of daily life can be used because the truth does not depend on them. Hegel also refers to music in this context. Music's content is not specific and it is, as such, the 'key

note' of Romanticism. Its task is 'not to echo objectivity itself [i.e. represent external objects], but rather to echo the way in which the inner self is moved in itself according to its subjectivity and inner soul [i.e. reflect feelings]' (*Ä* II p. 261). Music does not engage with objectivity in the manner that conceptual thought does. This will be the basis of his linking music to Romantic irony, which he regards as an avoidance of serious engagement with objective social reality.

Hegel points to the need for something which is beyond art:

> we get as the final point of the Romantic per se the randomness of the external and the internal and a falling apart of these two sides, via which art negates itself [*sich aufhebt*] and shows the necessity for consciousness to appropriate higher forms for the grasping of truth than art is able to offer (*Ä* I p. 509).

The higher forms are evidently those of philosophy. Instead of being concerned with the actual results of the Idea's move into the pain and division of natural existence, philosophy's task is to show how this form of the existence of the Idea can be transcended. What, then, does this imply for the theory of art? The art form that most evidently relates to Hegel's account of why Romantic art 'negates itself' is the novel, that form which, as Bakhtin will suggest, can encompass all other literary forms, which therefore is able to incorporate any aspect of transient existence.

The prose of the modern world

It is no coincidence that there is little sustained discussion of the novel in the *Aesthetics*. There is something bizarre about Hegel's argument. In the period where philosophy reaches the stage where the Absolute, the reconciliation of our thinking and the world, can be explicated, reality, daily life, has become 'prosaic'. For Hegel the novel 'in the modern sense presupposes a reality which has been sorted out into *prose*' (*Ä* II p. 452). The novel, in a typical Hegelian reversal, becomes concerned with how the 'poetry' of life – usually in the form of an idealistic hero – attempts to reassert its rights against the prose of daily existence. For Hegel this can end tragically or comically. The hero may founder on the contradiction of his ideals with the reality in which he tries to realise them, or he may, as often in Goethe, become reconciled with the social order by insight into its necessities. As an empirical point about the novel of Hegel's time this is very apt. What is so odd, and is not just

explicable via Hegel's evident conservatism in his later years, is why he is happy to juxtapose the highest reconciliation in philosophy with his view that life in bourgeois society has become wholly prosaic.

A notorious passage on what Hegel refers to as the 'novelistic' – that clash of novel hero and reality paradigmatically present in the figure of Don Quixote – demonstrates the oddity of Hegel's view. Hegel considers the hero who confronts the world with his ideals: 'These battles are, in the modern world, nothing but the years of apprenticeship' – he uses the word *Lehrjahre*, echoing Goethe's *Wilhelm Meister* – they are 'the education of the individual via existing reality and they gain their meaning thereby'. The resultant education of the hero leads to the following:

> finally he usually does get his girl and some job or other, marries and becomes a Philistine like all the others; the wife runs the household, children inevitably arrive, the adored woman who initially was the Only one, the Angel, looks roughly like everyone else, the job involves work and unpleasantness, the marriage the burden of domestic life, and so it is that one ends up with the hangover that everyone else has (*A* I p. 568).

The passage is by the author of the most impressively consistent metaphysics of the modern era: how does Hegel reconcile its resigned cynicism with the claims of his system?

The passage makes sense in relation to Hegel's arguments about the priority of the universal concept over the contingencies of individual thinking. By putting the dialectic of recognition, which by now increasingly takes the form of accommodation to the necessities of bourgeois society, before individual productivity, Hegel undermines any attempt to show how social change is *motivated*. Motivation is subsumed into the wider structure of 'objective spirit', the realisation of how individual thinking can only come to its truth via its being collectively recognised in a particular socio-historical context. Theory once again triumphs over praxis.

This is apparent in the following passage from the conclusion of the *Philosophy of History*:

> for world history is nothing but the development of the concept of freedom. But objective freedom, the laws of real freedom demand the subordination of the contingent will, for the contingent will is formal. If the objective is reasonable in itself, then insight into this reason must be based on this, and then the essential moment of subjective freedom is also present . . . Philosophy moves to contemplation through its antipathy to the movements of

direct passions in reality . . . Only the realisation that what has happened and happens daily not only does not happen without God but is also essentially His own work can reconcile *Geist* with world history and reality.[22]

Philosophy makes Romantic art redundant: it transcends the ethereal and contingent data of everyday life – the 'direct passions' – which have now become part of art in the novel. Hegel's judgement that the novel, in common with all art, is therefore a form of *Geist* which no longer fulfils our highest need, and will become redundant in the face of philosophy, has most recently been rejected in Rorty's contention that philosophy should become a kind of literature. More obviously, the view is contradicted by the stubborn refusal of the novel to disappear from the repertoire of means we use to make sense of the modern world. It is worth looking briefly ahead to an influential later view of the novel to suggest why Hegel's view is so questionable.

In his *Theory of the Novel*, written in the face of the outbreak of the First World War, Georg Lukács works at times with Hegelian arguments. He also, though, has assimilated key aspects of Romantic thinking, and of Kierkegaard. In consequence, he completely changes the interpretation of the way in which modern reality has become 'prosaic'. For Lukács the prosaic development of reality and the individual's resultant sense of alienation, graphically expressed by Hegel in the passage on the novel's hero, become the main problem. The novel becomes the expression of 'transcendental homelessness', the locus of the search for meaning in a post-theological culture. The search for meaning in a world where the significance of individual existence is subordinated to the progress of the general is not passed over, as it is in Hegel, as a necessity which can be coped with by philosophical insight into how it could never be otherwise. The First World War, of course, made this a little difficult.

The dominant idea of Lukács' book is the Romantic realisation that the subject can never achieve that absolute self-coincidence Hegel sees as expressed in philosophy. 'Irony', the central term in Lukács' theory, which he borrows from Friedrich Schlegel, is the expression of the ultimate failure of subjectivity to find a truth which would make it at home in the world. It is the subject's failure to coincide with itself within a wider totality that is *constitutive* of the novel form. This argument has evident links to the idea in Schelling's *PA* that in the modern era 'Poesie' is 'only possible for he who can create for himself a mythology, a closed circle of "Poesie" out of his very limitations' (I/5 p. 444/27). It also

involves the Romantic realisation of the failure of the reflection model of subjectivity: the subject continually fails to grasp itself in the mirror of the subjective and the objective world. Instead, then, of the work of art being transcended into something higher, it becomes a reminder of how subjects can never attain a total sense of their place in the world.

Aesthetics and non-identity

Adorno claims in *Aesthetic Theory* that:

> Hegel's philosophy fails in relation to the beautiful: because he equates reason and reality . . . he hypostasises the structuring of all being by subjectivity as the Absolute. He regards the non-identical solely as a fetter on subjectivity, instead of determining the experience of non-identity as the telos of the aesthetic subject, as its emancipation.[23]

Adorno's concern is with the repressions that are inseparable from the constitution of subjectivity in modernity, which he sees as being revealed, and transcended, but only on the level of appearance, in art. Hegel's philosophy, which Adorno regards as the paradigmatic philosophy of modernity, fails to express that aspect of subjectivity which resists being subsumed into generality, such as the irreducibility of pain or loss for the individual suffering it. This has roots in the Romantic idea that art should 'represent the unrepresentable', being always inherently incomplete, but therefore able to point to what completion would be by the sense of lack it engenders. The 'non-identical' might sound rather like Derrida's *différance*. Derrida does talk about the violence inherent in the reduction of difference to identity, but he reverses the problem Adorno sees in Hegel by making subjectivity an effect of its indefinable other, language. If what is having the violence done to it, the subject, is constituted as itself by its necessary other, language, it becomes hard to say what is suffering the violence.[24] The problem of reflection theory recurs even here: what suffers must already have some form of existence prior to its being violated by its other.

Adorno's objection to Hegel's philosophy is connected with the problems inherent in the philosophy of reflection, although Adorno does not always escape these problems himself. Hegel presupposes that the model of mind's 'being with itself in the other' means that thought and its other are identical. For Adorno this leads to the danger of assuming that the way the world is conceptualised at any time is ultimately self-legitimating, because it always already involves the union of

the subject and the object. For Adorno there can be no such legiti-
mation. This again brings him close to Derrida, whose philosophy *is*
important for the way in which it has reminded us of the dangers of
'identity thinking', albeit from a position which cannot itself ultimately
be sustained. For Hegel the way a period conceptualises the world is
eventually validated by its being part of *Geist*'s immanent recognition of
itself.

Adorno's attention to the 'non-identical' which cannot be subsumed
into the wider truth of *Geist* stems also from his conviction, derived from
Marx and Max Weber, that the modern world is characterised by
rationalisation of all spheres of social life. The process of rationalisation
functions much as Hegel's philosophy can be seen as functioning: it only
admits the particular to the extent that the particular can be made to fit
the general. This has important and not always negative implications in
the development of legal systems and in the natural sciences, and even
on the level of the exchange process. This is combined, though, with
growing problems regarding the meaning of these developments.

The sphere of meaning production itself becomes administered in the
form of what Adorno and Horkheimer term the 'culture industry', which
might be regarded as the perverted form the 'new mythology' takes in
administered capitalism. Adorno sees the side of Hegel's philosophy
which subsumes the particular as prefiguring the way the modern world
has become dominated by general systems of rationalisation.
Rationalisation does not lead to the realisation of freedom which Kant
and German Idealism saw as the task of Reason. The Understanding
comes to function as the machine that the Idealists were afraid of: it does
not become part of the more important task of Reason. This leads to
Adorno's insistence on that which cannot be rationalised away – the
non-identical – as the locus of emancipation. Adorno does not renounce
reason. Instead he insists on the awareness of the repressions involved in
what reason has been so far.

It is important to remember that the aim of Hegel's philosophy is
largely the Idealist aim. Habermas gives a useful reminder of the
historical significance of what Hegel was trying to do: for Hegel the
'unification of *single* individuals with their *particular* community in the
horizon of a *general* cosmic order which myth achieves should be repro-
duced by philosophy'.[25] The advance on a mythological order is that the
legitimation of that order has to be rationally demonstrated. The
development of modern art can, though, be seen as an indication of why
philosophy is unable to perform the role of meaning creation that

mythology performed in earlier societies. Schelling's remarks on the need to create a closed circle of mythology hint at this, as do some of the Romantic conceptions of art. It does seem that the most significant aesthetic production in modernity – Kafka, Proust, Schönberg, Charlie Parker – is resistant to being integrated into the dominant ways in which the society where it originated makes sense of things. The hopes for a new aesthetic mythology do not materialise. The modern art that we still engage with is important precisely because of its resistance to generality. Its meaning is not exhausted by analysis, its being assimilated to a general viewpoint, and it has a coherence which is not that of a coherent argument. Such art may not fulfil our highest need: it does seem clear, though, that it can suggest why Hegel's philosophy could not do so either.

Repeatedly, in considering the role of aesthetics in modern philosophy, it has become apparent that the links between art and sensuous particularity also point towards issues in language which are central for both analytical and recent continental philosophy. It is to the issue of language and aesthetic theory that I shall now turn. Schleiermacher can, in this perspective, be seen as offering viable methodological alternatives to many of the untenable arguments, both of Hegel, and of post-structuralism.

6

Schleiermacher:
aesthetics and hermeneutics

Individuality

The work of F. D. E. Schleiermacher (1768–1834) on aesthetics and
hermeneutics raises questions concerning language which are too often
regarded as originating in Wittgensteinian and post-Wittgensteinian
philosophy, or as being the preserve of post-structuralism. Schleier-
macher's work is also closely related to the main concerns of contem-
porary literary theory. Though his roots are in the Idealist tradition – his
early work owes much to Schelling – his attention to language leads him
to insights that transcend the Idealist framework. Schleiermacher's
philosophy is notable for the way it does not give the dominant role to
scientific cognition or to a totalising dialectic. Its key arguments seem,
though, to have been either ignored or misunderstood until very
recently. It should become evident from what I say, for example, that the
account of Schleiermacher given by Gadamer in *Truth and Method*
needs radical revision. The resources offered by some aspects of
Romantic philosophy have still to be properly understood. In looking at
Schleiermacher I shall not be dealing with his theology, impressive
though it often is, because most of his philosophy can stand without the
theology.

Schleiermacher is one of the first philosophers to take the 'linguistic
turn'. Whilst Kant sees the 'conditions of possibility' of knowledge as
being the necessary categorial operations of our consciousness,
Schleiermacher sees these conditions as dependent on language. This
view had already been suggested by Hamann as early as 1784, in his
critique of Kant, the 'Metacritique on the Purism of Reason'. Hamann
suspects Kant's separation of the sensuous and the conceptual. He
maintains in his own inimitable manner that our need for language in
order to communicate rationally necessarily entails more elements than

an abstract notion of reason will countenance.

Hamann's argument is worth quoting at length, because its baroque form is also part of its content:

> So another main question remains: *how the capacity of thinking is possible?* – The capacity to think *right* and *left before* and *without, with* and *beyond* experience? One needs no deduction to prove the genealogical priority of *language* before the *seven* holy functions of logical propositions and conclusions and their heraldry . . . the whole capacity to think depends on language . . . *Sounds* and *letters* are therefore a priori forms in which nothing which belongs to the sensation or to the concept is met and are the true aesthetic [in the sense of having to do with sensation] elements of all human cognition and reason . . . Words therefore have an *aesthetic* and *logical* capacity. As visible and audible objects they belong with their elements to *sensuousness* and *intuition*, but in terms of the spirit of their *employment* and their *meaning* they belong to the *understanding* and to *concepts*. Consequently words are both pure and empirical *intuitions* as well as pure and empirical *concepts*: *empirical* because the sensation of sight or sound is affected by them, *pure* in so far as their significance is not determined by anything which belongs to those sensations . . . Meaning and its determination results . . . from the linking of a sign [*Wortzeichen*], which is a priori arbitrary and indifferent, but a posteriori necessary and indispensable, with the intuition of the object itself, and via this repeated connection the concept itself is communicated to, impressed and embodied into the understanding as much by the sign as by the intuition itself.[1]

Language therefore 'deconstructs' the opposition of the empirical and the a priori because it is both sensuous and intelligible. Hamann also deconstructs the opposition of spoken and written language, refusing to give priority to the voice over script in the process of signification. As we saw, he arrives at this position through a desire to celebrate difference as the endless articulation of the diversity of God's universe. God gives him the moment of identity, which makes difference significant, and which his post-structuralist heirs wrongly think they can do without.

The important consequence in Hamann is that a notion of reason which escapes from its location within a historically specific language becomes impossible. This does not mean that reason becomes impossible: it means that it cannot make absolute claims. This argument will be one of the main foundations of modern hermeneutics. For Hamann the idea of a 'general philosophical language' is an idealist illusion. A language is necessarily bound to the contingencies of its particular historical development and this should not just be seen as a problem, in

that it broadens the scope of the possibilities of articulating the world. Schelling's point about the extent to which thinking entails a level of 'intuition' which is inherent in language, and which links language to aesthetics, echoed this. Ideas which result from Hamann's prophetic reflections are systematically developed by Schleiermacher.

The most obvious fact about Schleiermacher's work is the extent to which it has been misinterpreted by subsequent thinkers: an ironic fate for one of the greatest theorists of interpretation. As Manfred Frank has shown[2] – and my account owes much to his – Schleiermacher's arguments are actually often more convincing than many of the shibboleths of contemporary philosophy. Schleiermacher is at heart an Aristotelian, and his thinking is often remarkably close to that other great Aristotelian, Marx. He begins his *Aesthetics*, for example, by insisting that 'praxis has always been something earlier than theory'[3] (*A* p. 1). Schleiermacher wants to suggest that 'individuality' is a part of all philosophy, and thus of any cognitive, ethical, or aesthetic praxis. What he means by this can be understood by looking at his *Dialectic*. Somewhat surprisingly, given Schleiermacher's status as a Protestant theologian, the nearest equivalent of the *Dialectic*'s most significant arguments can be found in some Marxist thinkers, such as Bakhtin, and in Sartre.

Schleiermacher's key moves are best understood in relation to Hegel. As we saw, Hegel's system finds the Absolute through the recognition of why philosophy and science constantly change. Hegel's *Logic* is based on contradiction and process. Once the transience of systems of thought becomes apparent it becomes possible to unite the differences of the various systems in the process of the Absolute. The *Logic* is thus an account of thought's reflection upon itself, a self-contained science of knowledge as change, which can articulate itself: hence the idea that it is analogous to a symphony. Disagreement in this system is ultimately revealed to be part of a higher agreement, because disagreement is the very condition of agreement. Everything particular is only particular via its mediation by the general. This dependence on the other means that nothing can stand on its own as irreducibly particular. It must come to itself via the concept, which articulates its truth. For this reason art, which is tied to sensuous particularity, is a lower form of spirit than philosophy.

Schleiermacher is suspicious of the assumption that there can be total or final agreement. In the *Aesthetics* he says that, as aesthetics is necessarily connected to the rest of philosophy, one would require a generally agreed system of philosophy to found aesthetics: 'But this would mean

deferring the matter to infinity' (*Ä* p. 48). Not being attached to deferral to the extent to which Derrida claims to be, he is able to write an *Aesthetics* which in many ways tells us more about art than Hegel's. Like the early Romantics, with whom he had close, but often critical contact, Schleiermacher does not believe in philosophy's ability to articulate the Absolute: 'Absolute, Highest Unity, Identity of the Ideal and the Real are schemata' (D 1814/5 p. 67). In the 1833 *Dialectic* he says 'we must be satisfied with arbitrary beginnings in all areas of knowledge (*D* 1833 p. 149), and, echoing Friedrich Schlegel: 'beginning in the middle is unavoidable' (*D* 1814/5 p. 104). The orientation towards praxis means that:

> instead of setting up a science of knowledge in the hope that one can thereby put an end to disagreement it is now a question of setting up a doctrine of the art [*Kunstlehre*] of disagreement in the hope that one can thereby arrive at common bases for knowledge (*D* p. 43).

The difficulty of translating the word *Kunstlehre* points to why Schleiermacher's position, despite its acknowledgement of the dialectical nature of thought, stays outside a Hegelian model.

The word *Kunst* in Schleiermacher varies in meaning between the older sense of technique or craft and the newer sense which refers specifically to 'art' as the product of human freedom which is the object of aesthetics. The meanings of the word are only partially separable. The word involves in all its uses the sense of the active, productive, or creative, which Schleiermacher sees, however minimally, as inherent in thought at every level. *Kunst* points to that which is not reducible to rules: a rule may be necessary, its application is not. Only the context of an argument can make it clear what is meant, and even then the matter is rarely unambiguously clear, because the context requires one to make ungroundable, fallible judgements about what is the real matter in hand. Such judgements are always open to revision. The real functioning of the legal process is an obvious example of what Schleiermacher means. Language plays an essential role in dialectic, even at the level of trying to understand Schleiermacher's arguments. Any attempt to understand the notion of a *Kunstlehre* in English entails an irreducible sense of contextuality that cannot be transcended by an overall concept. We must ourselves engage in the hermeneutic operations which Schleiermacher will show are essential to philosophy.

Schleiermacher places the emphasis of the *Dialectic* on the 'wish to know'. This entails the desire to overcome disagreement. The

apparently trivial point has recently given rise to considerable philosophical disagreement. Schleiermacher, like Habermas, insists upon the necessity for a counterfactual notion of *possible* agreement, in communication with others about the world, as well as some access to what is being argued about. Nothing from outside the dialectic will absolutely guarantee the truth, but this does not mean that we therefore dismiss the very idea of validity. Schleiermacher maintains: 'Disagreement per se presupposes the acknowledgement of the sameness of an object, as well as there being the relationship of thinking to Being at all' (D 1833 p. 132). This does not mean that the disagreement will necessarily be settled. It *does* mean that we cannot rule out a priori the *possibility* of it being settled.

If I thought the piece of music we were listening to was by Haydn and you thought it was by Mozart, we could establish an agreement about the issue, given more information and interpretation from sources we agreed upon as valid. This is a long way from the Hegelian idea that the disagreement is part of the necessary overall process of knowledge, which can be resolved in absolute knowledge: we might look at the wrong sources, for instance. This would not mean that our dispute could not be settled to our mutual satisfaction, however relative this agreement might turn out to be.

Some recent French thinkers seem unaware of these really rather obvious points. Under the influence of Nietzsche's equation of truth and power, they become obsessed with the failure of Hegelian arguments, assuming that if anyone claims validity for something in a manner which does not fulfil the absolute criteria that Hegel unsuccessfully tried to provide, they are covertly attempting to enforce their views. The implicit demand is more metaphysical than many of the arguments they oppose – as though truth could only be legitimated at the level of the Absolute. This sort of metaphysical certainty is foreign to much modern philosophy: Fichte already saw truth in terms of consensus.[4] Lyotard's *Le différend*, for instance, which seems to think that argument is based on irreducible difference, and that agreement must therefore be coercive, completely ignores, as we saw Derrida doing, the need for some kind of identity in thinking if there is to be difference at all.[5] If there is nothing but conflict, then there are no conflicts because we would have no criterion for identifying them. Schleiermacher sees this as an issue of praxis : 'if we take this relation of thought to Being away: then there is no conflict, but as long as thought only remains purely in itself, there is only difference' (*D* 1833 p. 134). What you hear in the piece of music is not

what I hear, but this does not stop us arguing about who wrote the piece, to which *both* of us have listened. An argument is not an argument if *a priori* it cannot be settled. Schleiermacher enables one to take account of the fears of the thinkers of difference. He can accept the fact that any conceptual agreement may be an imposition upon something which inherently resists identification. He does this, though, without involving himself in the absurd consequences that result from the farewell to agreement and identity on any level.

Schleiermacher attaches fundamental importance to the activity and motivation of thought: 'thought is activity' (*D* p. 409), 'wanting to think is the beginning of thought' (*D* p. 174). He does not assume, as later thinkers like Schopenhauer and Nietzsche will, that he somehow knows what this motivation really is. In a section on 'The Relation of Art and Science' he stresses the importance of considering the *genesis* of any particular piece of knowledge. This does not collapse the difference between genesis and validation, but it questions whether validation is necessarily the sole issue for philosophy. Even a strict area such as mathematics has two sides to it: once a series of theorems have been established by a mathematician

> we do not see how the person who put the whole together moved from one proposition to another. The art of discovery/invention [*Erfinden* has both senses] is different from what has been discovered/invented; the connection and the way that one has got from one to the other is not at all the same (*D* p. 74).

Different thinkers can arrive at the same result via different routes: the routes do not exist a priori independently of the activity of their being thought.

Schleiermacher does not deny the importance of systematic thought but suggests that an adequate dialectic would also require a 'theory of discovery'. Because the *activity* of the will must be present in the genesis of any scientific discovery the real process of discovery will always entail an aspect of 'art', 'free productivity', which is not reducible to the way in which it is subsequently theorised. Philosophy must be concerned with this free productivity, which, for Schleiermacher, is what self-consciousness is. To the extent that even mathematical discovery involves the activity of single persons, which he sees in terms of 'art', in the sense of productivity, thinking has a

> further element whereby the area of knowledge is limited, by virtue of which in thought everyone is different from everyone else. This is the Individual

[*das Individuelle*]. To the extent that there is some of this everywhere no act will completely correspond to the Idea of knowledge [in the Idealist sense of the unity of thought and what is thought] until after this element has been eliminated. And this can be only indirectly solved if the totality of the Individual as such, i.e. with its foundations, is known, and with this we have a completely endless task (*D* p. 131).

This might be seen as entailing the kind of implicit scepticism involved in the notion of *différance*, or in Lyotard's assumptions about arguments.

For Schleiermacher, though, it entails the anti-Idealist realisation that, once we have assumed our inherent individuality, knowledge must be the always incomplete attempt to move beyond disagreement. There is no absolute court of judgement. The aim of publicly accountable knowledge is to diminish destructive social conflicts generated by our irreducible otherness to each other. Again the Aristotelian side of his philosophy comes to the fore: he does not start from the kind of absurdly Social-Darwinist image of the 'agonistic' essence of social life present in Lyotard, where consensus is coercion. Schleiermacher is concerned with what we are always already doing anyway. This does not mean that the infinite differentiality that is the result of individuality should be ultimately overcome. Schleiermacher's concern with aesthetics makes it clear that he does not think the necessary overcoming of difference in scientific knowledge for the sake of the community is a value in itself.

Schleiermacher distinguishes between 'identical activities' and 'individual activities'. Seen abstractly, thinking is 'identical':

> But if we now look at thinking in reality, then everyone thinks here in a specific language, and there is already a difference in this; so that in general we posit thought as identical, but at the same time we posit that it differentiates itself in reality (*A* p. 51).

No two people think exactly alike. Stating this entails identical thinking, because it is a general judgement. Its content, though, is the reality of individual difference, which the statement cannot articulate.

Conceptual knowledge always entails a structure of reflection, of difference or division. For an Idealist philosophy which does not accept Hegel's version of reflection this raised the problem that the Absolute could not be articulated, because the articulation would have to divide what must be One. The issue is now also seen from the other end: the in-dividual is also not reducible to reflection, as the word suggests: it cannot be divided. We cannot already *know* that what is thought belongs to reason. We have to work on the assumption that thought can reach

agreement, but there is no ultimate guarantee that it will, because of the inherently individual nature of thinking. In Leibniz, for example, the particular is revealed as being deducible from the general: 'in the least substance eyes as piercing as those of God could read the whole sequence of the things of the universe'.[6] For Hegel 'Being' only comes to itself via its determination into particularity, but the particularity is precisely a moment of the coming to itself of the general.

Schleiermacher argues that the Individual is not reducible to a concept. This prevents any foundations being established that would ground conceptual knowledge in absolute certainty: 'even incorrect thought can become common to all' (*D* p. 374). The certainty that Hegel wishes to establish derives from his presupposing that, however contradictory the movement of *Geist* appears to be, it in fact is the process of the Absolute: we cannot judge anything which is not always already within *Geist*. Schleiermacher wants to suggest that such a position would only be tenable if one already had 'the general construction of all knowledge in which all individual thinking is included [*aufgeht*]'. Without such a presupposition there is no way of saying whether there is any thought which 'is excluded from all influence of the Individual' (*D* p. 134). The 'absolute unity of Being' (*D* p. 224) is 'not a concept any more' (*D* 1814/5 p. 31), because the concept requires a reflexive separation of thought and object. The same applies to the Individual, as that which is not subsumable by the concept.

The essential issue for Schleiermacher is the attempt to transcend difference. There is no absolute guarantee that this will be possible. This does not mean, for the reasons suggested with regard to Derrida, that one can simply revel in differentiality. Individuality makes no sense without the criterion of its identification, the general, but neither is it exhausted by the criterion of its identification.

If knowledge is tied to language and language is tied to our specific organic being and its means of articulation, then reason itself 'only becomes an object to us via the organism, namely via language' (*D* p. 141). If one fails to appreciate this one presupposes an answer to the question of reason without considering the means we need to use to establish what reason is, as Hamann had already shown. Once one has made this step one has already set up the main issues of modern hermeneutics. Schleiermacher insists that hermeneutics is a necessary complement to the dialectic. The arguments about subjectivity we have seen earlier in the book can explain why this is the case.

Immediate self-consciousness

Kant's philosophy gave rise to the question of the relationship between the reflecting and the reflected self, the I as subject and the I as its own object. Kant was clearly aware of what was at stake in the attempt to ground philosophy in subjectivity. The identity of the subject could not be grounded in empirical consciousness: 'the empirical consciousness which accompanies my representations is in itself dispersed and has no relation to the identity of the subject'. If the potential chaos of empirical representations is to be avoided there must be a subject which creates a unity within them, otherwise 'I would have a self which is as multi-coloured and multiple as the representations that I am conscious of having' (*KrV* p. B 133). Kant admits the need to posit the *existence* of the I, whose identity must then be synthesised on the basis of the difference of its intuitions. However, Kant says we have no cognitive access to this I. The existent I therefore relies for its being itself upon its other, its intuitions, in the sense of that which is 'given to it'.

For Kant the categorial apparatus of our thinking was the a priori unifying factor in consciousness: 'the synthetic unity of apperception is the highest point to which one must attach all use of the understanding, even the whole of logic' (*KrV* p. B 134). Identity depends for Kant upon the unifying of the difference of intuitions. For Schleiermacher, on the other hand, consciousness is grounded in the fact that our *Being* is the 'linking of different moments' (*D* p. 272). This linkage cannot be a function of consciousness as cognition because cognition depends upon differentiation: what *connects* the phenomena of differentiating thinking must be a ground which is prior to the differentiation. Cognition is necessarily temporal, dependent upon the succession of intuitions, the *linking* of the phenomena must somehow transcend this temporality.

Schleiermacher distinguishes between Kant's synthetic 'I', and what he calls 'immediate self-consciousness':

> If we look at the single I as something which persists in the developments, thus as something constant and the same in a sequence of time, then the self-consciousness of this identity is only something derived (*Ä* p. 68).

The awareness of identity is after the fact of identity, as Novalis suggested in the idea that 'What reflection *finds*, *seems* already *to be there* – Attribute of a *free* act' (*FS* p. 112). Praxis should come before theory. The individual existential I is the basis of any reflexive act. It is the 'activity of the individual [*Einzelne*] as such in its difference' (*Ä* p. 69).

The difference is that of *my* individual self-consciousness from all other self-consciousnesses.

The question is how one gives an account of the linking of the different moments of consciousness whilst avoiding the problems we saw in Kant and the thinkers who follow the reflection model. Schleiermacher sees this in terms of two sides of self-consciousness: 'thought', which is our being affected by the world in, for example, scientific observation, and 'will', which is our ability to affect the world. Something must link the transition from one to the other, from our trying to understand an object to our trying to change the object, otherwise the continuity of self-consciousness becomes unthinkable:

> If at one moment the whole of life is not posited then this is a defect to which a supplement must be added [otherwise consciousness would disintegrate]. In the activity of thinking the consciousness of the object is also posited, in the act of will the consciousness of resistance is also posited; one moment completes the other. The transition of both moments into each other must include the positing of the other, that is, it must be posited as *pure immediate self-consciousness* (*D* p. 286–7).

This immediate, in the sense of unreflected, self-consciousness is what Schleiermacher sometimes terms, as Novalis does, *Gefühl*, 'feeling'. 'Feeling', as we saw, cannot feel itself: *Gefühl* is

> different from reflected self-consciousness = I, which only states the identity of the subject in the difference of the moments and thus depends upon a synthesis of the moments which is necessarily mediated (*D* p. 288).

The I that we can retrospectively synthesise as having 'accompanied all our representations', that I which can remember my childhood experiences as *my* childhood experiences depends upon an *existential* continuity which can never be fully present to consciousness.

Schleiermacher insists on the non-reflexive dimension of our identity as subjects: 'Each thought was for us up to now an act for itself and as thinkers we are only in the single act; but as beings [*Seiende*] we are the unity of all single acts and moments' (*D* p. 274). When I am playing the saxophone I do not think that 'I' am playing the saxophone: I play the saxophone, with all the thinking that involves. If I do think about myself doing it, then I do not do it very well. Sartre makes the same point in *Being and Nothingness*. Consciousness cannot be grounded in reflection:

> Consciousness is not a particular mode of cognition, called intimate sense or self-cognition, it is the transphenomenal dimension of the being of the

subject . . . Self-consciousness is not double. If one wants to avoid infinite regress it has to be an immediate and non-cognitive relation of self to self (*EN* p. 17–9).

For Schleiermacher the unity of our consciousness cannot ever be explained. We are dependent on the mode of Being of our self-consciousness in ways which we could not understand, because the very desire to understand cannot be explained in terms of what we think understanding is. The necessities of the hermeneutic circle begin to become apparent.

The failure of reflection to grasp self-consciousness points to what Schleiermacher terms the 'transcendent basis', which is where he locates 'God'. Schleiermacher says of the transcendent basis that it 'always remains outside of thought and actual being, but is always the transcendent accompaniment and basis of both' (*D* p. 307). Thoughts are always within the sphere of the conditioned, of the determinate: they are specific thoughts at specific moments. The object of thought is also within the sphere of determination. Both, though, entail a ground which transcends them. Seen in this way the transcendent basis and immediate self-consciousness are structurally related. It is only because there *is* consciousness that it can try to fathom itself. Its reflection upon itself is always *subsequent* to the fact of its existence and the fact of Being at all. As such, it can never immediately grasp the whole of itself.

Schleiermacher explains this further in relation to our pre-reflexive experience: 'We have no idea of the I [in the sense of reflected, synthesised self-consciousness] without reflection. This only gradually develops in human beings after their physical life has already begun' (*D* p. 291). The means via which this self-reflection comes about are partly linguistic. Becoming a reflexive 'I' entails, as Lacan puts it, the 'defiling' of the subject by the signifier 'I': a moment of disruptive non-identity is required for the synthesising of my identity. In terms of Schleiermacher's theory this does not imply that the I is simply a function of the general signifier that denotes it, as it did not for Novalis. If it were merely such a function, the individual, existential fact of consciousness would be reduced to the general means of articulation, the signifier.

We saw the problem with this in relation to Hegel in the last chapter. The I for Schleiermacher, though, is not a self-reflexive entity. Because it is not its own ground, consciousness is not reducible to what it is at any particular moment, or to its reflection in the other of itself. What sees itself in a mirror could only see *itself* if it *already* were in some way

familiar with itself. It is to account for this that Schleiermacher insists on the notion of unreflected self-consciousness. As has been repeatedly shown, the *mirror* cannot provide a criterion of identification: that would be a reification. Objects do not 'do' things. It is the I that moves into a new stage of its existence that is central, not the inert means of reflection. Whilst linguistic articulation is a necessary condition of consciousness, it is not a sufficient one.

Schleiermacher initiates a 'linguistic turn', but not in the manner that has come to dominate so much contemporary philosophy. He is not concerned to find the agreed rules of usage, the 'code' that makes intersubjective communication possible. The code cannot provide its own basis: the mirror cannot reflect itself. The basis is the potential preparedness and ability of individual language-users to accept that individual differences can be overcome in a higher agreement. For this reason Schleiermacher is able to account for linguistic change, the shifts in linguistic usage which redefine our relationship to the world, in a way that sees human subjects as potential initiators rather than passive objects of the worlds they make in language. This does not deny the extent to which people *can* be objects of language. It does insist that this is not all there is to the relationship of subjectivity and language. 'Poetic' usage, creative initiatives in language, are not a special case or deviations from a norm in such a theory, they are inherent in the very nature of language. It is for this reason that Schleiermacher's hermeneutics is so closely linked to aesthetic theory, and is radically opposed to any objectivist theory of language and of natural science. Let us now take a closer look at Schleiermacher's *Hermeneutics and Critique* and its relationship to his *Aesthetics*.

Art as free production

The 'hermeneutic circle', the attempt to understand the part via the whole and the whole via the parts, initially derives from the application of Schelling's identity philosophy to the question of interpretation. In 1808 Friedrich Ast, a pupil of Schelling, suggested a method for understanding texts from the past based on a reductive version of Schelling. For Ast, because Being is the unity of thinking and what is thought, we are able to reproduce the thought of the past through its essential identity with our own thinking. He uses the idea of the organism to ground understanding:

> The basis of all understanding and cognition is finding the spirit of the whole from the single part and grasping the single part via the whole . . . each is only posited with and by the other, just as the whole cannot be thought without the single part as a member of it and the single part cannot be thought without the whole, the sphere in which it lives.[7]

Schleiermacher breaks up this identity by his insistence upon the irreducibility of individuality in thought: the single part can only relate to the spirit of the whole via an unprovable postulate that the whole is the other and complement of itself. Schleiermacher also questions Ast's position by insisting upon the inextricable involvement of thought with particular languages, there being no 'general philosophical language' to overcome all the differences of particular languages. Importantly, this argument is associated by Schleiermacher with aesthetics.

To understand this we need to establish more clearly the foundations of the *Aesthetics*. Schleiermacher sees 'art' as necessarily involved in all the operations of our thinking. Art is 'free production . . . of the same functions which also occur in the controlled [*gebunden*] activity of humankind' (*Ä* p. 375). If I write the handbook for a nuclear power-station I am bound by the purpose of not having the station function like Three Mile Island or Chernobyl. No one is terribly concerned whether the productive act of writing the handbook has a value in itself for me because of my pride in my ability to construct flowing periods. To this extent my handbook would, in Schleiermacher's terms, be unlikely to be a work of art, even though some sentences in it may achieve aesthetic status. Art is an 'individual activity', a technical handbook involves 'identical activity': 'artistic activity belongs . . . to those human activities which . . . presuppose the individual in its difference from the other' (*Ä* p. 61). Art and individuality are inextricably connected.

Schleiermacher sees aesthetic productivity as part of 'immediate self-consciousness': what I synthesise after the fact as being my I depends upon acts which are not the result of what I *think* of myself: the acts are the result of my spontaneity. Aesthetic production is not to be subsumed into identical meaning for everyone, of the kind required for the instructions about how to run a nuclear power-station: 'not a trace of knowledge arises yet out of all thinking in poetry [*Poesie* with the sense of *poiesis*, productivity], it only expresses the truth of the single consciousness' (*Ä* p. 66). Knowledge would negate the individual truth in favour of what needs to be agreed upon in a linguistic community. The creative text allows for the unfolding of something which need never be just what

it becomes for the community. However, this does not mean that the individuality of meaning could not become collective.

The never to be realised, counter-factual goal of Schleiermacher's philosophy would be the 'individual-general', the sustaining of free individuality in a community which would not be threatened by it. The collective importance of the aesthetic is that it gives a vision of what this might mean. This is in certain ways close to the way freedom and beauty were connected in the System Programme. It suggests, though, that there could be no ultimate reconciliation of individual and general. This does not mean the attempt is pointless: as in the question of the striving for agreement, Schleiermacher sees the history of art as demonstrating that the attempt to combine individuality and generality in free human production is always already taking place.

By founding his aesthetics upon productivity Schleiermacher wants to escape the dichotomy between an aesthetics of reception and an aesthetics of production. He thereby also avoids the notion that there is an absolute Idea of art, to which certain works correspond and to which others do not. He assumes that judgements in this area are 'subjective'. His way of theorising this allows him to sustain a notion of the aesthetic that is not reliant on art being an inherent quality of the object. Schleiermacher's thinking is based on degrees, which do not allow of absolute transitions. For example: 'Because beauty is produced via human activity more than by anything else the production and reception of it are the same. Productivity and receptivity are only different in degree' (\ddot{A} Lehnerer p. 3–4); 'all people who make a work of art their own in some way are to be regarded as artists' (\ddot{A} Lehnerer p. 178). For music to be music the listener must hear it as music, which depends upon not using it for some other purpose.

At one end of the notional scale of human production – because the notional scale requires a reflexive splitting it cannot be absolute – is 'science', in the sense of agreed objective knowledge. Science is almost wholly receptive, but still requires human praxis for its coming into existence. At the other end of the scale is art, as wholly free productivity for its own sake. The difference is only ever relative: 'because humankind and living things in general can never be absolutely passive, . . . when receiving something one is also active' (\ddot{A} p. 98). Similarly there can be no absolutely pure work of art, as it will always involve aspects which are to some extent fixed. The most interesting arguments to emerge from this approach concern language and art.

Interpretation as art

Schleiermacher claims that 'interpretation is art' (*HK* p. 80). The consequences of this are wide-ranging, once one has established the other bases of his thought. It is important to remember that Schleiermacher does not shy away from difference and disagreement. For Schleiermacher the necessity for interpretation of the utterances of others is *always* present, and not just necessary in special cases. The 'stricter practice' of the 'art' of hermeneutics presumes that 'misunderstanding results as a matter of course and that understanding has to be desired and sought at every point' (*HK* p. 92). This radical position introduces aspects of the aesthetic into all forms of communication. Let us see now how Schleiermacher arrives at this startling position.

The initial step is the 'linguistic turn': 'There are no thoughts without discourse [*Rede*] . . . one cannot think without words' (*HK* p. 77). Manfred Frank has added the necessary proviso that is always present in Schleiermacher's argument, namely that this 'does not mean that the word itself thinks' (*HK* Introduction p. 26). The 'hermeneutic circle' in this context expresses the fact that any approach to understanding the world always implies assumptions which cannot be conclusively tested by some more basic foundation in science or philosophy – one cannot use science to retrospectively ground science. The circle results from the fact that 'each person is . . . a location in which a given language forms itself in an individual [*eigentümlich*] way', such that their language is particular, but it also results from the fact that 'their discourse is only to be understood via the totality of language'. These two quantities, the individual and the totality are, as we saw, not reducible to each other.

Language results from 'speech acts' (*HK* p. 80). It would not exist without our continually reproducing it. The speech *act* is inherently individual: it is your or my act, saying the same words is not the same speech act. As such, speech acts 'cannot be subordinated to calculation', they are not what Schleiermacher calls 'mechanical'. The notion of the totality of a language, the *langue* in Saussure's terms, is merely a postulate : 'No language is totally available to us, not even one's own mother-tongue' (HK p. 84). There are no linguistic 'rules . . . that would carry the certainty of their application within them' (*HK* p. 81). Whilst it is clear that there are endless linguistic rules and constraints, without which we could not communicate, this does not make it clear what status such rules have, and does not account for the ways in which language is actually used. Schleiermacher introduces the notion of art again:

The full business of hermeneutics is to be regarded as a work of art, but not as if carrying it out finished in a work of art, rather in such a way that the activity only has the *character* of art because with the rules the application is not given as well i.e. cannot be mechanised (*HK* p. 81).

The argument results from the way art is seen as free productivity of individuals.

The level of language which might seem 'mechanisable', reducible to a set of rules that explains its functioning, Schleiermacher terms the 'grammatical'. This corresponds to the *notional* totality of the linguistic system. However, such a totality is infinite 'because every element is . . . determinable by the other elements' (*HK* p. 80). We encountered this argument in a different context in Schelling's 'Würzburg System', and in Hegel. Schelling saw the process of science as infinite because '*Every single being is determined by another single being*, which in the same way is determined by another single being etc. into infinity'. I related this to differential views of language, such as Derrida's. Schleiermacher's argument avoids the antagonism to the subject and the logical pitfalls that we saw in Derrida. On one level Schleiermacher converges with Derrida: because each linguistic element is affected by its context it would only be fully determinable if one were able to specify all conceivable contexts in advance. However, Schleiermacher is interested in the praxis of communication, rather than just in language's differentiality. The fact that language is a result of speech acts leads him in important new directions: the users of language are individuals, and the existence of the language is dependent upon their acts: 'language must individualise itself. Otherwise it can only be thought of as a capacity but not really exist' (*HK* p. 363–4). Humboldt argued the same point: '[language] has nowhere, not even in writing, a permanent home, its so to speak dead part must always be reproduced anew in thought'.[8] The individuality that Kant reserved for the genius in art, who established new rules via aesthetic production, is thus potentially carried over into all areas of linguistic usage and thus into all areas of human activity.

As Hamann had done, Schleiermacher argues that there cannot be a general language which would subsume all particularity into itself. One can either see this as a terrible problem or regard it as inherent in the very nature of objective thinking as *Gesprächsführung*, which requires the endless activity of interpretation. Schleiermacher's argument prevents one from assuming that what I see and think about the world could be shown to be the same as what everyone else sees or thinks: 'We cannot

know whether the other person hears and sees just as we do' (*D* p. 371). To *know* this we have to *assume* an identity in the way we schematise our perceptions. Schleiermacher suggests we must make this assumption, but making this assumption requires the medium in which we exchange what happens in our consciousness with others: language. It is, though, one thing to assume that the use of the same terms is necessary if we are to think the same thoughts, and quite another to assume that we *do* in fact think identically. If consciousness were just a function of language this would be the case. Obviously, though, it is not the case, otherwise we would not need to talk to others in the first place in order to reach agreement about the nature of reality.

Schleiermacher takes the standard example of colours as a demonstration of the way in which knowledge has to function. He does not deny that what another person sees as the *Bild*, the 'image' of the colour, may be different from what I see:

> This can never be established, but this does not matter if the object is only the same one that I have and the other person describes the same actions in relation to the object as I describe (*D* p. 373),

a position not so far from that of the later Wittgenstein. Schleiermacher claims that 'all communication about external objects is a constant continuation of the test as to whether all people construct identically' (ibid.). Whilst, for example, there is no serious doubt that there is a phenomenon called now, by me, a rainbow, how the rainbow is described depends upon the relativity of knowledge. There is no guarantee that any series of classified observations can be generally grounded in certain knowledge that is common to all people:

> The identity in the construction of thought as the element of knowledge is only manifest in language [i.e. the system of iterable signifiers with which we communicate]. But there is no general language, therefore there is also no general identity of construction. Thus this characteristic is not realised and will not be realised. All attempts to reach a general language are failures; for the agreement about a general language is itself subordinated to particular languages (*D* p. 374).

It is worth noting that Gadamer[9] attributes this point to Wittgenstein, which is perhaps the most spectacular demonstration of his failure to take Schleiermacher seriously. If one wished to be able to articulate the identity of subject and object one would have to presuppose an 'absolutely general language. But there is no means of producing such a

language . . . For language is not always susceptible to construction and remains connected to the area of nature' (*D* p. 379).

Such arguments seem to imply a hopeless relativism that would make any kind of understanding between people impossible, let alone any reliable knowledge. Schleiermacher helps counter this implication with his most controversial and misunderstood term: 'divination'. 'Divination' makes aesthetic theory inseparable from the rest of philosophy. Since Dilthey in particular, 'divination' in Schleiermacher has been assumed to mean *Einfühlung*, 'feeling one's way into' another person's thoughts via their writings. Such a notion has rightly been attacked as psychologistic, and has helped produce some truly awful literary criticism. Even from the arguments seen so far it is evident that Schleiermacher could not have meant this. Furthermore, he did not use the term *Einfühlung*.

His own explanation of 'divination' uses the telling example of childrens' initial language acquisition. Language entails the general, without which we could not communicate: 'Everyone seeks to fix the general image for themselves and others' (*D* p. 373). The problem, which we already encountered in relation to reflective judgement in Kant, is how the general schema is to be applied to a potentially infinite series of different objects which are supposed in some way to be the same, e.g. a tree. The obvious answer would seem to be comparison, but this does not solve the problem. For comparison to answer the question one would need a 'platonic' tree, an essential idea that determines the subsequent series of comparisons. What has been said about language so far precludes this: the tree is only a tree to the extent to which it is not everything else. Comparison is potentially endless: by comparing this object 'tree' with the next object one never arrives at any certainty, unless one has already presupposed that the first object really is a tree. One is otherwise faced with infinite regress. Schleiermacher makes it clear that this is precisely the situation in which everyone finds themself when they first learn language.

Any attempt at understanding another's utterance, which *per se* entails difference from the other person, involves the hiatus between the use of general signifiers and the particular individual process of understanding. For children this is radically the case:

> They do not yet have language, rather they are looking for it, but they also do not yet know the activity of thinking because there is no thinking without words: on what side do they begin [i.e. by comparison or 'divination']? They

have not yet got *any* points of comparison but they only gradually acquire them as the basis of an unexpectedly quickly developing comparative procedure; but how do they fix the first thing? (*HK* p. 326).

The answer is 'divination'. But what does the term really mean?

Divination involves 'production', 'creation' (*Erzeugung*). Children have what Schleiermacher calls an 'inner mobility towards creation on their own part' (*HK* p. 327), which goes along with a 'directedness towards the reception of others'. Schleiermacher used the same terms in relation to art. There is no absolute point from which the process of language acquisition can be said to begin. Schleiermacher makes assumptions, based on the behaviour of children, about the human species' essentially social nature. The emphasis on language reflects these assumptions, but his other premises make it evident that these assumptions are not foundations for certain knowledge. Children are individual: each organism is radically other for another organism. Because of Schleiermacher's notion of consciousness, acquisition of language cannot be simply the accommodation of consciousness to a system of signifiers in which it mirrors to itself what it is. This would get us into the reflection circle again. Consciousness is inherently 'production' and 'creation', which is channelled into a sign system, but is not a function of that system. For this reason *all* use of language can be *potentially* creative and any attempt to make understanding an objective science is bound to fail.

The act of 'divination', then, is not a mystical act of identification with another speaker or a written text. It is instead a necessary component of our everyday, and always incomplete, praxis of understanding each other and the world. When I say something which is understood by another or understand something they have said, this does not mean that I simply reproduce the words used with an identical sense, as Wittgenstein largely implies. It means instead that, as Frank has put it, I 'carry out another articulation of the same linguistic chain'.[10] Because it is the articulation of a different individual there is always an aspect which is different, even when the 'same' sentence is used. Try repeating the same sentence over and over to somebody else: its significance keeps shifting.

This stress on the individual productive 'activity' runs counter to some contemporary thinking in this area. Schleiermacher gives a useful example that makes the importance of his position clearer when he expresses his admiration for childrens' powers of language acquisition:

> it seems to me that we only smile at the wrong uses that children make of the elements of language they have acquired – which they not infrequently make only via too much logical consistency – in order to console ourselves for or revenge ourselves on this preponderance of an energy which we ourselves no longer possess (*HK* p. 327).

The children create new forms of language in their attempt to produce communication with others. At the same time, every time we ourselves fail to understand or make ourselves understood, some aspect of this 'energy' must come into play in order to attempt to overcome our misunderstanding. Individual lives are always a *never completed* series of attempts to grasp, via divination and comparison, the meanings of others. The acquisition of 'grammar' is vital in this but

> the more the soul [in the sense of the thinking person] already possesses, its receptivity becomes more sluggish in its movements, so that even in the most lively soul, precisely because each in its individual being is the non-being of the others, it is the case that non-understanding will never completely dissolve (*HK* p. 328).

This is akin to a historical materialist view of the working of language as what Marx will term 'practical consciousness', which is tied to our organic being and which could never become a 'general philosophical language'. The argument also includes, albeit with a different philosophical justification, the awareness that has developed in post-structuralism of the unclosability of signifying systems. Schleiermacher's theory, however, sustains the notion of individual subjectivity whilst doing justice in an enlightening and accessible way to fundamental insights into the instability of meaning.

Literature and the 'musical'

The area where questions about the transformation of language have, at least in the modern period, been a key issue, is the 'poetic', in the sense of the creative and the 'literary'. It is also the area where most philosophies of language have been signally inadequate because they treat the poetic as a special case in language. The genesis of the 'literary criticism' industry in the English-speaking world or 'literary hermeneutics' in the German speaking world – whose roots can be traced to this period – testifies to the aptness of Schleiermacher's central arguments. If understanding were essentially based on finding agreed rules of meaning, let alone absolute certainty about proper linguistic usage, why do so many

people in the modern period spend so much time in institutionalised conflict over the utterances of others? Why are there no 'definitive' interpretations of major literary, or, for that matter philosophical, works?

Schleiermacher's argument makes it clear that the incursion of questions of creativity in language does not stop at the literary. By centring his attention on the presence of an individually productive aspect even in the most apparently rule-bound activity he is able to claim that 'everywhere, including the realm of science [meaning natural science] there is a free play of thoughts which is a preparation for artistic production' (*HK* p. 180). Lest this merely seem Romantic hyperbole, it is worth remembering, as I suggested in Chapter 2, that recent research into the history of science in the early nineteenth century reveals just how far the apparently 'pure' advance of science involved elements of 'creative thinking' and poetic association. These cannot simply be subtracted from the 'hard' science which emerged from the process. The very notion of 'hard' science tends to work with the postulate of a theory-neutral language which has eradicated all linguistic overdetermination from itself. A cursory reading of any science book can soon disabuse one of the idea that this actually happens.

Schleiermacher sees no absolute difference between 'aesthetic' and other areas of intellectual production. Although *Poesie* is *bildlich*, concerned with intuition and particular images, it will be present even in the most rule- and observation-bound activities:

> The more distinct the laws of a form are, the more empty is the production of individuality. In this way the individual life is opposed to what is mechanised. But the relation of the two varies in different texts. The individual never completely recedes (*HK* p. 191).

To this extent science and art 'cannot possibly be totally opposed to each other' (*HK* p. 194). There will always be a tension between the notional general status of any signifying system and its use in practice, which can never be wholly accounted for in advance. Schleiermacher opposes 'poetry', creative, literary production to 'prose', which would include any discursive practice, including the natural sciences: the

> general hermeneutic difference between poetry [i.e. literature] and prose is that in the former the singular wishes to have its particular value as such, in the latter it only wishes it in the whole, in relation to the main thought (*HK* p. 140).

The *Dichter* (poet in the sense of any 'creative writer') most directly confronts this issue, but its implications are inherent in all linguistic usage.

Schleiermacher sees language as having a 'logical' and a 'musical' aspect. It is the latter which is constitutive of *Poesie*. The 'productivity' that leads to articulation in language is internal: 'but it only becomes external via the sound [*Ton*]. This is analogous to the musical element and in the use of language we always get an impression of this musical element' (*Ä* p. 633). The musical element is evidently the 'melody' and 'rhythm' of a particular utterance, as well as the fact that it appears sensuously as moving airwaves. Schleiermacher is concerned with language as a series of moving transitions, not as a set of static elements. Whilst it is a mistake to attribute determinable semantic potential to this level of language, it is absurd to pretend that it does not exist, or that it is insignificant. The illocutionary force of any utterance is affected by it. For Schleiermacher the human mind has a strong tendency 'to be able to represent itself purely in its mobility, apart from everything logical' (*Ä* p. 400). Musical production makes us 'conscious of the mobility of human self-consciousness' (*Ä* p. 395). To the extent to which this mobility has no determinate content, it enables Schleiermacher to establish it as a criterion of aesthetic autonomy. It is free activity for its own sake. The link of this to literature is important: the very emergence of a modern conception of literature is connected to music, as we shall see in the next chapter.

The identification of a 'literary style' depends to a significant extent upon the rhythm of an author's sentences. This rhythm depends upon characteristic recurrences of linguistic elements and their combination. The 'logical' is that which is open to examination as to its truth status. This status must have to do with general criteria of judgement which, though articulated in particular utterances, should transcend the particularity of the individual utterance. Once again one is confronted with the relation between the particular and the general. Even in the realm of the 'logical', though, 'a sentence can as an expression in language be completely adequately formed in terms of its logical constitution, but it offends us because it does not satisfy the musical' (*Ä* p. 635). This might seem precious or the remark of an aesthete. This is only the case if one reduces language solely to its pragmatic functions, which is precisely what Schleiermacher wishes to avoid.

Oliver Sacks cites the case of the aphasiacs who, whilst incapable of understanding distinct words as such, were able to unmask a lying

speech by President Reagan by perceiving the way in which language
was being used on the musical level. Sacks says of aphasiacs that one has
the feeling 'that one cannot lie to an aphasiac': they

> have an infallible ear for every vocal nuance, the tone, the rhythm, the
> cadences, the music, the subtlest modulations, inflections, intonations,
> which can give – or remove – verisimilitude to or from a man's voice.[11]

Most of the audience of aphasiacs laughed at Reagan's speech. The real
sense of the 'musical' was lacking in what Reagan said: 'it was . . . above
all, the false tones and cadences of the voice, which rang false for these
wordless but immensely sensitive patients' (ibid.). This, then, is a
political issue, as well as an aesthetic one.

One can readily understand what is at stake in Schleiermacher's
connection of aesthetics and language. The fact that it requires a shared
mental pathology to make it collectively obvious that Reagan made
mendacious speeches suggests the extent to which the particular sensi-
bility to the movement of language that Schleiermacher is concerned
with is easily lost, or may never develop. The aesthetic is, as we have
continually seen, concerned with the irreducibly particular, the truth of
which cannot be exhausted by extracting the propositional content of
utterances. It is possible, if unlikely, that Reagan made a factual state-
ment during the appearance in question that even the Nicaraguan
government would not disagree with. The falsity of what he said does
not just depend on this: it depends upon a level of language which this
kind of aesthetic theory tries to keep from oblivion.

Art in this perspective is concerned with articulating what 'identical'
thinking represses because of its exclusive orientation towards fixing a
world of stable objects. The difficulty of writing aesthetically appro-
priate philosophy, as long as philosophy sees its task as transcending the
particular, is highlighted by this approach. The *Dichter* for Schleier-
macher has to 'provide something that cannot really be given by lan-
guage, for language only ever provides the general' (*Ä* p. 639). A flower
in a botanical handbook (Schleiermacher's example) must be described
via a schema that applies to others of the species. This is no problem in
pragmatic terms: one recognises the type if the schema fits. A flower in a
literary or other aesthetic context – this applies also to painting: think of
Van Gogh's sunflowers – cannot be seen as a type. If the depiction of a
flower in a botanical handbook is judged to have aesthetic value this will
not depend upon its being able to be used as a means of identifying the
flower in a field. A 'poetic' evocation of a flower will also hardly be

judged by whether it enables you to recognise and pick the flower on a summer's day. For Schleiermacher 'the poet . . . is concerned with the truth and complete determinacy of the singular' (*Ä* p. 639). The truth of the singular cannot be the truth of identifying thinking. There is, however, a serious problem in trying to explain what kind of truth this might be: much of the discussion of aesthetic theory in this century results from the problem.

The problem has to do with language. Language can only function via iteration: repeating the same signifier is one condition of meaning. The importance of literature in modernity is based on the production of new meaning, not on the confirmation of existing meanings. Schleiermacher says that in literature 'the changing, floating, purely transient aspect of the state of mind [*Gemütsstimmung*] should be represented [*zur Anschauung gebracht*]' (*Ä* p. 640) against the fixity of the signifier. In music this already happens because the articulation is never conceptually determinable. This seems to create a tension between music and language, in that language is 'simply irrational in relation to the singular' (*Ä* p. 643). Iterability and singularity are evidently opposed, yet meaning requires both. Thought requires language if it is not to be indeterminate, and even the activity of our will requires the articulation of *what* is willed. This articulation is obviously more complex than the simple schematisation required for identifying entities in the world: what I want very often does not exist in the world, so I am hardly able to identify it in terms of knowledge.

It is at this level that Schleiermacher's dynamic view of language becomes so significant. The key factor is the 'musical'. The 'musical' 'consists of nothing but transitions . . . by virtue of this, language is capable of directly representing the changeable in spiritual being' (*Ä* p. 642). It is worth noting that this is another case where music is analogous to Hegel's *Logic*, which tries to characterise the pure movement of thought. The *movement* between signifiers or statements is what matters for Schleiermacher. The effect generated by such movement is not amenable to a general theory of language. The semantic potential of a poem, for instance, is connected to the level of its formal organisation. The form is constituted by the movement between the signifiers as the poem is read.

For Schleiermacher *Poesie* is not an extension of language or a new creation within language. The possibility of creativity 'is already originally in language, but admittedly it is only the poetic where it appears' (*Ä* p. 643). Language is the articulation of a world which is otherwise inert,

whose meaning is not immanent within it and not already present within those who can use language to produce meanings. At the point at which language realises the potential for new significance it is necessarily individual. This shows up most obviously in the fact that 'there can be no concept of a style' (*HK* p. 172): what matters about creative writers cannot be reduced to what they have in common. New forms of articulation constantly do arise that cannot just be explained by the existing rules. The point of theory is not to be able to reduce this difference to identity. Schleiermacher's theory shifts the centre of gravity of philosophy in the direction of language as dynamic praxis which can only subsequently be theorised. In the same way as the subject's self-reflection is subsequent to its existential basis, the way the world is opened up in language only becomes rule-bound once an individual articulation becomes part of a socially accepted and repeatable code.

The code is, though, inherently unstable, and Schleiermacher was fully aware that this instability is not something which philosophy should just try to overcome. The meaning of a word is dependent upon context:

> in its single appearance the word is isolated; its determinacy does not result from itself but from its surroundings ... The complete unity of the word would be its explanation and this is as little present as the complete explanation of objects (*HK* p. 106).

A word is understood 'via its being together with the words that surround it' (*HK* p. 116). The argument should by now be familiar: a word can only possess its sense via what it is not. The word involves, as it does for Derrida, a constitutive lack that must be completed by the words in the rest of the signifying chain.

The difference from Derrida lies in the fact that Schleiermacher sees this as a process between individuals in social life, not as something somehow happening 'in language' itself. For Schleiermacher there is an essential asymmetry between the desire to regulate linguistic practice and the semantic potential inherent in any utterance for an individual user of the language. As Manfred Frank puts it:

> In fact I never know what associations of meaning my partner in dialogue connects with the signifiers uttered by myself or by him. No criterion which is independent of dialogue guarantees that he and I connect the same referent [*Sach-Anzeige*] with the same word or sentence.[12]

The banal sense of the 'inadequacy' of language to experience is, in these terms, not just to be explained away by the empirical failure of the

language user to command the available resources of linguistic articulation. It is precisely the 'image' in the sense of the particular, unique happening of an unrepeatable moment, that is 'outside language' (*HK* p. 408), irreducibly particular in relation to the existing system of articulation. Because he takes individuality so seriously this means that Schleiermacher also sees non-violent communication between individuals as an imperative. In this way a theory of language inseparable from aesthetics adumbrates a political theory which would allow individuality to articulate itself without overriding the individuality of others.

Schleiermacher maintains that there is no symmetry of words and concepts: 'If someone wants to reduce words to concepts they always come to a multiplicity which cannot be united' (*HK* p. 366). The sense that words have an existence which is not reducible to how they are conceptually understood has been a factor in many of the arguments we have looked at so far. The effects of utterances are not limited to their propositional content, or the illocutionary intent of the speaker or writer. This obviously is the case in poetry. Schleiermacher's linking of this to music reminds one of Hamann's point that language is both sensuous and intelligible, as is music. Hamann had already suggested that the 'oldest language was music'.[13]

In *The Order of Things* Michel Foucault claims that

> The threshold between Classicism and modernity . . . has been definitively crossed when words cease to intersect with representations and to provide a spontaneous grid for the knowledge of things. At the beginning of the nineteenth century they rediscovered their ancient enigmatic clarity.[14]

By 'Classicism' Foucault means that time when words and representations intersect. Foucault points to something significant, but his argument is questionable. The divorce of language and representations is related to what Schleiermacher means by the irreducibility of words to concepts: Schleiermacher is writing at the time of words rediscovering their 'clarity'. The 'ancient enigmatic clarity' of language seems to be analogous to Schelling's view of language as 'faded mythology'. In mythology the idea that signifier and signified were separate could make no sense, so they do not even need to intersect. Foucault's argument is based on a Heideggerian philosophy of origins: for words to *re*discover their clarity means that they once had it. This version of the argument seems questionable to me.

More interesting is the fact that at this time in the early nineteenth

century in Germany the judgement that music without words was the highest form of art was becoming more and more current. The change in the status of language and of music relates to the reflection upon subjectivity that we have been considering. The initial fact about music that is important in this connection is that within a piece of music the notes exist for their own sake, without being bound to representation. It should be emphasised here, in order to avoid misunderstandings later in my argument, that this does not mean that the way the notes in the music of a particular society are ordered is not bound up with ideological questions: composers do not compose in a vacuum. The order of the notes is, though, never wholly comprehensible in terms of their social determination, because the order cannot be shown just to represent some other form of social practice or structure. Music is inherently able to sustain a degree of aesthetic autonomy, however minimally this may be the case in particular examples. The ideologically misused idea of music as a universal language is not merely a deception: in contrast to the incomprehensibility of unfamiliar natural verbal languages, unfamiliar music can make some kind of sense. This sense is somewhat akin to the sense of gestures in communication with someone who does not share your language.

Foucault claims that serious attention to the consequences of the shift in language away from representation only emerges later in the nineteenth century with Nietzsche: this is evidently not the case, in the light of the arguments concerning music we have seen so far. The emergence of the sense of language as being for its own sake, which is linked clearly to aesthetic theory, is linked in Germany to thinking about music. Schleiermacher shows this in the *Aesthetics*, by his attention to the 'musical' in language.

Music, like language, can be regarded as a system of differences with no positive terms: notes become what they are by their relation to other notes within a tonal system. Hegel linked this idea to the *Logic*. At a social level, music is differentiated from its other, noise, in terms of the accepted musical language of a particular society. What is acceptable can, of course, be changed by individual creative initiative.[15] The same, as Schleiermacher's arguments suggest, applies to language. In both music and language, deviating too far from any convention prevents the medium from being a form of communication. The locus of such deviation in modernity tends to be art, hence the association of art and madness. I have already suggested how these questions affect the individual subject's attempts to articulate him or herself in relation to the

dominant society. The interesting question will be why, in this historical context, music becomes so central.

Connections between language and music keep emerging in the early nineteenth century. Schelling points to one way of conceiving the issue of language and music when he links rhythm and self-consciousness in the *Philosophy of Art*. Rhythm is a means whereby difference can be transformed into identity: it can perform the function of Kant's 'reflective judgement' by synthesising a potentially endless series of phenomena into a significant unity. Novalis argued something similar. Schelling states: 'rhythm is . . . the transformation of a succession which is in itself meaningless into one which is meaningful' (I/5 p. 321/493); endless multiplicity becomes unified. Random repeated noise can become significant once it is schematised into some form of identity: this can be language or music. Interestingly, it is again music, as I suggested in relation to Hegel's *Logic*, where the fulfilment of the Idealist aim of the unifying of the transient moment in a higher totality is often seen as being located.

For Schleiermacher language is the means of schematisation that makes thought possible: the repetition of the signifier is a condition of meaning. The signifier, as Hamann had already suggested, is arbitrary and only becomes that signifier via its repetition: there is no essential relation between a word and what it designates. The signifier itself must be realised in some form of matter: either as script, marks on a surface, or the movement of the atmosphere as articulated sound. To the extent that consciousness and the creation of meaning are inextricably linked, as Schleiermacher has suggested, the boundary between the musical and the conceptual is not absolute. Some Eastern languages depend upon difference of pitch for semantic differentiations. Difference of pitch is obviously present in nature before semantic differentiation. Wittgenstein says that

> Understanding a sentence in language is much more related to understanding a theme in music than one thinks . . . One could imagine people who might possess something which is not totally dissimilar from a language: tonal gestures, without a vocabulary or a grammar ('Speak with tongues') . . . 'But what would the meaning of the sounds [*Laute*] be?' – What is it in music? Even if I do not at all want to say that this language of tonal gestures would have to be compared with music.[16]

Oliver Sacks' aphasiacs also suggest the way in which the rhythmic and the musical play an essential and never fully determinable role in meaning.

Rhythm as iterable difference – the same beat only becomes the same beat via the occurrence of the next 'same' beat – can be seen as the ground of linguistic articulation: the signifier can only become a signifier via its iteration. It is also dependent upon the gaps between itself and the other signifiers, upon 'determinate nothing'. I shall return to this issue in the coming chapters. At the same time, the signifier's meaning in any real act of communication is never just determined by its iterability. The other factors of context which cannot be determined in advance, the traces of the surrounding signifiers, are also essential, in the same way as the notes in a piece of music only make sense as part of the piece. Meaning is also dependent upon the movement of self-consciousness between the moments of articulation. What is clear is that the rhythmic and the musical are not contingent additions to language. This further supports Schleiermacher's case that interpretation has to involve 'divination'.

When discussing music in the *Aesthetics* Schleiermacher uses 'divination' in relation to the virtuoso's playing of the work of a composer:

> in performance there is always something which cannot be represented either by signs or words and which has to be found by divination. The composite marks which are supposed to represent the idea [of the whole piece] are largely laughable (*A* Lehnerer p. 75).

The score of the music is not the music itself. Virtuosity is simply mechanical and could effectively be computerised 'if one were to invent a complete system of marks for all the nuances that a note is capable of . . . finally one would be left, apart from reading correctly, just with the exactitude of touch and of the rests' (ibid. p 75–6). Recent technology has, of course, made this seem possible. Schleiermacher's point is that the mechanical side of interpretation does not constitute the real music, in the same way that effective interpretation of a text cannot be 'mechanised', and requires production on the part of the individual interpreter that is not subsumable into rules.

At a time when the adherents of 'artificial intelligence' are trying to persuade us that they will be able to construct language machines to do the jobs of translation and interpretation the view present in Schleiermacher is vitally important. In Schleiermacher's terms, the mechanisable aspect of language necessarily involves a reduction in the potential for signification that the need for divination counterbalances by introducing the individual into the process of understanding. Signification does necessarily entail rule-boundedness at some level. Yet rules – of

language, music, sciences – cannot be their own foundation. You cannot use science to ground science: the result is infinite regress. The production and use of rules is not the same as the rules themselves. Schleiermacher insists that rules do not bring their application with them. The rules come to us via language, which cannot, as the critiques of reflection we have been looking at made clear, be the logical foundation of itself: for this to be possible one would need Hamann's non-existent 'general philosophical language'. Novalis already spoke of music as a 'general language'. The 'musical' aspect of language emphasises the way that all communication has an irreducibly particular aspect which cannot be subtracted from it.

Whilst there is no doubt that the development of modern science depends upon the *exclusion* of much of this aspect of communication, or that such an exclusion is methodologically necessary, this does not allow us to assume the absolute priority of this dimension of the development of modernity. The growing awareness of the importance of the levels of communication suggested in Schleiermacher results precisely from seeing the negative consequences of this exclusion. Oskar Negt has suggested how, around Schleiermacher's time, 'human possibilities were superior to what was technically available'.[17] Now the opposite is increasingly the case: technical means have massively increased but what individuals can do with them has not kept pace. The advantage of Schleiermacher's approach is that it gives us reasons and means for theorising creativity in linguistic usage, and for explaining linguistic change. It does so whilst retaining the desire for a communicatively secured process of reason. Schleiermacher makes us aware that this reason must include the ineradicable aesthetic elements which he reveals in his account of self-consciousness. Schleiermacher also helps initiate many of the insights into language as praxis that will become central in the Bakhtin school and in the later Wittgenstein. He does so without the connivance with the assault of scientific modernity upon individual self-consciousness that is often characteristic of post-structuralism. Central to this achievement is his account of music. The ever greater gravitation towards the issue of music in the nineteenth century in Germany by those philosophers concerned with aesthetics will concern us in the following chapters. Philosophical aesthetics increasingly focuses on music as the paradigm for all art.

Music, language
and literature

Language and music

The understanding of music in German philosophy after Kant cannot be separated from that philosophy's perception of language. My reason for concentrating on music for much of the rest of the book is not because of a desire to write a specialised philosophy of music. The fact is that the relation of music to language, whether in the sense of music being seen as a language, or as revealing what language is unable to reveal, serves as an important indicator of the ways in which aesthetics in this period is linked to truth. Music can be regarded as a deficient means of articulation, or as a privileged one. This nexus is fundamental to the philosophical history of subjectivity being considered here.

In the last chapter Foucault was seen as arguing that a major change took place in language at the beginning of the nineteenth century. He regarded this as marking the threshold between 'Classicism', in which words and representations intersect, and modernity, where language is no longer tied to representation. Foucault's argument is oriented towards that development in literature which leads to 'poésie pure' and to the possibility that 'language may sometimes arise for its own sake in an act of writing that designates nothing other than itself',[1] as opposed to being the representation of a concept, or of a world. The way he tells this story omits any mention of Schleiermacher (or Humboldt). His examples are Grimm, Bopp, and, somewhat oddly, as we shall see, Friedrich Schlegel.

Foucault makes the emergence of philology and the attempt to make linguistics into a science inseparable from the emergence of 'Literature': 'Literature is the contestation of philology (of which it is nevertheless the twin figure: it leads language back from grammar to the naked power of speech)'.[2] The argument is dialectical: 'Literature' comes into

existence because of the emergence of the other of itself: a science of language. In the same passage Foucault goes on to see the work of Mallarmé in relation to this, characteristically giving language the attributes of subjectivity:

> To the Nietzschean question 'Who is speaking?' Mallarmé replies – and constantly reverts to that reply – by saying that what is speaking is, in its solitude, in its fragile vibration, in its nothingness, the word itself – not the meaning of the word but its enigmatic and precarious being.[3]

This observation can lead us to a more convincing approach to the change in the status of language than Foucault himself offers. The notion of the word minus meaning is close to the idea of a note in music.

Lévi-Strauss talks of musicality as 'Language minus meaning', and Novalis and Schopenhauer see music as a 'universal language', which somehow overcomes the lack of a general verbal language. Foucault concentrates on that aspect of reflection upon language which fits his thesis about the emerging new 'episteme': the fact that language itself becomes an object for science. The constitution of language as an object for science gives rise for Foucault to a dialectical opposite: Literature, which is, therefore, not an object of a science. It is, however, evident from Hamann onwards that a very different view of language also emerges in the *theory* of the time, most notably in Schleiermacher. According to this theoretical view it is impossible for language to be wholly transparent to itself. There is no 'general language'. The separation of a particular form of language into 'Literature' cannot, therefore, be wholly amenable to theory: the 'literary' is a potential of language *per se*, because of the ever-present role of individual productivity, and of what Schleiermacher called the 'musical'. The phenomenon I want to examine is the development of the idea of literary autonomy in German philosophy, as it takes place in relation to music. The implications of this development are not just important for aesthetics: they are also important for issues in contemporary philosophy.

Music is a topic that Foucault, like Heidegger, hardly ever seriously discusses, even though he was in fact very interested in it. This is not an isolated phenomenon: the demands of music as a discipline often lead to its untrained devotees being unwilling to commit themselves in discussion of it. The fact that its practitioners are themselves so often signally inept in enlightening others about music, except in performance, already points to what is at issue here. Theorising music is fraught with difficulties that lead one quickly into questions beyond music. Much

modern philosophy, and in particular much post-structuralist philo-
sophy, has a subterranean connection to music that has rarely been
adequately explored. It is worth also remembering how important music
was to Wittgenstein's conception of language. Music is neglected in
many accounts of philosophy and aesthetic theory, particularly by
Marxists, with the notable exceptions, in this century, of Adorno and
Ernst Bloch. At one level this is because music is, as Thomas Mann
claimed, 'politically suspect'. Its non-representational character easily
leads to it being disqualified as an emotional luxury which has not
attained the seriousness of real thinking and praxis. A somewhat ques-
tionable passage from Freud – do 'primitive languages' have *no*
grammar? – suggests why the language of music may be suspect in this
way:

> All the linguistic means via which the finer relations of thought are
> expressed, the conjunctions and prepositions, the changes of declination and
> conjugation, lapse, because the means of representing them are lacking; as in
> a primitive language without a grammar, only the raw material of thought is
> expressed.[4]

Freud is actually referring not to music but to dreams. The applicability
of the description to wordless music suggests how important music can
be in understanding subjectivity which is not reducible to conceptual
reflection. The 'royal road to the unconscious' sounds singularly like a
key aesthetic phenomenon.

Music has an odd dual status. On the one hand the basis of Western
music – the division of the diatonic scale – relates to the foundation of
the modern scientific world view, mathematics. On the other hand,
music's significance is, at least since the eighteenth century, often
perceived as being based on the emotions. Production and reception of
music engage the Understanding – the openness of music to invasion by
the new technologies makes this obvious, as does the importance of
musical rules. Music also engages the individual subject, in both
emotional and intellectual ways. Music's non-representational charac-
ter does, of course, make it liable to indiscriminate use in conjunction
with non-aesthetic practices like advertising. On the other hand, this
non-representational character can enable music to resist commercial
or other appropriation. The problems music poses for conceptual
thought make music an interesting test case for some of the major issues
of aesthetic theory.

Music comes to be seen by key nineteenth-century German thinkers

as the highest form of art. For this to be the case a substantial shift in the dominant view of music had to take place. The significance of this has philosophical resonances which we are still feeling. For reasons both to do with developments in music, and with developments in philosophy, music which is not accompanied by a verbal text, or which does not accompany a text, often comes to be regarded as more important than music with a text. From a union of music and language, where language is the senior partner, emerges a divorce, in which the formerly junior partner becomes autonomous and is no longer bound to represent what a verbal text can express. This happens together with the move towards non-representational conceptions of language. A potential fundamental change in the idea of truth is the result. If truth is supposedly inherent in the word, it is clear that anything which suggests that the word is no longer adequate as the expression of truth must have a devastating potential for philosophy. If music without words is a higher form than music with words, then music seems able to usurp the word's role as the locus of truth.

Hegel and music: the sayable and the unsayable

It is important first to return to Hegel, who regards music as a deficient mode of articulating truth, before moving on to thinkers who begin to give music a startlingly central role, such as the early Romantics, Schopenhauer, and Nietzsche. The difference between Hegel and the others with regard to music can also be seen as the difference between two important aspects of modernity. The failure to prevent this difference in the idea of modernity becoming too absolute, whereby Hegel is on the side of Reason, and the others on the side of irrationality, has led to many misunderstandings in the assessment of nineteenth-century German philosophy, most notably in Lukács' *The Destruction of Reason*. At the same time, the recent re-appropriations of Nietzsche in post-structuralism show little awareness of the need to do more than simply reverse Lukács' priorities, whereby Nietzsche embodies the 'virtues' that Hegel lacks. Much of the recent antagonism between Marxists and post-structuralists is a direct reflection of the tensions between Hegel and aspects of Romanticism which culminate in Nietzsche. Neither side has come off very well in the debate. It is time for a reassessment of this whole tradition.

In order to put Hegel's response to music in an appropriate context one needs to take a closer look at the change in the understanding of

music in Hegel's time. Carl Dahlhaus explores this change in *Die Idee der absoluten Musik* (The Idea of Absolute Music). At the end of the eighteenth century the idea that music with a vocal text was a higher form increasingly loses currency and 'conceptless instrumental music – and precisely because of and not despite its lack of concepts – was elevated to a language above verbal language'.[5] The concept of music that is replaced has Platonist roots. Music formerly consisted of Harmonia, Rhythmos and Logos:

> By Harmonia one understood regulated, rational relations of notes brought into a system, by Rhythmos, the temporal order of music . . . and by Logos, language as the expression of human reason.[6]

Composers, such as Haydn, had already begun to undermine this conception in praxis, well before the move away from the conception was grasped theoretically.

The necessity of the Logos, whether in the form of a liturgical text or as the words of a song, is still basic to Hegel's conception. Though he evidently enjoyed music, Hegel did not regard it as being particularly important, not least because of its necessary subordination to the word. His remarks in the *Aesthetics*, though enlightening in themselves, are probably most notable because of the way they epitomise a view of music which plays a role in much subsequent aesthetic theory, particularly in the Marxist tradition. Hegel's description of music is not far from Foucault's notion of the 'act of writing that designates nothing other than itself'. He does, though, draw the opposite conclusion about the value of such a act. In the section of the *Aesthetics* on 'Independent Music', music without words, Hegel says:

> Subjective inwardness constitutes the principle of music. But the most inward part of the concrete self is subjectivity as such, not determined by any firm content and for this reason not compelled to move in this or that direction, rather resting in unbounded freedom solely upon itself (*Ä* II p. 320).

The structure of the argument should be familiar from the *Logic*: 'subjectivity as such' is analogous to Being which only comes to itself by the other of itself: Nothing. Only when Being is articulated in the concept does it come to itself as the Absolute. Subjectivity for Hegel is only able to realise itself via objectivity, as the structure of reflection made clear. Music also requires the other of itself: if its principle is 'subjective inwardness', it must be externalised. The note expresses one

level of the substance, *Geist*, which is then transcended into higher forms. However, does the externalisation exhaust what the subject could be, or what music is? The problems of reflection we have already seen in Hegel recur.

For Hegel purely 'musical music' has to free itself from the 'determinacy of the word'. Instrumental, wordless, music will, he says, only really appeal to the expert. The expert will enjoy instrumental music because he will compare the music he hears with 'rules and laws he is familiar with' (*Ä* II p. 322), not in order to identify innovation, but rather to bring music under the concept. There is no sense in Hegel that music may be able to 'say' what no other means of articulation is able to. The expert will try to find 'more distinct ideas and a more familiar content' in the music:

> In this respect music becomes symbolic for him, but in attempting to grasp the meaning he is faced with puzzling tasks which rush quickly past, which are not always amenable to being deciphered and are capable in fact of the most various interpretations (ibid.).

Music thus entails the same issues as Schleiermacher sees in hermeneutics, which is concerned with the potentially endless variety of interpretation. The impetus of Hegel's philosophy is towards the increasing determination of Being by reflection. Hegel's suspicion of music results precisely from music's indeterminacy, from its failure to be amenable to unambiguous interpretation. Adorno's objections to Hegel's suppression of the 'non-identical' in art derive not least from Hegel's failure to see more in the problem of understanding music than a deficit on the part of music itself.

The musical note for Hegel echoes Mallarmé's idea of the word's 'fragile vibration': it is 'an expression which precisely by the fact that it is externality immediately makes itself disappear again' (*Ä* II p. 262). The body which vibrates to produce the note is negated in its static state, but it also returns to this state once the note has passed. Like other forms of art, but to an even greater extent, music is, therefore, characterised by transience. Furthermore, music's content is restricted:

> It admittedly also does have a content, yet not one in the sense of the visual arts or literature; for what it lacks is precisely objective formation [*Sichausgestalten*], whether it be formation into forms of real external appearances or into the objectivity of spiritual intuitions and ideas (*Ä* II p. 261).

Music thus lacks the engagement with the object world or the world of ideas, which would make it determinable. This is the task of the science

of music. Music fails to reach the level of conceptuality which is the result of the interaction of subject and object and remains just 'subjective'. Hegel makes the same point against Romantic irony, as we shall see. Whereas the plastic arts 'take up the forms of a broad, multiple world of objects into themselves', the note is 'completely abstract' (*A* II p. 261). It is worth noting here that this is strangely reminiscent of the objections Schelling and Feuerbach make to the end of the *Logic*, where, as Schelling puts it, the Idea 'has no need any more to become real any more and in any other way than it already is' (I/10 p. 152/569). Music and metaphysics are more closely connected than is often realised.

For Hegel the text which accompanies music or which music accompanies 'gives certain ideas and thereby tears consciousness away from that more dreamy element of feeling without ideas' (*A* II p. 306). It does not allow us to be randomly affected in our feelings in the way we supposedly are in purely instrumental music. On one level this makes obvious sense, if one sees the text as making the music be about whatever the text is about. Hegel does insist that the music must retain its own autonomy and not just be there in the service of a content dictated by the text. Essentially, though, Hegel considers that the higher form of truth is only possible via the articulation of conceptual ideas. Music can never attain this higher status because it is an expression of 'feeling' (*Empfindung*). 'Feeling' does not separate the subject that intuits from the object of intuition as we do in conceptual thinking when we define the attributes of an object: like a dream it takes place wholly within the subject and does not enter a structure of reflection which would give it objective validity.

Hegel's assessment of 'feeling' is consistent with his philosophical suspicion of Romanticism. Feeling, *Gefühl*, was the technical term in Fichte, Novalis, and Schleiermacher for the pre-reflexive spontaneity of the I. For Hegel it entails an unreflected presupposition which must be overcome for philosophy to be able to ground itself in the Idea. However, Hegel's attempt to establish his system in this manner raised the problems of reflection we have seen, and will be seeing again. For Novalis feeling could not be articulated reflexively because 'Feeling cannot feel itself' (*FS* p. 114). Feeling cannot be represented as itself because it is itself prior to reflection. It is the very basis of the possibility of philosophy, yet it cannot be represented.

The idea that a non-representational medium – music – might be most appropriate to 'represent' the irreducibility of self-consciousness to reflection occurs to more than one thinker in this period. The

temptation of this idea also results from the fact that the actual music of the time had already, before Hegel – and this is evident even from Hegel's being able to use it in the *Logic* – developed the kind of dynamic, all-embracing structure which Hegel will demand of pure thought. Music, though, is a non-representational form which concepts can never fully grasp: this will at times become linked to the idea that free self-consciousness cannot be understood in objective terms. The suspicion of philosophical representation that results from the new approaches to music in this period should not be dismissed lightly. They have arguably returned in another guise in contemporary philosophy, as we shall see in the next section.

The attribution of serious philosophical import to music in Hegel's time derives also from music's apparent proximity to nature. Hegel relates music to 'primitive' expressions, such as bird-song or wordless cries. Schleiermacher suggests the ambiguous status of music in relation to natural sound and to speech: 'For neither the expression of a momentary sensation by a . . . speechless natural sound, nor speaking which approaches song are music, but are only the transition to it' (Schleiermacher *A* p. 369). Music, it is essential to note, only results when there is a self-consciousness which *judges* it to be different from other types of articulation. The question is how this self-consciousness is to be understood.

In Hegel *Geist*, the universal process of thinking into which my consciousness must transcend itself to know itself, transmutes natural sounds into the higher form – music – in the same way that it takes the nature represented in a painting of a natural scene into something which is more than the contemplation of the scene unmediated by art would be. Music, like the concept which reveals the higher truth of sensuous immediacy, has to bring 'feelings into determinate relations of notes' and to 'take the natural expression out of its wildness, its raw state, and moderate it' (*A* II p. 273). The potential for repression in this process is evident: that which resists articulation into determinacy is unworthy of the concept. What, though, does philosophy do with it apart from try to suggest the need to overcome it? Hegel's dismissal of 'feeling' already suggests the problem, to which some thinkers of the time see art, and particularly music, as the answer. Hegel regarded the science of art, which articulates the conceptual truth contained in the sensuous appearance of art, as having become the higher form of truth. This view of art was already being questioned in Hegel's time. In the following, from E. T. A. Hoffmann's famous 1810 review of

Beethoven's Fifth symphony, the difference from Hegel's view is striking:

> Music opens up an unknown realm to man; a world that has nothing in common with the surrounding external world of the senses and in which he leaves behind all feelings which are determinable by concepts in order to devote himself to the unsayable.[7]

In one sense Hegel and Hoffmann both share a suspicion of the 'external world of the senses'. Their reasons are, though, very different. For Hegel the truth of music is eminently sayable in the form of philosophy. As we saw, in discussing the signifier 'I', Hegel maintained that the '*Unsayable*, emotion, feeling is not the most excellent, the most true but rather the most insignificant, most untrue' (*E* p. 56). For Hoffmann music can articulate the 'unsayable', which is *not* representable by concepts or verbal language.

Hoffmann's valorisation of music is, albeit unsystematically, related to the Romantic notion of 'feeling'. The point is not that music 'represents' feelings that are otherwise ignored by analytical thinking: the crucial aspect is the 'unsayable'. This is not always a mystical flight from Hegel's 'exertion of the concept', and has instead to do with the realisation that the life of my individual self-consciousness is not reducible to its conceptualisation. Hoffmann, it should be remembered, does not have a naive enthusiasm for music: he is both a talented composer, and a more than competent musicologist, as his review of Beethoven's symphony reveals. Hoffmann makes music into the means of access to other aspects of self-consciousness because of the way he sees the limitations of conceptual thinking.

Hegel's *Geist* articulates itself in an ascending series, culminating in philosophy. Conceptual articulation, a higher stage than music, depends upon language. The connection of language and music, though, gives rise to important problems for Hegel. Interestingly, Hegel himself actually describes music in a way which structuralist and post-structuralist thinkers would find appropriate to verbal language:

> the notes are in themselves a totality of differences, which can divide themselves and combine themselves into the most multiple kinds of direct consonances, essential oppositions, contradictions and mediations (ibid.).

The conception of the totality in which each element is the other of itself was already implicit in the analogies of music to the *Logic*.

The question is, given that sound and inscription, the media in which

both linguistic and musical articulation take place, are themselves required for understanding, how are they to be understood by philosophy? Schleiermacher had already shown that words and concepts are not symmetrical: concepts depend on words, and there are no concepts independent of linguistic articulation. Saussure suggested, applying ideas we have already seen in Idealism to language, that, instead of words being subsequent to ideas and representing them, the opposite is the case. The ideas themselves are dependent upon the differential articulation of the material of the signifier, whether the signifier be material marks or moving sound waves. The material itself is not central to the constitution of meaning: it is the *relationships* between the elements that count, not what the particular element is. Because meaning is independent of the specific form of existence of the signifier, it is not 'substantial', and seems to be grounded in 'nothing', the *difference* between signifiers. Saussure himself, it should be noted in passing, unlike his recent heirs, did not think that this obviated the need to think about the consciousness for which signifiers mean something.[8]

The structuralist view of differentiality derived from Saussure becomes a way of questioning the metaphysical division between the idea and the manifestation of the idea in language. The questioning of this division is fundamental both for post-structuralism and for analytical philosophy. Idealist thinking also must reject such a division: if there were an absolute division of sensuous and intelligible one would be returned to Kant's problems. Schelling's version of the issue points the way, as we saw in the comparison with Derrida, to contemporary questioning of metaphysics. Much the same applies to Schleiermacher. Schleiermacher's reflections on language paid great attention to music.

If, for Hegel, the determinate content of *music*, as opposed to the content of the text which music accompanies, is as closely linked to language as he suggests in his view of music with a text, then the relationship of concepts to language and of language to music must be more complex than he assumes. Linguistic elements can only signify within a context. Clearly something similar applies to music: the notes only take on their 'significance' in relation to musical contexts. Musical contexts are not absolutely different from linguistic contexts, as Schleiermacher demonstrated. Both verbal language and music require differential articulation of material. The question is whether one can make an absolute distinction between verbal language, as the medium of truth, and music. The distinction is now usually made at the level of use, as Schleiermacher's notion of language implied: we use language and

music differently. Hegel must make a much more emphatic claim.

The difficulties of seeing verbal language in the manner of Hegel were suggested in Hamann's remarks about the lack of a 'general philosophical language', and in Schleiermacher's hermeneutics, which opened up the need to consider dimensions of the functioning of language that are resistant to conceptual articulation. It sees these dimensions not as contingent additions, but as constitutive parts of language. Schleiermacher's attention to the 'musical', language as sound and dynamic transition based upon the movement of immediate self-consciousness, which cannot be objectified by philosophical reflection, thus has serious philosophical importance.

The problem with the way Hegel discussed the signifier 'I' in the *Encyclopedia* was that the structure of reflection failed to give a criterion of identity for the I. As Derrida has suggested, and at this stage of his argument he moves close to the critiques of reflection we have already looked at from Fichte onwards, the linguistic mirror in which I reflect myself – the signifier 'I' – is itself dependent upon difference, or *différance* for its own 'identity'. This makes both the I and the signifier unstable. In this perspective Hegel's description of music as a 'totality of differences' makes music less easy to distinguish from language than he realised. Language itself relies on difference, upon moving relationships between elements and, as such, tends to raise issues which are also issues in the comprehension of music. The central issue here is what deconstruction, in the wake of Heidegger, calls the 'metaphysics of presence'. What the term refers to can be seen in Hegel's conception of language in the *Phenomenology*.

Hegel describes language as

> the existence of Geist. It is self-consciousness which is *for others*, which is immediately *present as such* and is as *this* general [self-consciousness]. It is the self which separates itself from itself, which as pure I=I becomes objective to itself, receives itself in this objectivity equally as *this* self, as it flows together directly with the others and is *their* self-consciousness (*PG* p. 478–9).

Language is a moment of the substance's self-articulation: *Geist* would not be *Geist* without it, but language would not be communication with others without the total structure of *Geist* of which it is a part. In the *PG* the 'living substance is . . . Being, which in truth is *subject* or, what is the same, is in truth only insofar as it is the movement of self-positing or the mediation of itself becoming other with itself' (*PG* p. 23). No word can express the substance on its own but the substance becomes itself via the

process of self-reflection in the other of language. Language in Hegel is thus inherently part of the moving totality of *Geist*, the process of mediation of subject and object. Language's superiority to music is founded upon the fact that music lacks the 'objectivity of spiritual intuitions and ideas': music remains indeterminate in a way that language supposedly does not. Language and *Geist* reflect each other's presence.

The determinacy of language is already undermined by the fact that language always generates an excess of signification, which is not amenable to a final reduction to conceptuality, hence Schleiermacher's insistence upon the endless task of interpretation, which has no guaranteed telos. For *Geist* to achieve the highest conceptuality it has, for Hegel, as the *Aesthetics* argued, to overcome the sensuous, the finite, including the finite in language. It is arguable, however, that there is a sense in which 'absolute music' is able to do this more effectively than language as Hegel conceives it. Music, like verbal language, is a form of sensuous articulation, but it can be seen as a purer form of articulation, in that the relationships in music, at the same time as generating pleasure, can escape the kind of overdetermination which is inherently part of even the most abstract verbal language. The desire to express philosophy in purely mathematical terms results from the attempt to overcome this problem. The following passage from Lukács' 1910 *The Soul and the Forms*, which formulates an aim akin to Idealist metaphysics, suggests an analogous idea for music. The aim is to:

> arrive where everything becomes necessary because everything expresses the essence of man, nothing but that, completely and without residue – where everything becomes symbolic, where everything, as in music, is only what it means and means only what it is.[9]

Music is perceived here by Lukács as being best able to articulate the highest principles. Because the relationships in music are self-sufficient, music is not bound in the ways that other forms of philosophical articulation are. The language of philosophy generates an excess which is extraneous to its highest aim of total self-transparency. The 'excess' in musical signification can be seen as being of the essence of music, whose necessities are at one level solely its own. As such, the overcoming of the division between freedom and necessity can be seen as becoming sensuously, but not conceptually, available in music. Both Hegel and Kant believe that music is actually an empty play of forms because of its lack of determinate content. On the other hand, because

the significance of music cannot be determined in objective terms, it points to a notion of subjectivity which cannot be reduced to its reflection into objectivity.

Hegel's major problem is that he relies upon such a reflexive identification to ground his conception of language. Hegel has to presuppose the self-recognition of *Geist* in the other of language. Nothing within thought can guarantee that the verbal system of differential marks really reflects the truth of thinking, unless this has already been presupposed. The problem is the one identified by Schelling and Feuerbach in relation to the Idea: for Hegel *Geist* and language already have the telos of their identity within them, which means that ultimately there is nothing unsayable. Language's differentiality, though, means, as we shall see, that its own foundation is unsayable. Hegel claims, in a classic version of the 'metaphysics of presence', that *Geist*, having objectified itself in the other of language, returns to itself, realising that language was the other of itself. But, as we have repeatedly seen, *Geist* would *already* need to be familiar with itself for such a re-cognition to take place. The medium through which *Geist* articulates itself cannot provide *Geist* with a criterion for identifying itself. The connection of this problem to music has recently again been explored in deconstruction.

The presence of music

In his essay on Derrida, 'The Rhetoric of Blindness', Paul De Man describes the 'metaphysics of presence' as 'a tradition that defines Western thought in its entirety [*sic* (!)]: the conception of all negativity (non-being) as absence and hence the possibility of an appropriation or a re-appropriation of being (in the form of truth, of authenticity, of nature, etc.) as presence'.[10] In Hegel the presence of consciousness to itself is reliant on the other of itself: both the signifier, and the other consciousness. 'Presence' is supposed to be guaranteed by the structure of reflection, by the recognition of the other as the other of oneself. De Man thinks, with Derrida, that this conception can be deconstructed. Ironically, De Man's totalisation of 'Western thought' deconstructs itself when he sees Rousseau, in the same essay, as revoking this notion of presence in certain aspects of his view of music. De Man will also inadvertantly return us to the fact that parts of the tradition we have being considering did not, as we have frequently seen, just think of 'presence' in terms of the reflection model of consciousness.

De Man shows that, in the *Essay on the Origin of Languages*, Rousseau

was aware of the differential constitution of music and its relationship to language: 'With remarkable foresight, Rousseau describes music as a pure system of relations that at no point depends on the substantive assertions of presence, be it as a sensation or as a consciousness'.[11] What makes a musical sign a sign is supposedly neither its iterability nor its reference to a 'state of consciousness':

> Music does not imitate, for its referent is the negation of its very substance, the sound. Rousseau states this in a remarkable sentence . . . 'It is one of the main advantages of the musician to be able to paint things that one could not hear, whereas it is impossible for the painter to represent things you cannot see; and the greatest feat of an art which operates only by movement is to be able to convey by movement the very image of repose' (translation of Rousseau amended).[12]

De Man wishes, against Derrida's interpretation of Rousseau in *Of Grammatology*, to make Rousseau's own connection of music and language into a way of deconstructing the 'metaphysics of presence':

> Like music, language is a diachronic system, of relationships . . . The structural characteristics of language are exactly the same as those attributed to music: the misleading synchronism of the visual perception which creates a false illusion of presence has to be replaced by a succession of discontinuous moments.[13]

Although De Man may differ from Derrida in his reading of Rousseau, his argument is the same as Derrida's with regard to the deconstruction of presence, and it gives rise to the same problem.

De Man's and Derrida's attacks on presence are challenging because they move away from the idea that the process of the transformation of meaning could ever be brought to a close. Music is particularly apt as a way of suggesting this because of its inherent temporality, because it is non-representational, and, as Hegel put it: 'capable . . . of the most various interpretations'. De Man says of Rousseau's conception of the musical sign:

> the musical structure obeys an entirely different principle from that of structures resting on a 'full' sign, regardless of whether the sign refers to sensation or a state of consciousness. Not being grounded in any substance [in the sense of that which would guarantee that it is a sign at all by its transcendence of temporality, A. S. B.], the musical sign can never have any assurance of existence. It can never be identical with itself or with prospective repetitions of itself . . . the identities of physics have no bearing on the

mode of being of a sign that is, by definition, unaffected by sensory attributes.[14]

De Man assimilates this argument to a notion of aesthetic autonomy, based upon music's non-representational character, which allows it to be purely relational. This notion of autonomy will be transferred to painting and other forms of art, and Schlegel applies it to 'literature'. The relationship of music and language means that 'What is here called language . . . differs entirely from an instrumental means of communication',[15] because it is pure differentiality. Art becomes constituted by lack of 'plenitude': it is the opposite of substantialist metaphysics. The argument is close to Foucault's idea of the 'act of writing that designates nothing other than itself'. This is in many ways a negative version of Kant's sublime, and an inversion of the Romantic idea of music which emerged from it. Instead of independence from the sensuous pointing to the unrepresentable supersensuous, it now points to the end of 'presence', the end of metaphysics.

Metaphysics in this argument depends, therefore, upon language as instrumental means of communication, which is another version of Heidegger's idea of metaphysics as the subjectification of Being. The move beyond such subjectification in De Man leads to a view of art and language in which art and language are inexplicable in terms of a constitutive subjectivity. However, there are serious problems with the way De Man argues for the negation of 'presence', which suggest other possibilities of theorising the issue of language, music, and self-consciousness.

The initial problem is simple: what criterion does De Man have for talking about 'music' at all? However minimally, there must be some identity between differing cases of this form of articulation, which would enable them to be regarded as *musical* signs. This is also the case even if music and language are wholly assimilated to each other as 'pure systems of relations'. The very notion of *signification* cannot be just the result of the differentiality of the inert matter of the signifier: there must be that for which there is significance. As we saw in relating Schelling's identity philosophy to Derrida, the movement of difference must be available to something which remains the *same*, for it to be difference at all. The fact is that this kind of identification requires a notion of self-consciousness not based on reflection. In De Man's argument music is characterised by the sign which is the negation of the 'full' sign: a full sign functions, one presumes, as language does in Hegel, as the

presence of the infinite in the finite as the other of itself. In music the sign is supposedly empty. Is this, though, really a convincing way of approaching music, or language?

We arrive here at another result of the failure to think self-consciousness appropriately. Both De Man and Derrida necessarily reject, in much the same way, the reflection model of consciousness. Derrida does this in a manner which leads him at one point to what Manfred Frank appropriately refers to as a 'Hoffmann-esque Nachtstück'. At his most pessimistic, Hoffmann's despair at reflection led him to Fichte's worry: 'And do I really think or do I just think a thinking of thinking?' (*Werke* 2 p. 252): for Hoffmann music could provide a way out of this despair because it revealed the true life of self-consciousness beyond the dead matter of reflection.[16] Derrida evokes consciousness' dependence upon the unstable differential other of language via the bizarre metaphor of a mirror without a tain, which would reflect an uncontrollable otherness back to me – a characteristic Romantic nightmare. The metaphor of the unstable other could also be music in De Man's sense of the empty sign. Derrida moves from the mirror to the paranoid fantasy that 'A language preceded my presence to myself . . . a phrase was waiting for "you", is looking at you, is watching over you'[17] as a description of subjectivity's relationship to language. 'You' cannot know who 'you' are because you must surrender to the waiting signifier.

The argument is, though, incoherent: it gives one no way of understanding the most obvious facts of self-consciousness. It is true that I cannot give a cognitive account of my identity in the way I identify an object, and I may misrecognise my own motives. However, I have no trouble being aware that I *think* Derrida's argument is basically absurd, even if it turns out later not to be. I do not need to argue about this fact and am infallibly aware of it as I write this sentence. In the desire to avoid any sense that the subject could be 'self-present' Derrida transfers attributes of self-consciousness into language, making attributes of subjectivity into attributes of objectivity. Derrida's language that waits, looks, and watches still leaves one with the problem of how differential articulations can wait, look, pay attention, hear something as music, or think something absurd. The idea that these may be attributes of a consciousness that cannot be theorised in terms of reflection seems, as Frank shows,[18] not to have occurred to him. De Man's enlisting of music as a means of deconstructing 'Western thought in its entirety' in fact only reveals the inadequacy of his way of

thinking about self-consciousness. One cannot think of subjectivity in terms of self-presence, but that does not obviate the need to explain its role in the functioning of systems of articulation.

It is not inappropriate to link music to the problem of thinking about language and self-consciousness, as we already saw in Schleiermacher. Manfred Frank suggests that, in a view of language based on differentiality, the 'musicality' of language in poetry, which depends upon the rhythm of language, cannot be adequately explained by the assumption that there are two dimensions of language, the poetic and the referential:

> For if – according to Saussure – a language only consists of differences, and if, furthermore, the differences are unsayable, then one can justifiably claim that the unsayable is the ground of the sayable.[19]

The significance of the repetition of a word in a poem or, for that matter, in any text, is not inherent in the word repeated, but rather in the unsayable *transition* from the same, to the different, back to the 'same' which now has a different significance. What the subject does in language is 'unsayable' because saying something depends upon that which could not appear in the articulation itself. The articulation depends upon difference. Difference cannot be said because it is itself the condition of possibility of language. The other condition of possibility is the interpreting subjectivity for which the differential marks mean something. That meaning, as we saw in Schleiermacher, also depends upon the individuality of the subject.

The importance of the view of language suggested by Schleiermacher and Frank is not just important for art. It points to a dimension of communication which reveals aspects of subjectivity to which little attention is paid in the dominant conceptions of language in modernity. Oliver Sacks tells how difficult recognising aphasia can be, to the point of requiring a computerised voice synthesiser, because the patient would otherwise use all sorts of extraverbal cues to understand what is being said by another person: 'With the most sensitive patients, it was only with such grossly artificial mechanical speech . . . that one could be wholly sure of their aphasia'.[20] These patients have, tragically, lost something essential, but

> something has come in its stead, has been immensely enhanced, so that – at least with emotionally laden utterance – the meaning may be fully grasped even when every word is missed. This, in our species, *Homo loquens*, seems almost an inversion of the usual order of things: an inversion, and perhaps a reversion too, to something more primitive and elemental (ibid.).

Despite tending towards that side of Rousseau which invokes a pre-lapsarian state of things, which Derrida aptly unmasks in *Of Grammatology*, Sacks does suggest ways in which language in modernity can involve more than just the inescapable primary repression of the insertion into the symbolic order. At some level the dimension of language which is, as Schleiermacher put it, 'mechanisable' comes, towards the end of the eighteenth century, to be viewed with suspicion by many thinkers. The mechanisable side of language may be a repression of other vital dimensions of articulation, potentially present in language, which relate to deeper layers of self-consciousness. These dimensions are frequently associated with music.

In Proust's *The Captive* the narrator says the following on hearing the Vinteuil sextet:

> And, just as certain creatures are the last surviving testimony to a form of life which nature has discarded, I wondered whether music might not be the unique example of what might have been – if the invention of language, the formation of words, the analysis of ideas had not intervened – the means of communication between souls. It is like a possibility that has come to nothing; humanity has developed along other lines, those of spoken and written language.[21]

The pre-lapsarianism should not obscure the fact that there must be some real deficit in verbal language for the notion of another form of communication to arise in this way. Proust echoes ideas originating in German Romanticism – Novalis and others ponder the idea of a 'purely poetic language' with no determinate meaning – which lead the Symbolists at the end of the century to the attempt to write 'absolute poetry' as a means of renewing a language which is seen as increasingly inadequate to what the poet wishes to express. Even if this dissonance in the subject is insuperable, a naive wish for 'full presence', it is also the source of significant works of modern art.

The key issue is the rise of aesthetic autonomy. The fact is that the idea of the autonomous work of art comes about via the rise of the idea of absolute music. Both involve a change of attention, away from semantic determinacy in language, to the sense that what is really important is unsayable. We saw the philosophical basis of this in Novalis. However, this is a complex issue, and the links of later German Romanticism to Nazism suggest that one should tread carefully in this area. The philosophy of origins which suggests there was a time when things were better tends to forget that things might have changed because in other respects

they were so much worse. At the same time, ignoring the widespread feeling that the price paid for conceptual determinacy in communication is too high because it reduces sensitivity to other aspects of communication is a mistake. Sacks and Proust both point to a concern which has recurred in many ways throughout modernity, and has recently occurred again.

This concern is, I suspect, the social root of the amazing popularity of deconstructionist readings in literary studies in the USA. Misguided as the results of these have often been, they are a symptom of the repression felt by individuals in a culture which depends to such an extent upon the objectifiable determinacy of language for its functioning. In many ways this side of deconstruction is a re-run of early Romanticism's worries about the dangers of the potential tyranny of Enlightenment thinking. One can back up this claim by the fact that most of the theoretical basis of deconstruction is present in certain interpretations of Romantic thinking.

It can be suggested, as was already apparent in De Man's interpretation of Rousseau, that there is a 'birth of deconstruction out of the spirit of music', part of the genesis of which I want consider here. Romantic philosophy often sees music in ways which are analogous to deconstruction's view of texts. Understanding this requires a re-examination of the history of language and subjectivity in Idealism and Romanticism of the kind I have been trying to outline. The important historical phenomenon is the one Dahlhaus shows in *The Idea of Absolute Music*. Along with the flowering of musical creativity associated particularly with Beethoven, which gave impetus to the idea of absolute music, goes the elevation of music to a status which is inconceivable in Hegelian terms. This elevation changes the perception of language in the ways which are most coherently apparent in Schleiermacher. Instead of language being seen as an object of analysis and ordering by a science of language, its 'other side', the side of dynamic transition and resistance to systematic ordering, comes to the fore.

Infinite reflection and music

In the section of the *Aesthetics* on 'Irony' Hegel argues that Friedrich Schlegel's notion of irony is a result of Schlegel's Fichtean notion of the ego as the absolute principle of knowledge which posits the non-ego: 'What is is only through the ego and what is through me can just as much be destroyed by me again'; as such, everything is regarded as 'produced

by the subjectivity of the ego' (*Ä* I p. 72). The echoes of his remarks about music should be clear: music for Hegel is limited because it is subjectivity 'resting in unbounded freedom solely upon itself'. The freedom of Fichte's ego is completely abstract. In Schlegel this leads to the idea of living one's individual existence 'artistically', Hegel claims. All that I produce is solely 'appearance', lacking the 'seriousness' that results from engagement with an objective social reality. Because of this lack of seriousness any product of the subject can just as easily be dissolved in an all-consuming irony. There is no investment in subjectivity transcending itself into the objectivity which would result from the encounter with other subjects. The structure of this argument mirrors Hegel's concern that music fails to objectify itself either in the form of determinate objects or ideas. The puzzling side of music without a text for the expert, which made it 'capable . . . of the most various interpretations', is also present in Hegel's negative view of the implications of early German Romantic notions of irony. In the light of the varying contemporary versions of the indeterminacy of interpretation, this requires further investigation.

As we saw, one of the main targets of the contemporary attacks on modern metaphysics is Hegel. Many of the arguments against Hegel parallel aspects of the thinking of Schlegel and Novalis, figures who can hardly be regarded as proponents of the 'post-modern' era of indeterminacy announced so portentously by Lyotard and others. Modernity is much more diverse and complex than its critics allow. Much of the substance of the arguments against Hegel recurs in the context of music: it is no coincidence that one of the ancestors of post-structuralism, Nietzsche, will, despite all the other shifts in his philosophical position, retain certain aspects of a view of music which he develops early in his career. This view derives clearly from Idealism and Romanticism, as I shall show in the final chapter.

Friedrich Schlegel makes it clear how important he finds music, in the 'Literary Notes' of 1798:

> . . . beauty (harmony) is the essence of music, the highest of all arts. It is the most *general* [art]. Every art has musical principles and when it is completed it becomes itself music. This is even true of philosophy and thus also, of course, of literature [*Poesie*], perhaps also of life. Love is music – it is something higher than art (*LN* p. 151).[22]

Like much of the work of the early Romantics this piece of apparently shameless hyperbole is only comprehensible in relation to diverse other

statements on the same subject. Early Romanticism juxtaposes positions in a manner which does not lead to an overall unambiguous statement about the matter in hand. To understand what might be meant by 'music' in this context – it is evidently rather more than most people would understand by the term – we need to look again at the philosophical tendencies of early Romanticism. Novalis saw music as allowing the mind to be 'for short moments in its earthly home' because we are '*indeterminately* excited by it'. The very fact that Romantic thinking does not insist upon the primacy of conceptual determination means that interpreting the significance of such thoughts is something of a tightrope walk. Schlegel and Novalis can be read in terms of the central argument of the present book: they offer resources for a view of subjectivity which does not reduce it to a structure of reflection. Sometimes, however, they can also be read in the terms of the sort of post-structuralism exemplified in Derrida and in De Man's reading of Rousseau on music.

The key secondary work for this very difficult area is still Walter Benjamin's 1919 *The Concept of Art Critique in German Romanticism*. Though subsequent research has revealed much about the early Romantics that Benjamin could not have known, his approach has remained valid in its essential outlines. Benjamin, like Hegel, regards Fichte as *the* figure behind the development of early Romantic thinking. Fichte's insistence upon the irreducibility of the subject to objectivity led, as we saw, to a potentially endless exploration of just what consciousness might be or of how it works. A serious conception of Romanticism, for Benjamin, depends on how one approaches the possibilities of this exploration. Benjamin argues that Schlegel and Novalis start with aspects of Fichte's thought but that they reach, albeit not always consistently, an essentially different position from Fichte.

The question of reflection is the central issue for Benjamin. The attempt of modern subjectivity to grasp itself goes hand in hand with the genesis of aesthetic theory. We saw how Fichte and others raised the problem of the regress of reflection in the attempt of consciousness to ground itself as the principle of philosophy. In order to escape this regress, in which the I doing the thinking must separate itself from the I that is thought, and yet at the same time somehow establish its identity with itself, Fichte posits an immediacy of consciousness which does not depend upon reflection. Benjamin describes this process as follows:

Thus Fichte is looking for and finds an attitude of mind in which self-

consciousness is already immediately present and does not need first to be summoned by a reflection which is in principle endless.[23]

The essential principle of consciousness is the free action, the *Tathandlung*. This ground of reflection cannot be available to reflection because it is required for the reflection to take place at all. In Benjamin's terms it therefore remains unconscious, and in some way external to reflection. However, Benjamin suspects notions of the unconscious. This leads him to explore the idea that the Romantics offer a different conception of reflexivity, which is not dependent upon an unconscious foundation.

Benjamin sees 'endless reflection' as the central idea in early Romanticism. Regarding the process of reflection as an *empty* infinite regress, whereby self-consciousness could never result because the series I think I think I . . . etc. carries on *ad infinitum* is, Benjamin claims, not necessarily the only way to see reflection. The Romantics see the process of reflection as the potential for endless articulation, and thus as something 'fulfilled'. Hamann had seen endless reflection in terms of a celebration of the multiplicity of God's creation. For the Romantics, in Benjamin's reading, articulation is its own foundation, and does not require an immediate foundational point from which to develop. There is in this view no 'action' of the kind Fichte regards as the necessary origin of thought, which thought itself cannot articulate. For the Romantics, Benjamin claims, 'reflection is logically prior . . . Only with reflection does the thought emerge that is reflected upon'.[24] The idea is quite close to Hegel, for whom, as we saw, the immediate always already requires the other of itself. The thought is always already split by reflection. Whether this interpretation is applicable to the Novalis of the Fichte-Studien is more than dubious, as the concept of 'feeling' suggested.

Benjamin wants to point to the – non-Hegelian – sense in Romanticism that there is no ultimate goal of articulation beyond the process's endless diversity, which connects nature, art, and language, without the need for an initial self-presence of the subject in terms of which this takes place. This is similar to Hamann, for whom a reduction of articulation would diminish the capacity to celebrate the divine. Hamann, as we saw, considered music to be the oldest language.

In the light of what we discovered above in relation to Hegel and Derrida, it is not surprising that Benjamin's position is similar to Derrida's account of *différance*. Derrida states in *Positions* that

'différance is not preceded by the originary and undivided unity'.[25] The subject is secondary to the movement of *différance*:

> the subject . . . depends upon the system of differences and on the movement of différance . . . it is not present and above all not self-present before différance . . . it only constitutes itself by dividing itself.[26]

The Romantic notion of 'endless reflection' can, then, be regarded as a version of 'absolute difference' which has no originary point of identity from which to organise or ground the movement of differentiation. Thought can, in this view, create endless new reflections that cannot be 'foreclosed' by an original or terminal foundational act or thought. Benjamin maintains that Schlegel and Novalis understand 'the endlessness of reflection as a fulfilled endlessness of connection [*Zusammenhang*, which also means 'context']: in it everything is supposed [to connect] in an endlessly multiple manner'.[27]

The notion of *Zusammenhang* is analogous to Derrida's 'text', in which each element can only signify via its bearing the traces of the other elements of an indeterminable context. One is reminded of Derrida's dictum that 'il n'y a pas de hors-texte', the 'text' being the 'condition of possibility' of what Derrida charmingly refers to as the 'effect of subjectivity'. Because we are always already located within the language we use to consider subjectivity there can in Derrida's terms be no access to subjectivity which is not already within the 'general text' required for there to be subjectivity at all. In the same way as Derrida rejects Heidegger's notion of Being because it would have to possess the status of a 'transcendental signified' that is beyond any possible articulation and would escape the 'play of différance' of the general text, the Romantics, as seen by Benjamin, refuse Fichte's and Schelling's notions of the Absolute because it must always already involve difference. This is another, but, as I shall suggest, problematic, way of stating the difference between an Idealist and a Romantic conception of philosophy.

Schlegel ponders the question of foundations in philosophy and suggests:

> In relation to every concept and every proof one can again ask for a concept and a proof of the same [concept and proof]. For this reason philosophy must begin in the middle like the epic poem, and it is impossible to present it and add to it piece by piece in such a way that the First would be completely founded and explained for itself from the very start.[28]

This argument denies any founding status to such concepts as Fichte's I or Being: they can never be stably grounded in an extra-linguistic manner because language always involves difference. It suggests, as Derrida does, that such a concept will always be dependent on an unstable other, which robs it of any inherent identity.

There are, though, problems with this version of how Romantic philosophy sees endless reflection. Winfried Menninghaus, who links his interpretation of the Romantics to both Derrida and Benjamin, characterises endless reflection like this: 'one can say that the whole "Being" of endless reflection consists, as a totality of relation, in the reflectings of all its parts: a decentered continuum of centres of reflection'.[29] Unfortunately this does not make sense. For something to be a '*centre* of reflection' it must have a periphery which is not itself. The critique of reflection theory made it clear that such a centre would have already to be non-reflexively aware of itself for it to be able to define itself against its other. If the 'decentred' centres (?) (elsewhere Menninghaus talks of difference becoming a '(non-absolute) Absolute' (!)[30]) do not have a way of being centres and not peripheries, it is impossible even to use the notion of a centre: there would be no difference between centre and periphery. Menninghaus' interpretation, and at times Benjamin's, is simply another version of the discredited reflection model of consciousness, which, in its haste to escape any foundation in subjectivity, ends up with no way of accounting for the most obvious features of awareness and self-awareness. A non-reflexive conception of individual self-consciousness like Schleiermacher's is perfectly able to allow that philosophy could not found itself from the very start, which is why it sets up a dialectic which tries to facilitate the admittedly endless, but socially necessary, attempt to overcome difference without repressing individuality.

Despite these objections Benjamin's version of endless reflection can be productively linked to a theory of the work of art, and to a theory of language, which point forward to many of the issues of contemporary literary theory. In the process art is seen in a manner similar to the *System of Transcendental Idealism*: it is in fact at times given a higher status than philosophy. How, then, is the theory of endless reflection linked to the work of art?

The argument resembles Schelling's contention that art works can be endlessly interpreted 'as if they contained an infinity of intentions, whereby one can never say whether this infinity lay in the artist himself or just in the work of art' (I/3 p. 620/688). The similarity is based upon

the sense in which art works resist being reduced to objects of knowledge, to being determined as an object by a subject. The *STI* saw art, in characteristic Idealist fashion, as that which combines the conscious and the unconscious, which thereby involves a moment of stasis, in which all reflection ceases. The identity of subject and object is documented in art which is, therefore, the organ of philosophy. As we saw, Romantic philosophy does not allow a direct intuition of this identity, and instead sees it as only present in the sense of incompleteness we feel in relation to art, which always points to more than it can say. This leads to potentially infinite reflection and the introduction of temporality into the understanding of art.

For Schlegel the work of art is the medium of reflection which can never be exhausted, for the reasons which Novalis adduced to explain the unrepresentability of the Absolute. The

> romantic work of literature [*Dichtart*] is still in a process of becoming; yes, that is its real essence, that it can eternally only become, can never be completed. It cannot be exhausted by any theory.

The work of art multiplies itself 'as if in an endless row of mirrors' (*KSF* 2 p. 115). The problem with this is present in the metaphor: if a mirror only reflects in another mirror there is nothing to be seen. At the point where Romanticism joins *différance*, where each signifier is only mirrored in the uncontrollable other of itself, the problems we have explored recur. Often, though, the argument is closer to Schleiermacher's account of interpretation and the 'musical'. The 'mirrors' can be individual self-consciousnesses who can never exhaust the work of art, but who also contribute to its mode of existence as a dynamic entity. This enables one to understand why major works of art can outlast the varying manners of their reception.

Schlegel's theory has become most familiar in relation to the concept of irony and the theory of the novel. In discussing the novel, though, he frequently links it to music. The two are not wholly separable. This is because Schlegel uses music to ground the aesthetic autonomy of the literary. There is a tendency in recent literary theory to assume that any notion of the 'literary' is indefensibly Platonist. Any argument invoking Literature supposedly fails to take account of the fact that literature is a contingent historical product. However, it is important to be able to give an account of how the potential for meaning of texts is never reducible to the explication of the text in psychological, historical, and other terms. This, it seems to me, is one way in which the notion of the literary can

still be effectively used. It is a less mystified version of the phenomenon to which we saw Foucault referring at the beginning of the chapter.

Even though, as has often been argued recently, one can see the same rhetorical and 'musical' aspects of language in the *Sun* and Jane Austen, this does not mean that it is pointless to show just how much else goes on in enduringly significant texts of a culture, which does not go on in a sustained fashion in popular newspapers. Schleiermacher's refusal to make absolute divisions in aesthetics makes this possible: there may be a great line of verse in today's *Sun*, but Shakespeare's sonnets tend to consist of little else. Hopefully nobody but historians will read today's *Sun* in four hundred years' time.

Derrida emphasises how important the emergence of the notion of 'literarity', which he sees mainly as an achievement of Russian Formalism, is to his project of philosophical deconstruction.[31] He maintains that the notion of literarity enables one to avoid reducing texts to thematic, sociologistic, historicist, or psychologistic readings, as well as forcing one to see how this aspect of a text is also present in philosophical writing. It is, though, vital to be able to describe properly how this awareness of the over-determination of literary discourse – which is a product of the issues being considered here – comes into being historically.

The theory of endless reflection is connected in complex ways to the new awareness of music, and to the actual music emerging at this time in Germany. The two cannot be separated: without the growth of the public importance of instrumental music the theories being discussed here are much less easy to account for. The genesis of an important philosophical idea is, therefore, related closely to aesthetic theory and praxis. (This is not, of course, to deny that philosophical ideas do not influence significant art, including music.) Schlegel maintains in the *Athenäum-Fragments* that:

> Many people find it strange and ridiculous if musicians talk about the thoughts in their compositions; and often it can happen that one sees that they have more thoughts in their music than about it. But those who have a sense for the wonderful affinities of all arts and sciences will at least not look at the matter from the flat viewpoint of so-called naturalness, according to which music is only supposed to be the language of feeling, they will in fact not find it per se impossible that there is a certain tendency of all pure instrumental music towards philosophy. Must pure instrumental music not create a text for itself? and is the theme in it not as developed, confirmed, varied and contrasted as the object of meditation in a sequence of philosophical ideas? (*KSF* 2 p. 155).

The polemic against the doctrine that music is just the expression of emotions is accompanied by an extension of the significance of music that leads to a completely different view of language.

The aspect of language which is not semantically determinable and is also present in music is given a status that is at least equivalent to language's pragmatic utility. The referential and the expressive sides of language are of equal importance. Given philosophy's necessary relation to language this means that music can itself have a 'tendency towards philosophy'. Elsewhere Schlegel refers to Kant's repetition of ideas as making his texts 'musical enough', and to Kant's 'musical repetition of the same theme'. Menninghaus sees the notion of musicality in language, where repetition creates other dimensions of reflexivity, as directed against language's functioning in terms of already established meanings and direct referentiality. It does not mean, then, as both Foucault and De Man implied, that language becomes something purely self-referential, in the form of Literature, the dialectical other of the science of language. Strangely, it was Schlegel whom Foucault saw as one of the initiators of the science of language in this period. Foucault's account makes the genesis of the notion of literary autonomy too separate from the aesthetic praxis of the time.

Language ceases to be regarded from the point of view of representation, for reasons more connected with other areas of aesthetics, particularly music. The 'musical' aspect of language has nothing to do with representation, what it articulates has to be understood in terms of the differential organisation of language, but it is not simply reducible to this, as we saw. This dimension of language gives the impetus to what Foucault sees as the separation of literary language from the 'discourse of ideas'. Schlegel says of the novel:

> The method of the novel is that of instrumental music. In the novel even the characters may be treated as arbitrarily as music treats its theme (*LN* p. 146).

In the famous review of Goethe's *Wilhelm Meister* Schlegel uses the analogy of the novel to music, seen in such statements as 'The second book begins by repeating musically the results of the first' or 'This harmony of dissonances is even more beautiful than the music with which the first book ended', as a way of grounding the autonomy of the literary art work.

This autonomy is not least a result of the change in the conception of music we have been looking at. Music with a text is no longer superior because language as representation is no longer able to claim that it

exhausts the truth. In Romanticism the truth lies in what language cannot say. The changed perception of the non-representational character of music, which makes it into the highest art for Schlegel, becomes a model for the other arts. Knowing about music does not exhaust the significance generated by its internal relationships, its potentially infinite reflection, because they cannot be understood as representing anything determinate. Similarly, instead of characters and events being the 'final purpose' of the novel, whereby the novel would be seen as 'representing' a world in the way, say, a newspaper or history book would, Goethe's novel is a book 'which one can only learn to understand out of itself', which is an internally self-reflecting structure (*KSF* 2 p. 159–61). Any part of the text will have a different significance if seen in relation to any other different part. One may wish to reflect the text in the history of its time, but that will not exhaust it.

Music embodies the idea of a freedom which cannot be represented but which is yet of fundamental importance. Novalis writes of the 'musical spirit of language', claiming that:

> If one could only make people understand that language is like mathematical formulae – they constitute a world for themselves – they only play with themselves, express nothing but their wonderful nature, and that is why they are so expressive – that is why the strange game of relationship of things reflects itself in them. Only by their freedom are they members of nature (*NW* p. 426).

This idea is carried over into a view of literature which refuses to reduce the literary to any other form of conceptuality. There can be no higher discourse for Schlegel, such as philosophy. If there were, the potential of reflection would cease.

Modernity simultaneously generates systematic determination of more and more areas of life, and the counter to this, the awareness that such determination involves a process of repression. Aesthetics is the area where this awareness is articulated. The reception of art becomes a constant battle between those wishing to fix signification, be it by historical research, attention to the life of the artist, computer analysis of texts, etc., and those, like the Romantics, who see such an enterprise as inimical to the very nature of art, and demand attention to the capacity of art for generating ever new significances. Deconstruction is, in this view, another version of Romanticism's questioning of the legitimacy of an Enlightenment which sees its task as the ordering of reality by scientific reason. Its theoretical roots are undoubtedly in aspects of Romanticism.

The danger of this side of Romanticism lies in the tendency to elevate indeterminacy to the status of the ultimate virtue. However, the concern to avoid 'foreclosure', to avoid arresting the 'play' of *différance*, must at some level be grounded in the *meaningfulness* of the objections to foreclosure. This is a historical question: the tendency in modernity is for there to be shifts in the perception of art from times where the desire for order prevails, to times where order is perceived as stifling. This is not an abstract issue: the debates about the function of art in the face of fascism, which often led Walter Benjamin to very reductive views for reasons of political responsibility, make it clear that there is no theoretical answer to these issues. At some point, then, the 'infinite reflection' in the work of art has to be seen in relation to someone engaging with that work. Of course, there is no need to assume that this subject will provide an absolutely transparent, self-present ground for meaning. Without a subject of some kind, though, it is hard to see how one could ever even begin to talk about problems of meaning. In the present case, pondering the significance of the historical shift that leads to the conceptions of language and music we have been looking at requires a *motivation* that does not derive from texts themselves. Texts are inert until subjects engage with them.

A history of subjectivity in modernity must take account of the links between the rise of the idea of absolute music and the emergence of radical ideas about art and interpretation of the kind suggested in the notion of infinite reflection. At the moment when, as is most evident in Fichte, subjectivity becomes the principle concern of philosophy, those dimensions of the subject which otherwise may have remained unarticulated come to the fore, along with the realisation, seen in the Romantics, of the potential boundlessness of what this may entail. The theory and praxis of music is the area in which this realisation is most fully expressed.

Connecting this kind of history to other histories of the period involves problems that have rarely been satisfactorily dealt with in the 'history of ideas'. Once it is clear that much that is historically important does not take place at the level of conceptual articulation, the history of subjectivity articulated in aesthetic theory cannot be told with means which give priority to conceptuality. The growth of the importance of music in the German-speaking public sphere in the early nineteenth century is connected to the failure to develop a politically effective public sphere. Much of the energy of Beethoven's music derives from his admiration for the French Revolution, and to his subsequent sense of

political impotence in the Restoration period. Rudolf Bahro has suggested that the political energy which sometimes appears in Fichte's best writings on freedom, and which elsewhere led to direct political action, which is repressed in the Restoration period, is only really articulated in Beethoven's music.[32]

Questions considered so far in philosophical terms here become political questions. On the one hand, music's growing importance can be associated with political impotence and the concomitant development of 'inwardness'. Hegel saw this as the subject indulging itself in an abstract freedom which never has to engage with the public political sphere. On the other hand, music can also be a sphere of articulation which sustains the potential for new articulation that results from otherwise repressed aspects of the development of the subject in modernity. Furthermore, it is a medium, which, unlike the other arts of the time apart from drama, involves collective reception, of the kind Schelling regarded as so vital to Greek tragedy. Aspects of Romantic thinking and the music of the period suggest that there is more to the politics of culture than can be theorised in a Hegelian framework. The case of Wagner will bring out these tensions further. This will be apparent in Nietzsche's reactions to Wagner.

The route which can be traced from the change in perception of language associated with music at the very beginning of modernity, via Schopenhauer, Nietzsche and Heidegger, to post-structuralism, needs to be re-examined in this perspective. Arguments about the politics of deconstruction can learn from this side of aesthetic theory. Despite the repeated references to post-modernity, the arguments are being carried on in the terms largely established at the beginning of modern philosophy. Given the fraught history of the politics of this aspect of German philosophy, a historical awareness of the theoretical issues is vital if old mistakes are not to be repeated.

Nietzsche:
the divorce of art and reason

Schopenhauer: the world as embodied music

Adorno warns in *Negative Dialectics* that 'The new beginning at a supposed zero-point is the mask of strenuous forgetting'.[1] Recent post-structuralist approaches to Nietzsche tend to ignore Adorno's warning by seeing Nietzsche as a complete novum in Western philosophy. I want to begin this chapter with reflections on Schopenhauer, and Marx, before moving on to Nietzsche, in order to reveal how much all three thinkers rely upon the questions posed by Idealism and Romanticism. Even the 'new Nietzsche' can be shown to be confronting some often rather old problems, and he sometimes does so less impressively than his antecedents.

The difference of Schopenhauer from the thinkers considered so far, which he shares with Nietzsche, lies in his pessimism about reason. Schopenhauer rejects Hegel's attempt to show an inherent sense in history, insisting on the primacy of the facticity of reality over our conceptions of it. In doing so he gives art, especially music, an even more emphatic role in philosophy than it had in parts of Idealism and Romanticism. Whereas Schelling sees art as part of a progressive coming to terms with the dark motivating forces upon which reason is founded, Schopenhauer does not.

Like Fichte, Schelling, and Hegel, Schopenhauer develops his philosophy by asking questions about Kant's division of the world into the phenomenal and the noumenal. Where he differs from Kant and the post-Kantians is over the 'in itself', to which, for Schopenhauer, we have direct access. The world's 'most inner essence, its kernel, the thing itself' Schopenhauer terms 'according to the most immediate of its manifestations: Will' (*SSW* I p. 67).[2] The Will is the fundamental reality, motivating the world which science sees in terms of appearance.

What is meant by the Will can be understood via our own body:

> The parts of the body must . . . completely correspond to the main desires via which the Will manifests itself, must be the visible expression of these desires: teeth, gullet and intestine are objectified hunger; the genitalia the objectified sex drive; grasping hands, swift feet correspond to the already more indirect striving of the Will which they represent (*SSW* I p. 168).

The phenomenal world is grounded in a single force which objectifies itself in different ways in all of nature. This view of nature relies, without admitting it, on Schelling's assumption that: 'As the object is never absolute then something per se non-objective must be posited in nature; this absolutely non-objective postulate is precisely the original productivity of nature' (Schelling I/3 p. 284/352). Schopenhauer calls this productivity Will. The Will is the ground of finite appearances, and is apparent to us in that consciousness in which each person 'recognises his own individuality [*Individuum*] in an essential way, immediately, without any form, even that of subject and object . . . as the knower and the known here coincide' (*SSW* I p. 172–3). This is also hardly distinguishable from the version of 'intellectual intuition' Schelling developed, by extending Fichte's point that 'If I think an external object then the thought is different from the object, but if I think myself then subject and object are one' (I/6 p. 154/164) to all objects. My thoughts of my empirical self are equally transient, part of the realm of appearance, which means they cannot grasp the Absolute. 'Intellectual intuition' points to something beyond reflection, to the ground of our thinking which cannot appear in reflection. Schopenhauer does not like the term 'the Absolute', but his notion of the Will has the same status as the Absolute.

Schopenhauer converges with those post-Hegelian philosophers, such as Feuerbach and the early Marx, who insist upon the primacy of sensuous existence over the attempt to subsume it into philosophical abstraction. The danger of this view is that sensuous existence lacks any meaning if it is not related to some higher principle. The realisation of just how problematic our existence becomes once one radically questions the capacity of subjectivity to attain such a principle is the prime motivation of Nietzsche's philosophy.

Schopenhauer's Will is inherently at odds with itself: 'the Will in itself . . . is an endless striving' (*SSW* I p. 240): all its objectifications continually fight each other for superiority. We saw the potential for this vision in Kant, who was insistent that we could transcend it as rational

beings. For Schopenhauer the capacity for transcending the battle in nature is only momentary and does not lead in an ascending direction: each particular being simply owes its existence to its negation of other parts of existence. A similar view will emerge in Nietzsche's idea of the 'will to power'. As in Nietzsche, knowledge is just a means for preserving the individual: subjectivity becomes identified with self-preservation, not with a higher principle of reason. However, as if unable to tolerate the consequences of such a view, Schopenhauer introduces a higher form of cognition: art. The structure of Nietzsche's *The Birth of Tragedy* is implicit in this move.

The conception of art Schopenhauer develops derives from Kant's notion that aesthetic contemplation is a pleasure without interest. Schopenhauer combines this with a Platonist metaphysics. The thing in itself and the Platonic Idea testify for Schopenhauer to the limitations of the phenomenal world. The only way in which we can transcend these limitations is by separating our cognition from its motivation via the Will. To do this one must lose the sense of one's individual, and thus will-bound existence, and lose oneself in contemplation of the object, becoming a *'pure*, will-less, painless, timeless *subject of cognition'* (*SSW* I p. 257). The source of the link of pessimism and aesthetics is now apparent: only by losing ourselves as sensuous subjects can we achieve truth. Contemplation dissolves the opposition of subject and object. The artistic genius is characterised by a capacity for objectivity which allows him (in Schopenhauer one can advisedly say 'him') to see the essence of things, their Idea, without being distracted by any relation to the object generated by passing wishes or desires.

For Schopenhauer, unlike many of the thinkers we have looked at, the object is aesthetic because of its generality. His aesthetic theory becomes a reversed Platonism: whereas Plato attacks art for only representing the single object, not the Idea, Schopenhauer maintains that art is the only way in which the Idea can be represented. Only by eliminating the illusion that the subject could relate to a world which means something to it *qua* sensuous subject can one attain a higher truth. In line with the anti-dialectical tradition that will continue with Kierkegaard, Nietzsche, and Heidegger, Schopenhauer does not allow the involvement of the subject as an inherent part of a larger story. He 'cannot help seeing the same thing in all history, like in a kaleidoscope one always sees at every turn the same things in other configurations' (*SSW* V p. 526).

Schopenhauer attempts to demonstrate the *metaphysical* truth of art via music. The truth of art is threatened by the new procedures of

legitimation applied in the scientific, legal and political spheres, which exclude the empirical subject from the realm of the highest truth. Schopenhauer still sees the highest truth in art, not science. Despite his antagonism to the sensuous subject Schopenhauer attaches great importance to the superiority of 'intuition' over concepts. 'Intuition' is contemplation which is able to apprehend the object without first seeing it in terms of analytical concepts. The Idea plays the same role for the artist that unconscious activity did for the genius in the *System of Transcendental Idealism*: it cannot be arrived at by analytical reflection or by judgements. The Idea cannot be explained scientifically. Schopenhauer explains intuition further via the example of literary metaphors, similes, parables and allegories. Though poetry uses concepts, that is not what makes it poetry. Poetry results from the way in which the concepts are made into *images*, which are not discursive in the way that descriptive language is.

A poem for Schopenhauer achieves its sense of completeness via its rhythm and rhyme. It thereby becomes a 'sort of music' and appears to be there for its own sake, and not 'as a simple means, as the sign of a signified [*Zeichen eines Bezeichneten*], namely the sense of the words' (*SSW* II p. 550). Once this priority has been established, the meaning of the words simply appears as 'an unexpected bonus, like words to music'. It should by now be easier to understand the investment Schopenhauer has in what he himself terms the 'metaphysics of music'. Music is the crucial component in a metaphysical conception of aesthetic autonomy. The reason for Schopenhauer's elevation of music is that, unlike other forms of art, music is non-representational. Music has the status of the 'true general language' (*SSW* V p. 507): it 'does not talk of things, but rather of nothing but well-being and woe, which are the sole realities for the *Will*' (*SSW* V p. 507). By omitting words, which would put one in the realm of concepts and abstraction, absolute music combines direct access to the world of feelings with a basis in mathematics.

Music in Schopenhauer speaks directly of desire, the basic principle of the Will, expressed in its being 'divided in itself'. Music is, though, grounded in 'completely determinate rules which are expressed in mathematics, which it cannot deviate from without completely ceasing to be music' (*SSW* I p. 358). Music crosses the Kantian divide of the sensuous and the intelligible in the manner that Hamann saw language as doing. The mathematical proportions are *heard* as meaningful connections. If the 'maths' is wrong because of the use of a note that does not take account of the proportions that the intervals are based on, the

music is also wrong. One does not have to know the mathematical way of expressing this to hear it. At the same time music 'directly affects the Will, i.e. the feelings, passions and emotions of the hearer' (*SSW* II p. 574). The language of music is general in the way that geometrical figures, the a priori forms of intuition, are general: 'the world of appearances or nature, and music' (*SSW* I p. 365) are, therefore, two different expressions of the same thing. Schopenhauer goes so far as to maintain that because music is the direct image (*Abbild*) of the Will it is 'the metaphysical to everything physical in the world, the thing in itself to every appearance. One could accordingly just as well call the world embodied music as embodied Will' (*SSW* I p. 366). As such, Schopenhauer, like the early Schlegel, sees music as closely related to philosophy: if one succeeded in giving a complete conceptual explanation of music one would have 'the true philosophy' (*SSW* I p. 369), where sensuous and intelligible are united. The point is, of course, that such an explanation is impossible.

Schopenhauer suggests that music best represents the unconscious forces which motivate our representations *and* the rest of the world: 'the composer reveals the innermost essence of the world and pronounces the deepest wisdom, in a language which his reason does not understand' (*SSW* I p. 363). This has two sides: on the one hand music *qua* aesthetic experience temporarily redeems one from the fundamental suffering in which life for Schopenhauer consists, on the other hand music does this whilst expressing precisely what makes life a torment. Music fulfils a similar role to tragedy, which presents the worst imaginable events in the form of aesthetic appearance. Schopenhauer, it should be noted, argues wholly within the musical tradition which develops with Viennese classicism: the resolution of tension within sonata form is the best example of the sort of music he means. What he says – and something similar will apply to Nietzsche's early view of Wagner – is predicated upon the development of a specifically modern music, which moves away from the contrapuntal music of the past and opens up the new harmonically-based dynamism and possibilities for subjective expression, seen most obviously in Beethoven.

The argument about the metaphysical superiority of music, Schopenhauer admits, cannot be proven. This is – and here he echoes Novalis – 'because it assumes and establishes a relationship of music as a representation [*Vorstellung*] to that which essentially never can be a representation' (*SSW* I p. 358). Schopenhauer argues that the basis of whatever reason we have is not cognitive, or teleological in a broader sense

involving the higher goal of the species, as it essentially was for Kant and German Idealism, and, despite their attacks on Idealism, Feuerbach and Marx. Instead, it is based on the need for self-preservation, and for the propagation of the species. Self-preservation is the 'basic endeavour of the Will in all its appearances' (*SSW* II p. 386).

Schopenhauer's problem is that he exchanges one ontological principle for another. The principle he rejects reaches its most sophisticated expression in Hegel's 'onto-theology' (Schopenhauer shares the term with Feuerbach, long before its adoption by Heidegger), in which Being is identified with Reason, and relies upon a notion of ultimate identity in difference. Schopenhauer's principle, the Will, relies upon ultimate difference in the identity of the Will. Reversing metaphysical arguments does not solve the problems which they entail. As we shall see in Nietzsche, arguments about ontological foundations of this kind invariably end up being circular. Discursive argument cannot establish the Will because the discursive argument will always already be motivated by what its job is to prove, namely the fact that the Will is the ground of all appearances, including the appearance of the argument itself.

This repeats the problem of grounding consciousness in reflection: if what is to be established is not already there in pre-reflexive form, discursive argument cannot create it. The difference is that, whilst reflection cannot account for consciousness, there is no denying the fact of consciousness. What allows us to assume we know the fact of the Will? Freud, as we saw when looking at Fichte and the problem of reflection, has a similar problem in relation to the id. Freud echoes Schopenhauer's view that music represents what cannot be a representation, by suggesting that a 'drive can never be an object of consciousness, only the idea [*Vorstellung*] that represents it', which requires, as we have seen, a different conception of the structure of consciousness if one is to show that there is more than the representation.

Despite the doubts one must have about his position, it is clear from the influence of Schopenhauer, not least upon Wagner, Nietzsche, and Freud, that he touches a nerve in the experience of modernity. The combination of music's non-representational character with its non-conceptuality seems to make it more apt to the experience of the I, that it is not, in Freud's phrase, 'lord in its own house', than other forms of art. Music makes limitations in conceptual thought and verbal language apparent in ways which then enable the irreducibility of other forms of art to be understood. The links of music to the theoretical articulation

of the notion of aesthetic autonomy we saw in the last chapter appear again here.

The main strand of the arguments we have followed so far is concerned with the failure of subjectivity to ground itself and with how, in aesthetic praxis and theory, this can be the basis for a view of the free *potential* of subjectivity which can never be theorised in advance by philosophy. Schopenhauer's response to the insight that subjectivity cannot be its own ground, in the last part of *The World as Will and Representation*, is to try radically to eliminate the individual subject as the location of sense. Schopenhauer's emphasis on the deficiencies of subjectivity can only be a fundamental problem on the assumption that we have access to what is lacking, namely something which transcends the contingency of the world of ourselves as finite, sensuous subjects. Schopenhauer wishes to ground this lack in subjectivity in his philosophy of art, which at least temporarily takes the subject beyond itself into a state which abolishes the torment of individuation and reveals intuitively the essential nature of existence.

The problem is the unquestioned, absolute, status which art must have if his argument is to work, which is why the argument is based on music, as the form of art least tinged by empirical representation. Schopenhauer's argument is again suspiciously circular: real art is what reveals the truth of existence. The argument presupposes an essence of art. The essence must already be familiar if we are to be able to see something as an object of aesthetic contemplation. This raises the question of how those who have not gained access to the denial of the Will can acquire knowledge of this essence. The only access they could have is via the work of art or the intuition of beauty. Schönberg criticises 'Schopenhauer's demand that the evaluation of works of art can only be based on authority. Unfortunately he does not say who bestows authority nor how one can acquire it'.[3] Clearly, even beyond the circularity of Schopenhauer's argument, there is something arid about its implications. It leads to a static notion of art as the temporary negation of contingent subjectivity, omitting any sense of the complex developments in the history of subjectivity required for modern notions of beauty and forms of art to emerge in the first place.

The problem is that Schopenhauer already knows the answer. A metaphysics of art of this kind reduces all art to having the same ultimate significance. Sustaining a sphere of complete philosophical autonomy for aesthetics removes it from the role of actively enlightening us about the nature and limits of our capacity for reason. It makes such a task

seem ultimately futile by making art in the last analysis the negation of finite sensuous existence, rather than a means of interpreting that existence. As theological compensation is no longer available for Schopenhauer, there must be another compensation. Art becomes the abstract negation of the drive for self-preservation: when one is absorbed in aesthetic contemplation this all-determining drive temporarily ceases to dominate.

However, theories based on the concept of self-preservation must at some stage give an account of the self that preserves itself. This is one essential role of reflection upon art in the theories considered so far. Schopenhauer lacks an adequate consideration of the possibility of *coming to terms*, including by art, with the awareness of our consciousness's ground in its other, whether one calls the other Nature, the Id, Life, or the Will. The problem of such ontological principles, which will, in the wake of Bergson, come to be known under the collective heading of Vitalism, is that they are interchangeable names for the intuitively known basis of all reflection. Once one has assumed that this higher force is the ground of reflection there is little more to be said about it, apart from to reveal its workings in all areas of life which might have previously been regarded as being based on reason, altruism, individual creativity, etc. The concomitant suspicion has, though, been generated by a process of *reflection* upon what motivates what we call reason. At this point the argument for self-preservation becomes circular: the reflection that the motivation behind our reflection is self-preservation cannot be proven. The premise that aesthetic contemplation is essentially a holiday from self-preservation can be seriously questioned as being an unjustified reduction of art.

Having identified the importance of the non-representational art of music, Schopenhauer fails to deal with it in a philosophically adequate manner. The problem with Schopenhauer's argument is that he tends to reduce music to one significance, which, despite all claims to the contrary, he articulates in the general language of theory. Schönberg noted this of Schopenhauer in a way which echoes some of the arguments we have already seen elsewhere in the book:

> he loses himself . . . when he tries to translate details of this language *which the reason does not understand* into our terms. It must, however, be clear to him that in this translation into the terms of human language, which is abstraction, reduction to the recognizable, the essential, the language of the world, which ought perhaps to remain incomprehensible and only perceptible, is lost.[4]

The point about the Romantic view of music seen in the last chapter was that it did not rely on being the representation of the ontological ground of existence for its significance. As such, music could still remain an expression of freedom.

The importance of music in modernity, which is, albeit inadequately, recognised by Schopenhauer, lies in the fact that a non-representational medium seems to generate both individual and general significance in a culture more and more dependent upon the collective conceptual articulation of nature in natural science. The issue of how modern cultures can sustain meaning leads to a recapitulation of the issues of the *System Programme*, which can be seen in both Marx and the early Nietzsche. Schopenhauer is on the one hand oriented towards the future, in his anti-metaphysical rejection of a redemptive view of nature both internal and external, and the past, in the way in which his aesthetics becomes subordinated to Platonic metaphysics. Nietzsche will confront the problem of how one can overcome metaphysics whilst regarding art as vital to human existence. He thereby radicalises the question of the significance of art and beauty more than anyone in the nineteenth century. In order better to understand Nietzsche's attempts to overcome metaphysics, one needs first to look briefly at Marx's engagement with art.

Marx, myth and art

The questions that will set the agenda for aesthetic theory in the twentieth century appear in a now notorious passage from Marx's Introduction to the *Grundrisse*, written in 1857. In the passage Marx ponders the relationship of art to the general development of society.[5] Why is it that societies, such as in ancient Greece, whose capacity for controlling nature is not highly developed, can produce great works of art? Nietzsche will ask related questions about Greek art in *The Birth of Tragedy (BT)* (1872).

Marx sees Greek art as based on mythology, which he, echoing Idealism and Romanticism, characterises as a collective 'unconsciously artistic processing [*Verarbeitung*] of nature'. Mythology makes sense of natural forces via the imagination, by telling stories about them and making them into images. Such images give a feeling of control over what is otherwise alien to ourselves. This control is an unconscious version of what art does consciously. What, though, happens to art, whose basis for Marx is the overcoming of nature in the imagination,

when we can really control natural forces in a consciously purposive manner through technology?

Marx asks:

> Is the contemplation [*Anschauung*] of nature and of social relations which is the basis of Greek fantasy and thus of Greek mythology possible with self-actors [i.e automatic machinery] and railways and locomotives and electric telegraphs?

For Marx modern art requires the artist to have a 'fantasy independent of mythology' because modern science 'excludes all mythological relationship to nature'. Marx is faced with the questions posed by Hegel in the *Aesthetics* about the role of art in modernity. The essential truth for modern societies is located in the sciences and theoretical discourse, or, in Marx's case, in political praxis. The role of the aesthetic therefore becomes problematic, as we saw in the conflicts over 'intuition', that relationship to the object which does not subsume it into a general category.

The importance of the non-representational and non-conceptual medium of music in the nineteenth century is more easily understood in the light of Marx's assumptions about the need for fantasy which is not based on mythology. The rise of the idea of music as the highest form of art associated with the emergence of autonomous art points to a crisis in the status of art. If mythology is no longer possible as a mode of articulating truth, a role which has been taken over by the sciences, fantasy must have recourse to a medium which articulates in a non-representational and non-conceptual manner. How music relates to nature both internal and external will become a major area of contention in twentieth century music theory. Such questions are inseparable from the issue of subjectivity: Marx points to changes in the relationship of subject and object which occur in modernity when nature comes to be seen in terms of instrumental reason's capacity to control it. This should, in principle, lead to the disappearance of myth. However, Marx underestimates those dimensions of subjectivity which are not catered for by such control. The importance of the early Nietzsche lies in his attention to the reasons for the failure of this control to achieve the integration of humanity and nature which was the aim of the later Kant and of post-Kantian philosophy.

The problem Marx indicates becomes apparent in the art of the second half of the nineteenth century. Zola, for instance, who writes novels which try to articulate the experience of modern industry, will, in

La bête humaine, make a locomotive into a mythical object, giving it a status equivalent to anthropomorphic nature in mythology. Zola's novels combine modernity with a re-mythologising of nature, e.g. in *La terre*. They also mythologise 'second nature', human society and its products, e.g. in the links of the mine to Tartarus in *Germinal*. Art in the nine-teenth century shows a tendency to adopt mythical patterns as a way of sustaining itself in the face of a society whose essential processes are no longer visible in the actions of individuals.[6] The need for the 'new mythology' is evident in the way that the art of the period tends to invoke old mythology as a way of trying to come to terms with modern society. The importance of such art points to difficulties in Marx's analysis.

The re-emergence of mythology can partially be understood in terms of Max Weber's suspicion that the diverse value-positions of rationa-lised modern societies could end up looking to most people like the kind of multiplicity of competing natural powers represented in mythology in traditional societies. On such a view art remains grounded in the attempt to organise into images and stories, or other forms of articulation, those aspects of modern social life whose functioning makes little sense to us as sensuous individuals: the issues of the *System Programme* keep recur-ring. The Introduction to the *Grundrisse* does not offer any explanation of why it might be that in modern art, or, for that matter, in modern societies, mythology is far from disappearing, despite the increasing control over nature. Indeed, in the case of Wagner's *Ring*, mythology in conjunction with music forms a new, compelling, if questionable, res-ponse to capitalist modernity. In Wagner the mythology on its own is no longer believable: its force seems to have been transferred into the music. Marx's view cannot adequately account for such phenomena.

Marx moves instead to another question: whilst it is not surprising that Greek art and epic have their foundations in 'certain forms of social development', the 'difficulty is that they still give us aesthetic pleasure and in certain respects are valid as a standard and unattainable model'. This would seem to contradict his developmental view of history as the process of elimination of imaginary control over nature in favour of real control, as well as suggesting that the relationship of the mythical and the aesthetic might be more complex than he assumes. This complexity becomes clear in the early Nietzsche's work on music and mythology. Marx tries to overcome the problem of Greek art's continuing signifi-cance by suggesting that the Greeks are the children of the human race: they have a naïveté that we can no longer have, but which we value in children and which we try to 'reproduce on a higher plane'. The charm

of Greek art lies in the fact that its basis – 'unripe social conditions' –
can never return (*wiederkehren*). This exercise in nostalgia is, as has
often been noted, inadequate to account for the perception throughout
Marx's century and beyond that Greek art has a power which it is vital
for us to understand.

However, the attempt to suggest against Marx that Greek art is 'eter-
nal' in its appeal is hardly serious: what grounds do people have for
making such a claim, which presumably must also apply to the future?
Similarly, the related idea that Greek art's appeal results from the
universality of its themes can be used to argue for the immortalisation of
American 'soap opera', which also deals with families and power. The
real question is not answered by trivial humanist generalisations, and
Marx at least does not descend to their level. His initial puzzlement at
the continuing power of Greek tragedy is in many ways an appropriate
response, as the arguments of Schleiermacher and the Romantics
suggested: Greek tragedy's capacity for generating new meaning in
differing social contexts can never be definitively explained. Marx's
problem lies in his failure to distinguish the function of myth in a cul-
ture from the significances myth can help to generate in an aesthetic
text.

Marx's direct contributions to aesthetic theory are not in fact that
substantial, drawing as they do upon existing views from German
Idealism and Romanticism. Had his contribution been more consider-
able there would not have been the need for the immense amount of
intellectual effort spent by Marxists in trying to develop an understand-
ing of art. Marx's important work on aesthetics concerns the conditions
and possibilities of artistic production in relation to a general theory of
social labour. Marx reminds us more emphatically than anyone else in
his century that one cannot divorce questions of art from the develop-
ment of society as a whole. Little that he says, though, is able to account
for the specific power of aesthetic products.

It will be clear from this that I do not think, as Terry Eagleton and
others do, that Marxist aesthetics should really be subsumed into a
theory of ideology. The case of music should make it apparent that
subsuming all art into ideology is inherently problematic. This move
tends to rely upon an uncritical acceptance of natural science's role as
the arbiter of truth in modernity, with anything which does not have
scientific status being put into the basket of ideology. The significant
Marxist aesthetic theory which emerges after Marx, in the twentieth
century, with Lukács, Bloch, Benjamin, and Adorno, by no means

adopts the view of art as ideology, and is concerned with the resistance of art to ideological appropriation.

The key aspect of Marx's thought which is developed in later Marxist aesthetic theory, is the theory of commodity. As modern capitalism develops, the whole world becomes reduced to equivalence via the exchange principle. Kant stressed the importance of that which has no price in his concept of dignity in the *GMS*. Part of the critique of the commodity form's reduction of the world to equivalence can itself be seen to derive from aesthetic theory's idea of the particularity of the object. Commodity form is a form of 'reflection' in the sense we explored in Idealism: *what* the object is *qua* commodity becomes wholly defined by its negative relationship to other objects within a differential system that Marx rightly regards as a kind of metaphysics. The truth of the sensuous object is not empirically available: its value is in terms of the market. Within capitalism the object is defined as its exchange value: this is constituted in relation to other exchange values and has nothing to do with the intrinsic being of the object, either as use value, or as object of aesthetic concern.

Adorno's concentration on aesthetic autonomy derives from his sense that the ordering of nature by science and the penetration of the commodity form into all spheres of exchange dominate the subject's relation to the object. The idea that a Marxist aesthetic theory should be based on the concept of autonomy is rather odd. Significant Marxist aesthetic theory develops out of the tension between the abolition of aesthetic autonomy, the view of art as a means towards achieving the extra-aesthetic tasks of the historical situation, and the defence of the independence of art, as the place where otherwise repressed potential may be able to survive, including the potential which may have previously received its expression in mythology. The tensions between the beautiful and the sublime, between the new mythology and aesthetic autonomy, keep on recurring.

Nietzsche will often be the overt or covert source of ideas, or alternatively the target, of such thinkers in the Marxist tradition as Benjamin and Adorno. The varying versions of Nietzsche's thought draw out the implications of the questions we have been concerned with more radically, if not always more convincingly, than anyone else in the nineteenth century. Marx shares with Nietzsche an antagonism to theology, which is seen as a hindrance to human potential. Both radicalise the critiques of dogmatic theology that are central to the genesis of modern philosophy in Kant and his successors. Whereas Idealism's response to Kant

was an attempt to integrate his insights into a whole which he failed to achieve, the critiques which follow Idealism tend to lead to the idea that such integration is possible neither in philosophy, nor in art: either because it is *per se* impossible, or because it must be achieved in practice.

The subject's dominant role, which reached its high point in the early Fichte, is diminished in the light of a developing realisation of the inherent dependence of the subject upon a ground it can never fully grasp. With the later Nietzsche this will result in an attack on the very notion of the subject, whose consequences, as we have seen, are still very much with us in contemporary theory. The tradition of philosophy whose aim is the critique of metaphysics, the conception of the true world as beyond the world of sensuous existence, continually undermines itself. In contrast to Hegel, the process of philosophy's self-undermining ceases to be seen as a progression that incorporates the refuted views of the world into a higher synthesis. The course of history loses any inherent principle and is seen as meaningless.

Responses to the destruction of a metaphysically grounded notion of history work in two key directions, best seen in Marx and Nietzsche. Marx worked towards a realisation of philosophy in history which would make philosophy superfluous, as mythology is supposedly made superfluous by insight into its origins in an underdeveloped capacity to control natural forces by technology. Marx is the first to talk of the 'end of philosophy', both in the sense of goal and in the sense of abolishing philosophy, an end which would come about by achieving in practice the goals that Idealism formulated in theory.

Nietzsche's work submits the optimistic goals of Idealism to their most radical test in ways which set the agenda for the aesthetics and philosophy of the twentieth century. He questions the legitimation of any putative higher collective historical goals in mankind on the basis of a new link between subjectivity and its motive force, which he will term the 'will to power'. Much of Nietzsche's most important work originates, though, in an attempt to transform the philosophies we have considered so far. Music plays a vital role in this attempt, for reasons we shall now consider.

Art, myth and music in The Birth of Tragedy

Nietzsche's first major work, *The Birth of Tragedy From the Spirit of Music*, published in 1872, addresses the relationship between mythology, art, and science examined in the Introduction to the *Grundrisse*. The *BT* can

be read as what happens to the ideas on art and mythology encountered in the *System Programme* and Friedrich Schlegel's *Discourse on Mythology*, in the light of Schopenhauer's philosophy and the growing separation of aesthetic, moral and scientific concerns in the second half of the nineteenth century. It is important to remember just how much the *BT* derives from the traditions we have considered so far, in order to be able to assess Nietzsche's later attempted break with these traditions.

In the *System Programme* art was seen as a means whereby the Idea of freedom could be made available in a sensuous manner. Human and natural teleology were linked in a non-abstract way. The *System Programme* concluded with the demand for a 'polytheism of the imagination and of art', and a 'mythology of *reason*', which would integrate into the whole of society the potential released by science, art, and critical philosophy, in the manner that myths integrated nature and society in traditional cultures. The *Discourse on Mythology* already began to question whether what was required was just a 'mythology of reason', looking also to the productive potential of the 'original chaos of human nature'. These conceptions were bound up with the revival of the figure of Dionysus, the God who combines creation with destruction, who is the 'other of himself'. Schopenhauer's Will, inherently divided against itself, and most directly manifested in music, is also the other of itself in a non-teleological sense. It should therefore be no surprise that Nietzsche sees Schopenhauer's Will as Dionysus in the *BT*, where he links Dionysus to music.

The process of 'infinite reflection' in Romantic art was, as we saw, associated with music. The connection of Dionysus to music encountered in the *BT* is already present in Schelling's 1811 *Weltalter* ('Ages of the World'). In the *Weltalter* Schelling attempts to show how consciousness arises out of unconscious nature. He suggests this process is far more of a struggle than it is in the *STI* or the identity philosophy. He uses music as a means of explaining the process. 'Divine madness', the chaos associated with Dionysian intoxication, is a result of the battle between that aspect of nature which wishes to remain part of the inherently unconscious primeval One – which is now a force of contraction, in contrast to the absolute 'I' of the *STI* which has to limit itself to become conscious of itself – and that aspect which strives beyond the One towards consciousness, which is a force of expansion:

> As long as the contracting force maintains a predominance over the expanding force it is stimulated on the inside in a still dull manner into a blind unconscious activity [*Wirken*] by the beginning battle; mighty, violent

. . . products arise, like those which arise from the play of forces in dreams when the reasonable soul does not intervene and the forces work for themselves (*WA* p. 43/ Vol 4 of *Ausgewählte Schriften* p. 255).

Schelling sees the development of consciousness as the painful liberation of a potential which is always threatened by the force of contraction. This is the beginning of the line of argument he develops in the later *Philosophy of Revelation*. This philosophy moves away from the idea that there is an inherent 'I' whose development is like that of an organism, towards a more fragile and contingent sense of reason's struggle to emerge from brute nature.

The story is not far from the model of consciousness which will lead Freud to the dictum that 'where It [*Es*] was, I [*Ich*] should become'. Schelling sees music as a way of expressing the conflict between consciousness and its ground. Dionysus's waggon, which is pulled by wild animals, is accompanied by music:

> For, because sound and tone only seem to arise in . . . that battle between spirituality and physicality, only music can be an image of that primal nature and its movement, for also its whole essence consists in circulation, as it, beginning from a tonic [*Grundton*], always finally returns to the beginning, however many variations it may go through (op. cit. p. 40/252).

Music expresses the ground of diversity in unity. The unity is not, though, the kind we saw in Hegel's account of music: it suggests rather the circular time of mythology. In another version of the *Weltalter* music is seen in terms which parallel Schopenhauer's view of the Will and music: the relation of notes in a piece of music is similar to the 'original movement' of attraction and repulsion characteristic of nature's chaotic preconscious productivity.[7]

Schelling's overall story, though, unlike Schopenhauer's, is the story of how reason and freedom *can* emerge from this process. Understanding the emergence of something which is more than agonising chaos is the task of Schelling's later philosophy. In the *BT*, Nietzsche, much in the manner of Schopenhauer, uses almost exactly the same scheme to suggest the limits of our reason. Reason, in a way familiar from so much recent thinking, is seen as merely an illusion which we impose on a primal chaos.

The *BT* is an eclectic amalgam of many of the ideas we have looked at so far. In his own later self-criticism Nietzsche says that, in the *BT*: 'I sought laboriously to express strange and new evaluations with Kantian and Schopenhauerian formulations' (*SW* 1 p. 19).[8] He sees the novelty

of the book in the way that it set itself the task '*of seeing science from the viewpoint of the artist, but art from the viewpoint of life*' (*SW* p. 14). Much of the force of the book lies in its account of the limits of natural science as a means of creating meaning. By this stage of the nineteenth century, in which the positivist belief in science as the locus of truth is increasingly the norm, this is a provocative position. However, it should be clear from Schelling's and the early Romantics' views of the limits of the Understanding and the need to integrate its products into a 'new mythology' that this cannot really constitute the novelty of the *BT*. The real novelty of the *BT* lies in the way it separates aesthetics and morality, developing Schlegel's hints which were examined in Chapter 2.

The provocation of the *BT* for classical scholars of the time lay in its contention that the art which was the source of the ideals of a classical education, the ideals of the good, the true, and the beautiful, arose out of the insuperable violent and meaningless division within Being.[9] Because the ground of Being is so terrible the only way it can be justified is in the form of beautiful *Schein* ('appearance', but also 'illusion'). As such, aesthetics cannot be connected to notions of a potential organic relationship to nature, and is independent of an ethics oriented in a Kantian sense towards the goals of Reason. The terrible ground of Being, Dionysus, which has much the same role as Schopenhauer's Will, is revealed in *Rausch*, intoxication, as well as in music. The redeeming realm of appearance, which includes dreams as well as mythology and plastic and literary art, is Apollo. At the same time great art, initially in the form of Greek tragedy, requires both Dionysus and Apollo.

Once again, Schelling, whom Nietzsche almost certainly read,[10] anticipates Nietzsche: 'Not at different moments but at the same moment to be simultaneously drunk and sober is the secret of true poetry [*Poesie*]. This distinguishes the Apollonian enthusiasm from the simply Dionysian enthusiasm' (II/4 p. 25). Nietzsche, in the manner of Schelling's *Philosophy of Art*, sees Apollo and Dionysus as Greek culture's sensuous way of expressing what we now express in abstract concepts. Nietzsche converts Schopenhauer's metaphysics of art into a story, which in terms of its philological respectability is really itself a myth, about Greek mythology and its relation to modern culture.

The essential difference of the *BT* from Schopenhauer is that, instead of relating aesthetic contemplation to a 'buddhistic negation of the Will' (*SW* 1 p. 56), Nietzsche sees art as 'the completion and culmination of existence which tempts one into living on' (*SW* 1 p. 36). Art, as he will

later put it, is a 'stimulus to life'. Nietzsche derives important parts of his argument, probably via Schopenhauer, from Fichte's and the early Schelling's metaphysics, in which the manifestations of the object world are part of the process of the absolute 'I''s attempt to 'intuit' itself. This entails a similar view of art to the *STI*. Nietzsche uses some of the same vocabulary, albeit to produce a different vision: 'In the Greeks the "Will" wanted to intuit itself [*sich anschauen*] in the transfiguration of genius and the world of art' (*SW* 1 p. 36–7). As one can see, the *BT* is remarkably banal in relation to the inspiration and rigour of its philosophical ancestors.

As in Schopenhauer this process excludes any significant involvement of the subject: 'we demand in every type and every level of art above all and first of all the conquering of the subjective, redemption from the "I" ' (*SW* 1 p. 43). The artist's aesthetic contemplation must be devoid of 'interest' and desire:

> To the extent to which the subject is an artist it is already redeemed from its individual will and has become like a medium through which the one truly existent subject celebrates its redemption in appearance (*SW* 1 p. 47).

The subject is merely a mouthpiece for something greater: the argument is really another version of Schopenhauer's Platonic view of art. Like Schopenhauer, Nietzsche excludes the side of art which addresses us as sensuous subjects from the truth. Given the shared misogyny of Schopenhauer and Nietzsche, this offers an interesting line of inquiry, linking aesthetics to the philosophical concerns of recent feminism. Antagonism to the senses and antagonism to the female go hand in hand in much of the Western philosophical tradition. Nietzsche will, as we shall see, later revalue the senses, but he will not change his mind on women.

Nietzsche's vision is tawdry, compared with the Idealist and Romantic philosophers. It retains the faults of Schopenhauer in its glib assumption that the 'one truly existent subject', which could also be called Nature, Life, Will, is intuitively known. Fichte's and Schelling's struggles with the necessity for philosophy to grasp that which transcends reflection seem forgotten, as does their investment in freedom. Nietzsche apparently sees no problem in describing an absolute and suggesting how we have access to it. Significantly, the argument is couched in theological vocabulary. The point of art is not essentially anything to do with ourselves and instead is really for the pleasure of the 'true creator', indeed we ourselves are 'images and projections' for this

creator. One feels like a kind of plaything for a corrupt Roman emperor. The point of the argument becomes more apparent when Nietzsche asserts that we 'have our highest dignity in the significance of works of art – for only as *aesthetic phenomenon* is existence and the world eternally *justified*' (*SW* 1 p. 47). Art enables us to contemplate what is otherwise devoid of meaning, which includes ourselves.

Nietzsche goes on to use a suspect version of Schelling's argument that the genius combines conscious and unconscious production, to back up his own position. In the act of creation the genius merges with 'that primal artist of the world' (*SW* 1 p. 48) and thus transcends reflection by being both subject and object. Where Nietzsche's view of the importance of art can lead is apparent in a passage, written in early 1871 for the *BT*, but which was not included in the book. It may, therefore, seem unfair to refer to it. The passage is, though, wholly in line with some of the more odious élitist arguments of his later philosophy. In the passage Nietzsche reflects upon the necessary role of slavery in the genesis of Greek art and suggests that in modern culture 'the misery of the laboriously living masses must be further intensified in order to enable a number of olympic people to produce the world of art' (*SW* 7 p. 339). If existence can only be justified aesthetically, then ethical goals have no significance in the face of the need to produce great art. At some unexplained level the production of this art, essentially as the new mythology, is supposed to be an answer to the problems of meaning in modernity. The Idealists and the early Romantics considered that a new flowering of culture would depend upon the creation of a new public sphere and universal free communication: art was inextricably linked to politics and ethics. Nietzsche's vision is that of a petit-bourgeois élitist and it has a more than problematic subsequent history.

In the *BT* the problem of modernity is, as it was for Schlegel's *Discourse*, the lack of a 'centre'. Nietzsche's formulations now are reminiscent of the theorists of 'post-modernity', though he lacks their celebration of the decentred state of culture, which is in part derived from aspects of his later work:

> think of a culture which has no firm and holy original abode [*Ursitz*], but is condemned to exhaust all possibilities and to nourish itself meagrely from all cultures . . . What do the massive historical need of dissatisfied modern culture, the gathering around itself of countless other cultures, the consuming desire to know, point to, if not to the loss of myth. . .? (*SW* 1 p. 146).

Unlike Schlegel and the Idealists, who wished to synthesise a new mythology out of cosmopolitan diversity, Nietzsche at this time sees the answer in terms of a '*re-birth of German myth*' (*SW* 1 p. 147). He will, one should remember, later move to a cosmopolitan, anti-nationalist position. Here, though, Nietzsche invokes a 'splendid, internally healthy, age-old power' (*SW* 1 p. 146) which is hidden under the surface of a decadent culture, and which can reawaken. The reawakening must presumably happen spontaneously and unexpectedly because the people who embody it have no say in its workings.

Given his thoughts on the need for the special producers of art to be sustained by the suffering of the masses, this is highly politically suspect. We are back with the philosophy of origins, which not only has a fairly disgraceful political reputation from the time of the later Romantics onwards, but is also philosophically incoherent. Nietzsche's invocation of the primal force is supported by his insistence on the separation of the aesthetic from any moral significance. The Dionysian force which produces tragedy, and which tragedy and music enable us to contemplate, is prior to any ethical consideration. He attacks those explanations of Greek tragedy which use ethical categories to explain it and insists that tragedy has nothing to do with a Schillerian 'arousing of moral-religious powers' (*SW* 1 p. 143). It is rather concerned with something autonomous and irreducible: the aesthetic contemplation of the horror which is the ground of existence. The argument relies on an ontology of 'creative natural powers' (*SW* 1 p. 145) which Nietzsche claims can only function properly in a culture unified by mythology.

All such arguments have to rely on invocation: nothing can discursively justify them. Our access to the creative forces is always as historical subjects. Any ontological claim concerning primal forces would imply the ability to identify these forces as the ground of our own thinking, which raises yet again all the problems of reflection seen in Fichte and Schelling: how can we *know* that it is the primal force which is acting? If it is to act as primal force it cannot be available to knowledge, which is secondary and derived. The primal force has nothing to do with the idea of a new mythology, based on freedom, which is a product of free communication: primal forces always already have their direction determined by their essence. The interest of the idea of the 'new mythology' in Schelling, and in that part of Schlegel's argument which stresses the need for a new synthesis of the tendencies of modernity, lay in the fact that it did not have recourse to a philosophy of pure origins, and saw the task of synthesis as *our* task.[11] Nietzsche, like

Schopenhauer, excises the subject from the genesis of the new mythology, which turns out to be the repetition of something old, as well as being attached to a particular nation, rather than to a cosmopolitan vision.

The early Nietzsche's ideas become more significant, as Schopenhauer's did, when they are applied to music. The failure of the Idealist and early Romantic vision of the new mythology can be seen to lead to the growing importance of music, as well as to the flowering of musical creativity in this period. This tends to confirm the idea that the turn to autonomous art is related to the failure of the Idealist vision to materialise. Wagner, of course, tries to combine mythology and music, and he is the central figure of the *BT*.

In the *BT* Nietzsche is concerned with the fact that everything in modernity, and particularly natural science, fails to give a basis for substantial meaning. The underlying assumption is of our irredeemable transience and fragility. The only possible response to our facticity is seen as our capacity to create illusions that sustain life. The *BT* radicalises Idealism's awareness of the limits of the Understanding into a view of all human activity as essentially 'artistic', in the sense that it creates significance which cannot be assumed a priori to exist in the world. Nietzsche pursues the consequences much further, retaining the idea of activity as 'artistic' in varying versions throughout his philosophical career. The capacity for the creation of appearances, which Nietzsche terms 'art', including science and religion in the category, is itself grounded in the Dionysian, which is the force that produces the phenomena.

Nietzsche, like Schopenhauer, tries to overcome the difficulty of explaining our access to the underlying ontological principle by reference to music:

> The world-symbolism of music cannot in any way be exhaustively grasped with language, because it is symbolically related to the primal contradiction and the primal pain in the heart of the primal One, and thus symbolises a sphere which is superior to all appearance and prior to all appearance (*SW* 1 p. 51).

Only music can give us a true idea of what the 'justification of the world as an aesthetic phenomenon' means:

> The pleasure which the tragic myth creates has the same home as the pleasurable feeling [*Empfindung*] of dissonance in music. The Dionysian, with its primal pleasure [*Urlust*], which is even perceived in pain, is the

common womb [*Geburtsschooss*] of music and of the tragic myth (*SW* 1 p. 152).

Dissonance in music reveals to us the inherent transience and incompleteness of individual subjective existence by suggesting at the same time a striving for the infinite, a striving for harmonic resolution, which is a return to the primal One. The *BT* does, however inadequately, suggest a way of understanding some of the appeal of music in modernity by linking it to the temporality of mythology, which does not entail the abstract sequential division characteristic of modern temporality.

Lévi-Strauss sees myth and music in The Raw and the Cooked as both

> languages which, in their different ways, transcend articulate expression, while at the same time . . . requiring a temporal dimension in which to unfold. But this relation to time is of a rather special nature: it is as if music and mythology needed time only in order to deny it. Both indeed are instruments for the obliteration of time.[12]

Art, in the form of music, though dependent upon the sensuous, transient world, is seen as transcending it. Nietzsche sees tragedy as affirming eternal life; the death of the hero is only the destruction of one form of appearance of the Will: ' "We believe in eternal life", tragedy shouts; whilst music is the immediate Idea of this life' (*SW* 1 p. 108). The rebirth of mythology is possible through music because music is the counter to 'Socratic optimism'. 'Socratic optimism' is the belief in the progress and perfectibility of mankind by science, which wishes to obliterate the insight into the real horror at the ground of Being. Art, in the form of music, is this counter because of its antagonism to conceptuality, and because of its revelation of the divided nature of all phenomenal existence, which can only be overcome in art. The later Nietzsche will come to question this view. The *BT* is too confusedly eclectic to be very enlightening: it points to important questions but gives inadequate answers. Nietzsche's other accounts of myth, music, and language sometimes offer more resources.

Myth, music and language

It is in the question of language and art, particularly music, that one can best see the difference – and the continuity – between the early and the late Nietzsche, and thereby try to understand Nietzsche's legacy for

subsequent aesthetic theory. The relationship of myth, music, and language is central to Nietzsche's view of Wagner in the *Untimely Meditation* published in 1876 entitled 'Richard Wagner in Bayreuth'. Here Nietzsche equates the poetic with the mythical in a manner derived from aspects of Schelling and the Romantics. Myth is a thinking in

> processes that can be seen and felt . . . Myth does not have a thought for its basis, as the children of an artificial [*verkünstelt*] culture think, but it is itself a form of thinking . . . The Ring of the Nibelungen is a massive thought system without the conceptual form of thought.

Wagner 'forces language into an original state where it thinks virtually nothing in concepts, where it is still itself poetry, image and feeling' (*SW* 1 p. 485–6). Nietzsche's formulations derive from the Romantic perception of the importance of music as a mode of articulation which tells us more than discursive language is able to. This idea is connected to the assumption that mythology functions effectively as a centre of meaning in cultures which do not have the conceptual apparatus of modernity. The foundation of this idea is an 'original state' of language that we have presumably lost.

Unlike Schleiermacher and the early Romantics, who saw music and language as complexly interrelated in ways that point forward to new potential in both, Nietzsche here espouses a philosophy of origins, suggesting that conceptual thought is a 'fall' from something higher. Unlike Schelling, he thinks that this can be immediately overcome. The connection between the growth in the importance of art, particularly of music, and of cultural pessimism, here has serious consequences. The desire to integrate science into a much wider vision of the potential, and the dangers, of modernity, which we observed in Idealism and the best of early Romanticism gives way to a desire to repress the real issues of modernity. Arguments similar to Nietzsche's will be reproduced in many, often proto-fascist, twentieth-century versions of Vitalist philosophy, such as Ludwig Klages' opposition of 'Soul' to conceptually corrupted 'Spirit', and in Heidegger's view that 'Western metaphysics' has 'forgotten' the question of Being in favour of the domination of Being by the subject in science and technology.

Nietzsche sees language as having 'fallen ill' because people are no longer able to communicate what matters. The 'illness' suggests a natural pathology which is independent of the subjects who speak language. Language is ill because it has become too closely linked to

conceptual thinking, and has lost its connection to feeling, and thus to nature. Language works solely by convention, like a machine. Only music, now seen as a 'return to nature' (*SW* 1 p. 456), as well as a 'purification of nature' (returning to nature and purifying it seem to me hard to combine, though recent advertising is doing its best), is the 'language of true feelings' (*SW* 1 p. 458). The language of 'false feelings', whatever that might mean, is presumably conceptual language. In such passages Nietzsche falls well below the level of thinking about music which enabled the Romantics to formulate notions of aesthetic and literary autonomy that were based on music's non-representational character, and upon language's dependence upon the 'musical'.

Nietzsche's argument abandons the dialectical tension between the subject and its ground in favour of a sense that reflective consciousness should be forgotten in favour of a power far above it. What is wrong with this is not that music may not tell us something fundamental about the deficiencies of language in modernity. It clearly does. It is the fact that the sufferers from this deficiency, individual subjects who have feelings here and now, seem not to count in Nietzsche's argument. The divorce of the aesthetic from the ethical, which can be the basis of the opening up of important new resources, can also lead to a dangerous aestheticism. The connections of music and a 'mythology of reason' are severed in favour of the idea of music as the return to mythical original forces. What this forgets, as Habermas has frequently pointed out,[13] is that the ideas of mythical origins result from a particular way of understanding the most technically advanced music of Western culture. The great achievement of Wagner's music, despite what Wagner may have thought he was doing, is to articulate specifically *modern* experience, not some primordial experience.

The key component in this issue is language, about which the early Nietzsche is anything but consistent. The tendency, for example in the 1870 *The Dionysian Weltanschauung*, is to see conceptual language as a deficient mode. Those forms of communication, that Nietzsche sees as 'languages', such as dance and song, which represent a more immediate access to the world of feeling, are given priority. These 'languages' are 'thoroughly instinctive, without consciousness' (*SW* 1 p. 572). The view of consciousness seems remarkably restricted, meaning, presumably, something like 'conceptual'. Wagner supposedly combines these 'languages' in a higher unity in his operas, mixing gestural and musical languages, the realm of the image, and the realm of sound. This does

little more than repeat the attack on conceptual language, always pre-supposing, against Schleiermacher, that there are absolute divisions between music and language.

The 1871 fragment on music and language is much more interesting. In it Nietzsche begins to realise the problems of Schopenhauer's ontology of the Will. These become evident because he adopts a more sophisticated view of language than he does elsewhere in this period. In the fragment words are only symbols, not of things in themselves, but of representations (*Vorstellungen*). As a consequence, even the notion of the 'life of drives' (*Triebleben*), which is the fundamental reality for Schopenhauer, is only a representation, and the ' "Will" is nothing but the most general form of appearance of something which is wholly undecipherable to us' (*SW* 7 p. 361). We saw the same point being made by Freud when he claimed that we only have access to drives via the representations that are attached to them. The 'something' sounds rather like Kant's thing in itself.

For Nietzsche the main forms of appearance of the primal basis are sensations of pleasure and unpleasure. These are symbolised in language by the '*tone of the speaker*', as opposed to the acoustic components, consonants and vowels, which are seen as 'gesture symbolism', in that they are gestures of the lips, tongue etc., as opposed to being articulations of conceptual truth 'behind' language. The outlines of an anti-metaphysical view of language are evident. The tonal basis, rhythm, pitch, dynamics, etc. is seen as 'the general basis which is comprehensible beyond the difference of languages' (*SW* 7 p. 361): music can transcend the boundaries of particular languages. Conceptual language depends upon 'gesture symbolism', the conventional, collectively repeated repetition of differentially constituted units – 'cat', 'mat', 'bat' etc. – which guarantee what Schleiermacher saw as 'construction', the creation of identity of cognitions by a habitual consensus about usage within a particular language.

It is worth remembering here Schelling's remarks in the *Philosophy of Mythology* on language as a 'faded mythology'. The suspicion of conceptual language which begins in Romanticism, which one can already see in the work of Hamann, is based upon its increasing tendency to convention and abstraction, which Nietzsche uses music to criticise, and which much of the literature of modernism will try to counter. Schelling saw mythology's creation of a syntax for reality as retaining an aesthetic sense of lively particularity, against the generality of the linguistic sign. Nietzsche suggests in the fragment that, whilst music may produce a

multiplicity of images, it is impossible for images or concepts to produce music because they are of a radically different order from each other. Music is able to articulate something that cannot be expressed by anything else.

In the fragment on music and language music takes on a status which it does not have in Schopenhauer, or in Nietzsche's other early work. Nietzsche establishes a way of attempting to understand the significance of aesthetic autonomy in music. Nietzsche makes it clear that regarding music as a language of feelings is mistaken: 'What we call *feelings* are . . . already penetrated and saturated with conscious and unconscious representations and thus not directly the object of music, let alone able to produce music out of themselves' (*SW* 7 p. 364). This overcomes the philosophy of origins by revealing how even feelings must have a history and depend on a symbolic order if they are to be articulated. Furthermore, it is clear that the genesis of music is not explicable in terms of feelings: the move from having feelings to creating music does not *have* to be necessary. Feelings, Nietzsche claims, are actually only symbols of *music*, which has a prior ontological status. This opposes the commonplace in some Romantic thinking that music is the language, in the sense of the 'representation', the substitute for, feeling, and is not that far from Novalis' and Hoffmann's conceptions of music. Nietzsche's view makes some sense if one ponders the fact that music can lead to the genesis of feelings which one had never had before hearing music. Nietzsche is trying to suggest that music is a wholly autonomous medium of aesthetic experience.

It is not always appropriate to see the import of music as 'really' based on something else. The complexity of the relationship of musical differentiation to linguistic differentiation means, as we saw in earlier chapters, that articulation of the world in whatever manner, be it music, science, or everyday communication, is reliant upon systems of differentiation which concepts, as themselves articulated in language, could never wholly grasp. There is no general philosophical language. Nothing, therefore, entitles one to say that the real basis of thought or language, including music, is the realm of feeling or the Will.

Nietzsche's position, like De Man's in Chapter 7, does not account for the subject which thinks and feels, or hears music *as* music. The argument suggests that the medium of articulation is independent of the living subject who articulates feelings or cognitions within it, which raises all the problems of reflection again. The medium is a necessary condition for the constitution of feelings, not a sufficient one. Music

must be there to be heard as music, but it must be heard. The constitution of music, as opposed to natural sound, requires, as we saw, a transition which is grounded in self-consciousness, even if reflexive consciousness is unable to grasp conceptually what music is. This is the point that is so often ignored. Nietzsche, though, like his heirs, has little interest here or anywhere else in accounting for a subjectivity which may be more than the result of its ontological basis in the Will, or, later, in the 'will to power'. He is here interested in an aesthetic medium whose ontological ground is not accessible. But, as we saw, removing the subject from aesthetics removes the point of art.

For Nietzsche music is not *reducible* to any manifestation of the Will. Nietzsche's argument is interesting as a statement about absolute music that goes well beyond the arguments seen in Schopenhauer. The argument depends upon the refusal to give the cognitive dimension of language any priority because that dimension is itself grounded in the 'tonal basis', the musical in language, which, as we saw, is regarded as generally comprehensible in ways that particular, conceptual, languages are not. Despite all the other shifts in his philosophical position, Nietzsche will sustain the notion of the need to avoid reducing music to something else throughout the turbulent changes his philosophy undergoes.

The view of music in the fragment is reminiscent of the later Heidegger's approach to language, and shares its fundamental fault. Language, as Heidegger puts it, 'is in its essence neither an expression nor an activity of man',[14] is 'more powerful and more weighty than we are',[15] and is the 'house of Being'.[16] Language is 'of Being' in the 'subjective and objective genitive', in that it belongs to Being and is that through which Being reveals itself, much as Nietzsche sees music having the Will as its object without being simply a manifestation of it. Language functions in Heidegger as mythology, it is the horizon of reality which is not produced by a subject, as suggested by Ricoeur's description of Lévi-Strauss' mythology as 'a categorising system unconnected with a thinking subject'. Nietzsche's argument suggests much the same about music.

For Heidegger any attempt to analyse language is faced with the fact that it is always already there as the medium in which the analysis would take place and is always more than can be analysed. As we shall see, Heidegger has little time for music; his view of language's irreducibility, though, is dependent upon the tradition of aesthetic autonomy in ways he seems unaware of. Language, like music, can never be exhausted by

any other form of articulation. Heidegger bases his attempt to understand the essence of language on poetry. We get a sense of the essence of language, Heidegger claims, when we cannot find the right word: 'Then we leave what we mean in the unspoken, and by doing so, without really thinking it, we experience moments in which language itself distantly and fleetingly brushes us with its essence'.[17] This is basically a version of the Romantic topos of Unsayability, which is inseparable from music.

Both Nietzsche and Heidegger are close to that side of Romantic thinking, seen in Benjamin's interpretation of infinite reflection, which is not based upon self-consciousness. Their approaches are, thus, prone to the same difficulties in explaining consciousness and individual creativity in language, which Schleiermacher explains so effectively. These difficulties reach their culmination when Heidegger asks us to believe that 'language speaks, not man', and, more extremely, Derrida sees subjectivity as an 'effect' produced by the 'general text'. These positions are developed in the light of the later Nietzsche's attempt to demolish the notions of truth and subjectivity.

The illusion of truth

Nietzsche does not sustain many of the positions we have looked at so far, though there are important hints of later ideas in the fragment on music and language. However, the notion of music's untranslatability and irreducibility will become significant in the later Nietzsche's critique of metaphysics. The 1873 essay 'On Truth and Lie in the Extra-Moral Sense' contains the seeds of Nietzsche's later philosophy, which he will develop after the split with Wagner. The essay is at the same time a concentration of many themes which we have seen as originating in aesthetic theory, and which Nietzsche now attempts to make central to a new philosophy.

The essay is an attempt to refute the basis of Idealism, the idea of the ultimate identity of subject and object. The problem of truth, Nietzsche claims, arises from the attempt to make human perceptions of things generally valid. He denies the possibility of the Idealist demand:

> between two absolutely different spheres like that between subject and object there is no causality, no rightness, no expression, but at the most an *aesthetic* relation, I mean a suggestive transmission, a stammering translation into a completely strange language (*SW* 1 p. 884).

The argument is Kantian, except that the transcendental subject is now seen as an essentially random producer of metaphors. Truth is a

moving army of metaphors, metonyms, anthropomorphisms, in short a sum of human relations, which were poetically and rhetorically intensified, transmitted, elaborated, and which, after long use, seem canonical and binding to a people: truths are illusions which one has forgotten are illusions (*SW* 1 p. 880–1).

The text is unclear on how Nietzsche recognises the illusion, given that the recognition requires language for it to be articulated as an illusion. This is a recurrent problem, which Nietzsche never solves.

The intellect is a means for the self-preservation of the individual and is consequently most adept at deception. As such, its aesthetic creation of 'truth' is in fact part of this self-preservation: the divorce of aesthetics and ethics is now even more radical. Schopenhauer's Platonic aesthetics retained an ethical component in its valorisation of aesthetic contemplation as an escape from determination by the Will. Nietzsche now rejects this more emphatically than in the *BT*.

The locus of 'truth' is language, which is based on convention. The argument is not that far from Schleiermacher's notion of language as schema, as the creation of identity from difference: 'overlooking the individual and the real gives us the concept' (*SW* 1 p. 880). Schleiermacher saw all communication as 'a constant test as to whether all people construct identically', but was also able to account for linguistic innovation in terms of an individuality that could gain general acknowledgement. Inherent in Schleiermacher's argument was the notion of a desire for consensus based on mutual recognition of individuality. Nietzsche sees truth constituted in language as the socially instituted *compulsion* to construct identically. This points forward to those psychoanalytic theories which see insertion into the 'symbolic order' as a form of primary repression, in which language creates a hierarchy of fixed concepts into which individual impressions are forced.

Language as a means of cognition converts the world into something anthropomorphic, into the 'endlessly broken echo of an original sound' (*SW* 1 p. 883). In language the world becomes the reflex of humankind. This is a version of reflection, the splitting of self and other, which is yet supposed to be identity. The mistaking of the reflex of ourselves in the world for objective truth results, for Nietzsche, from the fact that 'man forgets himself as subject and, indeed, as *artistically creating* subject' (ibid.). This allows one to live with a sense of security, which would be destroyed if one were to realise the nature of this belief, namely that it is a creation with no external, or even internal guarantee. The capacity for

truth is thus linked to aesthetic production, which is *all* human production. The suspicion of 'truth' is a result of the way in which truth forces this production into a static frame: the basis of truth is, then, a potentially infinite productivity, much as it was in certain aspects of Idealist and Romantic aesthetic thinking. There are, though, key differences.

The lineaments of the theory of the 'will to power' are present in these arguments. 'Truth' is seen as the domination of one controlling power, the need for self-preservation based on identity, over the forces of infinite difference. Modernity is associated, as it was for aesthetic theory from Hamann, Schelling, and the Romantics onwards, with the repression of intuition (*Anschauung*). Nietzsche's concern is to defend this intuition against its being swallowed by abstraction. The reasons for this are the basis of the later Nietzsche's work, and explain his constant attention to aesthetics in the critiques of metaphysics.

Nietzsche's suspicion of the suppression of intuition is a function of two related aspects of his later theories: the critique of language as the creator of repressive identity seen in the essay 'On Truth and Lie', and the theory of Nihilism. Nihilism is inextricably linked with the history of philosophy: 'The need for *a metaphysical world* is the consequence of being unable to derive any *meaning*, any *what for?* from the world at hand. "Consequently", it was decided, "this world can only be *apparent*" ' (*SW* 12 p. 374). The state of 'psychological nihilism' is a result of three factors in modernity. The first is not finding any teleological meaning in existence, such as a movement towards a moral world order, so that 'becoming' ceases to have a goal and just becomes; the second is the realisation that there is no unity in the multiplicity of existence which would enable one to believe in one's own value as part of something greater; the third is the loss of the belief in a supersensuous world, accompanied by the realisation that one cannot bear this world without the other world (cf. *SW* 13 p. 47–8). Nihilism is therefore a *result* of metaphysical beliefs which have turned out to be illusory. Having looked for sense in a world which does not actually exist, the world which really exists appears senseless. Schopenhauer's philosophy devalued the transient sensuous world in favour of art as access to the non-transient world, in order to deal with irredeemable facticity. Nietzsche now has to take a very different course, because there is only one world.

It is misleading to claim that this course is a logical development from the awareness of the failure of the metaphysical theories of previous Western philosophy. The critique of metaphysics is not just a critique of

the illusory idea of a true world apart from the transient world of the senses. It actually questions the legitimacy of any such divisions between sensuous and intelligible – something which is often anything but clear even to Nietzsche himself, but which was already suggested in aspects of Idealist philosophy. The suspicion of the sensuous world characteristic of Western philosophy, be it in Kant's insistence on the necessity for it to be grasped by categories, or in Hegel's demonstration of the inadequacy of 'sense-certainty', can be strategically countered by a revaluation of the sensuous, as the role of aesthetics in modernity demonstrates. Nietzsche (presumably approvingly) cites Feuerbach's attack on Hegel: ' "healthy and fresh sensuousness" . . . against "the abstract philosophy" ' (*SW* 12 p. 261), for instance. This does not mean, though, that the sensuous becomes a new basis for philosophy: its very status as the sensuous depends upon its opposite, which has now been put into question.

Nietzsche has an unfortunate tendency in the face of such problems to opt out of confronting the real philosophical difficulty by either simply asserting his attachment to the opposite principle or by positing the intuitively available 'real' basis of the illusions of previous philosophy in the form of the 'will to power'. As with Schopenhauer's Will, the will to power is the irrational substance which is the principle of all change in reality. Change is the result of the victory of one quantum of will to power over another. Such arguments – the difference from Schopenhauer is that Nietzsche wishes to affirm this principle instead of seeking to deny it – are little more than a Vitalist replacement of a Kantian metaphysical position, in which the transcendental subject is the condition of possibility of knowledge, by a metaphysical notion of the will to power as the condition of possibility of any form of reflexive division, be it truth, desire, or whatever. Much of the confusion of Nietzsche's later philosophy is a result of the dilemmas generated by this ultimately metaphysical principle. At his best, though, Nietzsche is able to suggest more interesting perspectives than those offered by the will to power.

Music and metaphysics

Pursuing one of Nietzsche's constant concerns – music – can be a useful way of trying to make sense of the fact that his philosophy is often wilfully self-contradictory. Just how far Nietzsche can move is easily demonstrated by two examples from the 1878 *Human, All Too Human*, which express the opposite of the view of music in the *BT*. The passages mark

the beginning of a complex series of new reflections on the significance of music which are part of Nietzsche's attempt to bring existing philosophy to an end.

The first is a reflection on religion and art which could be used to summarise Hegel's *Aesthetics* and involves the issue Marx considers in the *Grundrisse*, without the element of doubt inherent in Marx's view:

> One must have loved religion and art like mother and nurse – otherwise one cannot become wise. But one must see beyond them, be able to grow out of them; if one stays in their spell one does not understand them (*SW* 2 p. 236).

There is no suggestion here of the need for a Romantic synthesis of the kind still present in the *BT*, which would transcend divisions between art and science. Nietzsche tends, in complete contradiction to the *BT*, to see science as self-legitimating. The second example is a reflection on 'absolute music', which suggests that it is either a very primitive form of articulation or the result of the historical mixing of music with complex concepts and feelings:

> In itself no music is deep and significant, it does not speak of the 'Will', of the 'thing in itself'; the intellect could only think something like that in an age which had conquered the whole extent of inner life for musical symbolism. The intellect itself first of all *read this significance into* the sound (*SW* 2 p. 175).

The historical point is important: the 'notion' of absolute music is undoubtedly a result of particular historical developments. The subject is also present, for a change. However the passage neglects the questions of music, philosophy, and language we have looked at so far. It assumes, rather as Hegel does, that all there is to be said about music depends upon concepts, and that what it says is symbolism of 'inner life'.

Nietzsche also sees music in *Human, All Too Human* as a remainder of metaphysics: 'the highest effects of art can easily produce a resonance of the metaphysical string which has long been silent, indeed has broken' (*SW* 2 p. 145), referring as an example to part of the last movement of Beethoven's Ninth. Elsewhere he is insistent that 'Music is precisely *not* a general, supra-temporal language', arguing that music is a 'late-comer of every culture', and that contemporary German music may soon be incomprehensible to anyone else (*SW* 2 p. 450). The main point of such statements is that music cannot be, as it sometimes was for the early Nietzsche, and certainly was for Schopenhauer, a replacement for what is lost in the attack on the notion of the world as inherently rational.

Nietzsche is, one should note, spectacularly wrong about the music of his time.

Nietzsche is suspicious of music taking the place of the philosophy he wishes to get rid of. He remains aware, though, that music does pose important questions for philosophy. If music is not just the expression of emotions or a sensuous form of mathematics, it does become difficult to say what it is an expression of. Metaphysics is attacked by Nietzsche for trying to articulate an intelligible world which escapes the unreliability and transience of the world of the senses. Music has an odd and disruptive status in relation to the question of metaphysics, as we have repeatedly seen.

Music in the broadest sense – which can just be rhythm (Schelling sees rhythm as the 'music in music') – is constituted by the materiality of the notes, as sensuous phenomena, and, also, like language, by the gaps between the notes, by differentiality. The gaps are 'nothing', but not in the sense of absolute non-being. Such a sense of 'nothing' cannot be thought because it has to be thought from a position of always already being. The gaps between notes, their differentiality, entails determinate 'nothing', without which musical articulation could not take place: the difference, say, between C and B-flat in a piece is not anything determinate, neither, though, is it nothing at all – it is not the difference between C and F, for instance. When the advert enjoins one to 'taste the difference', or, in this case, 'hear the difference', it is requiring something impossible. One can hear C or B-flat within a musical system, but not their difference. 'Hearing silence' is hearing nothing. The silences in great music are as important as the articulated sounds: the 'pause' in the second movement of Schubert's Great C-major symphony is not the same silence as any other silence. Music as a system of differences in time has as its basis that which cannot be articulated and is not sensuous: silence.

In the fragment on music and language Nietzsche suggested that the mistake was to see music as an expression of something else, the Will, rather than as something irreducible. This view, despite the faults we have detected, seems more convincing in the light of the above. If music is not reduced to an expression of an intuitively known principle it retains a status which does justice to the realisation that the ground of articulation cannot itself be articulated. Despite all attempts of modern science to determine what it is, music is still the best demonstration of the need for hermeneutics of the kind we saw in Schleiermacher. Music, as we saw in Chapter 7, can be both a temptation to metaphysics, if it is

supposed to announce some truth beyond itself, or it can be used to oppose metaphysics, because it is self-subsistent and non-representational. However music is conceptualised, it can never be reduced to reflection: analysis of acoustic frequencies or any other quantifiable aspect of music cannot exhaust music. The inherent dependence of music upon silence requires an approach which understands the nothingness which it necessarily entails – which will lead us again to self-consciousness. Nietzsche's main objection to Wagner – and this is one of the few constants in the philosophy of the later Nietzsche – will be that Wagner attempts to turn music into something else.

The significance of these issues for aesthetic theory goes well beyond the specific case of Nietzsche and Wagner. Nietzsche's own endlessly contradictory interpretations of what music is themselves become a pointer to what a post-metaphysical aesthetics might be. Art becomes the place where stubbornly unanswerable questions are preserved from the desire to give them cognitive or ethical answers. What is the aesthetic pleasure afforded by music? This does not mean there should not be a psychology of musical reception, a music history, a musicology. These disciplines should, though, be aware that the phenomenon of music is not exhaustible by what they could ever say because they all rely on pre-interpretations which cannot be absolutely grounded. The problem with Nietzsche is that he thinks separating autonomous art from the ethical and the metaphysical also involves the need to separate it from subjectivity.

Nietzsche suspects music which leads to the intoxication of the listener, which he associates with the effects of religion: 'The *dangerousness of the Christian ideal* lies in its value feelings, in that which can do without conceptual expression: my fight against *latent Christianity* (e.g. in music, in socialism)' (*SW* 12 p. 453). Certain kinds of music become part of the tradition of morality which Nietzsche wishes to transcend. Christian morality has no metaphysical ground once God is dead and is, thus, part of the history of nihilism. The music which points to religion gives the illusion of a higher purpose in which one can lose oneself. When this purpose is revealed as illusory, vital creative energy will turn out to have been directed towards a vacuous ideal, as, for Nietzsche, it is in religion. Nietzsche often relates music's lack of conceptual articulation to the attempt to replace theology. Music, in this view, allows the descent into indeterminacy which prevents attention being paid to those real concerns of daily life that become central once the greater goals are revealed as illusory.

At the same time, however, conceptual articulation for Nietzsche involves repressive identity, the reduction of the irreducible intuition to 'truth'. The positions are incompatible: the insistence on the concept necessarily represses individuality and indeterminacy. The tension between these positions is never resolved in Nietzsche. Unlike Schleiermacher he tends to think in a way which prevents mediation between extremes. If philosophy is, as Hegel suggested, 'its age grasped in thought', Nietzsche's position is philosophy: the tension he confronts is the tension in modern capitalism between the production of repressive identity and the production of isolated individuality.

Nietzsche claims that in Wagner the lack of articulation leads to 'swimming' instead of 'dancing' (*SW* 2 p. 434 and *SW* 6 p. 422), because the music loses all sense of balanced proportion and threatens to dissolve as 'music'. This reveals a great deal about what Nietzsche thinks music really is. Wagner is '*chaos* instead of rhythm' (*SW* 6 p. 422). Music is here, as it was for Schelling, rhythm, the 'transformation of a succession which in itself is meaningless into one which is meaningful . . . the institution of unity into multiplicity' (I/5 p. 493–4/321–322). This can be interpreted with reference to Nietzsche's adherence, in the later work, to a 'classical aesthetics', an aesthetics of proportionality. However, this does not explain the real difficulties which Nietzsche tries to confront when he talks about music: the roots of his adherence to a classical ideal are much deeper.

In his influential work on Nietzsche Heidegger concurs with Nietzsche's objections to Wagner, but misunderstands them in a way that has important consequences for more than just music. Like the Nietzsche of the passages from *Human, All Too Human* Heidegger is Hegelian in relation to music. One suspects he simply borrows part of the argument from Hegel's *Aesthetics*. Heidegger gives little evidence in his writings of being aware of music in a way which would bear seriously on the rest of his philosophy. He seems to be following Nietzsche, but is actually following Hegel, when he discusses the 'Gesamtkunstwerk':

> According to the intention the music should be a means of showing the drama to its best advantage; but in reality music becomes the real art in the form of the opera. . . . Poetry [*Dichtung*] and language remain without the essential and decisive forming power of real knowledge. The dominance of art as music is artificial and thus the dominance of the pure state of feeling.[18]

The supposed 'dominance of feeling' is the culmination of what Gadamer, following Heidegger, will term the 'subjectification of

aesthetics', the location of the significance of art in the feelings of a subject. Aesthetics, the 'logic of sensuousness', is the historical complement of the end of great art. The fact that music takes on the status as the predominant art:

> already has its basis in the increasingly aesthetic attitude to art as a whole; it is the conception and evaluation of art from out of the naked state of feeling, and the increasing barbarisation of the state of feeling itself into the naked seething and surging of feeling which has been left to itself.[19]

However, if one can show that music is not to be understood as the triumph of the subjective in aesthetics, then the argument that the rise of aesthetics is just part of the subjectification of Being ceases to be convincing. This is why Nietzsche's difficulties with music have more than just local significance for aesthetics, and go to the heart of the debate about aesthetics and modernity.

It is clear that Nietzsche, unlike Heidegger, does not regard music as inherently only an expression of feeling. Indeed, as we saw, Heidegger's own discussion of language may be more reliant on the example of music than he realises. Heidegger's argument about Wagner misses most of the point both of Nietzsche's variable view of music, and of his critique of Wagner. Nietzsche is in fact not often concerned with music's domination of the verbal arts. At the beginning of *The Case of Wagner* Nietzsche says:

> Have people noticed that music *liberates* the mind? gives the thought wings, that one becomes the more a philosopher the more one becomes a musician? – It is as though lightning flashes through the grey sky of abstraction (*SW* 6 p. 14),

suggesting that musical articulation can counter philosophy's suspicion of the sensuous.

Nietzsche's real concern is with the fact that in Wagner the music is 'theatrical', and thus lacks the essential attribute of the aesthetic, the absence of an ulterior purpose. The crucial passage is the following, which, for once, is consistent with many others:

> Wagner was *not* a musician by instinct. He proved this by giving up all lawfulness and, more exactly, all style in music, in order to make of it what he needed, a theatre-rhetoric, a means of expression, of the amplification of gestures, of suggestion, of the psychologically-picturesque. . . . he *increased the linguistic capacity of music into the unmeasurable* –: he is the Victor Hugo of music as language. Always provided that one first of all considers it valid that

music *should be allowed* in certain circumstances not to be music, but language, but a tool, but ancilla dramaturgica (*SW* 6 p. 30).

As in the much earlier fragment on music and language, 'real' music is regarded as radically autonomous, not reducible to language, to representation, or to being an expression of feelings. Language in this context is rhetoric, pragmatic utterance. Far from underestimating music, or just seeing it as the culmination of the decline of art into subjective feeling, as Heidegger does, Nietzsche is aware of how important music is for many of his arguments. This is precisely because it is not pragmatic and not just an expression of the desires of a subject.

Heidegger's antagonism towards music relies on his conception of it as a medium of feeling, which is supposed solely to be a function of the subject. He thereby misses an important point of the kind he himself makes about language in poetry. If, as Nietzsche suggested, music itself can bring about new – aesthetic – feelings in the subject, of a kind which can only be produced by such a non-representational medium, rather than just express existent feelings, the relationship of aesthetics and subjectivity has to be re-examined. This becomes particularly apparent with regard to art's relationship to sensuousness. It is, incidentally, odd that Heidegger, who wishes to bring metaphysics to an end, should adopt the antagonism of a Plato to the world of the senses in his view of music.

Nietzsche's attitude to the aesthetics of music brings out more interesting connections of music and metaphysics. The fifth book of *The Gay Science* spells out the questions raised by music in the later Nietzsche. In section 370 Nietzsche outlines his critique of 'Romanticism', which he associates with German music, Schopenhauer, and Wagner. Art is seen as a way of dealing with the contradictions of 'growing, struggling life'. Life necessarily involves suffering. If the suffering is a result of an excess of life, then a 'Dionysian' art is required, which is linked to an acknowledgement of the tragic unavoidability of destruction if life is to remain creative. 'Romanticism' is the result of the needs of those who suffer from the '*impoverishment of life*, who seek peace, quiet, a calm sea, redemption from themselves by art and knowledge, or also intoxication, convulsion, numbing, madness' (*SW* 3 p. 620, cf. also *SW* 6 p. 425). 'Romanticism' shares attributes with metaphysics, and Christian metaphysics in particular, which lead one away from the immediacy of sensuous life here and now.

In section 372, entitled 'Why we are not Idealists', Nietzsche

considers the traditional antagonism of philosophy to the senses in a manner not so far from the *BT*'s view of Socrates:

> 'Wax in the ears' was at that time almost a condition of philosophising; a real philosopher did not hear life any more, in so far as life is music, he *denied* the music of life, – it is an old philosophical superstition that all music is music of the sirens (*SW* 3 p. 623–4).

Nietzsche ponders whether the best thing to do is to see the question the other way round, to acknowledge that 'Ideas' may be more dangerously seductive than that which appeals to the senses. An unwritten section of the projected but abandoned *Will to Power* is entitled 'Value of "transience" ' (*SW* 13 p. 210), suggesting Nietzsche's opposition to Schopenhauer's metaphysics of art. He refuses to oppose the transient to an illusory, metaphysical eternity.

The positive investment in certain, usually Italian, music for the later Nietzsche lies in the fact that it does not seem to need the metaphysical supports he sees music as acquiring from Schopenhauer and Wagner, which he terms the 'religious need masked as music' (*SW* 13 p. 210). His concern is with music which creates diversity, not unity. In section 373 of *The Gay Science*, ' "Science" as Prejudice', Nietzsche attacks the notion that natural science's mathematisation of the cosmos is the only possible interpretation of the world, indeed he suggests that it may turn out to be 'one of the *most stupid*, that is, most lacking in meaning [*sinnärmsten*] of all possible world-interpretations'. He cites as evidence the fact that a scientific evaluation of music which relies upon 'how much of it can be counted, calculated, brought into formulae' would be absurd: 'What would one have grasped, understood, recognised of it! Nothing, almost nothing of that which is really "music" in it!. . .' (*SW* 3 p. 626). He leaves open the question of what 'music' is in such a context, thereby avoiding the trap of making it into a fundamental principle.

The problem becomes how to discuss music at all. Nietzsche mixes a bewildering number of different ways of talking about music in the later work. In a note of 1884 Nietzsche sees music as

> an echo of states whose conceptual expression was *mysticism* – feeling of transfiguration of the individual. Or: the reconciliation of inner contradictions into something new, *birth of the third* (*SW* 11 p. 75),

suggesting a dialectical reconciliation that lies outside conceptuality. Elsewhere, in the notes of Autumn 1887, Nietzsche can still claim that

> *In relation to music* all communication via words is brazen; the word dilutes and dulls; the word depersonalises: the word makes the uncommon common (*SW* 12 p. 493),

now using music as a corrective to the view of language in 'On Truth and Lie'. Such statements have a metaphysical ring to them, suggesting music's ability to say more than other forms of articulation can, as opposed to the view that music says what music can. Nietzsche, though, is insistent that music should remain free of traditional metaphysics. His dividedness in this area goes to the heart of his philosophy.

Aesthetics, interpretation and subjectivity

In order to understand the implications of these bewilderingly diverse views we need now to look more closely at Nietzsche's views of subjectivity and art in the later philosophy. This is an area of baffling complexity. The tension in these writings derives from their varying conceptions of the status of aesthetics. Most notoriously, in one of his more excessive attempts to avoid metaphysics, Nietzsche sees aesthetics as 'nothing but an applied physiology' (*SW* 6 p. 418), rejecting Wagner's music for its detrimental physical effects:

> And so I ask myself: what does my whole body really *want* from music at all? For there is no soul... I think it wants its *relief*: as though all animal functions should be speeded up by light, bold, lively, self-confident rhythms (*SW* 6 p. 419).

The best music is that most suited to the organism, and 'aesthetics is indissolubly bound to... biological preconditions' (*SW* 6 p. 50). All this does, though, is to found the explication of one phenomenon, art, on another interpretation of the world, biology, giving the latter primacy. One can equally do the opposite and suggest that the existence of the science of biology itself is really founded in 'aesthetic' production, as Nietzsche effectively argued in the essay on 'Truth and Lie', when looking at the way the subject determined the object. Nothing in biology will be able to account for a particular piece of music, as nothing in a piece of music can explain the physiology of the organism which produced it. The two are not wholly unconnected: there have to be organic bodies for there to be music, but getting from biology to music cannot be done by biology, and vice versa.

Whilst it is undeniable that organisms function in terms of rhythm, which is perhaps the most fundamental aspect of music, defining rhythm

itself requires a medium, language, which depends upon rhythm, in the form of repetition, *and*, as we have repeatedly seen, a consciousness for which rhythm is meaningful succession. Hermeneutic decisions are unavoidable in such areas: music can be investigated in relation to biological rhythms, but that does not mean one can maintain in a non-circular way that aesthetics is dependent on biology. Hearing music as a biological stimulus for the organism, rather than as a means of articulation available to a subject, depends upon the structure of regarding something 'as' something. It also ignores the question of whether art works should be seen from the side of production or of reception: why should one organism want to make a means of stimulation for another? How are the two organisms related? This question inevitably leads to questions of communication and intersubjectivity, not to obeisance to the imperatives of science.

At his best Nietzsche is aware of such problems. The section, 'Our new "Infinite" ' of *The Gay Science*, relates to the refusal to reduce music to any evaluation in terms of something else: it follows on from the passage which mocks the pretensions of science to grasp music. In it Nietzsche posits a version of the Romantic notion of 'infinite interpretation' which points forward to existential hermeneutics. The 'perspectival character of existence', the result of the loss of the Absolute, Nietzsche argues, applies also to the human intellect itself, which can only see itself in terms of its own perspectives. The argument addresses the issue of reflection which we have found in Fichte, Schelling, and the Romantics: a perspective entails a splitting of two aspects which prevents the possibility of showing their identity, unless one presupposes an underlying theological identity in which God is the sum of all perspectives.

The result is that the world 'has again become "infinite" for us: to the extent that we cannot reject the possibility that it *contains infinite interpretations in itself* (*SW* 3 p. 627). Later the infinity of interpretation is seen to depend upon the radical meaninglessness of existence, to which meaning must be given. Significantly, Nietzsche still sees the idea initially in relation to music: 'That is the way it is with notes [*Tönen*] but also with the destinies of peoples: they are capable of the most various interpretation. . .' (*SW* 12 p. 359). This evidently jars with the contention that aesthetics can be reduced to physiology, which is in these terms just one aspect of our perspectival relationship to the world and ourselves. The sense that aesthetics is precisely the place where the articulation of infinite interpretations can take place is lost in the view of

aesthetics as physiology. Nietzsche's ambiguous relationship to music is a result of his veering between a biological reductionist view of aesthetics, a related desire to rid aesthetics of any trace of metaphysics, and an attachment to Romantic aesthetics.

The stress on infinite interpretation, which Nietzsche often relates to music, is central to the later philosophy. In this connection it is striking how often in the notes from 1885 onwards Nietzsche echoes Idealist and Romantic views of subjectivity. One side of his efforts is directed towards the destruction of the notion of the unified subject in the name of the 'will to power' and of a world which is inherently never stable or unified. The subject is to be dislodged from a privileged position as the location of intelligibility by the revelation of its inherent dependence upon an ungraspable Other, which is yet also itself. In many ways Nietzsche says little that is fundamentally new on the question of subjectivity: much that we saw in Schopenhauer recurs, though usually in affirmative, rather than negative terms. He does, though, push certain questions we have already looked at a stage further.

Nietzsche, in common with his epigones, identifies philosophies of the subject with the metaphysics he wishes to overcome:

> What separates me most thoroughly from the metaphysicians is this: I do not concede to them that the 'I' is that which thinks: instead I take the *I itself as a construction of thought*, of the same status as 'matter' 'thing' 'substance' 'individual' 'purpose' 'number': thus as a *regulative fiction* (*SW* 11 p. 526).

The argument is not that far from Schelling's criticism of Hegel for putting the abstract categories before that from which they are abstracted, and parallels the general critique of Idealism that is common to Feuerbach and Marx. This does not, though, account for subjectivity, which, as we have seen, need not be regarded as a synthesised identity of the I. From Kant onwards, seeing it in these terms repeatedly raised all the problems of self-reflexive identification. In the passage quoted subjectivity is 'thought', which may subsequently try to synthesise itself into an 'I'. Nietzsche invokes a radical nominalism, whereby the world is an infinity of different aspects which we make into identifiable entities for our own purposes. All syntheses are, thus, to be explained by these purposes, not in terms of their truth: knowledge is power over, not unity with, or synthesis of, the object. Language perpetuates the delusions of metaphysics via the apparent necessities of the grammar of subject and predicate. The problem of whether the subject can become an object for itself is reformulated.

Nietzsche wishes to regard the synthesising of that which thinks into a subject and the synthesising of effects from 'outside' into an object as manifestations of the will to power which act upon each other. The subject's supposed unity, which Kant termed the 'transcendental unity of apperception', the I which must accompany all my representations, consists in fact of a series of warring aspects:

> We need unities in order to calculate: there is no reason to assume for this reason that such unities exist. We borrowed the concept of unity from our concept of 'I' ... If we did not consider ourselfs unities we would have never formed the concept of a 'thing'. Now, fairly late, we are thoroughly convinced that our conception of the concept of I does not guarantee any real unity (*SW* 13 p. 258).

Thought 'is just a *certain behaviour of drives in relation to each other*' (*SW* 3 p. 558). Nietzsche goes further: 'What we call "consciousness" and "spirit" is only a means and a tool by which not a subject but a *struggle wishes to preserve itself*' (*SW* 12 p. 40). Self-consciousness is reduced to self-preservation.

This reduction, though, scarcely enables one to account for self-consciousness. Nietzsche's constant concern is to avoid any reduction of the fluidity of existence, but he never takes account of the view of individuality, exemplified in Schleiermacher, which precisely does not posit a unified, self-transparent subject, but rather one which constantly strives to attain an impossible identity. The subject's lack of identity is what forces it into interpretation of itself, which is impossible to complete, but which is not simple dispersal. If it were such dispersal the most basic facts of conscious life would become inexplicable, much in the way I suggested they do in post-structuralism.

Nietzsche's difficulty lies in his denial that subjectivity could be a basis for truth, combined with his attempt to account for the undeniable fact of subjectivity. He does this by positing, in a manner not unrelated to Lacan's interpretations of Freud, an underlying true subject which deceives itself about its real nature: the will to power. No consistent line is discernable in his approaches to this issue. At times, for instance, he gets oddly close to Fichte, though he wants to avoid Fichte's Idealism, in favour of a voluntarism of the subject:

> 'Thingness' is only created by us. The question is ... whether that which 'posits things' alone is real ... *The subject alone is provable:* **hypothises**, *that there are only subjects* – that 'object' is only a kind of effort of subject on subject ... a *modus of the subject* (*SW* 12 p. 396).

The attacks on subjectivity as a ground of cognitive certainty often echo Schelling and Romanticism:

> One would like to know what *things in themselves* are like: but look, there are no things in themselves! But even supposing there were an in itself, an Absolute [*Unbedingtes*], then it *could not be known* for precisely that reason! Something absolute cannot be known: otherwise it would precisely not be absolute! (*SW* 12 p. 141).

Nietzsche echoes the notion of the infinite activity which limits itself that Schelling develops from Fichte in the *System of Transcendental Idealism*: the idea of an object is 'the sum of the *limitations* [*Hemmungen*] experienced of which we have become *conscious*' (*SW* 12 p. 98). There is not, though, as there was not for Schopenhauer, any teleological sequence in this self-limitation of the will to power. The ascending genealogy of consciousness seen in the *STI* now becomes a genealogy of repression, a genealogy of the growing obstruction of creative potential by science and morality. At one point Nietzsche adopts the central contention of the *STI*: '*visible* organic life and the *invisible* creative spiritual working and thinking contain a parallelism: via the "work of art" one can demonstrate these two sides most clearly as parallel' (*SW* 12 p. 139). He even, in true Romantic fashion, sees the world 'as a work of art which gives birth to itself' (*SW* 12 p. 119). Despite his radicality Nietzsche is forced to repeat many of the themes that have concerned us up to now. As I have tried to suggest, this is also the fate of his epigones.

Nietzsche's essential difference from the Idealist and Romantic tradition lies in his separation of the synthetic activity of thought from any notion of truth. For Nietzsche the true subject is unknowable: any attempt to define it is necessarily a misrecognition of something which cannot be given a recognisable identity. The problem is the same as that of thinking the Absolute. Now, though, the Absolute is conceived of as devoid of any unity. Nature, the radically other, is also the ground of our own being. Our knowledge of it is, in Kantian fashion, a construct, which Nietzsche, though, regards as generated by self-preservation. The self that is to preserve itself, however, is not a static identity: its main attribute is the desire to increase its power.

Schelling's Idealism presented aesthetic production as a way of comprehending nature which overcame the limits of the Understanding and thereby suggested a meaning that was lacking when nature was seen solely in terms of objectifying empirical science. Nietzsche, as we saw, starts from the premise of the radical meaninglessness of existence. In

The Gay Science he formulates this as a defiant challenge: the universe 'is neither complete, nor beautiful, nor noble, and does not wish to become any of these, it absolutely does not strive to imitate mankind! It is not touched at all by any of our aesthetic and moral judgements' (*SW* 3 p. 468). Such judgements he sees as still tinged with theology, and asks, echoing the young, Feuerbach-influenced Marx: 'When will we be allowed to begin *naturalising* ourselves with the pure, newly-found, newly redeemed nature' (*SW* 3 p. 469). In such remarks he still retains some aspects of early Idealist thinking, in that nature, though indifferent to our purposes, can stand for a way of being which is free of the constraints of theology. Furthermore, the sense we can make of the world when we have given up theological illusions will be generated by our own natural powers.

By the time of the work on the *The Will to Power* Nietzsche's view of art's relation to nature is more cynical, but the significance of the aesthetic has become even greater. Art has come to include science and philosophy of every kind, but not in a higher synthesis which would integrate us into nature, as suggested by the *System Programme* or the *Discourse on Mythology*. Instead:

> man must by nature be a liar, he must more than anything else still be an *artist*. . .And he is too: metaphysics, morality, religion, science – All inventions of his will to art, to lie, to flight from the 'truth', to the *denial* of the 'truth' (*SW* 13 p. 193).

The argument is close to the *BT*: without art the truth about existence would be unbearable. Art is the stimulus to life in the face of a terrifyingly meaningless existence.

By now, though, artistic production is production *per se*. This has a crucial consequence: *if subjectivity is solely another form of reflection of the will to power, aesthetic production has no privileged status over 'natural' production*. This becomes apparent when Nietzsche talks of 'interpretation'. 'Interpretation' is a version of Romantic 'infinite reflection'. Infinite reflection in Romanticism was a form of revelation of an unrepresentable Absolute. Nietzsche's 'interpretation', instead of being founded upon a sense of the wealth of productive potential in nature, is founded on an agonistic view of nature of the kind we saw in Schopenhauer. Nietzsche's 'interpretation' is a power struggle: 'The will to power *interprets*: in the constitution of an organ it is a question of an interpretation' (*SW* 12 p. 139). 'Interpretation' depends upon power differentials, whereby one force subordinates another: the plant

subordinates the materials it needs for its continued existence, mankind sees nature as the object of its fight for self-preservation, the artist subordinates the chaos of a meaningless world to his will.

Nietzsche separates 'interpretation' from subjectivity: 'One may not ask: "*who* is interpreting then?" rather interpretation itself, as a form of the will to power has existence (but not as 'being', rather as a *process*, a *becoming*) as an affect' (*SW* 12 p. 140). One is not far from that side of Romantic thinking which we earlier linked to post-structuralism, in which differentiality becomes the principle of reality, so that there can be no ultimate founding identity, only an endless moving chain of difference.

Nietzsche himself, though, suggests the problem of this conception of interpretation as a series of endless power differentials:

> Simple differences in power could not feel themselves as such: there must be a something there which wishes to grow, which interprets every other something that wishes to grow in terms of its value (*SW* 12 p. 140).

The description sounds suspiciously like that of a subject and raises again the problems of reflection: feeling oneself as oneself cannot come about via reflection in the other or by reflection upon oneself, one must have a pre-reflexive sense of oneself, which Fichte, Novalis, and Schleiermacher termed 'feeling', otherwise self-consciousness is impossible. The notion of a drive for greater power only makes sense if that which wishes to grow has an identity beyond its difference from the other, otherwise the growth in power could not be registered.

Nietzsche also has to confront the problem that a 'transvaluation of all values' itself requires that for which a value is a value. If value cannot, as Nietzsche himself suggests, be established simply by quantitive differentiation, in terms of quanta of the will to power, one must confront again the Idealist and Romantic views of a subjectivity which was not reducible to being a *function* of something else, and is the prior condition of seeing something *as* something. Nietzsche tries to deny the reality of self-consciousness' irreducibility. However, the kind of relation which would transcend quantitative difference presupposes a form of consciousness, which he is unable to account for satisfactorily. There is nothing in Nietzsche, or his successors from Heidegger to Derrida, which enables one to understand the fact of self-consciousness in a coherent manner.

The notion of 'interpretation' as aesthetic production, be it in the form of science, art, philosophy, or *nature*, continues aspects of

Romanticism to their extreme. At the same time this version of Nietzsche's argument precludes any consideration of aesthetic autonomy by reducing aesthetics to the 'intoxication' of the creative artist, which is 'the increased feeling of power; the inner compulsion to make of things a reflex of his own fullness and completion' (*SW* 13 p. 356). It also dismisses the aesthetics of reception as 'wench-aesthetics' (!) (*SW* 13 p. 357), because it involves a passive relation to the object.

In an odd way this makes aesthetics even more dependent upon a subject. Nietzsche would, no doubt, refuse to term the creative artist a subject, but transforming things into a reflex of oneself is again an attribute of subjectivity. In the critique of Wagner, though, Nietzsche attached substantial importance to the autonomy of music, in order to counter the reception of music as a replacement for theology. This is wholly at odds with the reduction of aesthetics to 'intoxication'. He tries to reconcile these views via the assessment of music's value in terms of its physiological effect: 'Keep in mind that every art which has physiology against it is a refuted art. . .One can refute Wagner's music physiologically' (*SW* 13 p. 471). However, if the value of music is assessed physiologically, it is being functionalised into a means for something else: the well-being of the organism. Aesthetic pleasure becomes just pleasure, and art ceases to have a status different from a tasty soufflé. Nietzsche's essential objection to Wagner's music was that it was in the service of something else. Nietzsche obliterates the basis of that objection by his recourse to physiology. As opposed to the period of the *BT*, Nietzsche now seems simply not to like the effect Wagner has on him. It is now a question of personal (physiological) preference: if Wagner makes you feel more powerful and in control, he can presumably be 'proven', rather than refuted. Nietzsche, by this time, happens to feel better listening to Bizet.

The contradictions of Nietzsche's position lead increasingly to an arbitrariness, which is explicable in terms of the theory of the will to power, but which also displays the problems this theory gives rise to. Any judgement about aesthetics becomes circular, in that it must be referred to the condition of possibility of differentiation: the will to power. A positive aesthetic judgement will increase the quantum of power, a negative judgement will diminish it. The aridity of this conception is obvious, though, as we saw, there are other elements of Nietzsche's thinking about art which are not so reductive.

The reason for Nietzsche's importance is precisely that he illustrates the extremes which result from the divorce of aesthetics from

metaphysics. This is not just Nietzsche's problem. It is the problem of most modern art. The divorce leads to contradictions which Nietzsche often tries to ignore, not least by reintroducing metaphysics in the form of the will to power. What, though, is the serious alternative in aesthetics when its metaphysical ground has been removed? How can one find a way beyond Nietzsche's contradictions? The vital issue is to find a way beyond them, not to repeat them, as many of his heirs are now doing. The side of Nietzsche which insists on difference over identity has, sometimes productively, lived on in deconstruction. One must, however, complement that side of modern thinking with an awareness that a non-repressive form of self-conscious identity, of the kind which art can point to, is a pressing political and philosophical necessity. In the conclusion I want briefly to suggest how the work of Adorno takes up the demand for such an identity by a productive appropriation, in the light of subsequent history, of the tradition we have been considering.

CONCLUSION

In contemporary philosophy and literary theory positions from the tradition we have been considering are still being repeated. I hope I have been able to suggest that a reconsideration of that tradition might lead philosophy and literary theory in more fruitful directions than seems likely on the basis of many current assumptions. The failure of much literary theory to be more than a rather scholastic reprocessing of texts in either a deconstructive or putatively historical-materialist mode is often a result of the unwarrantable assumption that literary theory has gone beyond aesthetics. 'Literature' is not a timeless category of Art: it is a historical phenomenon, but this does not invalidate the need to have a viable account of aesthetics. Such an account requires, above all, an adequate philosophical account of subjectivity, which has been signally lacking in most recent theory. The result of much contemporary literary theory often seems to be the conclusion that literature does not matter, or that it is just like any other writing. This farewell to the past must be questioned to see if it is not actually a way of repressing intractable problems. Similarly, a philosophy whose main aim is to celebrate the end of subjectivity in the name of some other principle, such as 'the signifier', or 'the sentence' is as reifying as the reality of capitalist modernity which it purports to oppose. There has been a remarkable amnesis in those recent theories which have announced themselves in terms of a new age. The issues they are concerned with are not 'post-modern', they are modern and involve the problems that emerge in modern philosophy.

Aesthetics emerged as a distinct area of philosophy as a consequence of the growing centrality of subjectivity in modern societies. The task of understanding our relationship to the world without the assistance of dogmatic theology, the attempt to build a future metaphysics, increasingly runs into difficulties for reasons which are apparent in the

reflections on aesthetics of all the thinkers we have looked at. The difficulties are those which the proponents of post-modernity claim to see as something new and unheard of.

Nietzsche's significance lies in his exploration of how the world would look if one tried to eradicate the metaphysical heritage completely. Important as they are, Nietzsche's approaches are inconsistently enlightening and must be complemented from other areas. Marxism is often concerned with much the same issues as Nietzsche. Much twentieth-century aesthetic theory – I am thinking particularly of Benjamin and Adorno – addresses the question of what happens to those aspects of experience, previously catered for by theology, which do not disappear simply because theology disappears. The most important answers to Nietzsche's élitist and frequently social-Darwinist ideas come from Jewish philosophers within the Marxist tradition. Their ideas have still to be adequately explored, first in the perspective that the present book has tried to establish, and second in relation to the other currents of philosophy which give central importance to art. The alternative response to Nietzsche's questions leads to Heidegger. However important Heidegger may be, there are serious reasons for rejecting his philosophy, of the kind I have tried to suggest in linking him in certain respects to the thinkers looked at in the present book. My advocacy of an aesthetic theory which leads in the direction of Adorno is based on my scepticism about Heidegger. In a subsequent volume I shall look more closely at the question of Adorno and Heidegger.

Aesthetic theory, as I hope to have shown, demonstrates, probably more than any other area of philosophy, that the story of modernity as the increasing 'subjectification' of Being is a gross over-simplification. The growth of subjective control via technology accompanies the increasing subversion of subjectivity via the awareness of its inherent dependence and inability to ground itself. At the same time a more and more differentiated view of subjectivity results, both in artistic production and in philosophical reflection about art. These issues were already apparent in Fichte and Schelling: the rigorous pursuit of the logic of the philosophical argument led in German Idealism to a prophetic sense of the actual historical development of subjectivity. Much depends upon the way in which the dependence of the subject was conceived. In Schleiermacher this dependence did not lead to the consequences seen in Schopenhauer and Nietzsche. The view of the ground of subjectivity as inherently antagonistic culminates in Nietzsche's attempts to do away with any notion of a subject at all, making the

subject subordinate to a more fundamental force. Nietzsche will be followed in this by many subsequent thinkers, who, unfortunately, ignore many of the issues in the present book.

Few, if any, of these thinkers are able to give a coherent account of the fact of self-consciousness which does not fall prey to the difficulties of the reflection model, making self-consciousness a reflex of something else, be it *Geist*, self-preservation, the symbolic order, or the movement of *différance*. Furthermore, the elimination of the subject from philosophy, and particularly from aesthetics, fails to understand that dialectical movement in modernity that liberates subjective capacities from tradition but also creates objective structures which function via the elimination of the individual subject. A philosophical attention to the irreducibility of individual self-consciousness has only recently reappeared on the agenda of contemporary discussion, particularly in the work of Manfred Frank. The story of modern art is far more effectively told in terms of the tension between individuality and the pressure of existing social and symbolic orders than in terms of a subjectless movement of Tradition, *différance*, the 'sendings of Being', or any other candidate for the vacant centre of aesthetic theory or philosophy.

The subject which is the concern of aesthetic theory from Baumgarten onwards inherently resists reduction into general categories. Aesthetic theory already suggests the difficulties of reconciling empirical, individual subjects with the notion of a general intelligible subjectivity. Hegel began to see the problem of the relationship of individual and general meaning in the passages we examined on 'Romantic art' and on Schlegel's irony. For Hegel, as long as art is part of the wider process of the development of Reason, it is self-legitimating. Once it is separated from the general development of the community, which is more and more dependent upon scientific, legal and political issues requiring the objective application of rules that transcend the individual case, art is left with a problematic alternative. The difficulties which emerge in painting in relation to the invention of photography can illustrate the broader philosophical problem.

Photography performs the function of stemming the tide of transience which follows the decline of theological time more obviously and efficiently than painting. Technology eliminates the individual subject that produces the image, by itself being able to produce instantaneous images of time. The elimination is evidently not total, but anyone could learn to use Nadar's camera, even though they could not produce his

photographs. Technology is able to perform the function of the eternalisation of transience which Hegel sees as *Geist*'s role in art. A particular aesthetic skill can be replaced in one of its aspects by a general technological means. Artists are then left with the choice of attempting to compete or of redefining their function. This is one way of understanding the eventual emergence of non-representational art, art which need not point to a truth in the world beyond its own forms. The other way is to connect its emergence to music. Such art sustains its aesthetic integrity by resisting the functionalisation characteristic of the photographic product.

Hartmut Scheible suggests that there are two alternatives. Art can put itself in the service of something else, of a particular world view, for example, lose its status as art, and become propagandistic, journalistic, part of advertising. Alternatively it can become the sphere of expression of a subjectivity which has no anchor in any collective reality beyond the development of the particular form in which the artist is working. Art becomes in this view either functional, or radically useless. A vital question is, though, whether in fact the two aspects are only exclusive of each other in the culture of modern capitalism, or whether, as Schleiermacher's aesthetics suggest, this separation is never total. Much twentieth-century aesthetic theory will be concerned with this issue.

Most of the important debate over art in the twentieth century is a repetition of issues that concerned the early Romantics and Hegel, which have been transferred in very concrete ways into a world more fully dominated by the exchange principle. Orthodox Marxist adherents of 'Socialist Realism', for example, opt for that side of Hegel which sees art as being overtaken by more fundamental concerns of the community, and thereby surrender the real potential of the aesthetic. The importance of this potential is evident in the triumph of the aestheticisation of commodities in advertising and elsewhere, which is one form of the new mythology in the present.

A major problem that radical aesthetic theory needs to confront in our century is the fact that, if one has lost metaphysical, or collectively binding criteria for the judgement of the products of subjective spontaneity, there is no sure way of distinguishing in advance the aesthetically significant from the politically reactionary. In the twentieth century aesthetic issues become dangerous, they cost lives and affect politics in ways which are not always immediately apparent. Failure to confront this fact can, and often does, have dire consequences for a

radical aesthetics. The problem of a non-metaphysical notion of aesthetic autonomy is central here.

I have suggested how the idea of aesthetic and literary autonomy emerges in relation to wordless music. The area least satisfactorily dealt with by most philosophical reflection on art is music. Once one looks more closely at the issue of language's relation to music the transitions between the aesthetic and other modes of articulation become ever more complex and important. The philosophical challenge of music lies in its non-representational character. Music best enables one to understand the nature and importance of modern hermeneutics. Hermeneutics of the kind I explored in Schleiermacher's work is largely ignored or misunderstood by much Marxist theory. Music's significance cannot be exhausted by reducing it to being the sum of its historical determinations. Music can act as a mirror of aspects of the circumstances of its production; this does, not, though, exhaust what it may be as music. Music is vital in the attempt to give an account of self-consciousness. Music is also, as we saw, a crucial component in tracing the roots of post-structuralism. Much of the appeal of post-structuralism, as I suggested, seems to me explicable in terms of its re-awakening of the issues in Romantic aesthetics, particularly concerning music and language, that had been repressed in much philosophical reflection in our century.

In this century it is, as has been often suggested, Adorno who most effectively refuses to ignore or simplify the philosophical significance of music and the political significance of aesthetic autonomy. Adorno's indebtedness to the tradition we have been considering is well-known. Recently the relationship between Adorno and post-structuralism has at last begun to be explored. Adorno is in many ways the best guide to the subsequent history of the central concerns of this book. Twentieth-century aesthetic theory in Germany is largely based upon the tension between the Hegelian-Marxist and existential hermeneutic traditions. As I hope to have shown, the relationship of these traditions is more complex than it is often made out to be. This is easily demonstrated in the case of Gadamer, who, though putatively a successor of Heidegger, is in many ways a Hegelian, who replaces *Geist* with Tradition. He also, apparently without knowing it, argues many points much in the manner of the Schleiermacher I have tried to present in this book.

Adorno himself clearly relates to both the Hegelian-Marxist and existential traditions, despite his attempts to exaggerate his – significant

– distance from Heidegger. These are, as I said, issues that need extensive treatment in another book. However, Adorno's key arguments in the areas I am dealing with should appear in a different light in relation to the story I have tried to tell. They should be able to suggest the contemporary importance of a reconsideration of the path from Kant to Nietzsche.

Adorno's reflections on music engage with the issues seen in Nietzsche. Adorno confronts the tension involved in trying to sustain a non-metaphysical, historically based, version of aesthetic autonomy at the same time as doing justice to the fact that, by the time he is writing, most art has been appropriated by the 'culture industry' as a commodity to be bought and sold for extra-aesthetic reasons. Adorno insists that Kant is right to maintain that no aesthetic theory is possible without the assumption that aesthetics must involve a moment free of 'immediate desire',[1] however much desire may be involved in the constitution of other aspects of the work of art. For Adorno the new significance of music in the early nineteenth century is a condition of aesthetic autonomy. The argument is much the same as in Schlegel's view of the novel: the perception of conceptless music enables one to see what in a piece of writing is not reducible to concepts.

Adorno is insistent that aesthetic autonomy be seen historically: 'the historical movement of all art takes place not least because of the instability of the purely aesthetic'.[2] Even in music there are aspects which are not 'purely aesthetic', which push music towards being a representation of something else. (Adorno does not, however, seem to reverse the argument and find aspects of the 'purely aesthetic' in artefacts that are not works of art: this is a result of his failure to theorise the relationship of art and subjectivity in an adequate manner.) Adorno cites those aspects of classical music which derive from functional music, such as the use of military music in Beethoven. Despite this, the fact that what music 'says' is radically untranslatable into any other medium, becomes, after the end of the eighteenth century, an index of aesthetic autonomy which is applied to other art. Autonomy is a result of art's being devoid of purposive rationality, as aesthetic pleasure already was for Kant.

From Adorno's historical perspective the importance of this has greatly increased. His concern is to find sense in something which cannot be integrated into the goals of a society – or a subject – which regards everything as valuable in terms of its own ends, and never sees any value in things for themselves. Kant termed the non-aesthetic

version of this idea 'dignity', that which is without price. Adorno himself sometimes arrives at a position not that far from Schopenhauer:

> In the last analysis it is the raison d'être of every art to withdraw from a raison d'être, from the legitimation of its own existence according to criteria of self-preservation, however sublimated that self-preservation might be.[3]

For Schopenhauer such an argument was grounded in the ultimate futility of the sensuous. Adorno seems to get near to such arguments at times:

> Art appeals against death by lasting; the short-lived eternity of the works is an allegory of an art which would not just be appearance. Art is the appearance of that which death cannot reach.[4]

At the same time, Adorno wishes to redeem the sensuous in art from its suspect status, hanging on to a metaphysical residue which derives from art's capacity to resist evanescence. His view derives, like the aesthetics of Idealism, from historically based fears about a world in which the Understanding becomes the main arbiter of the subject's relation to its own and external nature. Art's survival is still, however questionably, a form of truth which engages ourselves as sensuous subjects. From Adorno's perspective after Auschwitz, though, suspicion of making the world appear beautiful is now at least as important as the promise beauty may contain. However much it works as a means of sustaining meaning beyond the contingent goals of a particular society, aesthetic autonomy is threatened by the development which helped produce it in the first place: the liberation of subjectivity.

Adorno's view of the development of Western music is in fact a history of subjectivity. His history is a version of the story of the present book. One point needs to be made clear in this context. From what I have said it should be evident that I do not accept Adorno's notion of the 'primacy of the object' in the subject.[5] The legitimate point of the notion is to suggest to what extent the accumulation of historical pressures on the subject leaves no room for any serious autonomy. The notion fails, though, to escape the problems of reflection. For there to be a notion of an object at all there must be a prior subject which can see the object as an object. Adorno's argument tends therefore to block a priori any sense of the potential of individuality which is never reducible to the objectivity of the history in which it reflects and changes itself. Other aspects of Adorno's work do point to such possibilities, but they need different philosophical underpinning.

The development of art in modernity is linked to the liberation of the subject from theological constraints. This is best exemplified by music. From around Bach's time onwards the status of the rules of composition becomes increasingly a matter of free choice. Composers realise that received forms have no absolute status and that forms can be established by themselves as individuals, rather than received from tradition. How, though, can the individual subject produce something collectively significant in a medium which is devoid of the conceptuality which is the foundation of, say, scientific knowledge? Does what it produces relate to any other order of things, in the manner which founded the Idealist linking of natural beauty and the teleology of the organism? For Adorno the power of Beethoven's music lies in its attempt to reconcile received, and thus collectively significant, musical forms, such as sonata, variation, fugue, but also popular dance forms or marches, with the demands of the autonomous individual subject. Beethoven's late string quartets give the most extreme examples of the bizarre and compelling results of this process: sonatas of such brevity that they can hardly be heard as sonatas, variations where the scale and variety of the variations make the traditional centrality of the theme largely irrelevant, a massively complex fugue which follows counterpoint so far that harmony seems suspended. Beethoven's attempt in music to reconcile the particular subject and a general order, in the manner Hegel wished to in philosophy, is followed by the wholesale dissolution of received forms in Wagner.

The analogy in philosophy to Wagner is apparent in the open-endedness seen in Schelling, Schleiermacher, and the Romantics. This relates to the historical development of the antagonisms of bourgeois society, which are still part of our historical world, and which reveal the failure of the autonomous subject to establish a community of harmonious ends, despite the claims to universality of philosophies of subjectivity. In such a society, Adorno argues, the use of art to suggest a potential harmony becomes ideological, and true art must establish itself as critical of the social totality. Adorno, like Nietzsche, sees Wagner as moving music closer to language, and thus to the subject's attempt to express itself. This attempt, though, is based upon the disintegration of any binding forms in which the expression is possible. Within one view of aesthetics and modernity this, as I have suggested, leads to precisely what characterises the new potential in modern art. Schönberg sees this as the emergence of 'musical prose', which enables composers, such as Mahler, in *Das Lied von der Erde*, to extend the boundaries of music in

unheard directions. However, the implicitly positive side of such a view of modern art has a dialectical opposite.

The autonomy of art is only possible at the price of the renunciation of conceptually articulable general meaning – hence my linking music to the emergence of modern hermeneutics. Adorno often cites the literature of Kafka and Beckett as an example of this situation, as well as the music of Schönberg, Berg and Webern. Schelling pointed to the problem in the *Philosophy of Art* when he argued that the universality present in Greek mythology's ability to articulate truth via images was only available in modern art to artists who by their individuality create a 'closed circle of poetry'. Schönberg's music, which still has not been wholly assimilated by the general public, is a good example of this. Though such music undoubtedly articulates key collective aspects of the traumatic history of this century, it does so by following a logic developed out of musical principles which make it sound incomprehensible and ugly to many people. For Adorno music, and by implication the subject, is confronted with the contradictions between expression of 'what goes on inside human beings', which is inherently individual, and 'convention'.[6]

From Romanticism onwards, and particularly in Wagner, music is able more and more to find a language to express what Schopenhauer saw as the 'secret story of the Will': all those aspects of the inner life of human beings which cannot be adequately represented in verbal language. At the same time this expression becomes bound by convention: the diminished seventh chord, which Beethoven uses to make music more dynamic and open-ended and thus able to express something of the nature of autonomous subjectivity, later becomes a cliché for film music.

The convention extends for Adorno into the subjects whose experience such art expresses: modernity brings with it a potential for the impoverishment of subjectivity by convention which makes totalitarian politics possible. Even a means of articulation like music, which seemed able to 'say' what other media could not, becomes drawn into the sort of repetition characteristic of conceptual thought, and thereby threatens to lose its aesthetic status. In Wagner's operas the repeated link of stage action and leitmotiv begins to turn the musical phrase into an established signifier. This happens in a manner which has analogies to the way Hamann and others had seen language working: repeated connection of the signifier, here musical motif, to the intuition, here the stage action, is the basis of signification. For Adorno this is a form of

'identity thinking', which represses what is irreducibly different about the object.

Art articulates this irreducibility: the proximity to Romantic thinking, and to Nietzsche is clear. Adorno echoes Novalis's conception of art as representing the unrepresentable. Of course Wagner's music does more than turn music into a simulacrum of discursive language, but it also plays a role in the loss of a musical logic that is not simply subordinated to the intentions of an isolated subject. Wagner both creates unheard of possibilities and points to the limits of such creation. Adorno constantly tries to sustain a tension between the collective demand which would make art a part of a true community and an articulation of a repressed nature in ourselves, and the sense that the only possibility for art to suggest what this might mean may lie in the individual artist:

> In the face of the totalitarian unity which the eradication of difference directly proclaims as meaning, it may even be that temporarily something of the liberating social force has contracted into the sphere of the individual.[7]

He shares the Derridean fear of the reduction of difference, but links this to the individual in a way that Derrida never does.

At this point in Adorno's argument about the history of Western music aesthetic autonomy is at risk. Music's ability to create a realm which is not subordinated to purposive rationality is threatened: this is evident in the fact, for instance, that the expressive side of Wagner's music becomes the model for mass-produced film music. Instead of opening up a potentially endless domain of signification art is threatened with becoming an endless repetition of the same. The liberation of subjectivity can begin to feel like the opposite: individuality becomes swallowed by the objective force of already existing – subjectively established – ways of expressing it. Subjectivity becomes a form of objectivity. The battle for modern art, and the political challenge, is finding ways beyond this situation.

Adorno's story helps to explain the reasons why aesthetics might lead to an increasingly pessimistic view of subjectivity. The main locus in modernity of a non-instrumental relation to the world, aesthetic appearance, which is best exemplified in music, for the reasons we have seen, is colonised by the same instrumentality as dominates everything else. Adorno connects his view of art to the 'dialectic of enlightenment', in which the products of autonomous subjectivity, science and technology, which enable us to overcome the threat of external nature, end up imprisoning the subject in an objectivity of the same order as what has

supposedly been overcome. The ecological crisis is the best example of this dialectic. The result of seeing the world merely as an object to be overcome in the name of self-preservation has led to potential disaster.

From Kant onwards the realm which pointed to this danger was aesthetics. It is here that the apparently arcane issue of music and aesthetic autonomy becomes important as an index of how far modernity reduces nature to being the material which is dominated by the subject. Music, as we have seen, is hugely important in modernity, yet its significance, if not the logic of its material, is inherently at odds with notions of scientific enlightenment or technological control. The radicality with which Adorno approaches these questions – and some of the limitations of his view – are prefigured in Schopenhauer's pessimistic assessment of the fundamental nature of subjectivity and his conception of art as an escape from the drive to self-preservation of the Will. Adorno tends towards an inverted Hegelianism, where the progress of *Geist* is in fact the progress of merely instrumental reason, a 'logic of disintegration' whose aim is the conceptual domination of nature and whose result is, in its most devastating manifestation, the atom bomb. His story is clearly influenced by Schopenhauer and has echoes of Heidegger's notion that the history of modernity is a history of the 'subjectification' of Being.

Adorno's story neglects – but not completely, as Heidegger does – some of the story of subjectivity that I have outlined in this book: hence my questioning of his formulation of the primacy of the objective. The relationship of aesthetics, language and the individual subject is more complex than Adorno often makes it, as should be clear from my discussion of Schleiermacher and some of the versions of subjectivity seen in Idealism and Romanticism. The boundary between the aesthetic and other manifestations of subjectivity is not as obvious as Adorno sometimes makes it, once one realises that language inherently involves more than repressively identifying the world in the terms of instrumental subjectivity.

The tensions in Adorno's position are inherent in the whole problem of aesthetic autonomy. In Schopenhauer, sustaining complete autonomy for aesthetics removed it from any active role in enlightening us about our capacity for a reason which would not be purely instrumental. Adorno is emphatic that this is not his view: his pessimism is not grounded in a verdict about the essential nature of reason but rather in intense historical reflection upon the failure of the Idealist hopes for autonomous subjectivity's reconciliation with a general order of society

and nature presented in the *System Programme*, and, in Adorno's view, falsely achieved in Hegel's system. Adorno, unlike his Heideggerian and post-structuralist counterparts, sustains the hope for a subjectivity which would not be merely founded upon self-preservation and which could sustain individuality against the objective forces which militate against it. Art is the area where this hope appears.

Because the fundamental principle of subjectivity was seen in negative terms by Schopenhauer and Nietzsche and their successors, art is simply seen as an escape from it. Adorno refuses to accept this consequence, not least because he interprets what subjectivity is in terms of what it has become historically. Art, particularly music, allows him to point to the image of a subjectivity which would not experience individuation as a torment. In this he remains true to the Idealist and Romantic heritage in ways that are still important today. Much of the significant work in contemporary aesthetic theory is directed towards a reworking of Adorno's heritage. I hope I have been able to widen the scope of the search for appropriate ways of understanding the possibilities of aesthetic theory in the present by redeeming some of the arguments of the past that have too often been forgotten. Moving beyond Adorno will require looking back, in the light of our intellectual experience, to the more neglected thinkers of the tradition considered in this book.

APPENDIX

The so-called 'Oldest System Programme of German Idealism' (1796)

recto

An Ethics. As the whole of metaphysics will in future come under *Morality* – of which Kant only gave an *example* with his two practical postulates and *exhausted* nothing, this ethics will be nothing but a complete system of all Ideas, or, which is the same, of all practical postulates. The first Idea is naturally the notion *of my self* as an absolutely free being. With the free self-conscious being [*Wesen*] a whole *world* emerges at the same time – out of nothing – the only true and thinkable *creation from nothing* – Here I will descend to the fields of physics; the question is this: how must a world be for a moral being? I should like to give wings again to our physics which is progressing slowly and laboriously via experiments.

Thus – if philosophy gives the Ideas and experience the data we can finally achieve the grand physics which I expect from later epochs. It does not appear that our present physics could satisfy a creative spirit which is like ours, or like ours should be.

From nature I come to *human activity* [*Menschenwerk*]. Putting the Idea of humanity first – I want to show that there is no Idea of the *State* because the state is something *mechanical*, just as little as there is an Idea of a *machine*.

Only that which is an object of *freedom* is called an *Idea*. We must, then, also go beyond the state! – For every state must treat free people as a piece of machinery; and it should not do this; thus it must *come to an end*.

You can see yourselves that here all the Ideas, of eternal peace etc. are only *subordinate* Ideas of a higher Idea. At the same time I want here to establish the principles for a *History of Mankind* and to completely expose the whole miserable human creation of state, constitution,

government, legislature. Finally come the Ideas of a moral world, divinity, immortality – the upturning of all superstition, the pursuit of the priesthood, which has recently been feigning reason, by reason itself. – Absolute freedom of all spirits who bear the intelligible [*intellektuelle*] world in themselves, and may not seek either God or immortality *outside themselves*.

Finally the Idea which unites all, the Idea of *beauty*, the word taken in the higher platonic sense. I am now convinced that the highest act of reason, which embraces all Ideas, is an aesthetic act, and that *truth and goodness* are brothers *only in beauty* – The philosopher must possess just as much aesthetic power

verso

as the poet [*Dichter*]. People without aesthetic sense are our pedantic philosophers [*BuchstabenPhilosophen*]. The philosophy of spirit is an aesthetic philosophy. One cannot be spiritual [*geistreich*] in anything, one cannot even reason spiritually about history – without aesthetic sense. It should here become apparent what it is that people lack who understand no Ideas – and admit faithfully enough that everything is a mystery to them as soon as it goes beyond charts and registers.

Poetry thereby gains a higher dignity, at the end it again becomes what it was at the beginning – *teacher of (History) Mankind*; for there is no philosophy, no history any more, poetry alone will survive all the remaining sciences and arts.

At the same time we hear so often that the masses should have a *sensuous religion*. Not only the masses but also the philosopher needs monotheism of reason of the heart, polytheism of imagination [*Einbildungskraft*] and of art, this is what we need!

First of all I shall speak here of an Idea which, as far as I know, has never occurred to anyone – we must have a new mythology, but this mythology must be in the service of the Ideas, it must become a mythology of *reason*.

Before we make the Ideas aesthetic i.e. mythological, they are of no interest to the *people* and on the other hand before mythology is reasonable the philosopher must be ashamed of it. Thus enlightened and unenlightened must finally shake hands, mythology must become philosophical and the people reasonable, and philosophy must become mythological in order to make the philosophers sensuous. Then eternal unity will reign among us. Never the despising gaze, never the blind trembling of the people before its wise men and priests. Only then can

we expect the *same* development of *all* powers, of the individual as well as all individuals. No power will be suppressed any more, then general freedom and equality of spirits will reign! – A higher spirit sent from heaven must found this new religion among us, it will be the last, greatest work of mankind.

(Trans. Andrew Bowie)

LIST OF TRANSLATIONS

This is not intended to be an exhaustive list, nor is it a critical list. It is merely an indication of the availability in English of some of the key texts I have discussed.

Kant

Critique of Pure Reason, trans. Norman Kemp Smith, London 1929.
Critique of Practical Reason, trans. Thomas Kingsmill Abbott, London 1952.
Groundwork of the Metaphysics of Morals, trans. H. J. Paton, London 1948.
Critique of Judgement, trans. James Meredith, London 1952.
Kant Selections, ed. Lewis White Beck, London 1988, has useful further information on translations.

Fichte

Science of Knowledge with the First and Second Introductions, trans. Peter Heath and John Lachs, Cambridge 1982.
The Vocation of Man, trans. Roderich Chisholm, New York 1956.

Hölderlin

Friedrich Hölderlin; essays and letters on theory, trans. and ed. Thomas Pfau, New York 1988.

Schelling

The Unconditional in Human Knowledge. Four early essays, trans. Fritz

Marti, Lewisburg 1980.
Ideas for a Philosophy of Nature, intro. Robert Stern, Cambridge 1988.
System of Transcendental Idealism (1800), trans. Peter Heath, Virginia 1978.
Philosophy of Art, Minnesota 1988.

Hegel

Aesthetics, 2 vols., trans. T.M. Knox, Oxford 1975.
The Phenomenology of Mind, trans. James Baillie, London 1910.
Science of Logic, trans. A. V. Miller, New York 1969.
The Difference between Fichte's and Schelling's System of Philosophy, trans. H. S. Harris, Walter Cerf, New York 1977.
Encyclopedia of the Philosophical Sciences, trans. A. V. Miller, Oxford 1970.

Schleiermacher

Hermeneutics: the handwritten manuscripts, trans. James Duke and Jack Forstman, Missoula 1977.
See also Müller-Vollmer, Kurt, *The Hermeneutics Reader*, Oxford 1986.

Schlegel

See *German Aesthetic and Literary Criticism: the Romantic ironists and Goethe*, ed. Kathleen Wheeler, Cambridge 1984.
The Aesthetic and Miscellaneous Works of Friedrich von Schlegel, trans. E. J. Millington, London 1849.
Dialogue on Poetry and Literary Aphorisms, trans. Ernst Behler, Pennsylvania 1968.
Lucinde and the Fragments, trans. Peter Firchow, Minneapolis 1971.

Schopenhauer

The World as Will and Representation, 2 vols., trans. E.F.J. Payne, Oxford 1969.
Parerga and Paralipomena, trans. E.F.J. Payne, Oxford 1974.

Nietzsche

The Portable Nietzsche, trans. Walter Kaufmann, New York 1954.

Basic Writings, trans. Walter Kaufmann, New York 1968.
The Will to Power, trans. Walter Kaufmann and R.J. Hollingdale, New York 1968.
There are numerous other easily available Nietzsche translations, particularly by Kaufmann and Hollingdale.

NOTES

As so many German books are published in Frankfurt am Main, I have used the abbreviation Ffm for convenience.

Introduction

1 Hartmut Scheible, *Wahrheit und Subjekt* Ästhetik im bürgerlichen Zeitalter, Bern 1984 p. 77. See also Hans Rudolf Schweizer, *Ästhetik als Philosophie der sinnlichen Erkenntnis*. Eine Interpretation der "Aesthetica" A. G. Baumgartens mit teilweiser Wiedergabe des lateinischen Textes und deutscher Übersetzung, Basel, Stuttgart 1973.
2 J. G. Hamann, *Schriften zur Sprache*, ed. Josef Simon, Ffm 1967, p. 114.
3 Ibid., p. 109.
4 Ibid., p. 116.
5 Ibid., p. 117.
6 Ibid., p. 107.
7 Ibid., p. 107.
8 Jürgen Habermas' latest book *Nachmetaphysisches Denken*, Ffm 1988 pays more attention to some of these figures than he has tended to in other recent work.
9 This issue has also re-emerged in contemporary analytical philosophy, most notably in Thomas Nagel's *The View from Nowhere*, Oxford 1986:

> One limit encountered by the pursuit of objectivity appears when it turns back on the self and tries to encompass subjectivity in its conception of the real. The recalcitrance of this material to objective understanding requires both a modification of the form of objectivity and a recognition that it cannot by itself provide a complete picture of the world, or a complete stance toward it (p. 6).

Nagel seems unaware of most of the tradition considered in the present book, though his arguments suggest a potential new meeting ground for the analytical and continental traditions.
10 Michel Foucault, *Politics Philosophy Culture*, ed. Lawrence D. Kritzman, New York and London 1988, p. 14.

11 Ibid., p. 50.
12. Ibid., p. 95. See also Peter Dews, 'The return of the subject in late Foucault', *Radical Philosophy* 51, Spring 1989, pp. 37–41.
13 Peter Dews, *Logics of Disintegration: post-structuralist thought and the claims of critical theory*, London and New York 1987.

Chapter 1

1 I have used the following editions: all ed. Wilhelm Weischedel: Immanuel Kant, Werkausgabe III and IV *Kritik der reinen Vernunft (KrV)* Ffm 1968; Kant Werkausgabe VII *Kritik der praktischen Vernunft, Grundlegung der Metaphysik der Sitten (KpV, GMS)* Ffm 1968; Kant Werkausgabe X *Kritik der Urteilskraft (KdU)* Ffm 1968. The page references are to the A and B versions of the original editions.
2 Dieter Henrich, *Selbstverhältnisse*, Stuttgart 1982, p. 176.
3 Ibid., pp. 179–83.
4 Manfred Frank, *Eine Einführung in Schellings Philosophie*, Ffm 1985 p. 39.
5 Ibid., p. 43.
6 Arthur Schopenhauer, *Die Welt als Wille und Vorstellung* in *Sämtliche Werke I*, ed. Wolfgang Frhr. von Löhneysen, Ffm 1986, p. 711.
7 Scheible, op. cit. p. 118.
8 Ibid., p. 120.
9 Hans-Georg Gadamer, *Die Aktualität des Schönen*, Stuttgart 1977, p. 25.
10 Scheible, p. 127.

Chapter 2

1 Peter Szondi, *Poetik und Geschichtsphilosophie* Vol 1, ed. Senta Metz, Hans-Hagen Hildebrandt, Ffm 1974, p. 221.
2 Friedrich Schlegel, *Kritische Schriften und Fragmente* Studienausgabe Vols. 1–6, ed. Ernst Behler and Hans Eichner, Paderborn, Munich, Vienna, Zürich, 1988 (*KSF*).
3 See, for example, Xaver Tilliette: "Schelling als Verfasser des Systemprogramms?" in ed. Manfred Frank, Gerhard Kurz, *Materialien zu Schellings philosophischen Anfängen*, Ffm 1975 p. 193–211.
4 Manfred Frank, *Der kommende Gott* Vorlesung über die neue Mythologie I. Teil, Ffm 1982 p. 188.
5 Ibid., p. 158.
6 Ibid., p. 158.
7 Bernhard Lypp, *Ästhetischer Absolutismus und politische Vernunft* Zum Widerstreit von Reflexion und Sittlichkeit im deutschen Idealismus, Ffm 1972, p. 13.
8 Scheible, op. cit. p. 124.
9 Novalis, *Schriften* Die Werke Friedrich von Hardenbergs Vol. 3 Das

philosophische Werk, ed. Paul Kluckhohn and Richard Samuel, Stuttgart 1968, p. 413.

10 Karl Heinz Bohrer: "Friedrich Schlegels Rede über die Mythologie", in ed. Karl Heinz Bohrer, *Mythos und Moderne* Begriff und Bild einer Rekonstruktion, Ffm 1983, p. 56–7. See also Jürgen Habermas, *Der philosophische Diskurs der Moderne*, Ffm 1985 p. 110–5.

11 Ibid., p. 59.

12 Claude Lévi-Strauss, *The Raw and the Cooked*, New York, Hagerstown, San Francisco, London 1975, p. 11.

13 Hamann, op. cit., p. 111.

14 Frank, *Der kommende Gott*, p. 20. See also Jürgen Habermas, op. cit. p. 110–5.

Chapter 3

1 Dieter Henrich, *Konzepte*, Ffm 1987, p. 61.

2 It should be clear from the context that I think the traditional, rather than the Lacanian reading, is apt here. Aspects of Lacan's theories will be apparent in some of the verions of the I in Romanticism.

3 Sigmund Freud, *Studienausgabe* Vol. 1, *Vorlesungen zur Einführung in die Psychoanalyse Und Neue Folge*, ed. Alexander Mitscherlich, Angela Richards, James Strachey, Ffm 1982, p. 497.

4 Henrich, *Selbstverhältnisse*, op. cit. p. 62.

5 Werke 1 and Werke 2 = *Fichtes Werke*, ed. Immanuel Hermann Fichte, Vol 1 Zur theoretischen Philosophie I, Vol 2 Zur theoretischen Philosophie II, Berlin 1971.

6 See Manfred Frank, *Was ist Neostrukturalismus?*, Ffm 1984. See also Peter Dews, *Logics of Disintegration* op. cit., and my "Individuality and *Différance*" in *The Oxford Literary Review* vol. 7, nos. 1–2 1985 p. 117–30.

7 Henrich, *Selbstverhältnisse*, p. 64.

8 Frank, *Eine Einführung in Schellings Philosophie*, op. cit. p. 80.

9 Ibid., p. 78.

10 In ed. Frank, Kurz, *Materialien zu Schellings philosophischen Anfängen* op. cit. p. 124.

11 Friedrich Hölderlin, *Werke Briefe Dokumente*, Munich 1963, p. 490–1.

12 Ibid., p. 517.

13 Ibid., p. 518.

14 Ibid., p. 518.

15 Ibid., p. 519–21.

16 References are to Novalis *Schriften* Die Werke Friedrich von Hardenbergs Vol 2 (*FS*) and Vol 3 Das philosophische Werk I and II, ed. Paul Kluckhohn and Richard Samuel, Stuttgart 1968, and to *Novalis Werke (NW)* ed. Gerhard Schulz, Munich 1981.

17 See Manfred Frank, Gerhard Kurz: ' "Ordo inversus". Zu einer

Reflexionsfigur bei Novalis, Hölderlin, Kleist, und Kafka' in *Geist und Zeichen* Festschrift für Arthur Henkel, Heidelberg 1977 p. 75–92.

Chapter 4

1 *Fichte-Schelling Briefwechsel* ed. Walter Schulz, Ffm 1968, p. 140.
2 References to Schelling throughout are to Friedrich Wilhelm Joseph Schellings *Sämmtliche Werke*, ed. K. F. A. Schelling, I Abteilung Vols. 1–10; II Abteilung Vols. 1–4, Stuttgart 1856–61, Stuttgart 1856–61. The reference includes as the second page number after the / the page numbers of the easily accessible *F. W. J. Schelling Ausgewählte Schriften* Vols. 1–6, Ffm 1985.
3 Frank, Kurz, *Materialien zu Schellings philosophischen Anfängen*, op. cit. p. 41.
4 Ibid., p. 42.
5 Dieter Jähnig, *Schelling. Die Kunst in der Philosophie, Vol. 1, Schellings Begründung von Natur und Geschichte*, Pfullingen 1966, p. 233.
6 Lypp, *Ästhetischer Absolutismus* op. cit. pp. 105–6.
7 Odo Marquard: "Über einige Beziehungen zwischen Ästhetik und Therapeutik in der Philosophie des neunzehnten Jahrhunderts" in Frank, Kurz, *Materialien* p. 341–377. See also Marquard, *Transzendentaler Idealismus, Romantische Naturphilosophie, Psychoanalyse*, Cologne 1987.
8 Scheible, op. cit. p. 264.
9 Frank, *Eine Einführung in Schellings Philosophie*, op. cit. p. 90.
10 Theodor W. Adorno, *Ästhetische Theorie*, Ffm 1973, p. 254.
11 Ibid., p. 255.
12 Ibid., p. 403.
13 Hölderlin, *Werke* op. cit. p. 755.
14 Ibid., p. 757.
15 Martin Heidegger, *Unterwegs zur Sprache*, Pfullingen 1986, p. 254.
16 Ibid., p. 101.
17 See note 6 Chapter 3. See also Manfred Frank: 'Ist Selbstbewusstsein ein Fall von "présence à soi"? Zur Meta-Kritik der neueren französischen Metaphysik-Kritik', in ed. Dieter Henrich and Rolf-Peter Horstmann *Metaphysik nach Kant*, Stuttgart 1988 p. 794–811.
18 Peter Dews, *Logics of Disintegration* op. cit. p. 30.
19 Ludwig Feuerbach, *Grundsätze der Philosophie der Zukunft*, ed. Gerhart Schmidt, Ffm 1983, p. 94.
20 Martin Heidegger, *Sein und Zeit*, Tübingen 1979, p. 11.
21 Walter Benjamin, *Gesammelte Schriften* I, 1, Ffm 1980, p. 207. See also Irving Wohlfahrt: "On Some Jewish Motifs in Benjamin", in ed. Andrew Benjamin, *The Problems of Modernity*, London, New York 1989 p. 157–215.
22 Jochen Hörisch: "Das doppelte Subjekt. Die Kontroverse zwischen Hegel und Schelling im Lichte des Neostrukturalismus", in ed. Manfred Frank, Gérard Raulet, Willem van Reijen, *Die Frage nach dem Subjekt*, Ffm 1988,

p. 158.
23 Feuerbach, op. cit. p. 78.

Chapter 5

1 e.g. Richard Kroner, *Von Kant zu Hegel*, 2 Vols, Tübingen 1924.
2 I have used the following editions of Hegel: *Phänomenologie des Geistes (PG)*, Vol 3 Werkausgabe, ed. Eva Moldauer, Karl Markus Michel, Ffm 1970; *Wissenschaft der Logik* I, II, (*L* I, *L* II) Vol. 5, 6 Werkausgabe, Ffm 1969; *Vorlesungen über die Geschichte der Philosophie* Vol 18, 19, 20 Werkausgabe (*GP* I, II, III Ffm 1971); *Enzyklopädie der philosophischen Wissenschaften (E)*, ed. Friedhelm Nicolin, Otto Pöggeler, Hamburg 1959; *Ästhetik* Vols 1 and 2, (*Ä* I, II) ed. Bassenge, Berlin, Weimar 1965.
3 Habermas, *Der philosophische Diskurs der Moderne*, op. cit. p. 31.
4 Jürgen Habermas: 'Arbeit und Interaktion. Bemerkungen zu Hegels "Jenenser Philosophie des Geistes" ', in ed. Gerhard Göhler, *Georg Wilhelm Friedrich Hegel Frühe politische Systeme*, Ffm, Berlin, Vienna, p. 789.
5 Henrich, *Selbstverhältnisse*, op. cit., p. 155.
6 Hans Georg Gadamer: "Die verkehrte Welt", in ed. Hans Friedrich Fulda and Dieter Henrich, *Materialien zu Hegel's 'Phänomenologie des Geistes'*, Ffm 1973, p. 113.
7 Henrich, *Selbstverhältnisse*, p. 160.
8 Ibid., p. 190.
9 See my "Music, Language and Modernity" in ed. Andrew Benjamin, *The Problems of Modernity*, op. cit. p. 67–85.
10 Jean-Paul Sartre, *L'être et le néant (EN)* Paris 1943.
11 Manfred Frank, *Die Unhintergehbarkeit von Individualität*, Ffm 1986, p. 34.
12 Feuerbach, *Grundsätze*, op. cit. p. 76. As we shall see in the chapter on Nietzsche, Nietzsche is often indebted to Schelling, Feuerbach, and others in ways that have not often been noticed. Compare the following from *The Twilight of the Idols*:
 The *other* idiosyncracy of the philosophers (...) consists of changing round the last and the first. They put that which comes at the end – unfortunately! for it should not come at all – the 'highest concepts', that is the most general, the emptiest concepts, the last puff of evaporating reality, at the beginning as the beginning' (Nietzsche *SW* 6, p. 76).
13 Schelling, *Philosophie der Offenbarung* 1841–2 (PO), ed. Manfred Frank, Ffm 1977.
14 Foucault, op. cit., p. 14.
15 Scheible op. cit. p. 290.
16 Oliver Sacks, *The Man who Mistook His Wife For a Hat*, London 1986 p. 218–9.
17 Adorno, *Ästhetische Theorie* op. cit. p. 103.
18 Ibid., p. 103.

19 Freud, *Studienausgabe* op. cit. Vol 9, p. 559.
20 Genevieve Lloyd, *The Man of Reason* "Male" and "Female" in Western Philosophy, London 1984.
21 Scheible op. cit. p. 359.
22 G. W. F. Hegel, *Philosophie der Geschichte*, Stuttgart 1961, p. 605.
23 Adorno, *Ästhetische Theorie* p. 119.
24 For more on this issue see Peter Dews: "Adorno, Poststructuralism and the Critique of Identity" in *The Problems of Modernity* op. cit. p. 1–22.
25 Jürgen Habermas, *Zur Rekonstruktion des historischen Materialismus*. Ffm 1976, p. 103.

Chapter 6

1 Hamann, *Schriften zur Sprache* op. cit. p. 224–6.
2 In Manfred Frank, *Das Individuelle-Allgemeine* Textstrukturierung und-interpretation nach Schleiermacher, Ffm 1977. See also Frank, *Das Sagbare und das Unsagbare* Ffm 1980. For an ironic counter position, see Jochen Hörisch, *Die Wut des Verstehens*, Ffm 1988, whose rage tends to obscure the subversive aspects of Schleiermacher, however.
3 There is no standard edition of Schleiermacher's work yet; one is being prepared. I have used editions which are not wholly reliable because they include material from other people's lecture notes taken at Schleiermacher's lectures, but where the thinking seemed consistent I have not hesitated to use the texts. The editions are as follows: *Friedrich Schleiermachers Dialektik*. Im Auftrage der Preussischen Akademie der Wissenschaften auf Grund bisher unveröffentlichten Materials, ed. Rudolf Odebrecht, Leipzig 1942 (*D*); *Dialektik (1814–5) Einleitung zur Dialektik (1833)*, ed. Andreas Arndt, Hamburg 1988 (*D* 1814/15), (*D* 1833); *Vorlesungen über die Ästhetik*. Aus Schleiermacher's handschriftlichem Nachlasse und aus nachgeschriebenen Heften, ed. C. Lommatzsch, Berlin, New York 1974 (*Ä*); *Ästhethik (1819/25) Über den Begriff der Kunst* ed. Thomas Lehnerer, Hamburg 1984 (*Ä* Lehnerer), Hamburg 1984; *Hermeneutik und Kritik*, ed. Manfred Frank, Ffm 1977 (*HK*).
4 J. G. Fichte, *Nachgelassene Schriften* Vol. 2, Berlin 1937, p. 161.
5 See Manfred Frank, *Die Grenzen der Verständigung* Ein Geistergespräch zwischen Lyotard und Habermas, Ffm 1988 for a quite devastating critique of *Le différend*. Lyotard considers the argument of the contemporary French fascist, Faurisson, that, because all the direct witnesses of the gas chambers of Auschwitz are dead, one cannot prove that there really were any gas chambers used for mass murder, to be irrefutable. This seems to me like a completely perverse version of being unsure if the light is on when the fridge door is shut: if one gets in the fridge, closes the door, and suffocates, there is no proof; but, of course, even if one survives and gets out there is no guarantee that anyone will believe one's testimony to the presence or

absence of the light. I think there are more important ways of thinking about Auschwitz.

6 Frank, *Die Unhintergehbarkeit von Individualität* op. cit. p. 110.
7 In ed. Hans-Georg Gadamer and Gottfried Boehm, *Seminar: Philosophische Hermeneutik*, Ffm 1976, p. 116.
8 Humboldt, *Schriften zur Sprache*, Stuttgart 1973, p. 57.
9 Gadamar and Boehm, *Seminar* p. 323.
10 Frank, *Die Unhintergehbarkeit* p. 123.
11 Sacks, *The Man who Mistook His Wife For a Hat* op. cit. p. 78.
12 In ed. Florian Rötzer, *Denken, das an der Zeit ist*, Ffm 1987 p. 115.
13 Hamann, *Schriften zur Sprache* p. 224.
14 Michel Foucault, *The Order of Things*, London 1970, p. 304.
15 See Susan McClary, "A Musical Dialectic from the Enlightenment: Mozart's Piano Concerto in G Major, K, 453, Movement 2", in *Cultural Critique* 4, Fall 1986, p. 129–69.
16 Ludwig Wittgenstein, *Philosophische Untersuchungen*, Ffm 1982 p. 226–7, Nos. 527 and 528.
17 In *Ästhetik und Kommunikation* Heft 48 Jahrgang 13 p. 101. See also my "Oskar Negt and Alexander Kluge *Geschichte und Eigensinn*" in *Telos* No. 66, Winter 1985–6 p. 183–190.

Chapter 7

1 Foucault, *The Order of Things*, op. cit., p. 304.
2 Ibid., p. 300.
3 Ibid., p. 305.
4 Freud, *Studienausgabe* Vol. 1, op. cit. p. 462.
5 Ed. Carl Dahlhaus and Michael Zimmermann, *Musik zur Sprache gebracht*, Munich and Kassel 1978, p. 179.
6 Carl Dahlhaus, *Die Idee der absoluten Musik*, Munich and Kassel 1978, p. 14.
7 *Musik zur Sprache gebracht* p. 197.
8 See Frank, *Was ist Neostrukturalismus?* op. cit. p. 360.
9 Georg Lukàcs, *Soul and Form*, tr. Anna Bostock, London 1971, p. 23. I have been unable to get hold of the German text.
10 Paul De Man, *Blindness and Insight* Essays in the Rhetoric of Contemporary Criticism, Second Edition Revised, London 1983, p. 114.
11 Ibid., p. 128.
12 Ibid., p. 130.
13 Ibid., p. 131.
14 Ibid., p. 128–9.
15 Ibid., p. 131.
16 See Charles Lewis: 'Kant and E. T. A. Hoffmann: "The Sandman" ', in *Ideas and Production* 3, 1985, p. 28–43.
17 In Frank, 'Ist Selbstbewusstsein ein Fall von "présence à soi?" ', op. cit.

p. 809.
18 Ibid., p. 811.
19 Frank, *Was ist Neostrukturalismus?* op. cit. p. 601.
20 Sacks, *The Man Who Mistook His Wife For a Hat*, op. cit. p. 77.
21 Marcel Proust, *The Captive*. *Remembrance of Things Past*, Vol. 3, Harmondsworth 1981, p. 260.
22 Friedrich Schlegel, *Literarische Notizen* 1797–1807 (*LN*) ed. Hans Eichner, Ffm, Berlin, Vienna, 1980.
23 Walter Benjamin, *Gesammelte Schriften* I, 1 op. cit. p. 25.
24 Ibid., p. 39.
25 Jacques Derrida, *Positions*, Paris 1972, p. 17.
26. Ibid., p. 41.
27 Benjamin, *Gesammelte Schriften*, I, 1 p. 26.
28 Quoted in Winfried Menninghaus, *Unendliche Verdopplung*. Die frühromantische Grundlegung der Kunsttheorie im Begriff absoluter Selbstreflexion, Ffm 1987 p. 56.
29 Ibid., p. 47.
30 Ibid., p. 87.
31 *Positions*, p. 93–4.
32 Rudolf Bahro, . . . *die nicht mit den Wölfen heulen*, Cologne, Ffm 1979.

Chapter 8

1 T. W. Adorno, *Negative Dialektik*, Ffm 1966, p. 79.
2 References are to Arthur Schopenhauer, *Sämtliche Werke* (*SSW*) ed. Wolfgang Frhr. von Lohneysen, Ffm 1986.
3 Arnold Schönberg, *Style and Idea*, London, Boston 1975, p. 136.
4 Ibid., p. 141.
5 Karl Marx, *Grundrisse der Kritik der politischen Ökonomie*, Berlin 1974 p. 30–1. All references to Marx are to this passage.
6 See my Ph.D. thesis *Problems of Historical Understanding in the Modern Novel*, unpublished dissertation, University of East Anglia 1980. See also Adorno, *Versuch über Wagner* Ffm 1974.
7 Frank, *Der kommende Gott*, op. cit. p. 19.
8 References are to Friedrich Nietzsche, *Sämtliche Werke* Kritische Studienausgabe in 15 Bänden, ed. Giorgio Colli and Mazzino Montinari, Munich, Berlin, New York, 1980 (*SW*).
9 See Wolfgang Lange: "Tod ist bei Göttern immer nur ein Vorteil. Zum Komplex des Mythos bei Nietzsche" in ed. Bohrer, *Mythos und Moderne* op. cit. p. 111–13.
10 See Manfred Frank, *Gott im Exil* Vorlesungen über die neue Mythologie II. Teil, Ffm 1988 p. 55–7.
11 See Habermas, *Der philosophische Diskurs der Moderne* op. cit. Chapters 3 and 4.

12 Lévi-Strauss, *The Raw and the Cooked* op. cit. p. 15–16.
13 See Habermas above.
14 Martin Heidegger, *Unterwegs zur Sprache*. Pfullingen 1959, p. 19.
15 Ibid., p. 124.
16 Ibid., p. 166.
17 Ibid., p. 161.
18 Martin Heidegger, *Nietzsche 1*, Pfullingen 1961, p. 102–3.
19 Ibid., p. 105.

Conclusion

1 Adorno, *Ästhetische Theorie*, op. cit. p. 23.
2 T. W. Adorno: "Uber das gegenwärtige Verhältnis von Philosophie und Musik", in *Gesammelte Schriften* Vol. 18 Musikalische Schriften V. Ffm 1984, p. 157.
3 Ibid., p. 152–3.
4 Adorno, *Ästhetische Theorie*, p. 48.
5 My thanks to Manfred Frank who helped change my mind on this issue.
6 Adorno, Über das gegenwärtige Verhältnis", p. 161.
7 T. W. Adorno *Minima Moralia*, Ffm 1951, p. 11.

INDEX

Bold numbers indicate a chapter or section of a chapter on the author or topic in question.